No. 104. American Willow, (Wound Handle). $6.00 Per Doz.

No. 108. Am. Willow, (Ash Loaded). $9.00 Per Doz. Lightest and Toughest made.

No. 109. Lyman's Patent Self-Adjusting Bat. $9.00 Per Doz.

MUTUAL B.B.C. MODEL.

No. 110. Ash and American Willow Bat. $3.50 Per Doz.

No. 100. Hill's Patent Spring Bat. $9.00 Per Doz. Best Sapling Ash.

No. 101. Hill's Patent Fluted Bat. $6.00 Per Doz. Best American Willow.

No. 102. Picked American Willow Bat. 8.00 Per Doz. Full French Polished.

No. 103. Same as No. 102. Half Polished. $5.00 Per Doz.

No. 153. No. 152.

No. 155. No. 154.

No. 157. No. 156.

No. 165. No. 164.

PECK & SNYDER Manufacturers, 126 Nassau Street, New York.

BASEBALL AMERICANA

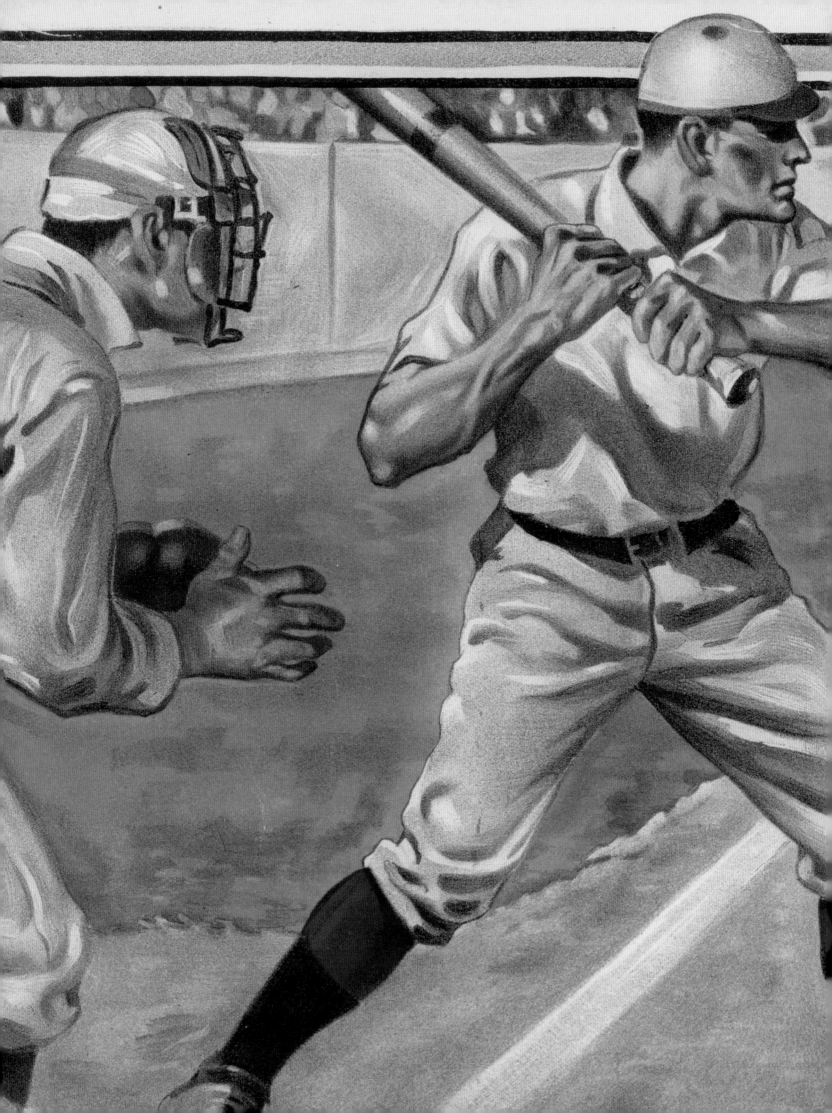

BASEBALL AMERICANA

Treasures from the Library of Congress

Harry Katz

Frank Ceresi ★ Phil Michel ★ Wilson McBee ★ Susan Reyburn

✳ Smithsonian Books

 An Imprint of HarperCollinsPublishers

"B is for Boy,"
The New York Primer,
S. S. & W. Wood, 1837.

Text quoted on page 79 excerpted from *The Glory of Their Times* by Lawrence S. Ritter. Copyright © 1966 by Lawrence S. Ritter. Reprinted by permission of HarperCollins Publishers.

BASEBALL AMERICANA. Copyright © 2009 by Library of Congress. All rights reserved. Printed in China. No part of this book may be used or reproduced in any manner whatsoever without written permission except in the case of brief quotations embodied in critical articles and reviews. For information, address HarperCollins Publishers, 10 East 53rd Street, New York, NY 10022.

HarperCollins books may be purchased for educational, business, or sales promotional use. For information, please write: Special Markets Department, HarperCollins Publishers, 10 East 53rd Street, New York, NY 10022.

FIRST EDITION

Designed by Laura Lindgren

Library of Congress Cataloging-in-Publication Data
Baseball Americana : treasures from the Library of Congress / Harry Katz ... [et al.].
 p. cm.
 Includes index.
 ISBN 978–0–06–162545–9
 1. Baseball—United States—History. 2. Baseball—Collectibles—United States. I. Katz, Harry.
 II. Library of Congress.
 GV863.A1B3758 2009
 796.357—dc22
 2009013148

09 10 11 12 13 OV/LEO 10 9 8 7 6 5 4 3 2 1

CONTENTS

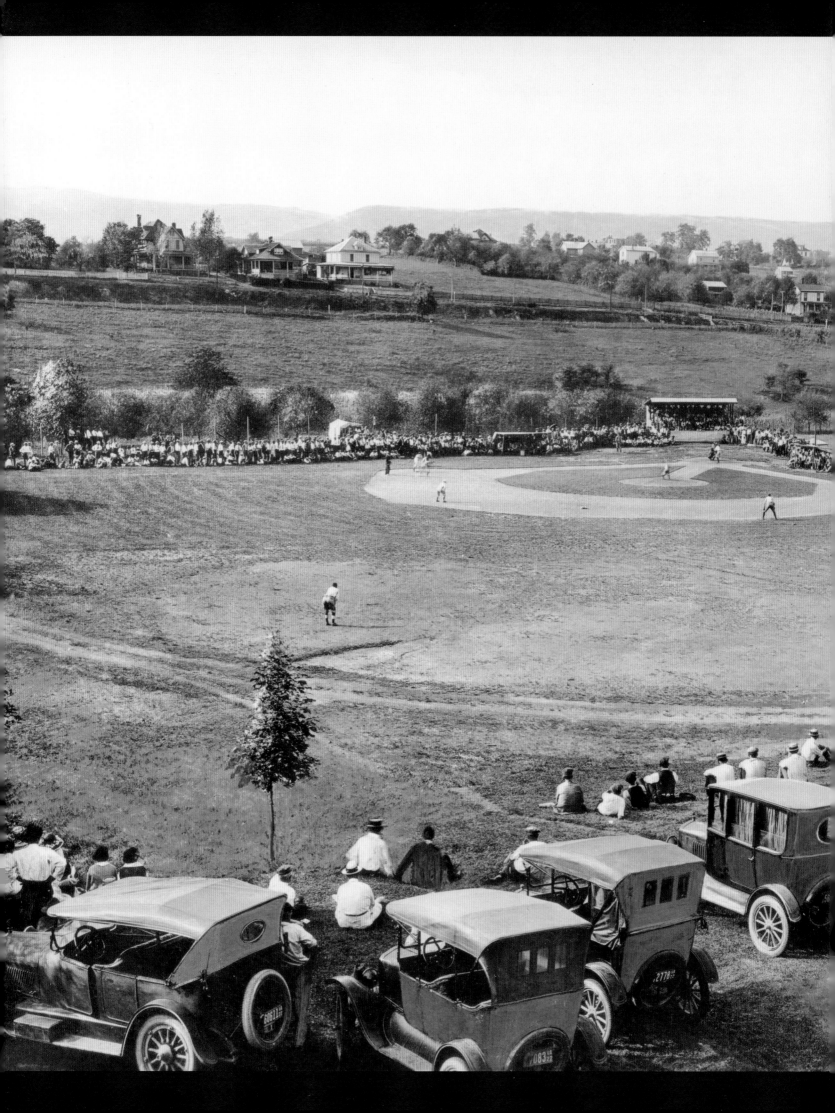

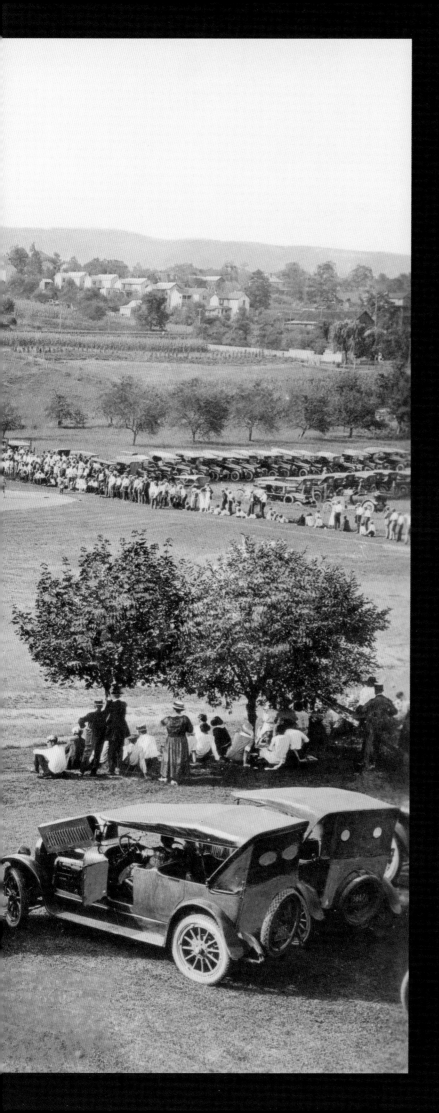

I believe in all that—in baseball,

in picnics, in freedom.

—Walt Whitman,
June 5, 1888

★

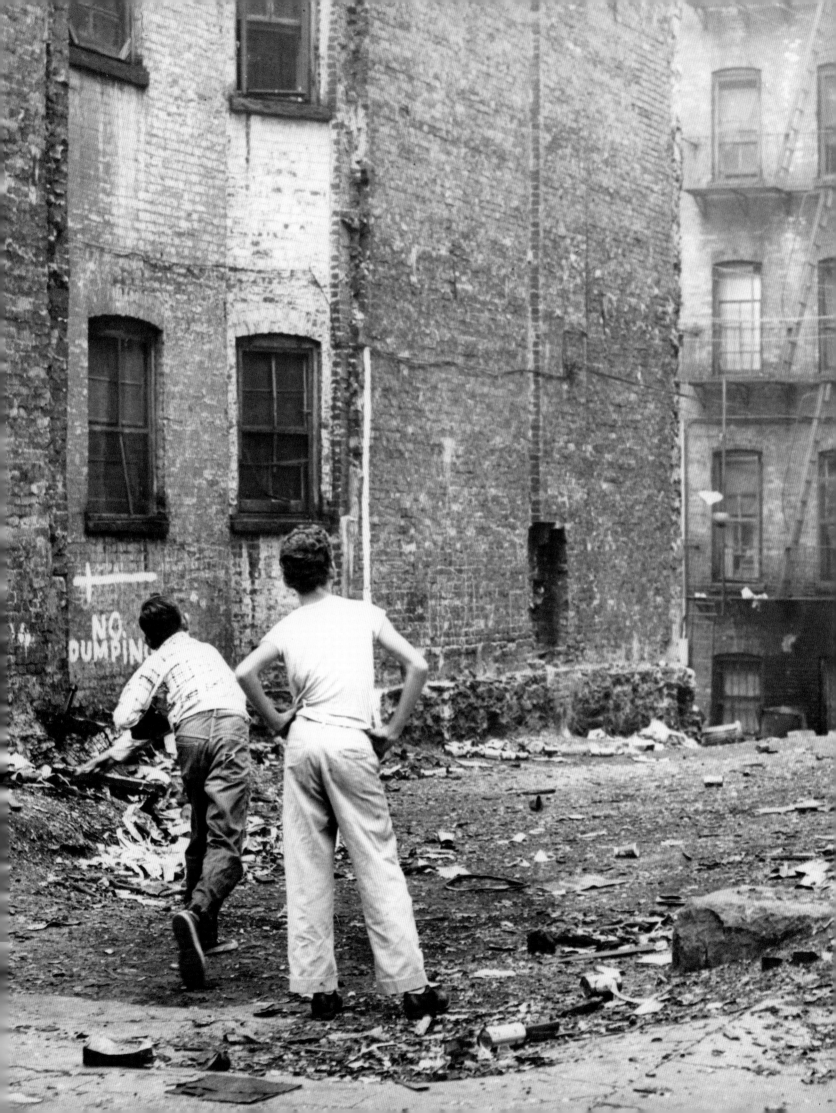

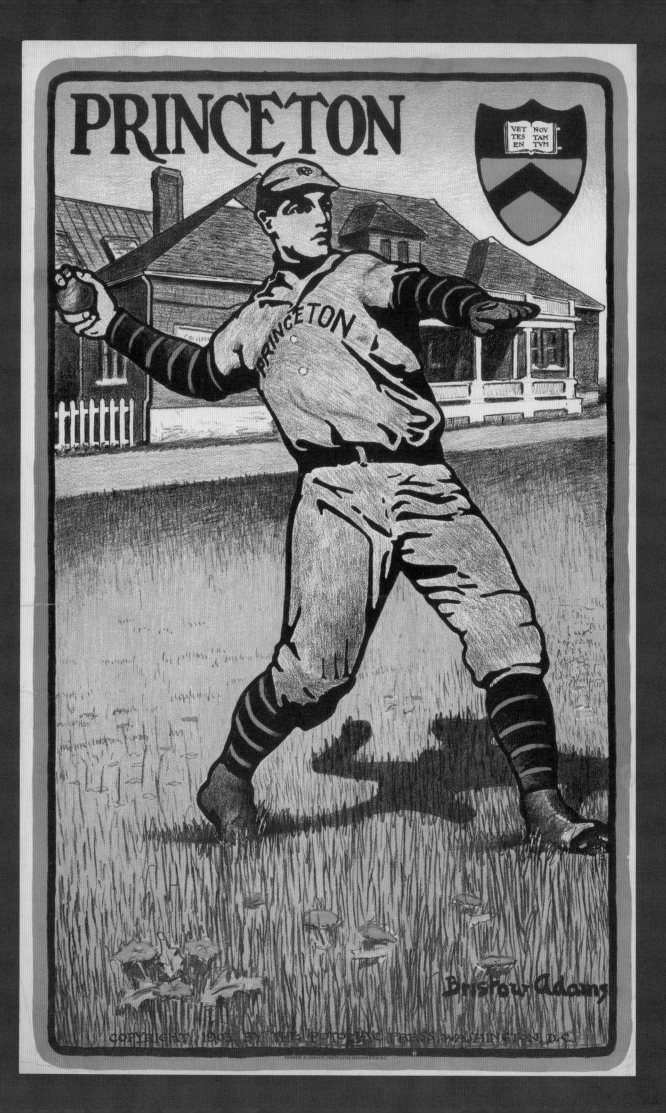

FOREWORD

Have you forgiven your mother yet? I didn't think so, and I don't blame you. When you went off to college, she decided to restore order to your room, to make it more suitable for a college man. In the process, she tossed out what she took to be unimportant detritus of your childhood, including that shoe box—the one your black canvas Converse high-top sneakers came in—overflowing with Topps baseball cards that would have forever held the ambrosial aroma of the pink slabs of bubblegum that came with the cards but were not the point of plunking down your nickel for a pack with five cards.

Have you forgiven yourself? Of course not. When you went off to college you decided to put aside childish things and give yourself over to the life of the mind. So when, as a freshman, you came home at Christmas break, you were a practicing existentialist with Albert Camus' novel *The Stranger* in your hip pocket and Jean-Paul Sartre on your mind. You took one glance around the room you had vacated as a callow youth four months ago and were embarrassed for intellectuals everywhere. Asking yourself "WWKD"—What would Kierkegaard do?—you tossed out that shoebox full of baseball cards. Good grief.

Fortunately, neither your mother nor you could get your hands on the baseball artifacts that the Library of Congress has and that this book celebrates. The library, which surely is the world's most beguiling place not named Cooperstown, has compiled this banquet of baseball artifacts and photographs that illustrates, among many other things, how old baseball is, and how old some of us are.

One hundred years ago, only three sports could capture the nation's imagination—boxing, horseracing, and baseball. And by then, baseball was in its *third* century as an American pastime. On page two of this volume you will find an excerpt from the 1786 diary of an undergraduate at the College of New Jersey (later Princeton). He recorded having trouble "both catching and striking the ball." Well, most of us are failed baseball players.

In the nineteenth century, baseball helped to teach a formerly Puritan nation how to play. And the Civil War, which shattered the nation, spread the game (see pages 21–22) that would soon become one of the nation's shared, and hence unifying, preoccupations. On page 52 you will find a photograph of the 1896 Pittsburgh Pirates, whose leader was a former catcher named Cornelius McGillicudy. As Connie Mack, he owned and managed the Philadelphia Athletics until 1950, when he was eighty-seven.

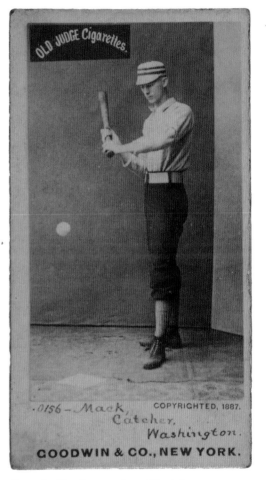

Connie Mack, catcher, Washington Statesmen (American Association), Goodwin & Co., 1887.

OPPOSITE: **Poster by Bristow Adams, published by Andrew B. Graham, Washington, D.C., 1903.**

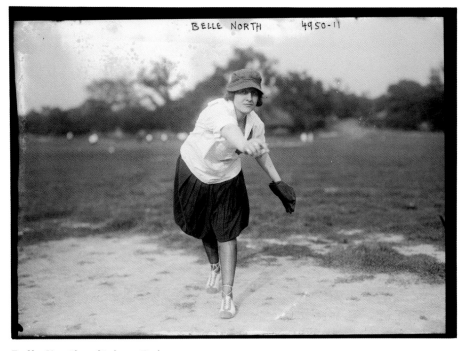

Belle North, pitcher, Bain News Service, 1919.

In 1950, at age nine, this writer saw his first Major League game in Pittsburgh's Forbes Field, a photograph of which, in its 1909 inaugural season, is on page 85. The hit song of the day, "Goodnight, Irene," was being piped through the field's loud speakers. I was visiting my grandfather, a Lutheran minister, up the Monongahela River in Donora, Pennsylvania, home town of Stan Musial, whose face on the cover of *Time* magazine can be seen on page 166. Musial was one of many young Pennsylvanians who saw baseball as a way to avoid a life in their state's coal mines and steel mills. It was not until near the second half of the twentieth century that Pennsylvania lost its rank (to California) as the source of the largest number of Major League players.

Forbes Field was torn down in 1971. Well, most of it was: A bit of the left field wall still stands where is always did, near the University of Pittsburgh. But in 1970 the Pirates moved into Three Rivers Stadium, which they left in 2001 for their new "retro" ballyard which is in some ways an echo of . . . Forbes Field.

We are always being told that we cannot turn back the clock. Nonsense. We can, and sometimes should. Fortunately, baseball has done so with its new old-fashioned ballparks, which are exceptions to the rule that most improvements make matters worse. But, then, because baseball is approximately as old as the Republic—the diary of a soldier at Valley Forge in the winter of 1778 speaks of a game of "base"—the game often has a retrospective frame of mind.

Today's oldest venue, Boston's Fenway Park, opened in 1912, the year the *Titanic* sank. Many Civil War veterans saw games there, and at Wrigley Field, which opened in 1914. Nevertheless, what the Civil War historian, Bruce Catton (1899–1978), said is still true: If you took someone from the era of President McKinley at the end of the nineteenth century and put him or her in a ballpark early in the twenty-first century, the time traveler would feel right at home. The game looks remarkably as it did way back when. Of how much of America can that be said? Readers of this sumptuous book will be time travelers, too, but moving in the other direction, back into the sometimes strange yet strangely familiar past of the game that is permanently present in the nation's mind.

— George F. Will

PREFACE

As a former amateur ballplayer and lifelong fan of the game, it is with great personal pleasure that I introduce this groundbreaking visual history of baseball, drawn exclusively from the Library's pictorial collections. Renowned as the world's greatest repository for books and information, the Library of Congress is also a remarkable treasure trove for special collections, among them the most comprehensive collection of historic baseball images in existence. The Library has acquired and preserved photographs, prints, drawings, cartoons, and other graphic works chronicling the sport's great figures, venues, incidents, and events from creators, collectors, publishers, and numerous other sources. The authors, along with Library of Congress specialists and staff, have plumbed the depths of these holdings, uncovering an array of images produced as far back as 1787, the year the U.S. Constitution was adopted and our nation created.

Contemporary historians have amply documented that neither Abner Doubleday nor the year 1839 were particularly significant in the sport's origins; that widely held birth myth was created by patriotic men solely to anchor baseball's ties to the young United States. In fact, ongoing scholarship indicates that baseball began as one of many English bat-and-ball games brought by citizens and soldiers to the American colonies in the eighteenth century. Each year now seems to bring some startling revelation pushing back the birth of baseball far beyond the familiar historic timeline.

Abner Doubleday's mythmakers meant well but need not have worked so hard to link the sport with the nation. As our authors illustrate with delightful insight and perspective, America and baseball grew up together, a democratic sport for a democratic nation. Transcending class and gender, no other sport is so embedded in our history and consciousness. Walt Whitman, Henry Thoreau, and Mark Twain sang the game's praises while American boys and girls played catch and ran the bases. As with so many Americans, my own youthful efforts as a ballplayer gave way to a spectator's appreciation of the professionals' prowess exemplified by such Major League stars as Jackie Robinson, Mickey Mantle, Frank Robinson, Hank Aaron, and Cal Ripken Jr. Every American generation has come of age with its own perspective on a pristine ball field of grass and dirt, the happy sounds of bat hitting ball, the mad dash for the base, and spectators lustily cheering on the play.

With its emphasis on cunning and coordination, technique and teamwork, baseball enjoys wide-ranging appeal. It has transcended its early roots to become a global game, spanning the world and attracting an international audience. Asian players star in the Major Leagues alongside players from the Dominican Republic, Venezuela, and Cuba. Teams from the United States no longer dominate international tournaments—America's Game is taking on the world.

The Library of Congress has a global reach as well, through the Internet. The Library's award-winning Web site (www.loc.gov) features many of the images included in the book, special online exhibitions, as well as thousands of other baseball and sports-related pictures and documents. Materials from the Branch Rickey papers, the Fay Vincent Oral History Project Collection, the Benjamin K. Edwards Collection, the George Grantham Bain Photo Company, and other great collections from which this book was created are digitally available to a worldwide community of students, teachers, historians, and just plain sports fans.

We can learn a lot about America by looking at baseball. The development of leisure, sports and fitness, entertainment, publishing, consumerism, national advertising, transportation, communications, industrial archaeology, the growth of cities, the cult of celebrity, and the influence of popular culture are just some of the topics scholars will find relevant to the history of baseball in the United States. No sport has ever been as popular or as deeply entrenched in our shared past and collective memory. I am proud to say that no book has ever brought the sport's history so vividly to life as *Baseball Americana: Treasures from the Library of Congress*. Undeniably, preserved at the national library, the National Pastime belongs to we the people.

— James H. Billington
Librarian of Congress

**Young American Indian,
Haskell Institute team mascot,
lithograph, 1902.**

BASEBALL AMERICANA

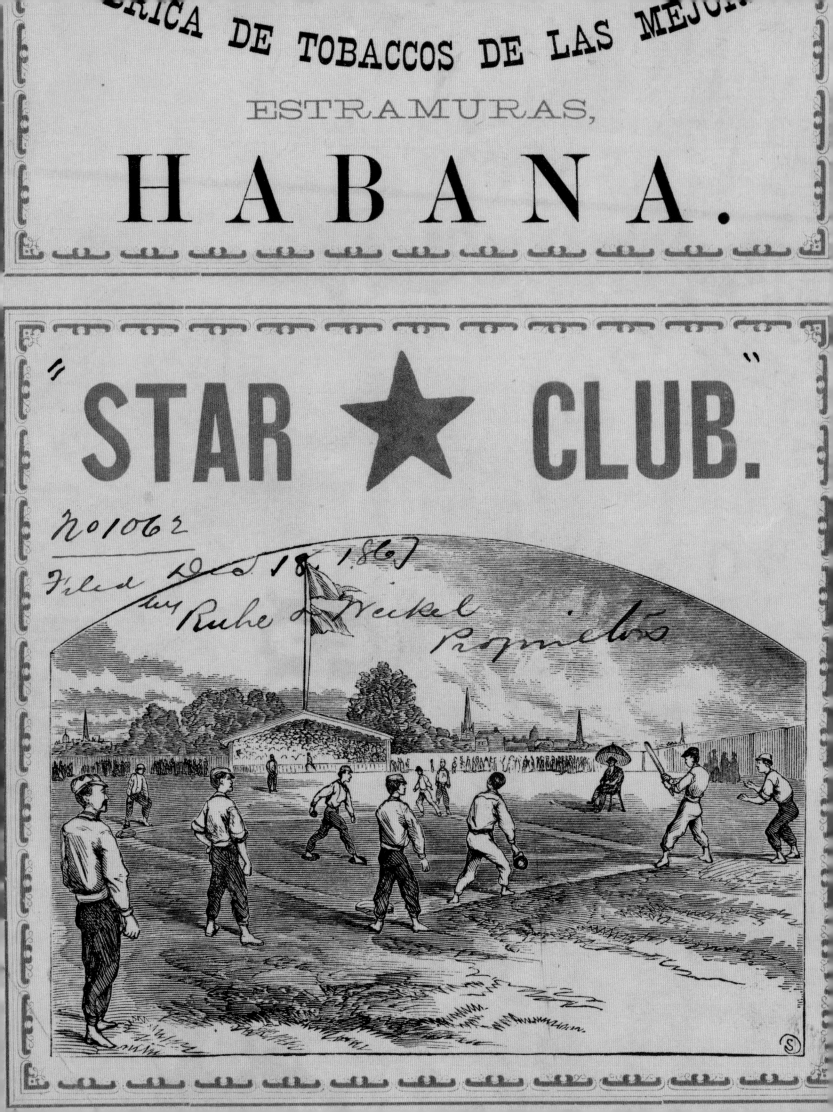

"OLD TOWN" TO YOUR TOWN
⟨The Game's Early Years⟩

The game of baseball was not always the well-ordered sport it became, played on elegantly manicured fields bordered by crisp white lines. As historians debunked the widely held myth that Abner Doubleday of Cooperstown, New York, invented the sport out of whole cloth in 1839, they have discovered its deeper American origins. The game's visual genealogy can be traced back to at least 1787, the same year the Constitution was adopted, when the American edition of an English book for children included in its pages a poem and illustration dedicated to "Baseball." *A Little Pretty Pocket Book,* published in Worcester, Massachusetts, introduced pictorially to the new nation the sport ultimately known as the National Pastime.

OPPOSITE: **Star Club Habana, from wood engraving, tobacco package label, 1867.**

ABOVE AND OPPOSITE: Diary of John Rhea Smith, Nassau Hall, College of New Jersey (Princeton), 1786. Soldiers in the Continental Army had referred to "playing ball"—which could mean a variety of games—in their letters and diaries during the American Revolution, but what may be the first recorded reference to *baseball* in America appears a few years after the war, in the diary of a young college student. Smith, a sociable fellow prone to procrastination in his studies, wrote in March of 1786: "22nd Wednesday A fine day play baste ball in the campus but am beaten for I miss both catching and striking the Ball." Smith's use of the term "baste ball" is curious, yet it is also more precise than simply saying he "played ball," and it is closer to the game's eventual name.

Soon after Smith's graduation, school officials expressed considerable concern about play "with balls and sticks in the back common of the College." According to the minutes of a November 26, 1787, faculty meeting, officials viewed the game as "low and unbecoming" for gentlemen as well as "an exercise attended with great danger to the health by sudden and alternate heats and colds as it tends by accidents almost unavoidable in that play to disfiguring and maiming those who are engaged in it. . . . We are accountable to their Parents & liable to be severely blamed by them. . . . Therefore, the Faculty think incumbent on them to prohibit both the students & grammar scholars from using the play aforesaid."

In 2003, just down the road from Worcester in Pittsfield, Massachusetts, historian John Thorn and former Major Leaguer Jim Bouton located among courthouse records a 1791 statute aimed at protecting the windows in a new town meetinghouse. The statute prohibited anyone from playing "baseball" within eighty yards of the building. From such early archives it is also clear that the developing sport was not universally accepted in the young republic. Towns such as Worcester and even Cooperstown, New York, the future home of the National Baseball Hall of Fame, banned youngsters from playing the game. While George Washington was president, kids already scattered at the sound of breaking glass and others viewed ball games as a public nuisance.

Although tied to such diverse English games as trap ball, old cat, goal ball, and tut ball, as well as a Dutch game called stool ball, baseball developed a separate identity and rules in America, just as the new nation was establishing its own. The earliest pictures of these variants appear in illustrated books for children; they were generally simple vignettes of girls and boys tossing a ball or holding a bat, labeled with the varied names by which the games were called in developing years. These pictorial editions served as decorative books, educational guides, seasonal gifts, and books of poetry and prose. At this initial stage of growth, while horse racing and boxing drew large adult crowds to public arenas, baseball was attracting youthful players locally and informally, creating future ballplayers and the beginnings of a knowledgeable and passionate fan base.

Requiring numerous players on each team, baseball truly began in towns and cities, principally in New England, New York, and the Mid-Atlantic states. More isolated or rural areas to the south and west were exposed to the game later, with the coming of soldiers and settlers from the East. The first teams were

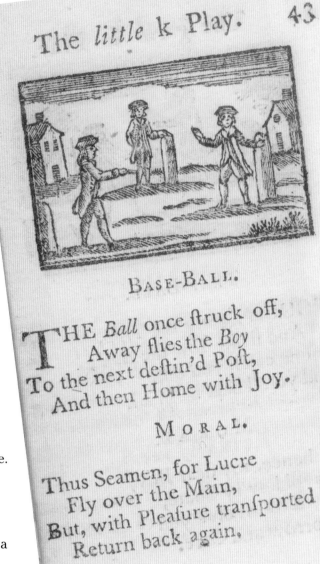

The little k Play. 43

BASE-BALL.

THE Ball once ftruck off,
 Away flies the Boy
To the next deftin'd Poft,
 And then Home with Joy.

MORAL.

Thus Seamen, for Lucre
 Fly over the Main,
But, with Pleafure tranfported
 Return back again,

RIGHT: *A Little Pretty Pocket Book*, **first American edition, 1787.** In 1744, in England, John Newberry published his first children's book, *A Little Pretty Pocket Book*, featuring woodcut illustrations of outdoor activities suitable to "instruct and amuse" children. Over the caption "Base-Ball," three boys play a bat-and-ball game; the accompanying verse refers to a batter striking the ball, running the bases, and then finally heading "home," proving without question that the roots of baseball existed well before the United States of America came into being. The soft, cloth-covered book was reissued many times, and in 1787 Isaiah Thomas published this first American edition in Worcester, Massachusetts.

OPPOSITE: *Youthful Recreations*, **J. Johnson, Philadelphia, 1810.** J. Johnson published this small "chapbook" showing a woodcut of "trap ball," a children's bat-and-ball game similar to the English game of "old cat." Both of these games were early variants of baseball. "All work and no play make Jack a dull boy" the book cautioned. Trap ball, popular with youngsters in early nineteenth-century New England, featured a device connected to a spring (a "trap") that when touched sent the ball flying into the air, and the batter then swung at the ball.

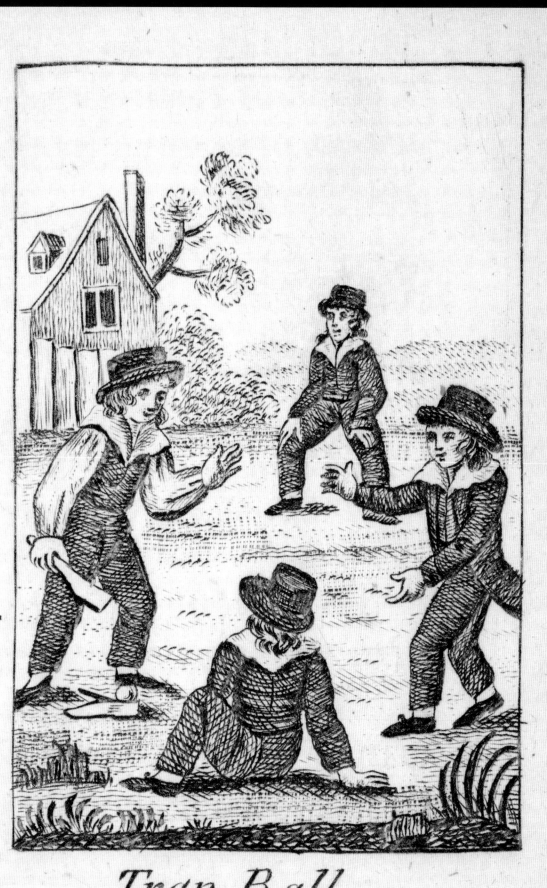

Trap Ball.

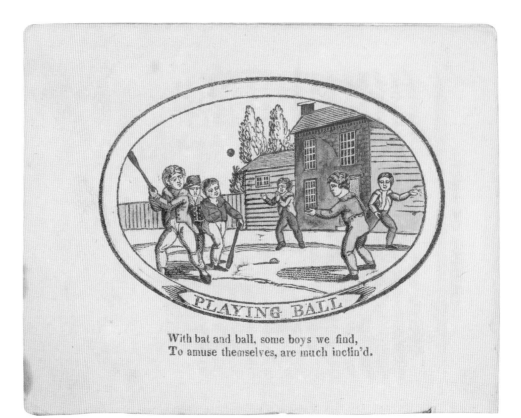

With bat and ball, some boys we find,
To amuse themselves, are much inclin'd.

29

Tossing the Ball.

Tossing the ball is nice amusement for little girls, and it requires a considerable degree of agility to be expert at it : but persevering attention, and practice, will produce wonders ; in short, that which seems almost impossible, is attained thereby. Two or three balls at once have been kept up, and that so prettily, by a little girl, as to astonish the spectators.

If at work, or at play,
 You e'er wish to excel,
In whatever you do,
 You must strive to do well.

typically formed by members of social clubs and workers in factories, organizations that did not exist in the hinterland. Gentlemen, or men of more than moderate income, established baseball clubs early on. They had the time and the means to learn the sport, travel to ball fields and play scheduled games with rival teams, as well as furnish equipment and uniforms.

The glory of nineteenth-century America, however, was the increasing fortunes of an ever-larger middle class. Industrialization gave rise to free time for wage workers as they came off their shifts or enjoyed regular days off. While factory or neighborhood teams often scraped by on limited local means, political or commercial patrons sometimes stepped in to support larger urban clubs. For example, the New York Mutuals, a working-class team in lower Manhattan, represented Tammany Hall, the city's Democratic political machine led by the notorious William Magear "Boss" Tweed in the 1860s and early 1870s.

Despite the game's strong urban roots, the origins of baseball in America have always been thought of and described as pastoral, undoubtedly because the sport requires an open field, meadow, or relatively level, smooth, and trimmed pasture. Baseball's idyllic qualities—a challenging team sport played outdoors and demanding, even showcasing, an individual's special skills—attracted countless enthusiasts of both sexes and all races and of varying social and economic circumstances. Nonathletes, called "muffins" for their tendency to muff plays, also took part.

At first, organized American baseball developed a dual identity. In New England, the sport was known as "town ball" or "the Massachusetts game," featuring base paths laid out in a square instead of a diamond, and a rule allowing fielding players to put out the batter, or "striker," by hitting him with a thrown ball,

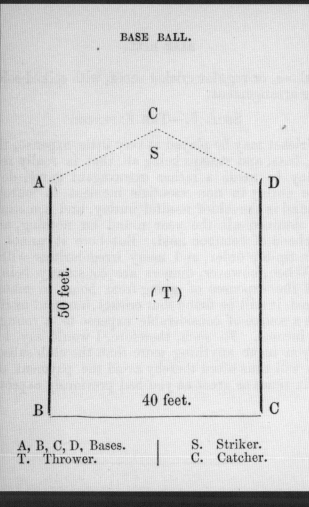

BASE BALL.

A, B, C, D, Bases. | S. Striker.
T. Thrower. | C. Catcher.

"New York Game."

Catcher.

Striker's Home Base.

Point.

15 Yards.

30 yds. l. 3 ft. w.

30 yds. l. 3 ft. w.

Pitcher's ⊚ Point.
Line of 12 ft.

3d Base, 1 ft. square.

1st Base. 1 ft. square.

30 yds. l. 3 ft. w.

30 yds. l. 3 ft. w.

Short stop.

2nd Base, 1 ft. square.

Left Field.

Right Field.

Centre Field.

Diagram of Base Ball Field.

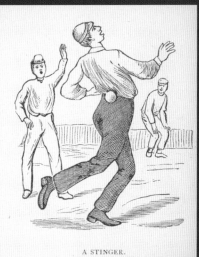

ABOVE: *A Stinger,* **woodcut, 1888.** This image, produced long after the New York rules prevailed among ballplayers, illustrates one of Massachusetts town ball's distinctive features: runners on the base paths could be put out with a well-placed throw to the body.

A STINGER.

ABOVE LEFT: *A Manual of Cricket and Base Ball,* **Mayhew and Baker, Boston, 1858.** The first twenty pages of this soft, cloth-covered booklet is devoted mainly to the English game of cricket, but it is the final four pages on baseball that give it historical importance. Furthermore, the book was published during a time when baseball clubs were rapidly being organized across the land. The booklet's most important illustration features a simple and easily understood diagram of "the Massachusetts Game" that was so popular in New England at the time. Accompanied by text that lays out the basic rules of the game, the diagram is the first printed illustration of a baseball field geared toward an adult audience, and the manual played an important role in spreading knowledge of baseball rules.

ABOVE RIGHT: *The Base Ball Players Pocket Companion,* **Mayhew and Baker, Boston, 1859.** Considered perhaps the most important of all of the early American baseball books, the slim *Pocket Companion* is devoted almost entirely to contrasting "the Massachusetts Game" (or "old Town Ball") with "the New York Game." The book is of extraordinary historical importance, published as it was at the height of the controversy over which region's rules would govern the sport. The *Companion* goes on to describe the New York Game as "fast becoming in this country what cricket is to England, a national game. . . ." The book features woodcuts portraying players referred to as "Throwers" (pitchers), "Catchers," "Base Tenders," and "Strikers" (batters). It also included an influential club constitution that was replicated by baseball teams then forming nationwide.

RIGHT: *The Striker,* **1859.**

OF BASE BALL. 17

THE STRIKER.

2*

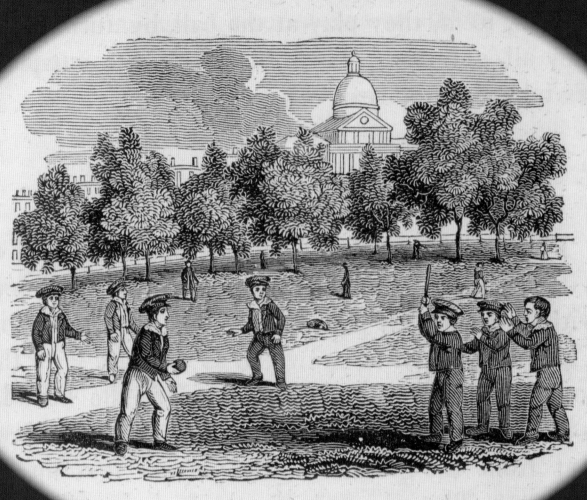

Playing Ball.

Playing Ball—Book of Sports, **Robin Carver, Lily, Wait, Colman and Holden, Boston, 1834.** Schoolboys play ball on Boston Common, the nation's first public park, a leafy retreat at the city's historic heart. Generations of Bostonians grew up playing sports on the Common in the shadow of the elegant Charles Bulfinch-designed statehouse, completed in 1798. While ballplayers shared the field with local livestock, by the 1850s, cows were banned and organized regional games featured such teams as the Boston Olympics and South Walpole Rough and Readys. Baseball fields still span the spot where the sport has been played since the early nineteenth century.

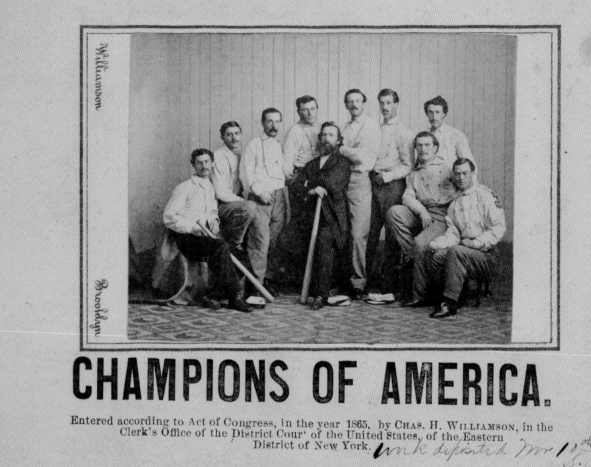

Base Ball Club

CHAMPIONS OF AMERICA.

Entered according to Act of Congress, in the year 1865, by CHAS. H. WILLIAMSON, in the Clerk's Office of the District Court of the United States, of the Eastern District of New York.

called "soaking," before he reached base. Town ball flourished in New England and elsewhere on the eastern seaboard. A group of young men in Philadelphia who formed the Olympic Ball Club to play town ball in 1833 may have been the very first organized baseball-related team in America. In 1838, they created and published rules aptly called their "constitution."

The Philadelphia Olympics established a precedent if not a model for the Knickerbocker Base Ball Club of New York, which had a far-reaching and sensational impact on the sport. Conceived and created in the 1840s by a group of upper-middle-class gentlemen in Manhattan, the Knickerbockers met regularly to play "for health and recreation." They competed against each other and occasionally against teams from other boroughs. In 1845, Knickerbocker Alexander Joy Cartwright, a bank teller and part-time volunteer fireman, suggested that the team play scheduled games against local clubs. To govern these games, on September 23, 1845, the Knickerbockers instituted what came to be known as the "New York rules." They subsequently took their game beyond an increasingly crowded Manhattan to Hoboken, New Jersey, where they practiced and played on a grassy sward called Elysian Fields, overlooking the Hudson River.

Champions of America, baseball card, Charles H. Williamson, 1865. Established in 1855, the Brooklyn Atlantics dominated the first decade of baseball in New York City, winning championships in 1861, 1864, and 1865, when local photographer Charles Williamson produced this remarkable team portrait. Considered perhaps the earliest extant dated collectible baseball "card," this photographic souvenir was handed out to supporters and even opposing teams in an admirable gesture of bravado from the brash Brooklynites.

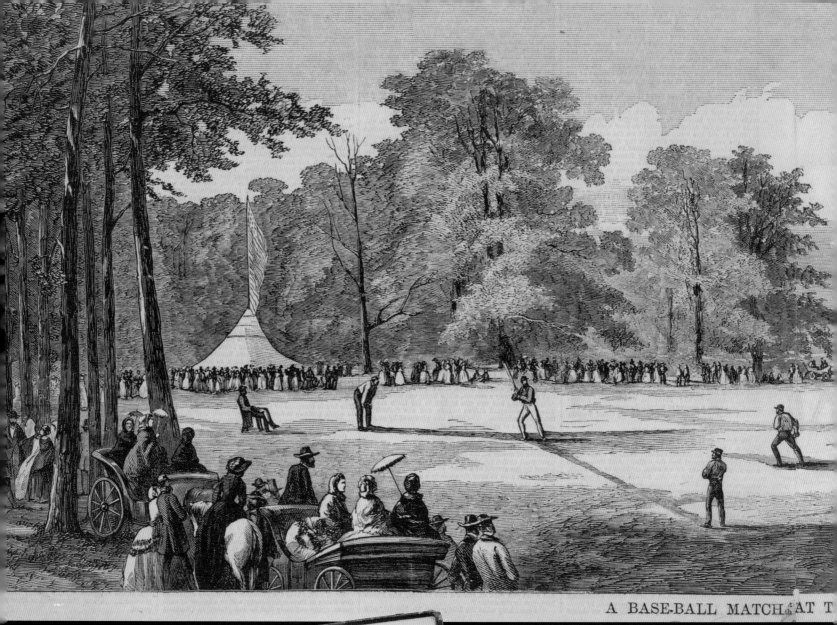

A BASE-BALL MATCH AT T

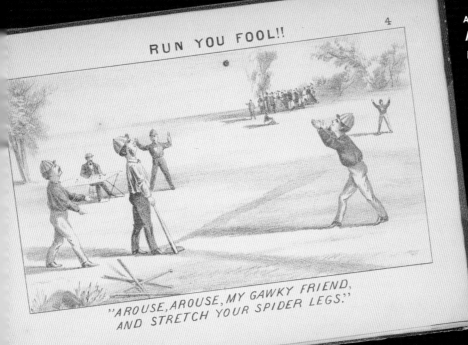

RUN YOU FOOL!!

"AROUSE, AROUSE, MY GAWKY FRIEND, AND STRETCH YOUR SPIDER LEGS."

ABOVE: *A Baseball Match at the Elysian Fields, Hoboken*, print from wood engraving, 1859. As lower Manhattan filled with new immigrants, new streets, new businesses, and new buildings, base-ballers sought greener, quieter pastures beyond the city's bounds. They found a home across the Hudson River in Hoboken, New Jersey, where open lands beckoned a ferry ride away. The Elysian Fields grounds became a popular destination for participants and spectators enjoying both the new sport and a respite from city stress. *Harper's Weekly*, the nation's leading pictorial journal, published companion illustrations of cricket and baseball matches played at the Elysian Fields in its October 15, 1859, issue, with the following thoughts:

> Our advice to all who wish to understand these games is, to go and see them played, and after that to learn them on the field. They will thus not only be enabled to understand the accounts in the news-papers, but will likewise develop their muscles and improve their stamina.

LEFT: *"Run You Fool!!,"* from *Baseball as Viewed by a Muffin*, S. Van Campen, 1867.

ELYSIAN FIELDS, HOBOKEN

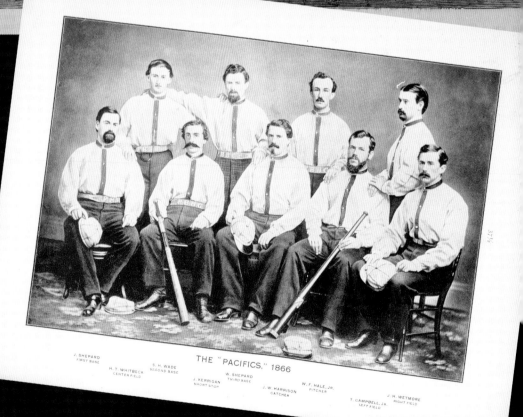

THE "PACIFICS." 1866

J. SHEPARD
FIRST BASE

H. T. WHITBECK
CENTER FIELD

S. H. WADE
SECOND BASE

J. KERRIGAN
SHORT STOP

W. SHEPARD
THIRD BASE

J. W. HARRISON
CATCHER

W. F. HALE, JR.
PITCHER

T. CAMPBELL, JR.
LEFT FIELD

J. H. WETMORE
RIGHT FIELD

RIGHT: **The Pacifics, 1866.** Baseball spread to the West Coast by the 1840s with settlers pursuing land, opportunity, and gold, and U.S. troops sent to take possession of the territories. Transplanted New Yorkers encouraged San Francisco baseball, and with brothers William and James Shephard, who had played with the Knickerbockers at Elysian Fields, founded the Pacific Base Ball Club in 1862. In 1866, the city hosted the Pacific Base Ball Convention.

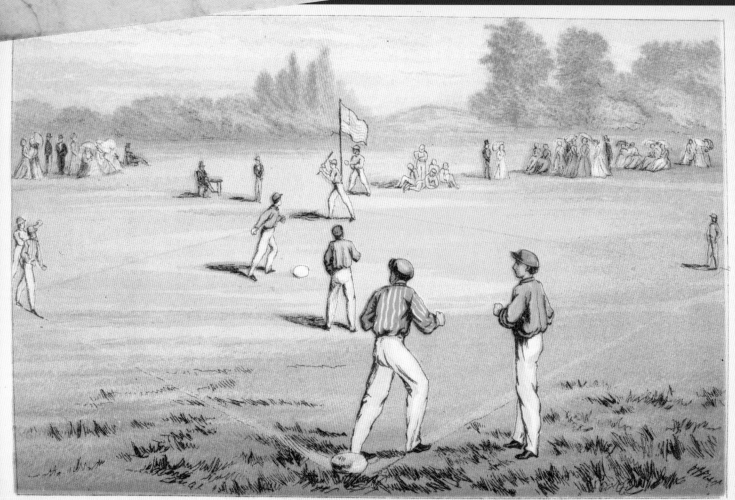

AMHERST EXPRESS.

EXTRA.

WILLIAMS AND AMHERST
BASE BALL AND CHESS!
MUSCLE AND MIND!!

July 1st and 2d, 1859.

LEFT: *Amherst Express. Extra.* July 1 and 2, 1859. In the summer of 1859, two neighboring New England liberal arts colleges met in a calculated test of muscle and mind; these concurrent baseball and chess matches between Amherst College and Williams College, played at a neutral site to ensure fairness, were the country's first organized intercollegiate games. At the time, organized baseball was about a year old on both campuses. According to the broadside, experienced players were few and sides were chosen by ballots from the students at large. The teams played Massachusetts Rules, with thirteen players per side.

On game day, the crowd enjoyed "glorious" weather, "Williams appeared in the uniforms of club belts, Amherst decidedly in undress ... The Amherst ball was 2½ oz. and 6½ inches around. It was made by Mr. Henry Hebard of North Brookfield, Mass., and was really a work of art. The Williams ball we judged to be 7 inches in circumference and not to exceed in weight 2 oz. It was also covered with some leather of light color, drab or buff, so as not too easily distinguished by the batter." By comparison, modern Major League balls must weigh 5 to 5¼ ounces and measure 9 to 9¼ inches around.

Foreshadowing countless college victory rallies to come, news of Amherst's dominating 73-32 win sparked a campus-wide celebration: "In a few moments the students were assembled en masse upon the college hill. The chapel bell joined in the general jubilee, and sent forth its merriest peals. A large bonfire was kindled, and the event was celebrated with a copious display of enthusiasm and rockets."

BELOW: **Baseball scene,** *American Boy's Book of Sports and Games*, Dick & Fitzgerald, New York, 1864.

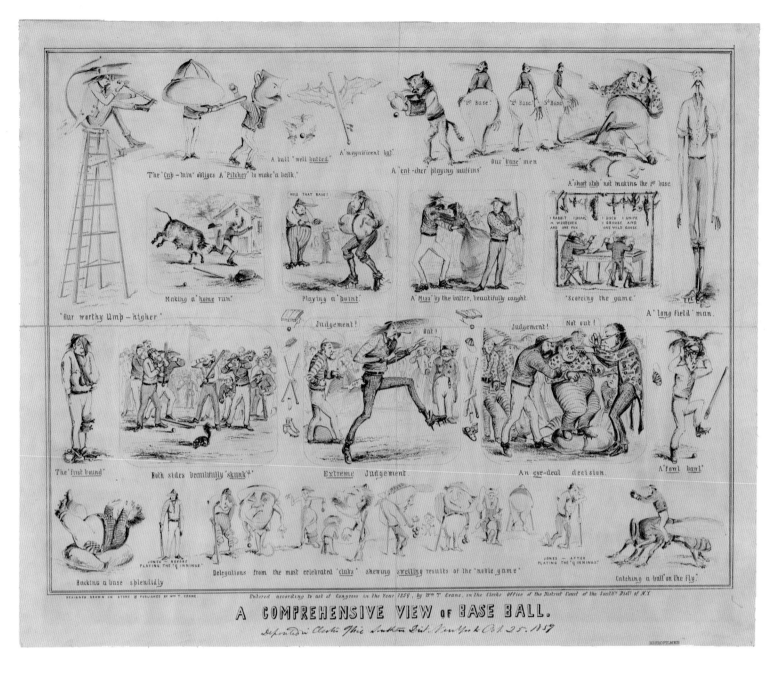

By the 1850s, New York City was a hotbed of baseball enthusiasm. The Knickerbockers, their cross-town rivals the Gothams, and other clubs such as the Mutuals, Eckfords, Unions, and Brooklyn Atlantics played regularly scheduled contests before crowds that often traveled some distance to see them, and players began to distinguish themselves by their performance on the field. New York City was home to a burgeoning newspaper industry with a rapidly expanding regional and national readership. The press championed the sport, promoting big games and sensationalizing newfound stars. Transplanted Englishman and cricket booster Henry Chadwick became the country's first sportswriter, developing a passion for baseball and numerous innovations in the new field of sports journalism. Known even during his own lifetime as the "Father of Baseball," he tirelessly promoted the sport, and through his singular advocacy he helped solidify baseball as America's game.

Chadwick and a few others introduced box scores and game accounts to the sports pages, and game results were sent swiftly across the country, hastened along by other nineteenth-century innovations, such as the railroad and the telegraph.

A Comprehensive View of Base Ball, **William T. Crane, 1859.** Contemporary cartoon art is always a harbinger of popular trends, and baseball's introduction into comic drawings beginning in the 1850s reflects the sport's growing presence. This particular page of satirical vignettes by comic artist William Crane of New York City reveals his knowledge of the game through visual puns and graphic caricatures featuring scenes and slang already funny and familiar to his readers.

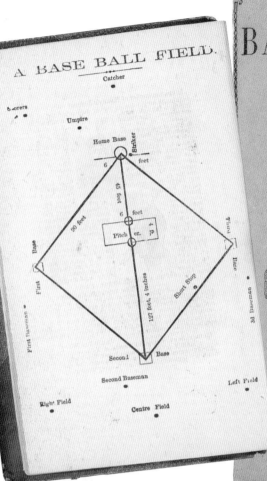

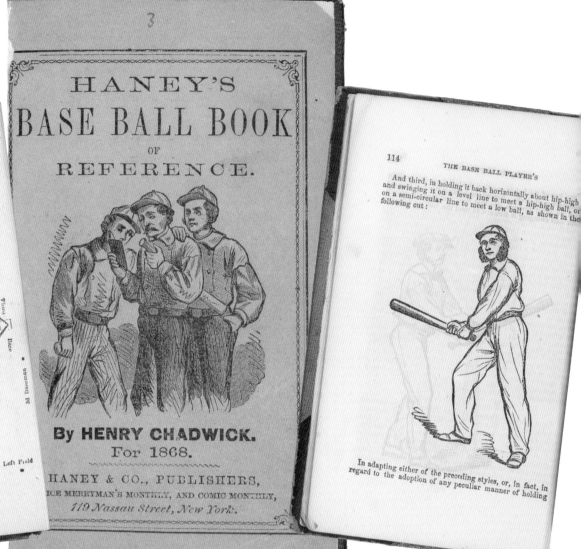

ABOVE: *Haney's Base Ball Book of Reference*, Henry Chadwick, Haney & Co., New York, 1868. The first comprehensive baseball book ever published, *Haney's* is especially significant not only because it contains "official" rules of the game, but also because it is filled with illustrations covering all aspects of pitching, fielding, and baserunning. The book's author, Henry Chadwick, often called the first serious baseball journalist, is credited with inventing the box score, among other innovations. His guide also contains rules for umpires and scorekeepers, the men tasked with keeping order and statistics during the game. In addition, the book features the first advertisements for bats, belts, shoes, uniforms, and other baseball apparel. There is even a section on how to play baseball on ice!

OPPOSITE: *Beadle's Dime*, dime novel, Beadle and Company, New York, 1868.

In 1857, the Knickerbockers and fifteen other clubs formed the National Association of Base Ball Players (NABBP). Their stated goal was to "promote additional interest in baseball playing" and to "regulate various matters necessary to its good government and continued respectability." Basing their game on the Knickerbockers' original rules, the NABBP also codified that there would be nine men to a side, bases would be ninety feet apart, and an umpire would have the power to call strikes. Furthermore, no one could catch the ball in their cap, only barehanded (the use of baseball gloves would not become standard until the late 1880s). Finally, the players decreed that no one was ever to be paid to play, although the trend of luring talented players to join teams in return for cushy local jobs had already begun. While much of what the NABBP dictated has remained in place into the modern era, their adherence to amateurism would soon be tossed aside.

In fact, team owners and managers, players, proprietors of potential game venues, and spectators soon realized the sport's vast commercial possibilities. Just one year after the NABBP formed, thousands of fans flocked to Long Island's Fashion Race Course, originally constructed for horse racing, to witness a three-game series between the "New York All Stars" and their Brooklyn counterparts.

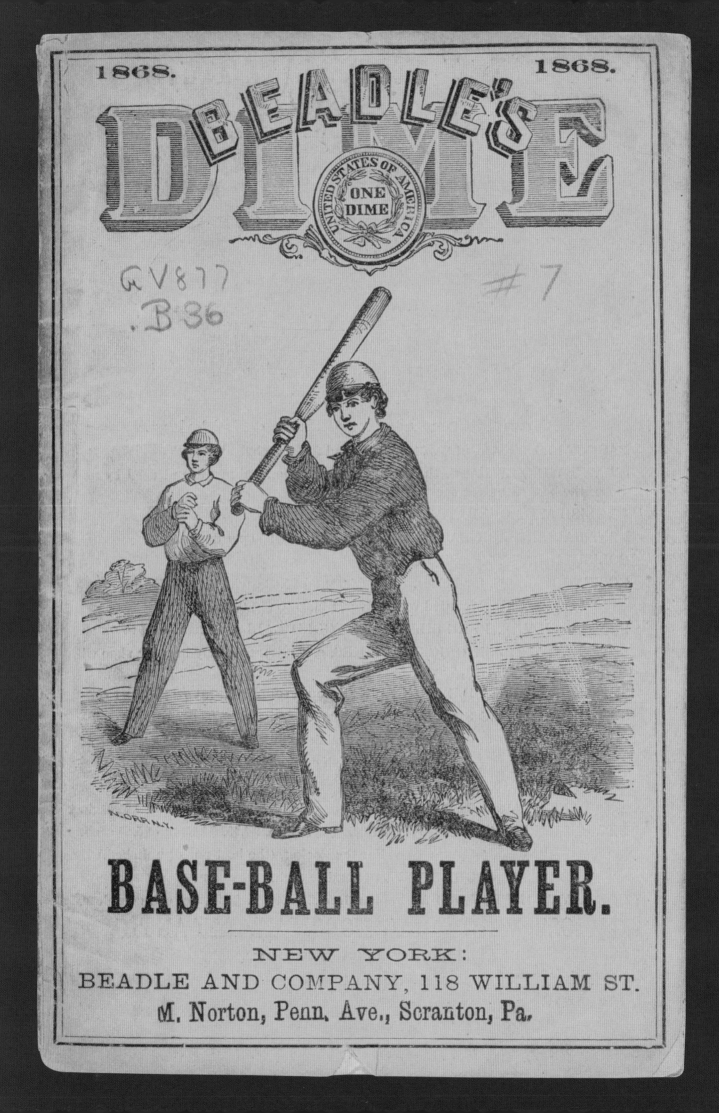

1868. 1868.

BEADLE'S DIME

ONE DIME

UNITED STATES OF AMERICA

GV877
.B36

#7

BASE-BALL PLAYER.

NEW YORK:
BEADLE AND COMPANY, 118 WILLIAM ST.
M. Norton, Penn. Ave., Scranton, Pa.

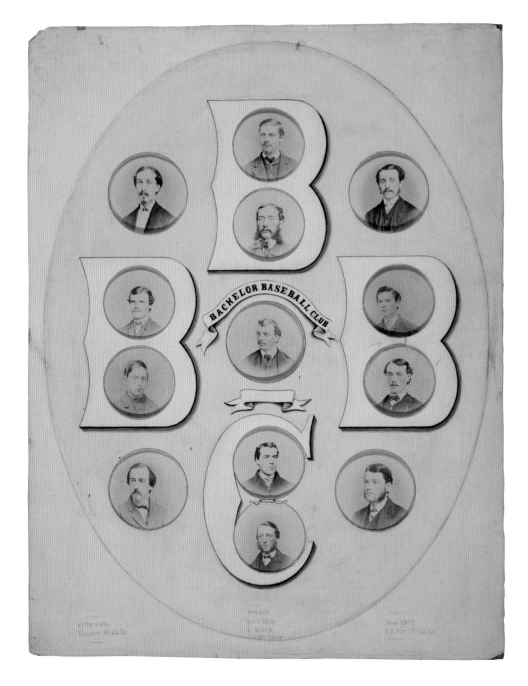

Bachelor Baseball Club, prints on carte-de-visite mounts, 1867. Baseball clubs formed around myriad social, political, and economic groupings, organizations, and societies. This unusual, possibly unique graphic artifact portrays the "Bachelor Baseball Club" from 1867. Presumably, only unmarried ballplayers came to bat for this picked nine. Portrait photographs during the Civil War era often took the form of cartes-de-visite, or calling-card-size photographs mounted on cardboard stock for durability. The individual portraits could be exchanged with friends, family, and loved ones, or incorporated into albums or elaborate large-format displays like this one. These cartes-de-visite, or their larger cabinet-style cousins, often bear photographers' imprints or inscriptions identifying the subjects. Experts consider such cards among the earliest collectible baseball cards.

Spectators paid fifty cents each to see the New Yorkers win two out of three and the opening of a new era in American sports history. The series' success, the standardization and game improvements resulting from the NABBP rules, and the city's powerful, influential press all helped make the "New York rules" the national standard, superceding the "Massachusetts game" and laying the foundation for the modern sport of baseball.

Throughout the nineteenth century, it might be argued, politics remained America's favorite spectator sport. Certainly in 1860, baseball took a backseat to the drama playing out in Washington, D.C., and state capitals across the nation. Abraham Lincoln's election as president in November set off a storm of anti-Northern, antiabolitionist sentiment in the South, and within five months the United States was engulfed in civil war. Ironically, historians agree that the Civil War greatly accelerated baseball's popularity. Soldiers from the Northeast

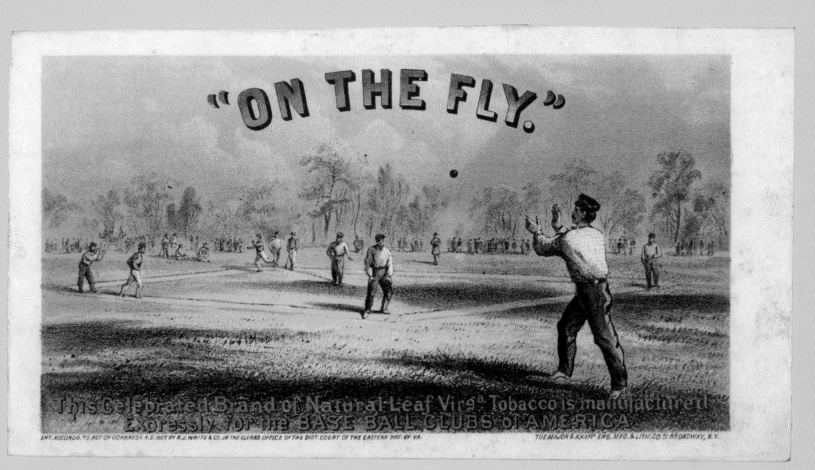

On the Fly, chromolithograph, tobacco package label, 1867. Pictorial advertising labels embellished commercial American cigar and tobacco boxes and bags as early as the 1840s. Beginning in the 1860s, they depicted baseball scenes. Printers made great strides in producing color after 1850, and the labels became increasingly ornate and decorative. Tobacco manufacturers and distributors selling Cuban cigars or Virginian and Turkish leaf vied with each other to attract buyers with bold, vibrant colors and contemporary scenes.

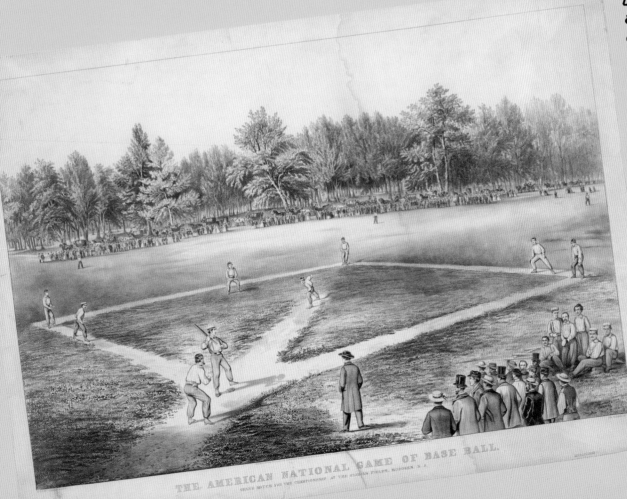

The American National Game of Baseball, **Currier & Ives, 1866.** America's greatest print publishers had their fingers firmly on the pulse of the nation during the mid-nineteenth century, and just as baseball was gaining widespread popularity following the Civil War, Currier & Ives created this panoramic view. The unifying "American" theme of sports, baseball instead of bullets, was not lost on a commercial firm seeking markets in a "Reconstructed" United States. Such telling details as the lack of gloves and the pitcher's underhand delivery emphasize the rudimentary origins of the sport and the documentary value of these early images.

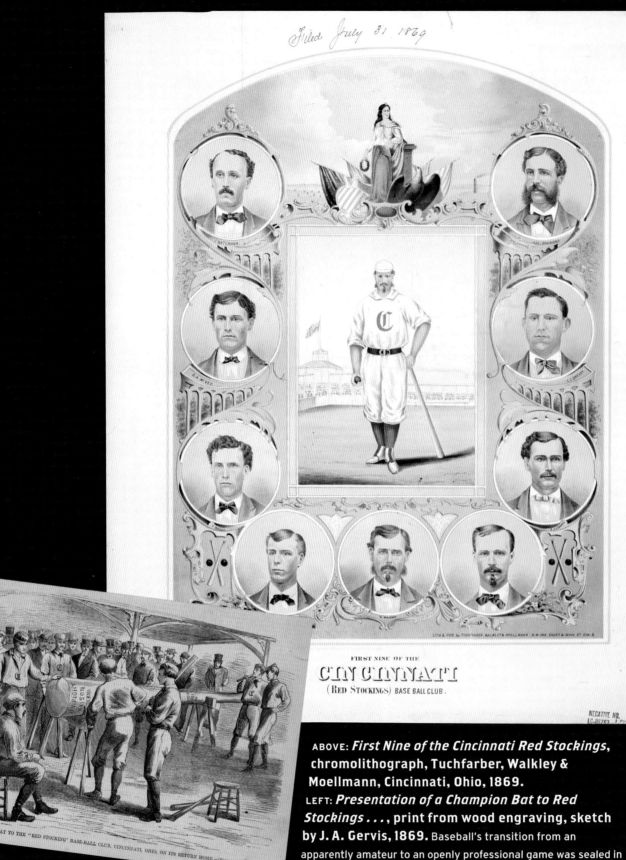

Filed July 31, 1869

FIRST NINE OF THE

CINCINNATI

(RED STOCKINGS) BASE BALL CLUB.

NEGATIVE NO.
LC-US262 [...] MICROFILMED

A CHAMPION BAT TO THE "RED STOCKING" BASE-BALL CLUB, CINCINNATI, OHIO, ON ITS RETURN HOME.—(SKETCHED BY J. A. GERVIS.)

ABOVE: *First Nine of the Cincinnati Red Stockings*, chromolithograph, Tuchfarber, Walkley & Moellmann, Cincinnati, Ohio, 1869.

LEFT: *Presentation of a Champion Bat to Red Stockings . . . ,* print from wood engraving, sketch by J. A. Gervis, 1869. Baseball's transition from an apparently amateur to an openly professional game was sealed in 1869. That year the Cincinnati Red Stockings, boasting the country's first fully salaried starting nine, swept through their season schedule undefeated. The "Red Legs" were led by player-manager Harry Wright, a former cricketer, and his younger brother George, both veteran talents, along with a mercenary roster featuring pitcher Asa Brainard and infielders Fred Waterman and Charles Sweasy. Of the picked nine, only first baseman Charles Gould called Cincinnati home. The team remained unbeaten well into 1870, reeling off twenty-seven more wins before succumbing to the Brooklyn Atlantics in extra innings. The Red Stockings' success quickly convinced other owners to stock their teams exclusively with paid players, and amateurs were soon banned outright from the professional leagues.

who were already familiar with the game cured their boredom and cheered themselves in camp by playing ball. Officers encouraged such games to foster camaraderie and improve morale, regiments challenged each other, and friendly rivalries developed during peaceful interludes. (There are even accounts of contests between Union and Confederate teams.) As skilled ballplayers instructed their untutored comrades-in-arms, interest in the game spread. On one occasion a game literally spread into dangerous territory, when Rebel soldiers came upon members of the 114th New York regiment at play. They captured the center fielder and—perhaps even worse for the Yankees—made off with their ball.

After the war ended, Army servicemen and veterans spread baseball to every region of the country. Weary of conflict, Americans embraced the game for the sheer fun and joy of playing and watching it. Baseball proved an effective antidote for a nation seeking refuge from the sorrow and shock of burying their beloved assassinated president, Abraham Lincoln, along with the hatreds and animosities engendered by the war. Abe was said to have enjoyed playing ball as a young legislator in Springfield, Illinois, during the 1840s, and it has been suggested that as president he and his young son Tad actually viewed a baseball game in progress on a lot adjacent to the White House. Lincoln's successor, Andrew Johnson, was the first president to formally meet with a baseball club in the White House, a practice that continues.

The postwar era marked baseball's first golden age. Laborers could beat gentlemen, mechanics best attorneys, Southerners defeat Northerners, or Baptists battle Methodists on the field with no hard feelings. For a while, blacks could challenge whites; occasionally people of color played on integrated teams from the lowest to the highest levels until the late 1880s, when baseball's Major Leagues barred black players until 1947. After the Civil War, Octavius V. Catto made news as a civil rights activist and community leader among black Americans in Philadelphia, where he organized and played for the Pythian Base Ball Club. The 1869 match between the Pythians and New York Olympics is considered the first formally organized game between white and black teams. Overall, the sport had a democratizing and unifying effect during the Reconstruction era. For many Americans, baseball became a cherished childhood memory.

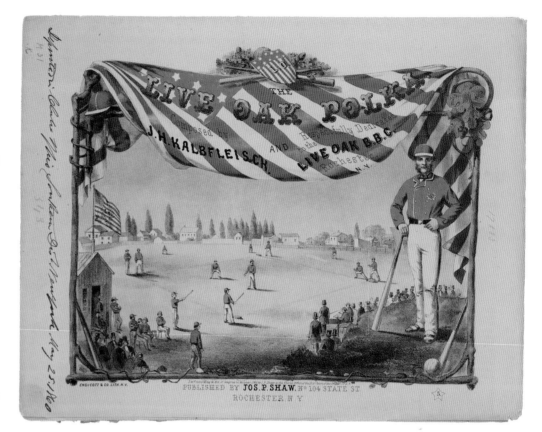

ABOVE: **"The Live Oak Polka," sheet music cover, 1860.**

OVERLEAF: *Union Prisoners at Salisbury, North Carolina*, Otto Boetticher, lithograph, Sarony, Major & Knapp, New York, 1863. There is no question that during the Civil War, Union soldiers took baseball seriously as a healthful pastime to relieve stress and while away their time in captivity. The Confederate prison camp at Salisbury, North Carolina, for example, was known for the quality of baseball played by its Northern inmates, and the spread of baseball to the South through this unusual and unfortunate venue is undisputed. As the war progressed and the quality of life and survival rate among Northern prisoners declined, no doubt baseball and other forms of exercise were dramatically curtailed. For a time, however, soldiers could reclaim their sense of freedom by swinging a bat and perhaps hitting the ball over the stockade.

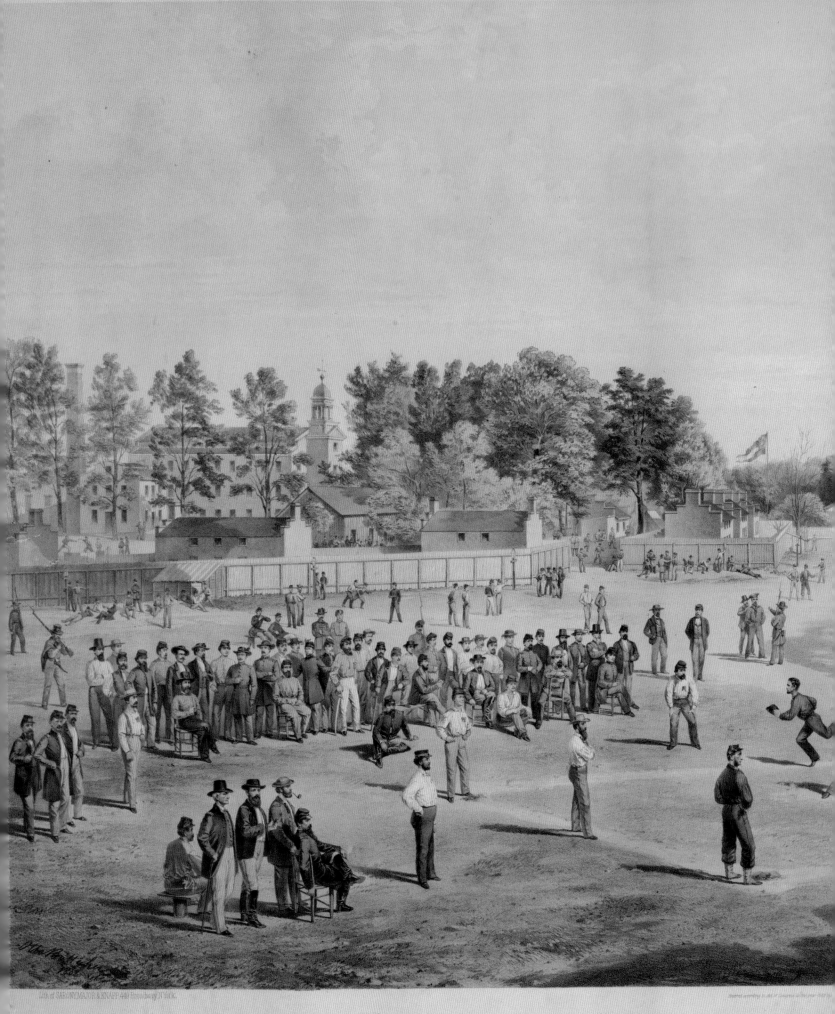

UNION PRISONERS

DRAWN FROM NATURE

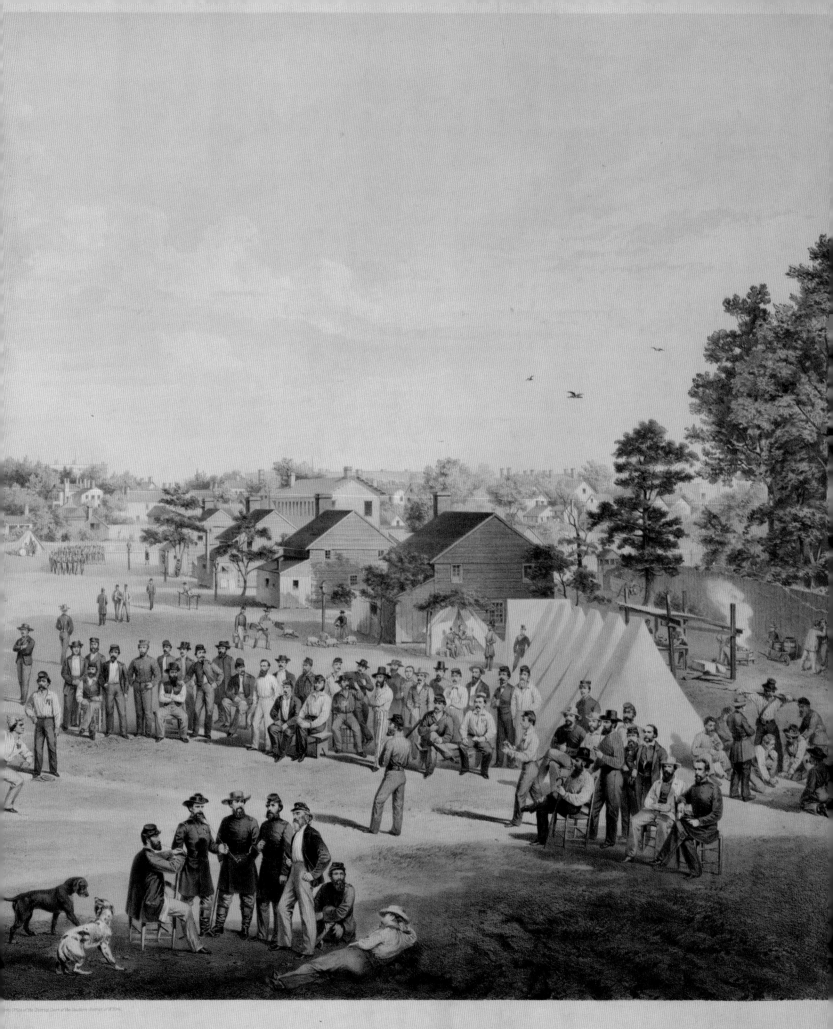

AT SALISBURY, N.C.

OTTO BOETTICHER.

HOME RUN QUICK STEP.

RESPECTFULLY DEDICATED
to the
MEMBERS OF THE
MERCANTILE BASE BALL CLUB
OF
PHILAD.ª
by
JOHN ZEBLEY, JR.

Philadelphia, LEE & WALKER 722 Chesnut St.

OPPOSITE: **Sheet music cover, 1861.**

RIGHT: **Advertisement, lithograph, 1869.**

BELOW: Pictorial sheet music covers offer some of the earliest images of American adults playing baseball. Created as attractive enticements to buyers of musical scores, such covers typically portrayed scenes of contemporary interest to a broad, popular audience. Often commissioned by local teams or patrons, such ditties as "The Live Oak Polka" (see page 19) were dedicated to the hometown nine, sold and distributed largely within a proscribed urban area, while the "Base Ball Polka" (1867) was issued and dedicated to the sport's "fraternity."

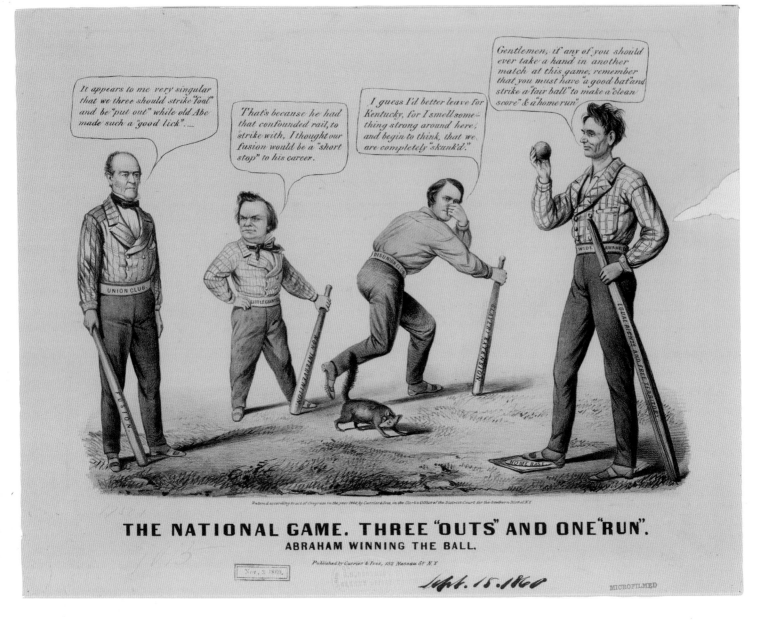

THE NATIONAL GAME. THREE "OUTS" AND ONE "RUN".
ABRAHAM WINNING THE BALL.

The National Game, **attributed to Louis Maurer, Currier & Ives, 1860.** This pro-Abraham Lincoln cartoon, published in the aftermath of his victory in the 1860 presidential election, portrays the president-elect along with his defeated campaign rivals—John Bell, Stephen A. Douglas, and John C. Breckinridge—opposing each other in a baseball game. Lincoln stands astride "Home Base," holding a split rail for a bat inscribed with the labels "Equal Rights and Free Territory," offering advice to the rudely "skunk'd" losers (note the small furry creature with the lifted tail): "Gentlemen, if any of you should ever take a hand in another match at this game, remember that you must have 'a good bat' and 'strike a fair ball' to make 'a clean score' & 'a home run.'"

Throughout the 1860s, the nationwide demand for talented teams grew. In 1867, the Washington, D.C., Nationals—a crack ball club comprising government workers, clerks, lawyers, and some war veterans—traveled by train to Ohio, Missouri, and Illinois for games met with great fanfare. Henry Chadwick was in tow when the team departed for baseball's first "tour of the west." The journalist provided newspaper accounts detailing the team's exploits and promoting the tour, which resulted in large and enthusiastic crowds, and the Nationals won all but one of their games. A year later, several New York–based teams followed suit, sweeping through the Midwest taking on all comers, spreading goodwill and deepening interest in the game. Then, in 1869, the renowned Cincinnati Red Stockings, baseball's first openly professional ball club (that is, the entire starting roster, or "picked nine," received salaries), journeyed cross-country on the newly completed transcontinental railroad, remaining undefeated through sixty-five games. Its players treated like celebrities, the team traveled lavishly and capped their tour with lopsided victories in the San Francisco Bay area. Each of these touring teams left new fans in its wake, and by the 1870s the public's thirst for baseball seemed unquenchable.

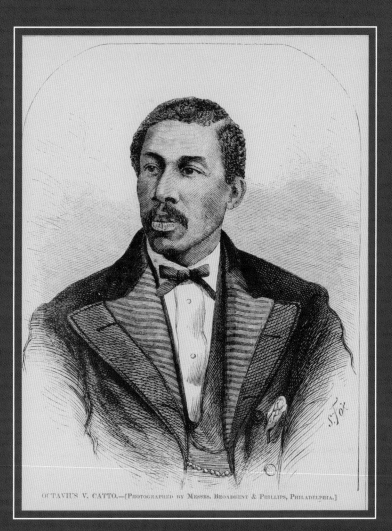

OCTAVIUS V. CATTO.—[PHOTOGRAPHED BY MESSRS. BROADBENT & PHILLIPS, PHILADELPHIA.]

Octavius V. Catto, print from wood engraving, based on photograph by Messrs. Broadbent & Phillips, Philadelphia, 1871. Although he is virtually forgotten, Octavius V. Catto must be one of the most remarkable figures in baseball's storied past. The son of a Presbyterian minister in Charleston, South Carolina, he grew up and was educated in Philadelphia, becoming one of the city's most accomplished young black men. During the Civil War, he helped found the Union League Association in Philadelphia and assisted Frederick Douglass and others in working toward their state's ratification of the Fifteenth Amendment, securing black suffrage. An exemplary scholar, athlete, and civil rights pioneer, he founded the Banneker Literary Institute and the Equal Rights League, and, by 1867, he had established and become captain and shortstop of the Pythian Baseball Club, the city's leading black baseball team. On September 4, 1869, the Pythians took on the New York Olympics, a white outfit. The *New York Times* reported the next day: "BASEBALL—A Novel Game in Philadelphia—A Negro Club in the Field—The White Club Victorious—The Pythian Base-Ball Club, (colored), after challenging a number of white clubs of this city, who refused to play, succeeded in getting an acceptance from the Olympic, which club defeated them by the score of 44-23. The novelty of the affair drew an immense crowd of people, it being the first game played between a white and colored club. Umpire—Col. Fitzgerald, of this city."

Catto paid dearly for his success and notoriety. Pennsylvania's passage of the Fifteenth Amendment in October 1870 led to citywide race riots during elections the following year. Catto, then a major in the National Guard, was gunned down in uniform by an opposition political operative while attempting to keep the peace. Thousands of citizens—both black and white—and numerous public officials attended his funeral, the largest public memorial in Philadelphia since the death of Abraham Lincoln.

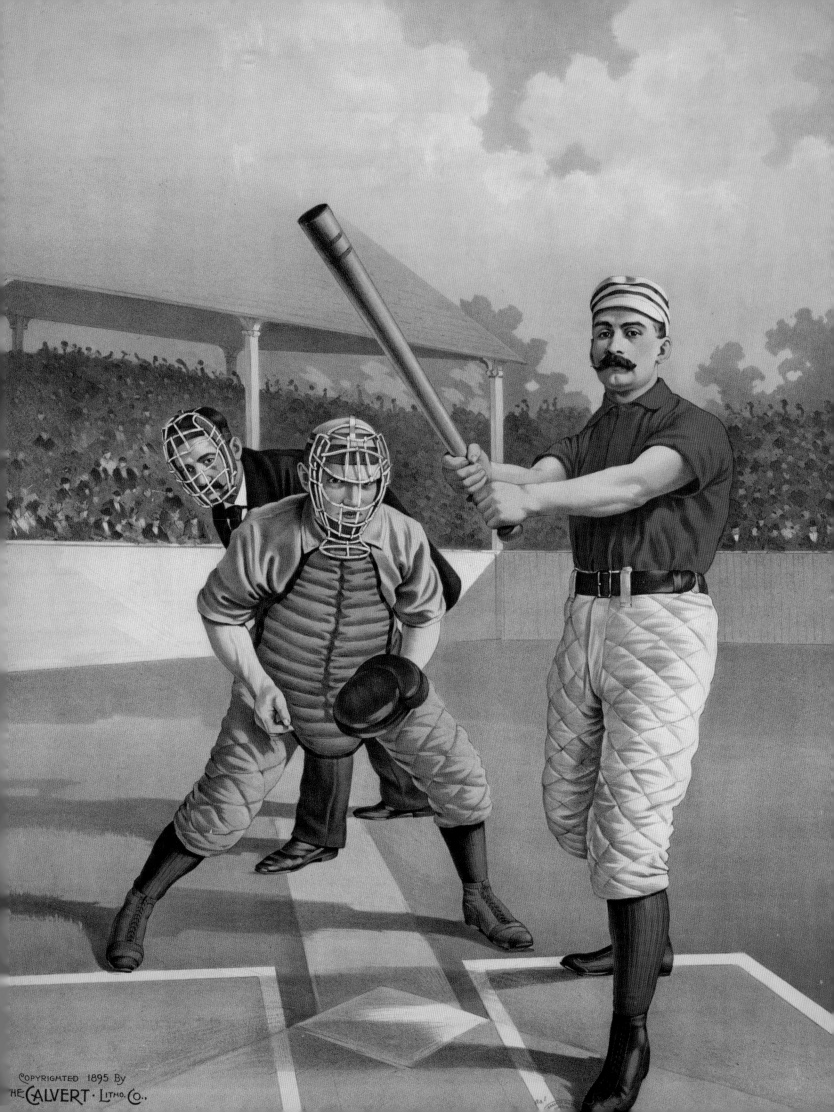

FIRST FANATICS AND HOME-RUN HEROES

⟨THE SPREAD OF THE NATIONAL GAME⟩
(1870–1900)

Mark Twain called the late nineteenth century "the Gilded Age," and he saw in baseball "the very symbol, the outward and visible expression of the drive, and push, and rush and struggle of the raging, tearing, booming nineteenth century!"

To keep up in this competitive environment, team owners soon realized they, too, had to offer more money to their talent. Patrons generally showed up in sufficiently large numbers to turn a profit at the gate—provided that teams had competent financial management. By 1871, clubs with a "picked nine" of paid professionals had become so numerous that they formed a new league, the National Association of Professional Base Ball Players (NAPBP). While player and sporting-goods

Stock poster, Calvert Lithographing Co., Detroit, 1895.

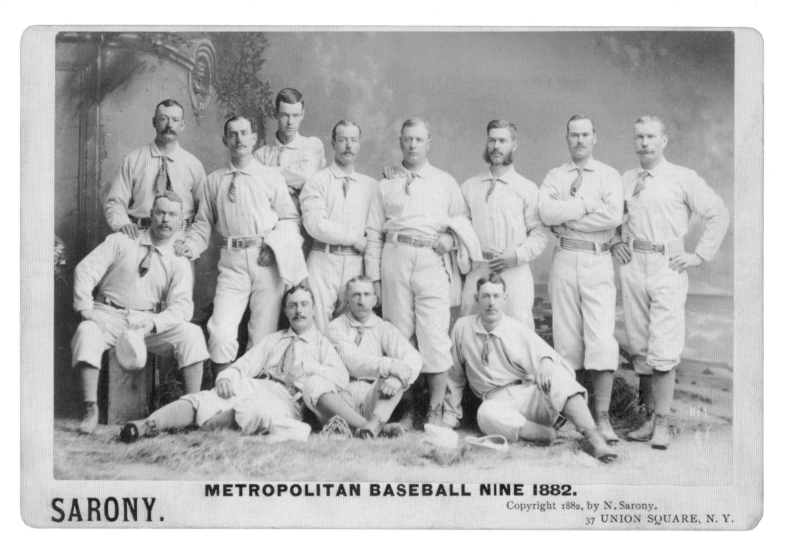

METROPOLITAN BASEBALL NINE 1882.

SARONY.

Copyright 1882, by N. Sarony.
37 UNION SQUARE, N. Y.

Metropolitan Baseball Nine, Sarony Studios, cabinet photograph, 1882.

By the 1880s, newspapers and journals from around the country sought to increase their readership by including baseball coverage in each issue. The most popular teams and players were highlighted in articles and illustrations, many reproduced from photographs such as this team portrait of the New York Metropolitans. The engraved illustration after this photograph appeared in *Harper's Weekly* on August 5, 1882.

magnate A. G. Spalding, Henry Chadwick, and others continued to champion the amateur game, professional baseball was growing steadily. In 1876, eight teams withdrew from the increasingly disorganized NAPBP and formed the National League of Professional Baseball Clubs, the same National League that competes to this day.

During the 1870s and 1880s, baseball bore only some resemblance to the modern game. Four bases and whitewashed foul lines defined the field. Players wore painter-style caps, lace-front flannel jerseys, and cricket knickers with colorful kneesocks and leather athletic shoes, some cleated. Few players wore gloves. Baseballs were constructed of horsehide stitched across wool yarn wrapped around a hard rubber core. By comparison with the modern hardball, the 1870s version was soft, or "dead."

Batters ruled the era; they could request pitch locations, called balls and strikes were not consistently required until 1879, and a foul ball was not considered a strike. Pitchers delivered the ball underhand or sidearm from forty-five to fifty feet away. Only in 1893 did rule makers push pitchers back to sixty feet six inches. Home runs were few and far between, as teams focused on methodically advancing base runners, rather than hitting for power. (Admirers of "small ball" in the modern game would recognize baseball from that early era.) In addition, the relatively soft ball and proximity to the pitcher dampened a hitter's power. To compensate, batters swung fast, hard, and low, challenging mostly gloveless

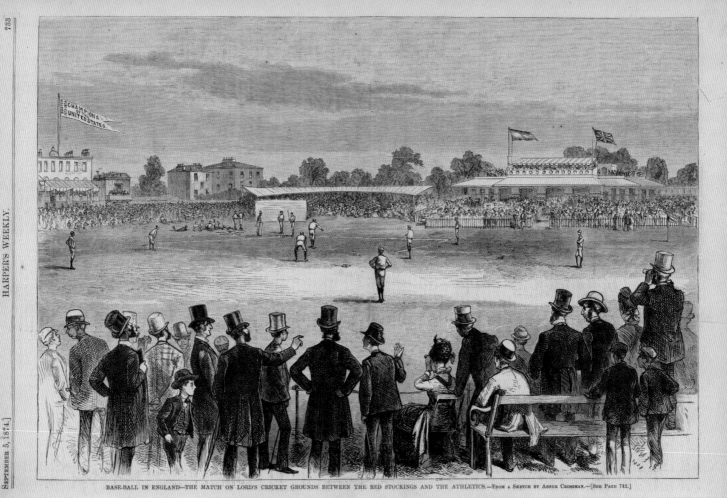

BASE-BALL IN ENGLAND—THE MATCH ON LORD'S CRICKET GROUNDS BETWEEN THE RED STOCKINGS AND THE ATHLETICS.—FROM A SKETCH BY ABNER CROSSMAN.—[SEE PAGE 742.]

ABOVE: Baseball in England, print from wood engraving, *Harper's Weekly*, September 5, 1874. During the summer of 1874, the Boston Red Stockings and the Philadelphia Athletics promoted baseball in England, playing exhibition matches in London and Liverpool. A British sporting weekly reported, "Baseball with the Americans is the sport of sports, as superior to all others as cricket is to us English in the way of summer pastimes. Its influence is unbounded and its supremacy pre-eminent over the American continent. Its popularity is so great that the professional exponents of the art can command salaries at which those of our professional cricketers sink into positive insignificance; and a skilful pitcher like Cummings of Chicago or Spalding of the Bostons may count on remuneration equal to that of an agile danseuse or an operatic star." The *Field* suggested that baseball, rather than cricket, appealed to Americans because they are "fretful of restraint and less tenacious of purpose than the English stock from which they sprung." Baseball "is an amusement that allows of no delays, that admits of no unequal division of labour, but keeps the interest unflagging until the finish."

RIGHT: Wright & Ditson advertisement, 1884. Catchers were wearing gloves well before their teammates, who did not deign to don them until the mid-to-late 1870s. Until then, a player's manhood was questioned if he showed up with a glove, even one with no padding or finger coverage. In 1877, Chicago first baseman Albert Spalding risked ridicule wearing a fingerless glove in the hope that it would inspire others to do likewise and generate sales for his fledgling sporting-goods company. Spalding's temporary brush with humiliation paid off; in time, other infielders, then outfielders, and finally, in the early 1880s, pitchers took to wearing gloves. Meanwhile, the catcher's mask made its first appearance in 1877 when Harvard's James Tyng wore one that his roommate, Fred Thayer, constructed for him. By 1884, when Wright & Ditson ran this advertisement, catchers' masks were commonplace and their "open sight" design differed from Thayer's model.

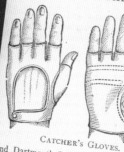

CATCHER'S GLOVES.

CATCHER'S GLOVES.

Our open-back CATCH-ER'S GLOVES are made from thick buckskin, hand sewed, and well padded. No better glove is made.

They have been severely tested by leading catchers of Boston, Providence, and Worcester clubs; also Harvard, Brown, Princeton, Yale, and Dartmouth Colleges; and care has been taken to make them an A No. 1 glove for the coming season.

	Per pair.
No. 1. Professional, Extra Heavy	
" 2. Amateur, Strongly Padded	$3 00
" 3. Youths' Hair Padded	2 00
" 4. Youths' Light Buck	1 50
	1 00

WRIGHT & DITSON'S OPEN SIGHT MASK

Is the latest in masks, and considered by catchers the best now in use.

No catcher should play behind the bat without one. It is a sure protection for the face, and gives the player every confidence.

No. 1. Extra Heavy, Professional	
No. 2. Heavy, Amateur	$4 00
No. 3. Light, Boys'	3 00
	2 00

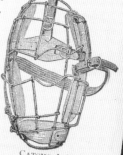

CATCHER'S MASK.

Address **Wright & Ditson**, 580 Washington St., Boston.

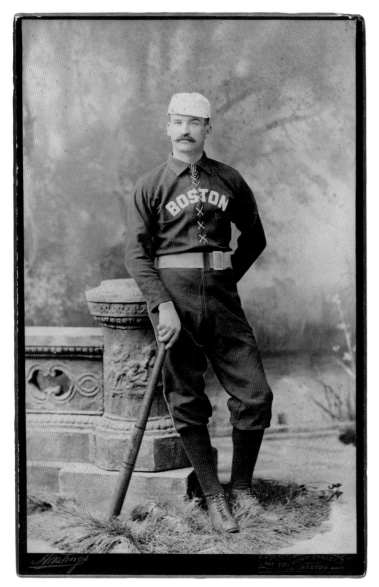

Michael J. "King" Kelly, imperial cabinet photograph by George H. Hastings, Boston, 1887. This large-format, deluxe studio photograph of King Kelly was taken the year he received baseball's first $10,000 contract and stole eighty-four bases. Arguably the game's most popular player and known for his baserunning prowess, Kelly legged out hits and committed thefts to crowds roaring "Slide, Kelly, Slide!"

fielders to make tough plays on the ground rather than catch easy flies in the air. They bunted and scrapped for runs, striving to get on base and move other runners along.

Mike "King" Kelly was the era's consummate star. Known for his slugging prowess, he could also run the base paths and push runs home, and his impressive-for-that-period 69 home runs pale beside his 950 career runs batted in (RBIs). He was a terrific team player, a perennial league leader in batting average, on-base percentage, slugging, doubles, runs, RBIs, and stolen bases. Kelly's on-field exploits, handsome features, and flowing handlebar mustache made him a favorite with fans, who serenaded him on the base paths, singing "Slide, Kelly, Slide!" a popular song written in his honor. Great hitters from the period, such as Kelly, Charles Comiskey, and "Pebbly" Jack Glasscock, sliced, slugged, chopped, and lined their way to stardom.

Scoring with the long ball during the early professional era was a relatively rare event. Roger Connor led all others; remembered as the "Babe Ruth of the nineteenth century," he hit only 138 homers over eighteen years and almost two thousand games. Among his celebrated contemporaries, only Sam Thompson, Cap Anson, and Fred Pfeffer achieved 20-home-run seasons, once each. Powerful, big man Dan Brouthers never hit 20, but he came close, foreshadowing the accomplishments of another oversize lefty slugger yet to come.

Opposed by such legendary hurlers as Asa Brainard, Hoss Radbourn, Tim Keefe, and John Montgomery Ward, hitters Brouthers, Kelly, Anson, and the rest carved out spectacular careers—becoming household names and popular icons as they helped to firmly establish the professional game. Furthermore, their collective experience also resulted in improved tactics—the hit-and-run and defensive infield shifts, for example—and better equipment, including the catcher's chest protector, mask, and padded gloves.

The new stars were bankable: owners, the players themselves, and business opportunists looked to capitalize on team visibility and individual fame. Technical advances in commercial photography and color printing and artful use of promotion and advertising created cults of celebrity for star athletes. Players saw their images emblazoned on trade cards and posters, tobacco, liquor and dairy products, candy, and other items. During the late 1880s, tobacco companies competing for profits inserted small printed or photographic portrait cards of ballplayers in their cigarette packs as premiums to attract buyers. These prototype collectible cards, featuring players in stiff poses, bestowed instant celebrity given previously to royalty, entertainers, champion pugilists, and Thoroughbred horses. They document the character and characters of the age—the photographs in telling detail, the prints in vivid color.

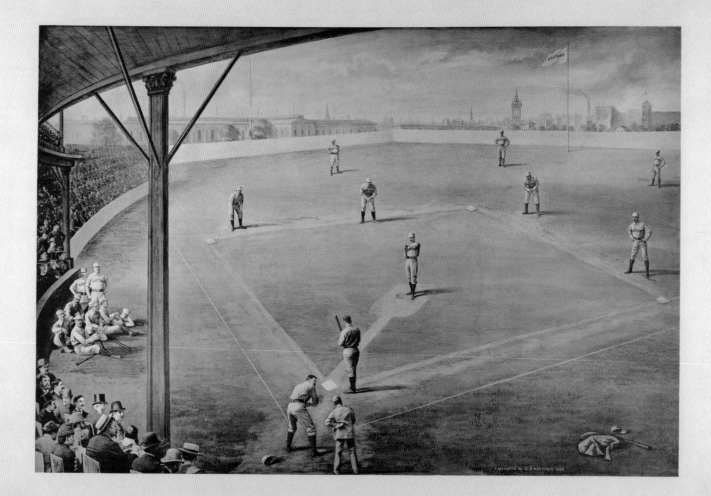

THE BOSTON BASE BALL CLUB.
1888.

Published by G. H. HASTINGS, Artist,
No. 147 Tremont Street, Boston.

The Boston Base Ball Club, **photo-etching by George H. Hastings, 1888.**
Combining photography and printmaking in a composite production collage, this unusual
vintage image depicts the Boston Beaneaters playing in front of a full house at their South End
grounds. Led by the likes of "Old Hoss" Radbourn, "$10,000" King Kelly, "Black Jack" Burdock,
and Billy Nash, the Beaneaters still finished the 1888 season a disappointing fifth.

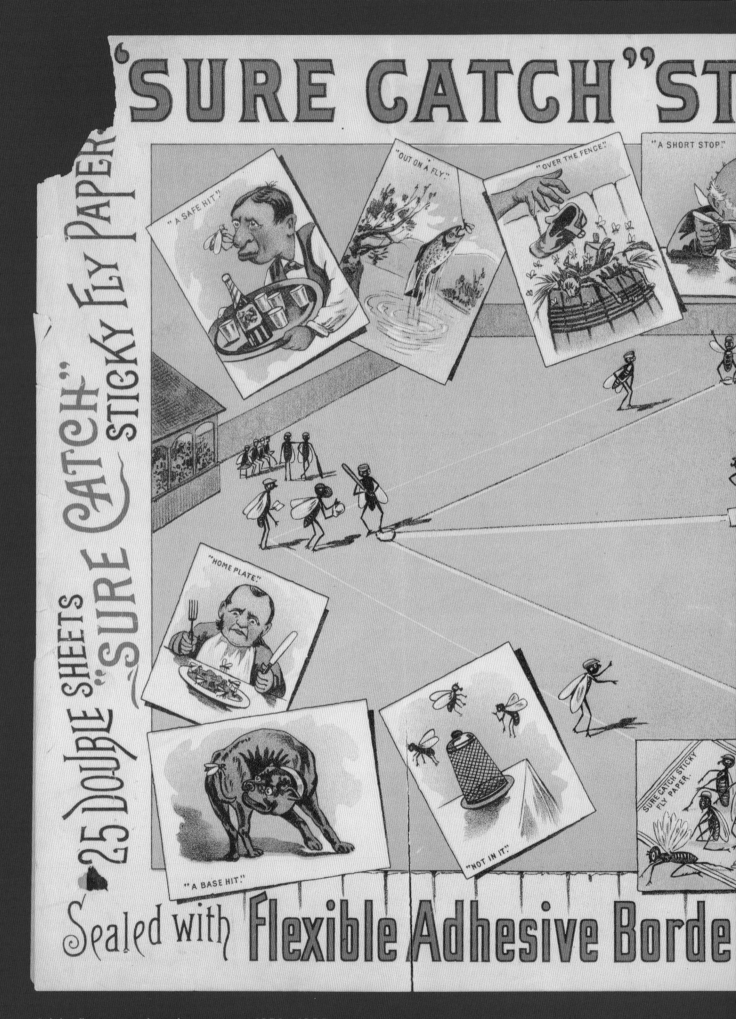

Sticky fly paper advertisement, ca. 1870s–1880s.

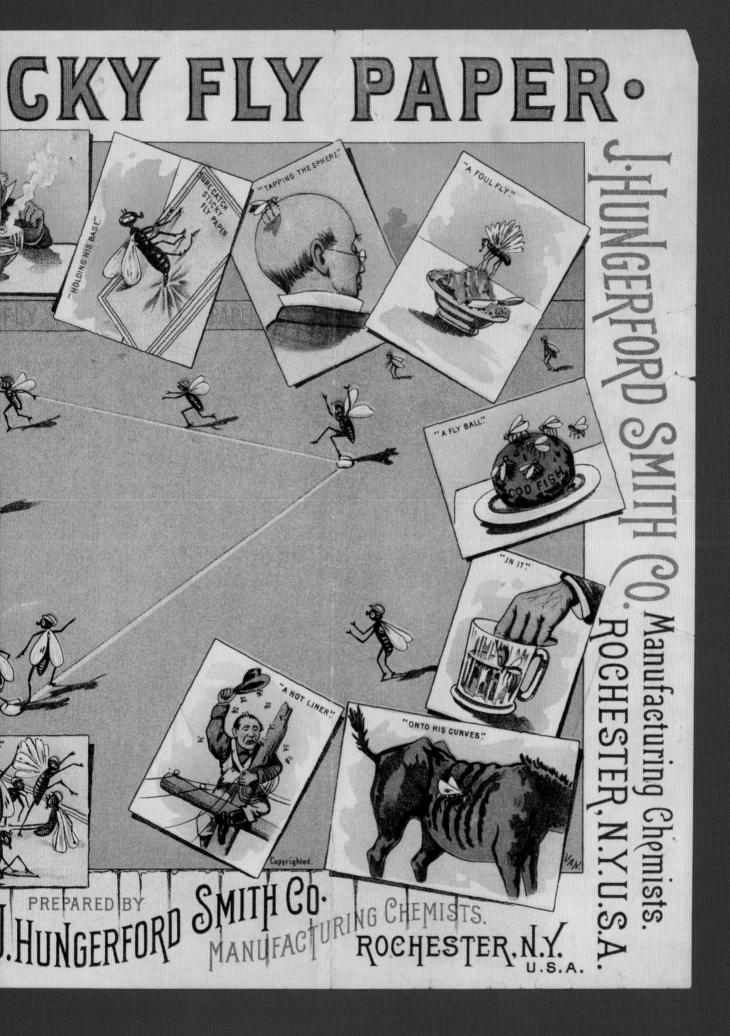

CITY OF SAN JOSE, CAL. 1875.

FROM AN ELEVATION OF 500 FT LOOKING NORTH
PUBLISHED BY W. C. GIFFORD,
OFFICE AT RHODES & LEWIS, 355 FIRST STREET, S. J.

ABOVE: **City of San Jose, Cal, 1875, A. L. Bancroft & Co. after C. B. Gifford, lithograph printed in colors, 1875.** OPPOSITE: **Pittsburgh, Pennsylvania, T. M. Fowler & James B Moyer, lithograph printed in colors, 1902.** Bird's-eye views offered a fresh aerial perspective to proud citizens and prospective residents of urban areas in America during the last quarter of the nineteenth century. Panoramic in scope and meticulous in detail, they encompassed entire cities, taking in not only the bustling downtowns with their rigorously laid-out street grids and monumental commercial and municipal buildings, but also the abutting leafy residential neighborhoods, light industrial areas, and outlying undeveloped tracts. Ballparks were ubiquitous by the 1870s, usually built on open land adjacent to fairgrounds, public parks, rail yards or riverfronts, or other sites offering easy access and transportation.

Baseball as big business also manifested itself in the construction of stadiums. In every major city where baseball was played, ballparks were built and admission was charged for entry. Some "band box" parks seating hundreds were expanded or replaced to accommodate thousands. During the 1880s and 1890s, new parks were built in Baltimore, Chicago, Philadelphia, Cleveland, Cincinnati, Brooklyn, and St. Louis.

Owners who managed their teams competently reaped rewards from their investment. Clubs charged fans for food and drink and sold colorfully illustrated game programs with scorecards that allowed spectators to keep score and identify their favorite players. The programs also featured paid advertising, which created additional revenue. Internally, owners fought for league supremacy, championship titles, productive players, and financial solvency. On the expense side of the ledger, players like King Kelly, empowered by their production and popularity, pushed salaries higher. In 1886, Kelly signed baseball's first $10,000 contract, with the Boston Beaneaters.

Not everyone shared the Major Leagues' bounty. For almost three decades, black players had enjoyed limited oportunities within professional baseball. Black communities in cities across America supported teams—academic,

PITTSBURGH,
PENNSYLVANIA.
1902.

amateur, and semiprofessional. Barnstorming exhibition games between black and white all-star teams were common and occasional roster spots opened on white teams for the skillful, willful few who persevered or passed review. In 1885, baseball's first all-black professional team, the Cuban Giants, took the field. As it turned out, they were just in time.

On July 14, 1887, Cap Anson, team captain, star pitcher, and league icon, threatened to walk his Chicago White Stockings off the field rather than face Newark's outstanding black battery mates, pitcher George Stovey and catcher Fleetwood Walker. That same day, the International League, to which Newark belonged, directed its secretary to "approve no more contracts with colored men." The league's decision and Anson's racist act contributed to baseball's

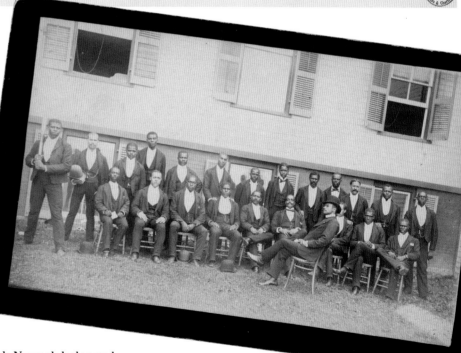

Baseball team, by Edward David Ritton, Danbury, Connecticut, ca. 1880.

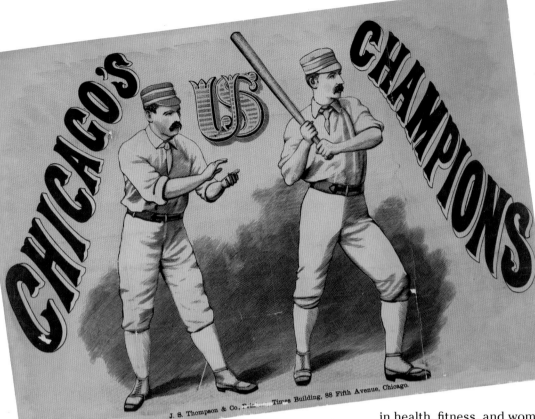

unwritten law, and black players remained banned from the American Major Leagues for sixty years.

By the end of the nineteenth century, baseball was an American institution, a symbol of the country's energy, confidence, swagger, and success. College rivalries drew huge crowds, while attendance at national amateur championships soared toward six figures. Ever more women competed in colleges and academies, and on occasional barnstorming tours, benefiting from reform movements in health, fitness, and women's rights. Kids played at school and in their neighborhoods, eagerly following their heroes' exploits on the sports pages and in dime novels. Writers, artists, illustrators, and cartoonists incorporated baseball into their work. Their descriptions, impressions, and accounts of games, along with their depictions of scenes and portraits of key players, enliven the historical view of baseball's first century.

Chicago's U.S. Champions, colored woodcut poster, J. S. Thompson & Co., ca. 1876. In the newly formed National League's first year, Albert Spalding and Cap Anson led the Chicago White Stockings to the championship. A local Chicago printing firm made a grand poster to celebrate the team's accomplishment.

Base Ball, **chromolithograph, Louis Prang & Co., 1887.** Boston-based Louis Prang & Company was the premier commercial color art-print firm in America during the latter half of the nineteenth century, producing original fine art designs as well as reproductions after paintings by Winslow Homer and others. Traditional Ivy League rivals Harvard and Yale are shown here in a chromolithograph created using a proprietary Prang process called aquarelle, the French word for watercolor. The method produced large and affordable print editions with the sophisticated look of original works of art.

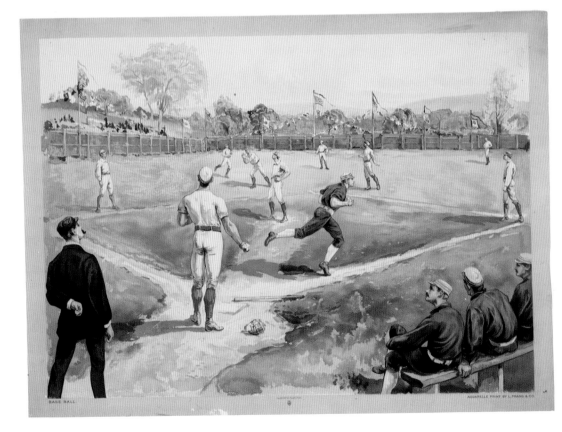

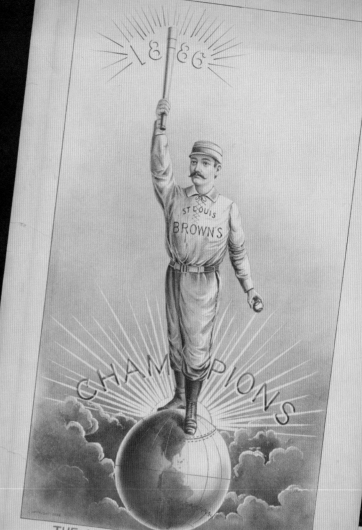

RIGHT: *The Monarchs of the Sphere*, depicting Captain Comiskey, by T. J. Nicholl, lithographic poster, 1886.
BELOW: *Famous World Beater St. Louis Browns*, cabinet photograph by F. W. Guerin, 1887. The *Famous World Beaters St. Louis Browns* featured many of the most notable players of the decade, including team captain and future Hall of Famer Charles Comiskey, center, who led the Browns through their most dominant and successful years. He became the first manager ever to win four successive pennants, directing the Browns to American Association championships from 1885 through 1888. James "Tip" O'Neill, a former pitcher, led the team in batting in 1886 with a .326 average, then topped that by hitting .435 the following year. St. Louis took the world championship in successive years, beating the Chicago White Stockings in 1886 and the Detroit Wolverines in 1887.

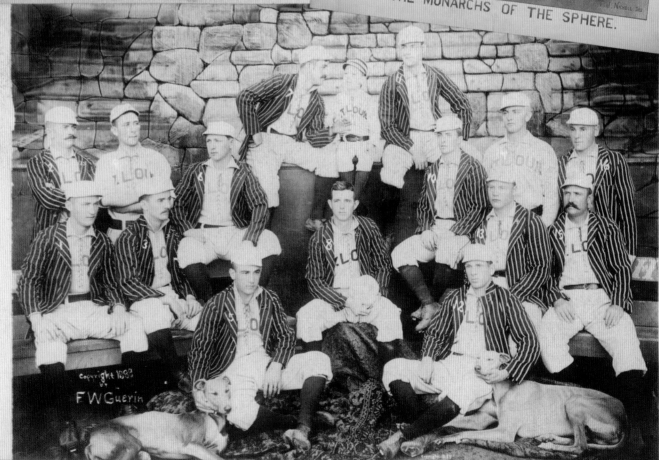

1—Boyle.	5—Chamberlain.	*The Famous World Beaters*	9—Browns Mascot.	13—Milligan.
2—White.	6—Robinson.	ST. LOUIS BROWNS.	10—McCarthy.	14—King.
3—Hudson.	7—Latham.	Champions of Am. Association Four Successive Years, 1885, '86, '87, '88.	11—O'Neill.	15—Dolan
4—Devlin.	8—Capt. Comiskey.	Worlds Champions, 1886, 1887.	12—Lyons.	16—He

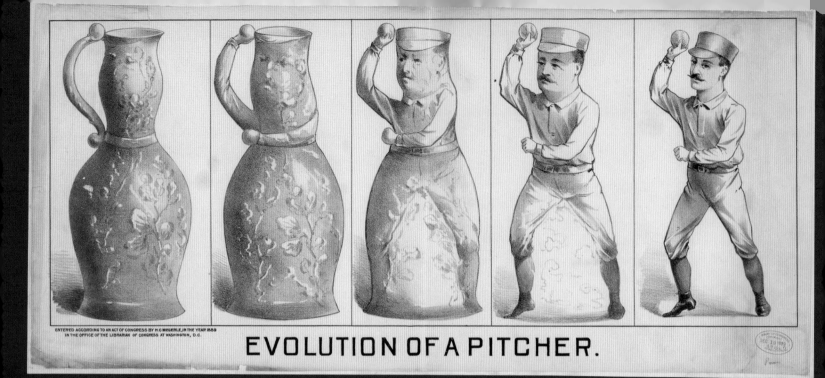

EVOLUTION OF A PITCHER.

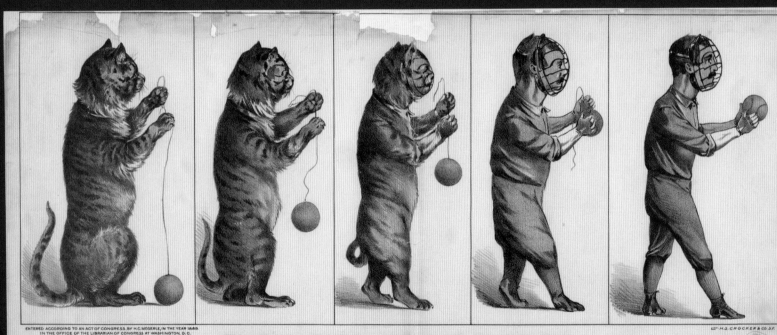

EVOLUTION OF A CAT-CHER.

TOP AND BOTTOM: **H. S. Crocker & Co.,**
San Francisco, 1889.

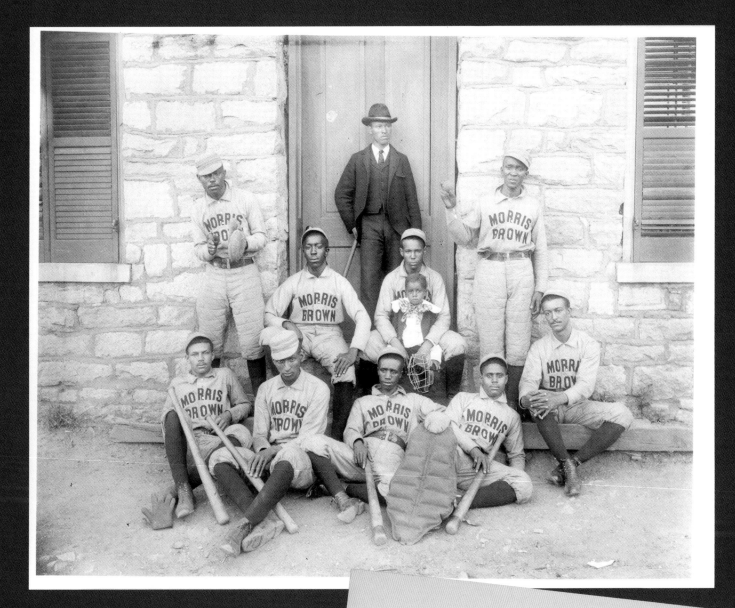

ABOVE: **Morris Brown Ball Club, ca. 1899–1900.** W. E. B. DuBois, then a sociology professor at Atlanta University, and Thomas Calloway, an educator and attorney, assembled a series of photographs as a testament to the accomplishments of black Americans since Emancipation. The series formed part of the American Negro Exhibit showcased at the 1900 Paris Exhibition. Included among the many treasured images was this photograph of ballplayers from Morris Brown College in Atlanta, Georgia.

RIGHT: *A Base Hit*, **lithograph, Currier & Ives after Thomas Worth, 1882.** Currier & Ives, remembered as America's most popular nineteenth-century commercial printmaker, produced more than seven thousand different designs. *A Base Hit* was issued as part of the firm's Darktown series by artist Thomas Worth, parodying the lives of black Americans. Although considered comic at the time, such demeaning imagery had serious consequences. Only a few years later, black ballplayers were banned from the Major Leagues.

A BASE HIT.

D stands for DIAMOND drawn flat on the ground.

E stands for EDWARD, who marks out the bound.

F stands for FOUL on which Arthur goes out.

G stands for "GO"—How the merry boys shout!

Baseball ABC, published by McLoughlin Brothers, New York, 1885. This brightly decorative, colorfully illustrated book taught children the alphabet using simple rhymes and letters illuminated with pastoral baseball scenes.

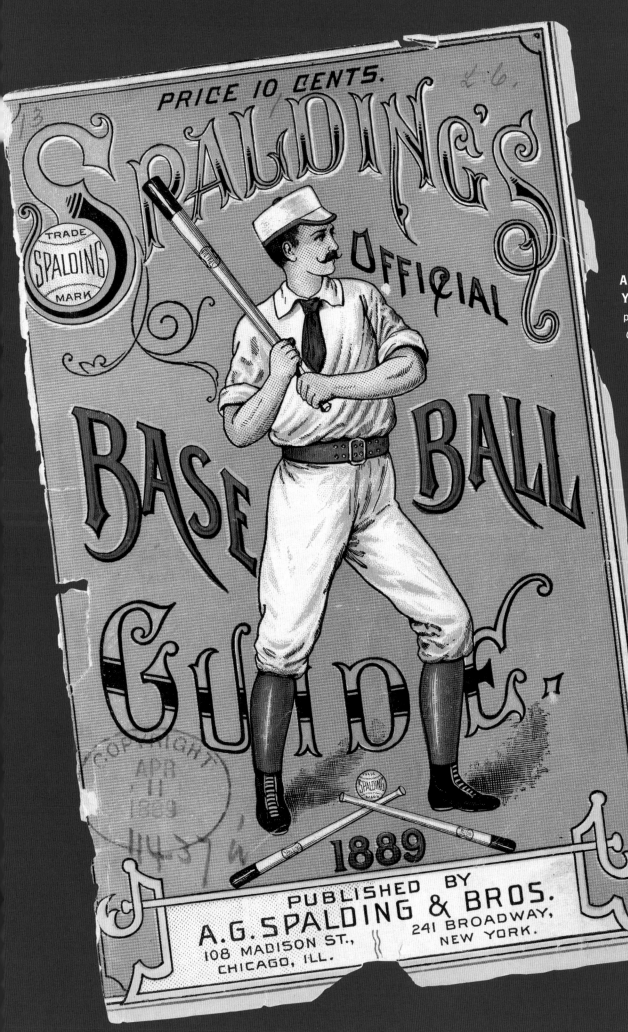

PRICE 10 CENTS.

SPALDING'S

TRADE SPALDING MARK

OFFICIAL

BASE BALL

GUIDE

1889

PUBLISHED BY
A. G. SPALDING & BROS.
108 MADISON ST.,
CHICAGO, ILL.
241 BROADWAY,
NEW YORK.

A. G. Spalding & Bros., New York, 1889. The leading baseball publication of its time, *Spalding's Official Baseball Guide* provided comprehensive coverage of the major—and many minor—league teams, including statistics, schedules, rules, photographs, and commentary. This 1889 edition included an article titled "The Lessons of the League Campaign of 1888," which pointed out that "star players do not make a winning team" (as in the case of Boston) and that "professional baseball playing has arrived at that point of excellence, and reached so advanced a position in regard to its financial possibilities, that . . . the capitalists who have ventured thousands of dollars in baseball stock companies can no longer allow their money to be risked in teams which are weakened by the presence of men of drinking habits."

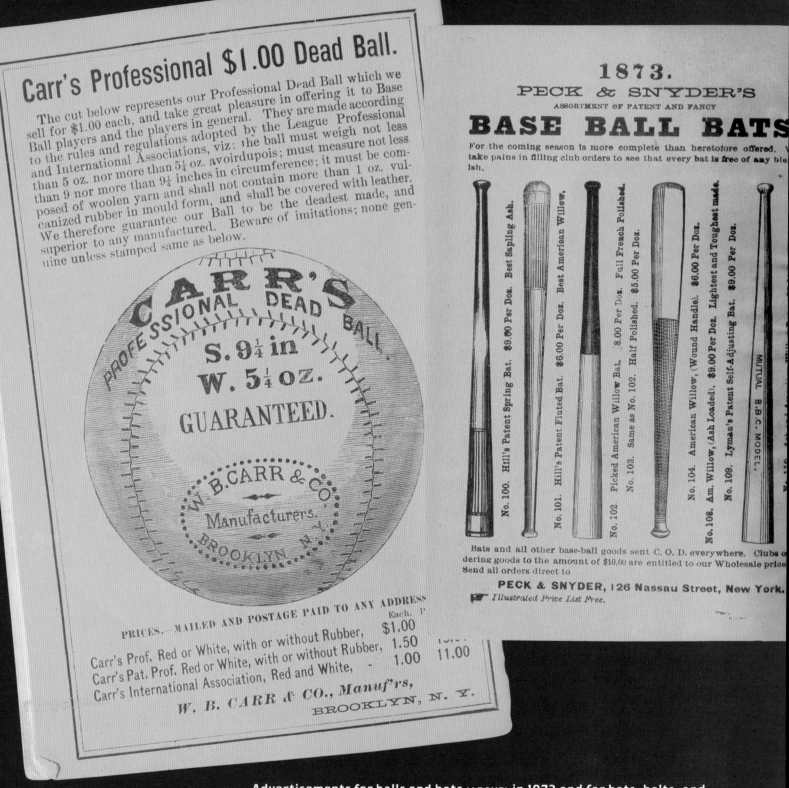

Carr's Professional $1.00 Dead Ball.

The cut below represents our Professional Dead Ball which we sell for $1.00 each, and take great pleasure in offering it to Base Ball players and the players in general. They are made according to the rules and regulations adopted by the League Professional and International Associations, viz: the ball must weigh not less than 5 oz. nor more than 5¼ oz. avoirdupois; must measure not less than 9 nor more than 9¼ inches in circumference; it must be composed of woolen yarn and shall not contain more than 1 oz. vulcanized rubber in mould form, and shall be covered with leather. We therefore guarantee our Ball to be the deadest made, and superior to any manufactured. Beware of imitations; none genuine unless stamped same as below.

CARR'S PROFESSIONAL DEAD BALL.
S. 9¼ in
W. 5¼ oz.
GUARANTEED.

W. B. CARR & CO.
Manufacturers.
BROOKLYN, N.Y.

PRICES.—MAILED AND POSTAGE PAID TO ANY ADDRESS

	Each.	P
Carr's Prof. Red or White, with or without Rubber,	$1.00	
Carr's Pat. Prof. Red or White, with or without Rubber,	1.50	
Carr's International Association, Red and White, -	1.00	11.00

W. B. CARR & CO., Manuf'rs,
BROOKLYN, N. Y.

1873.
PECK & SNYDER'S
ASSORTMENT OF PATENT AND FANCY
BASE BALL BATS

For the coming season is more complete than heretofore offered. take pains in filling club orders to see that every bat is free of any ble ish.

No. 100. Hill's Patent Spring Bat. $9.00 Per Doz. Best Sapling Ash.
No. 101. Hill's Patent Fluted Bat. $6.00 Per Doz. Best American Willow.
No. 102. Picked American Willow Bat. 8.00 Per Doz. Full French Polished.
No. 103. Same as No. 102. Half Polished. $5.00 Per Doz.
No. 104. American Willow, (Wound Handle). $6.00 Per Doz.
No. 108. Am. Willow, (Ash Loaded). $9.00 Per Doz. Lightest and Toughest made.
No. 109. Lyman's Patent Self-Adjusting Bat. $9.00 Per Doz.
MUTUAL B.B.C. MODEL.

Bats and all other base-ball goods sent C. O. D. everywhere. Clubs o dering goods to the amount of $10.00 are entitled to our Wholesale price Send all orders direct to

PECK & SNYDER, 126 Nassau Street, New York.
Illustrated Price List Free.

Advertisements for balls and bats (ABOVE) in 1873 and for hats, belts, and socks (OPPOSITE) in 1875. Advertisements for baseball equipment and uniforms appeared in a variety of publications, including sporting magazines, scorecard books, and rule books; those shown here were featured in Beadle's dime novels. In the late nineteenth century, every major American city boasted at least one ball-and-bat company. Wright & Ditson and Peck & Snyder were among New York's prominent manufacturers until Spalding bought out both firms—and several others—in the 1890s.

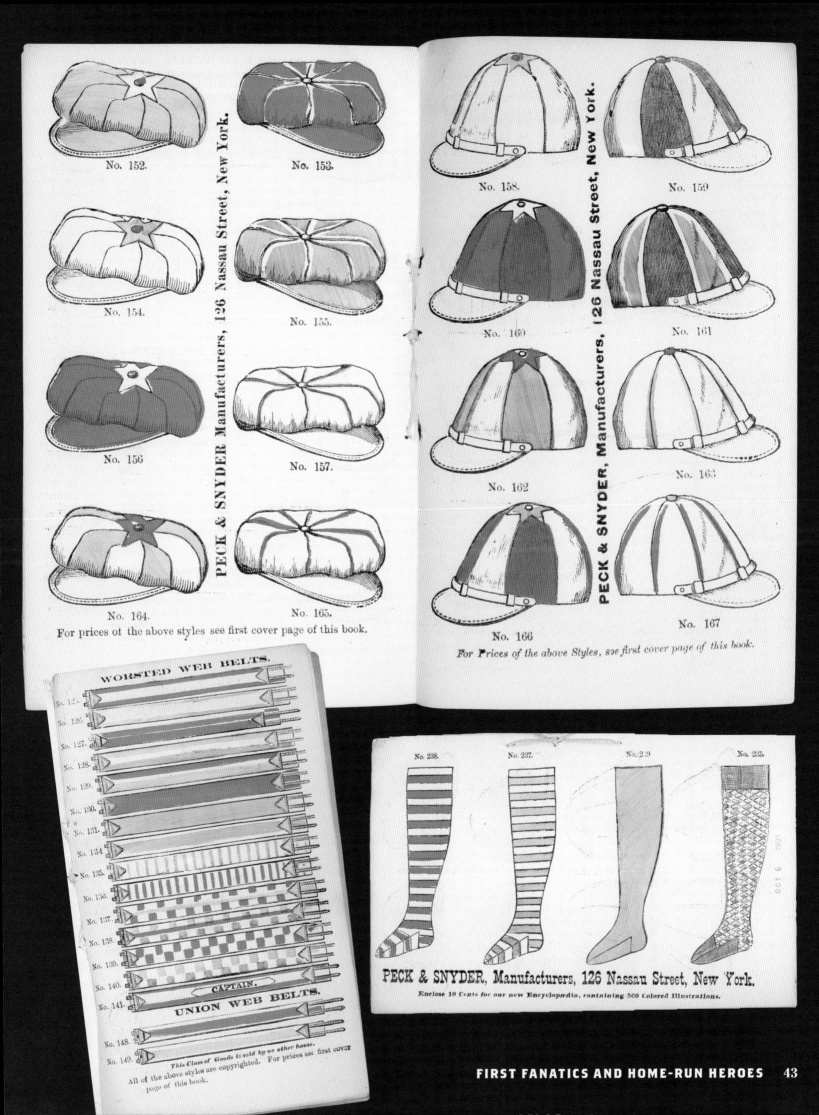

No. 152.

No. 153.

No. 154.

No. 155.

No. 156

No. 157.

No. 164.

No. 165.

For prices of the above styles see first cover page of this book.

PECK & SNYDER Manufacturers, 126 Nassau Street, New York.

No. 158.

No. 159

No. 160

No. 161

No. 162

No. 163

No. 166

No. 167

For Prices of the above Styles, see first cover page of this book.

PECK & SNYDER, Manufacturers, 126 Nassau Street, New York.

WORSTED WEB BELTS.

No. 125.
No. 126.
No. 127.
No. 128.
No. 129.
No. 130.
No. 131.
No. 134.
No. 135.
No. 136.
No. 137.
No. 138.
No. 139.
No. 140.
No. 141.
No. 148.
No. 149.

CAPTAIN.

UNION WEB BELTS.

This Class of Goods is sold by no other house.
All of the above styles are copyrighted. For prices see first cover page of this book.

No. 238.

No. 237.

No. 239

No. 235

PECK & SNYDER, Manufacturers, 126 Nassau Street, New York.

Enclose 10 Cents for our new Encyclopædia, containing 500 Colored Illustrations.

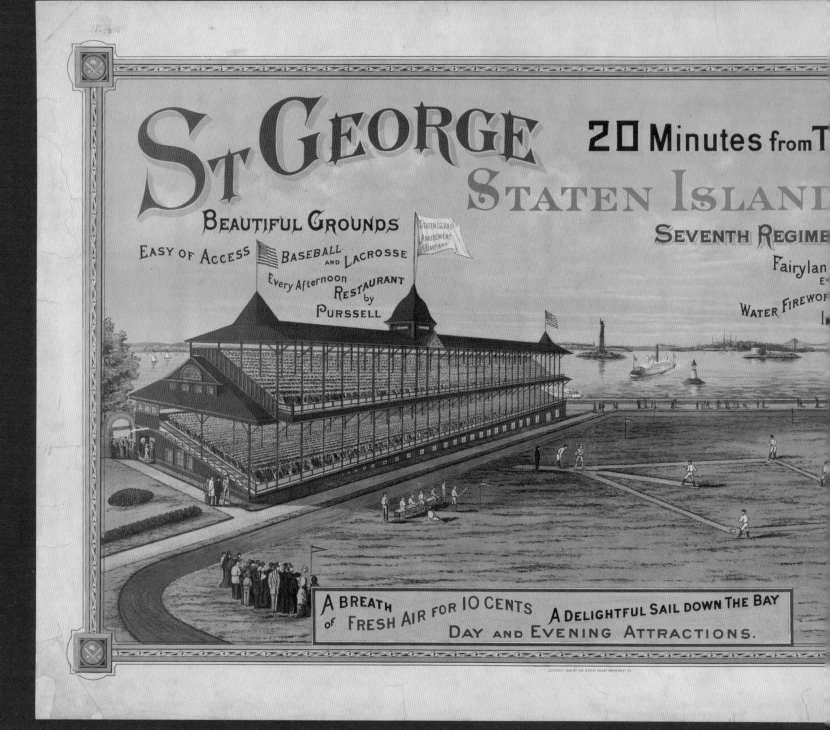

CLOCKWISE FROM ABOVE: **Chromolithograph, Hatch Lithograph Company, New York, 1886. Mount Pleasant House, White Mountains, New Hampshire, Detroit Publishing Co., ca. 1890s. Chromolithograph, New York Lithographing, Engraving & Printing Co., 1887.** As baseball transformed America's sporting scene, the country's resorts took notice. Horse-racing venues, such as the seaside St. George grounds on New York's Staten Island, was home to the Metropolitan Club, offering daily afternoon ball games and "A Breath of Fresh Air For 10 Cents" (ABOVE). In the 1870s, the gentlemen's game of polo was played within a section of grassy parkland situated near the northeast corner of Central Park in Manhattan, and by 1880, professional baseball was played on the grounds as well. In 1883, manufacturing magnate and New York Gothams owner John B. Day built a baseball park on adjoining lands at 110th Street and Fifth Avenue. Dubbed the Polo Grounds, the home of the Gothams (later the Giants), Yankees, and Metropolitans would become one of the game's most storied venues (OPPOSITE, BOTTOM). Farther north, summer guests at the Mount Pleasant House (OPPOSITE, TOP), a grand Victorian resort, could take in a ball game on the vast expanse of lawn in front of the hotel.

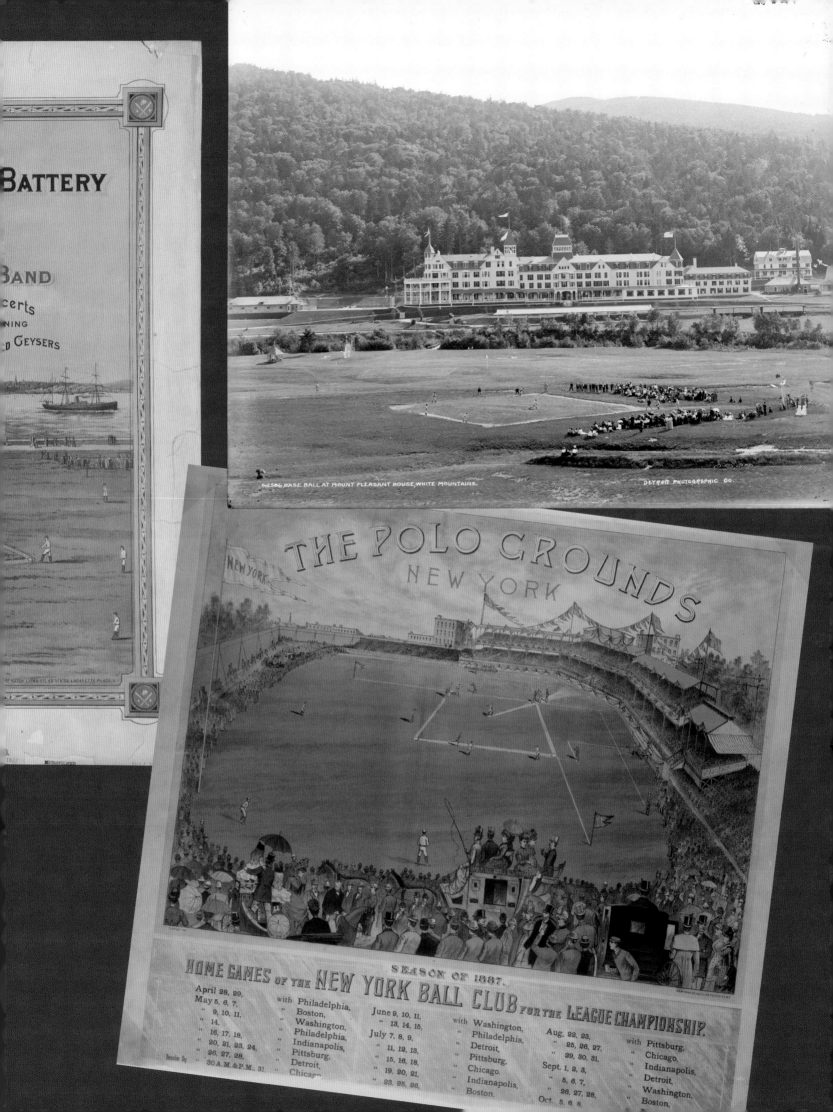

BATTERY

BAND

...certs

...ning
...D GEYSERS

612586 BASE BALL AT MOUNT PLEASANT HOUSE, WHITE MOUNTAINS.

DETROIT PHOTOGRAPHIC CO.

NEW YORK

THE POLO GROUNDS
NEW YORK

SEASON OF 1887.

HOME GAMES OF THE NEW YORK BALL CLUB FOR THE LEAGUE CHAMPIONSHIP.

April 28, 29,
May 5, 6, 7,
" 9, 10, 11.
" 14,
" 16, 17, 18,
" 20, 21, 23, 24,
" 26, 27, 28,
Decoration Day 30 A.M. & P.M. 31.

with Philadelphia,
" Boston,
" Washington,
" Philadelphia,
" Indianapolis,
" Pittsburg,
" Detroit,
" Chicago,

June 9, 10, 11,
" 13, 14, 15,
July 7, 8, 9,
" 11, 12, 13,
" 15, 16, 18,
" 19, 20, 21,
" 23, 25, 26,

with Washington,
" Philadelphia,
" Detroit,
" Pittsburg,
" Chicago,
" Indianapolis,
" Boston.

Aug. 22, 23,
" 25, 26, 27,
" 29, 30, 31,
Sept. 1, 2, 3,
" 5, 6, 7,
" 26, 27, 28,
Oct. 5, 6, 8,

with Pittsburg,
" Chicago,
" Indianapolis,
" Detroit,
" Washington,
" Boston,

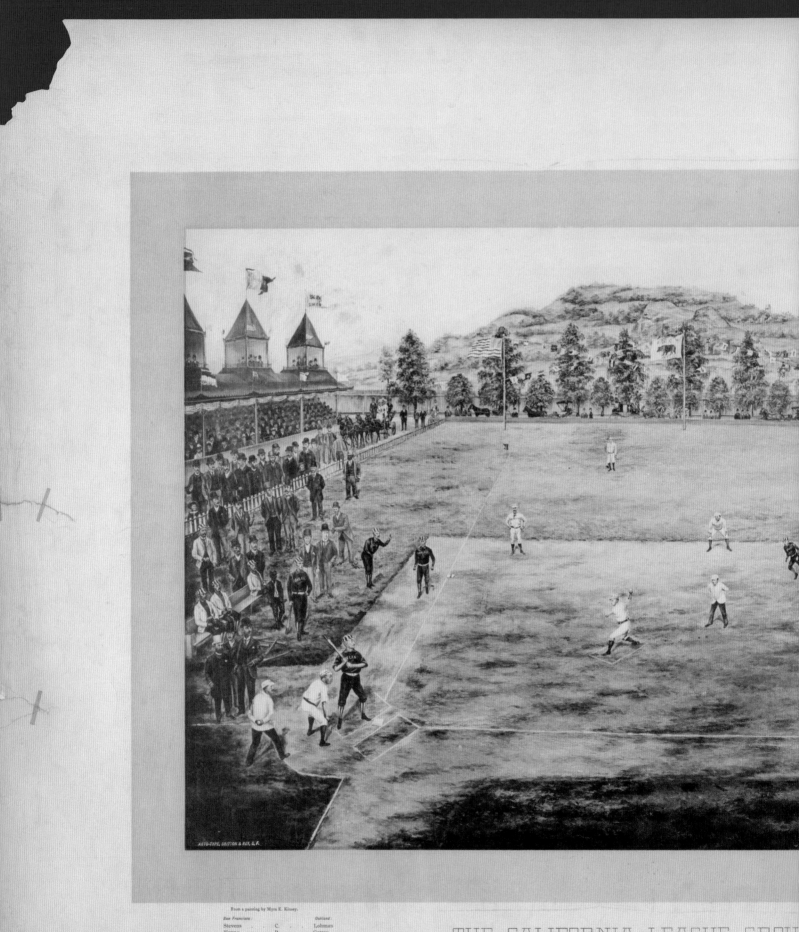

From a painting by Myra E. Kinsey.

San Francisco			Oakland:
Stevens	C.		Lohman
Young	P.		Carsey
Veach	1st B.		Dooley
Shea	2d B.		McDonald
Ebright	3d B.		Stickney
Everett	S. S.		N. O'Niell
Levy	L. F.		C. O'Niell
Hanley	C. F.		Hill
Speer	R. F.		Dungan

Umpires: J. F. Sheridan and J. F. Donahue.

THE CALIFORNIA LEAGUE GROU

SAN FRANCISCO vs OAKLAND, SEPTEMBER 9, 1890.

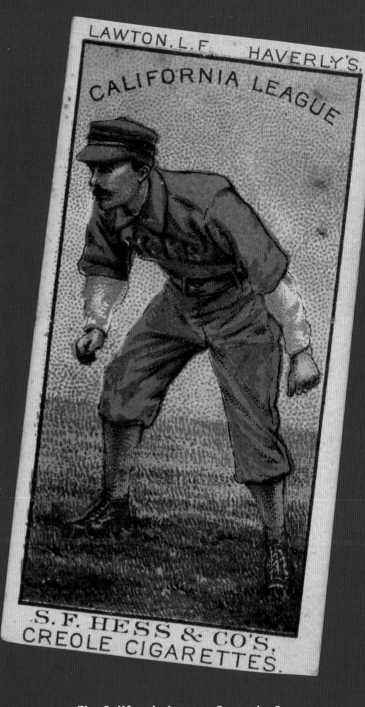

PROMINENT SPECTATORS:

President John J. Mone, Admiral Albert W. Havens, Col.
T. P. Robinson, Manager Henry H. Harris, Manager
M. E. Finn, Messrs. Walter Wallace, Joseph W. S.
Stapleton, W. H. Incell, C. L. Gage, Joseph C.
Langenlerfer, D. A. Foreman, Doc. Bushong, Geo.
J. Campbell, Paul E. Keller and Col. E. W.
Wainwright.

OPPOSITE: *The California League Grounds, San Francisco vs Oakland*, by Myra E. Kinsey, Britton & Rey, San Francisco, 1890. ABOVE: Jack Lawton, left fielder, the Haverlys, San Francisco, California League, chromolithograph, S. F. Hess and Co., 1888. By 1874, in California, San Diego teams were taking on Los Angeles squads while the Pacifics contested the Brooklyn Eckfords and other touring eastern clubs. Initially, San Francisco dominated baseball in the West, but occasionally such stars as Rube Waddell would turn up with Southern California clubs. Official league play opened in the late 1870s with numerous entities rising and falling through the decades, notable among them the California League of the 1880s and the Pacific Coast League, which was finally incorporated in 1903. Anchored by Bay Area teams, the California League spawned new urban ballparks and produced the region's first collectible cards.

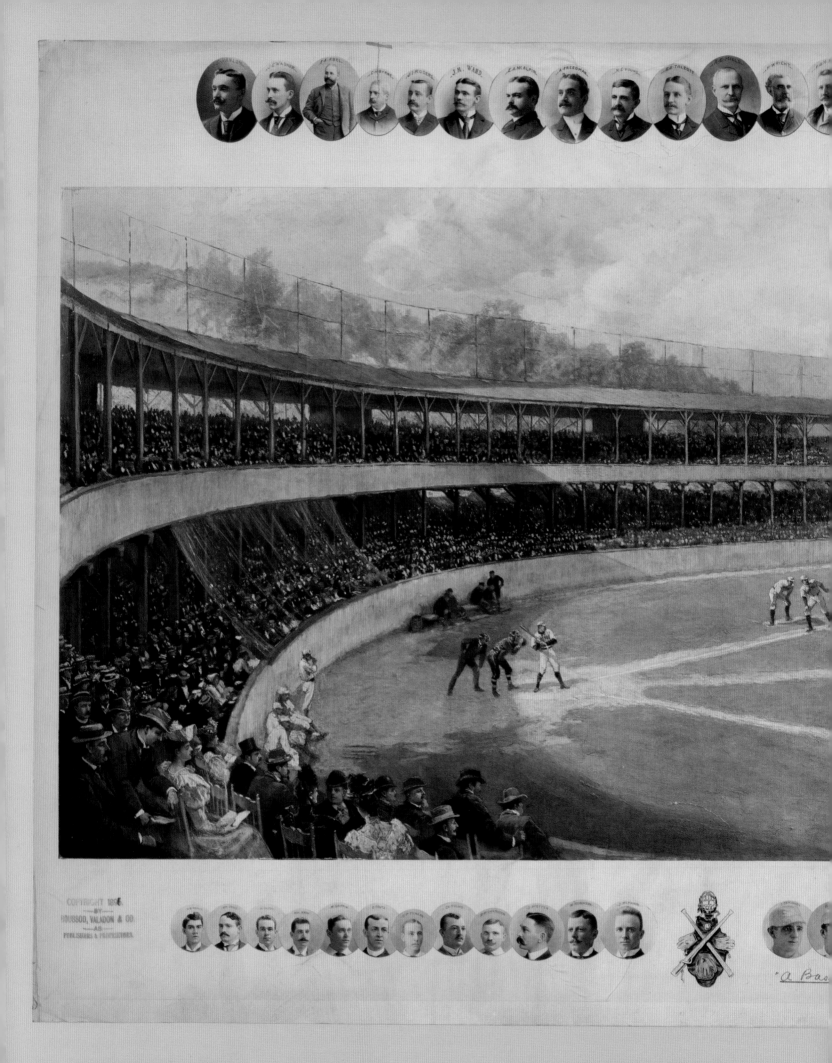

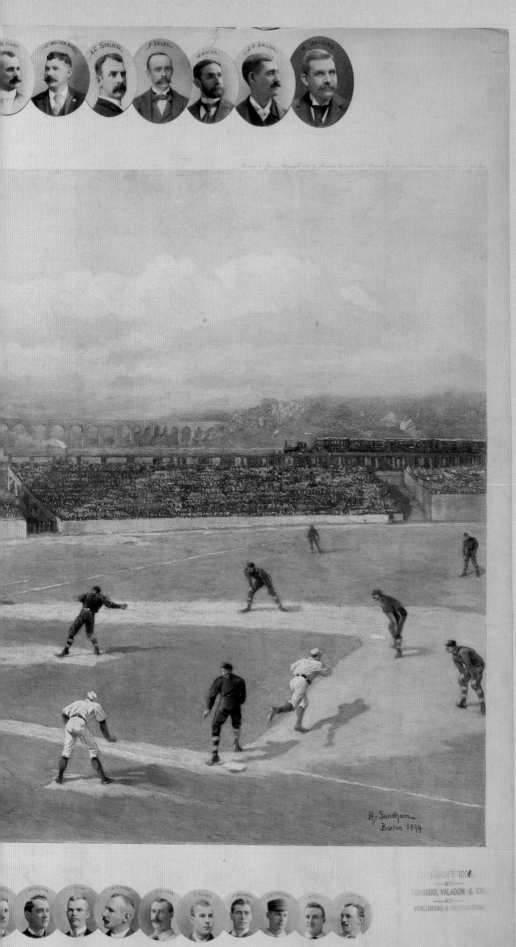

A Baseball Match, photogravure after Henry Sandham, Boussod, Valadon & Co., Paris, 1894.

LEFT: *A Baseball Match*, **photogravure after Henry Sandham, Boussod, Valadon & Co., Paris, 1894.** Often printed in Paris—then the art capital of the Western world—reproductive engravings were all the rage at the end of the nineteenth century, offering high-quality popular works of art at affordable prices. This rare photogravure combines elements of photography and etching to create a fine print of extraordinary clarity with richness of tone and texture. The scene is said to commemorate the Temple Cup of 1894 at the Polo Grounds, pitting the National League champion Baltimore Orioles against the runner-up New York Giants in a postseason series that the Giants swept in four games. Medallion portraits of club owners and league legislators—A. G. Mills, Harry Wright, A. G. Spalding, and C. Von der Ahe among them—appear above the scene while circular busts of such celebrated stars as Cap Anson, Cy Young, Hugh Duffy, Charles Comiskey, Ed Delahanty, Roger Connor, and Amos Rusie are printed below. Henry Sandham (1842–1910) was a noted artist, illustrator, and pioneer producer of composite photographs, becoming a charter member of the Royal Canadian Academy of Fine Arts in 1880. Copyrighted by the French publishers for the American market in 1896, the original scene was painted by Sandham in 1894 while he was living and working in Boston.

OVERLEAF: *Baseball*, **ceiling painting, in the Jefferson Building of the Library of Congress, Washington, D.C., 1897.**

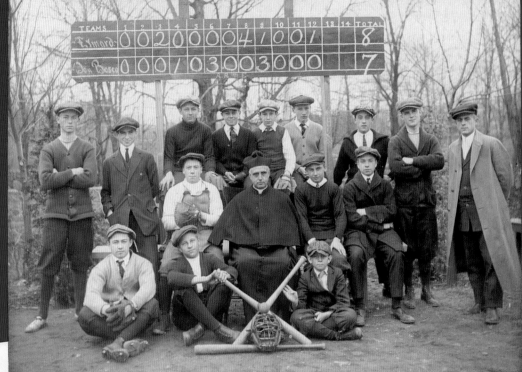

RIGHT: Eymard Seminary team, Suffern, New York, ca. 1900. The victorious seminarians pose before the scoreboard documenting their 8–7 victory over Don Bosco.

LEFT: U.S.S. *Maine* Baseball Team, 1898. After winning the Navy baseball championship in Key West, Florida, where they defeated the USS *Marblehead* 18–3 in December 1897, the USS *Maine* team posed for a photograph with their managers and mascot. Pitcher William Lambert (standing, far right), a fireman from Hampton, Virginia, was their star player and one of thirty black crewmen aboard the *Maine*. In January 1898, the battleship sailed to Havana Harbor, Cuba, where civil unrest was threatening Spanish rule. On the night of February 15, the ship's forward magazines mysteriously exploded, killing more than 260 men. Landsman John H. Bloomer (standing, far left) was the only player on the team to survive the disaster. Reports that a mine in Havana Harbor destroyed the ship prompted the rallying cry "Remember the *Maine!*" and in April, the United States declared war on Spain in support of Cuban independence.

RIGHT: The Pittsburgh National League Base Ball Club, 1896. The 1896 Pittsburgh Pirates were led by a youthful yet patrician string bean of a man, a former professional catcher by the name of Cornelius McGillicudy, also known as Connie Mack (seen here, second row, center, in his last year as the team's manager). A baseball tactician of the first order, Mack helped define the game as few have. Known as "the Grand Old Man of Baseball," he ended his active Major League tenure in 1950, at age eighty-seven, after a half century as manager and team owner of the American League's Philadelphia Athletics.

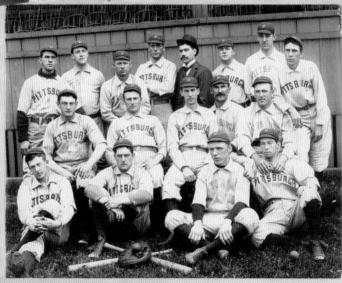

HUGH DUFFY,
CENTRE FIELDER OF BOSTON BASE BALL CLUB,
AND
CHAMPION BATSMAN OF THE WORLD.

LEFT: *Hugh Duffy . . . Champion Batsman of the World*, **photomechanical print, published by George D. Ide, Boston, 1895.** Along with fellow Irishman Tommy McCarthy, Hugh Duffy was known as one of Boston's "Heavenly Twins" during the 1890s. Duffy's phenomenal performance reached the ethereal in 1894, when he won the unofficial Triple Crown with 18 home runs, 145 RBIs, and a staggering .438 batting average. For good measure, Duffy also led the National League in doubles and slugging percentage that year.

BELOW: **Supplement to the** *Police Gazette*, **June 1, 1895.**

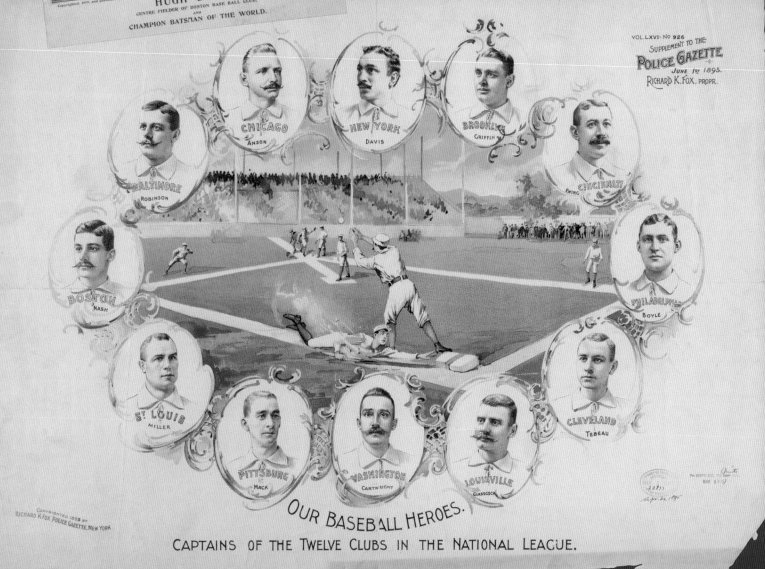

BASEBALL CARDS:
THE FIRST WAVE

★ ★

The first collectible baseball cards were not for kids—they came in cigarette packs. During the Gilded Age, the highly competitive tobacco industry was in the vanguard of national advertising and promotion. Beginning in 1887, rival tobacco producers inserted a variety of small cards depicting ballplayers into their packages to advertise their products. These were the first American collectible sports cards: issued in series and featuring photographic or chromolithographic (a color printing process) prints adhered to slim cardboard mounts. Although the cards vary in design and format, most are quite small, measuring $2^{5}/_{8}$ x $1^{1}/_{2}$ inches. By 1890, the major tobacco companies had consolidated into American Tobacco Company, a holding company. In the spirit of the age of robber barons, competition had ceased and so had the first card sets.

Among the first color-printed card series were Allen & Ginter's World's Champions, Goodwin Champions, S. F. Hess California League, and Buchner Gold Coin. The Allen & Ginter set, thought to be the earliest, is a beautiful set of great quality featuring fine commercial printing and good paper. Goodwin Champions represents an advance in commercial color printing; the portraits of

Harry Wright, manager, Philadelphia Phillies (National League), Chas. Gross & Co., 1887.

Harry Pratt Lyons, left fielder, and Billy Taylor, team trainer, Philadelphia Phillies (National League), Chas. Gross & Co., 1887.

Arthur A. Irwin and Albert J. Maul, Philadelphia Phillies (National League), Chas. Gross & Co., 1887.

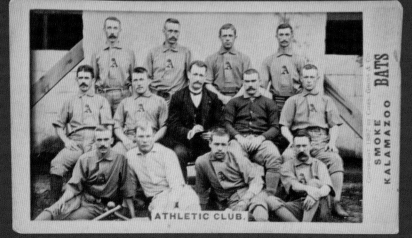

The Philadelphia Athletics (American Association), Chas. Gross & Co., 1887.

ABOVE: Back of baseball cards issued by D. Buchner & Company, 1887.

LEFT: Sam Barkley, first baseman, St. Louis Browns (American Association), D. Buchner & Company, 1887.

RIGHT: Jim O'Rourke, catcher, New York Giants (National League), D. Buchner & Company, 1887.

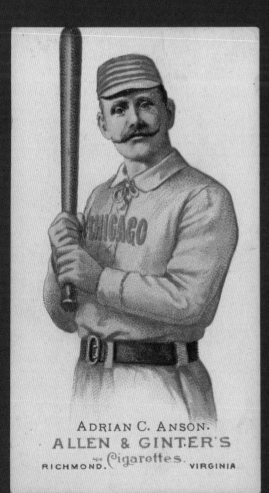

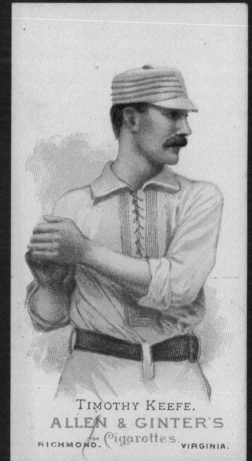

Adrian C. Anson, first baseman, Chicago White Stockings (National League), Allen & Ginter Co., 1887.

Timothy Keefe, pitcher, New York Giants (National League), Allen & Ginter Co., 1887.

Charles Comiskey, first baseman, St. Louis Browns (American Association), Allen & Ginter Co., 1887.

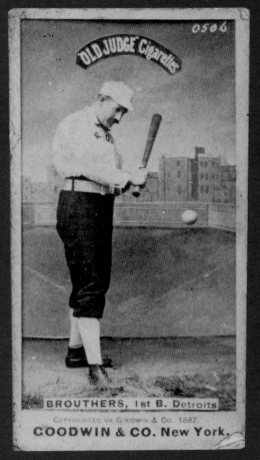

Dan Brouthers, first baseman, Detroit Wolverines (National League), Goodwin & Co., 1887.

Cal Broughton, catcher, St. Paul (Western League), Goodwin & Co., 1889.

Billy Sunday, center fielder, Chicago White Stockings (National League), Goodwin & Co., 1887.

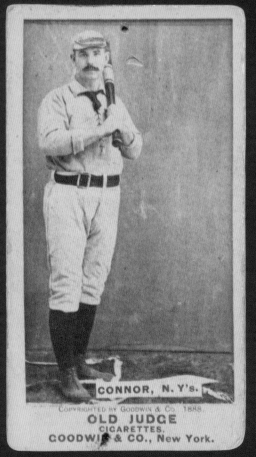

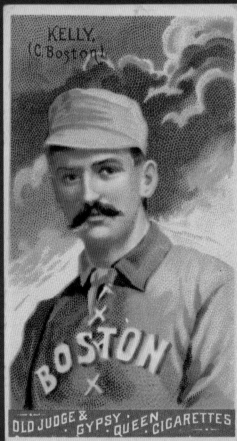

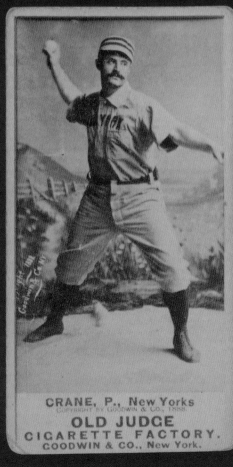

Roger Connor, first baseman, New York Giants (National League), Goodwin & Co., 1888.

King Kelly, catcher, Boston Beaneaters (National League), Goodwin & Co., 1888.

Cannonball Crane, pitcher, New York Giants (National League), Goodwin & Co., 1888.

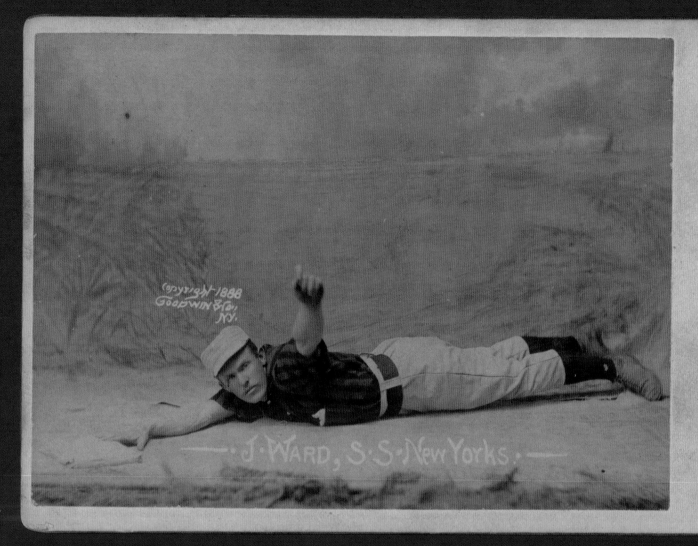

John Montgomery Ward, shortstop, New York Giants (National League),
Goodwin & Co., 1888.

Cap Anson and "King" Kelly are particularly striking. The Hess, Gold Coin,
and Kimball World Series Champions sets are less polished, possessing a
naive charm in keeping with the game's early growth. Color-printed
cards often included series information and promotional advertising on
the back.

 The granddaddy of the early sets is the Old Judge series of photographic
cards issued by Goodwin & Co. between 1887 and 1890. This series was
among the era's largest, comprising hundreds of players, managers, and
owners. Virtually all of the portraits in the series were taken in studios
and offer an array of posed slides, batters frozen in midswing, balls hang-
ing on string, fielders squatting or reaching with cupped hands. The Old
Judge series also included an oversize "cabinet" format set of photographs
offered to customers as a premium for sending in several dozen coupons.
The cards are a visual compendium of the professional game's early
character, equipment, apparel, and technique.

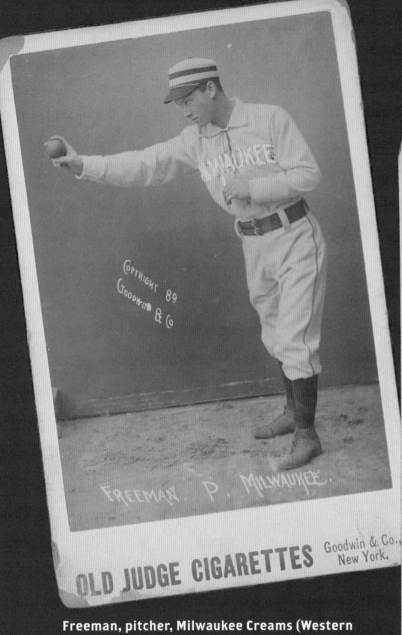

Freeman, pitcher, Milwaukee Creams (Western Association), Goodwin & Co., 1889.

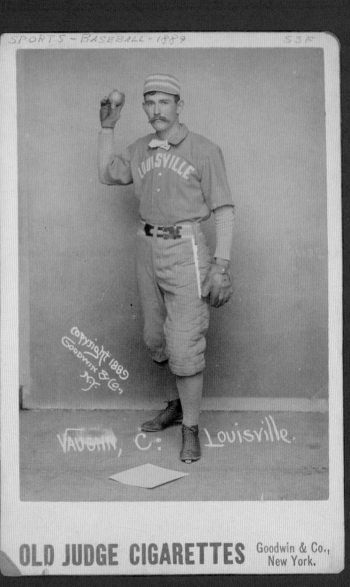

Farmer Vaughn, catcher, Louisville Colonels (American Association), Goodwin & Co., 1889.

The portrait poses might appear stiff and gawky, but in the 1880s, when commercial photography was still young, they would have seemed remarkably fresh. For baseball fans, the cards brought the players' faces into focus; decades worth of crude wood engravings and generic images had obscured their individuality. For smokers who enjoyed the game, cards were a sure enticement to buy another pack. The era of card collecting, not to mention the sports celebrity vogue, had only just begun.

OPPOSITE: **Washington Base Ball Club (National League), set of uncut cards, Goodwin & Co., 1887.**

WASHINGTON BASE BALL CLUB.

WASHINGTON.

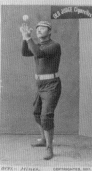
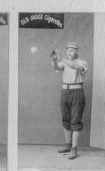
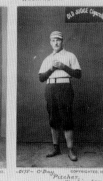
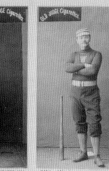

.0181—Hines, Centre Field. Washington.
GOODWIN & CO., NEW YORK.

.0183—Shock, Right Field. Washington.
GOODWIN & CO., NEW YORK.

.0174—O'Day, Pitcher. Washington.
GOODWIN & CO., NEW YORK.

.0175—O'Day, Pitcher. Washington.
GOODWIN & CO., NEW YORK.

.0180—Hines, Centre field. Washington.
GOODWIN & CO., NEW YORK.

.0195—Myers, Short Stop. Washington.
GOODWIN & CO., NEW YORK.

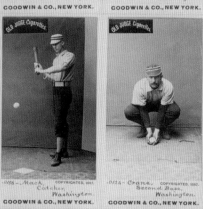

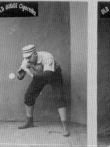

.0182—Shock, Right Field. Washington.
GOODWIN & CO., NEW YORK.

.0166—Farrell, Second Base. Washington.
GOODWIN & CO., NEW YORK.

.0184—Shock, Right Field. Washington.
GOODWIN & CO., NEW YORK.

.0177—Gilligan, Catcher. Washington.
GOODWIN & CO., NEW YORK.

.0178—Gilligan, Catcher. Washington.
GOODWIN & CO., NEW YORK.

.0192—Donnelly, Third Base. Washington.
GOODWIN & CO., NEW YORK.

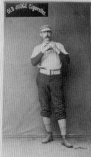

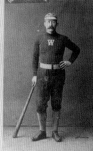
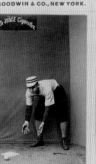

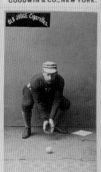
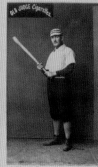
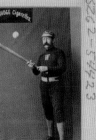

.0169—Whitney, Pitcher. Washington.
GOODWIN & CO., NEW YORK.

.0156—Mack, Catcher. Washington.
GOODWIN & CO., NEW YORK.

.0124—Crane, Second Base. Washington.
GOODWIN & CO., NEW YORK.

.0194—Donnelly, Third Base. Washington.
GOODWIN & CO., NEW YORK.

.0157—Farrell, Second Base. Washington.
GOODWIN & CO., NEW YORK.

.0164—O'Day, Pitcher. Washington.
GOODWIN & CO., NEW YORK.

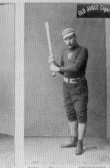
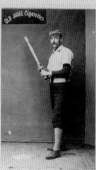
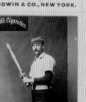

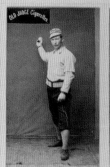

.0165—Farrell, Second Base. Washington.
GOODWIN & CO., NEW YORK.

.0172—Krieg, First Base. Washington.
GOODWIN & CO., NEW YORK.

.0196—Myers, Short Stop. Washington.
GOODWIN & CO., NEW YORK.

.0123—Crane, Second Base. Washington.
GOODWIN & CO., NEW YORK.

.0163—Deasly, Catcher. Washington.
GOODWIN & CO., NEW YORK.

.0166—Farrell, Second Base. Washington.
GOODWIN & CO., NEW YO

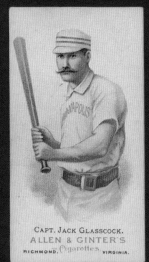

Captain Jack
Glasscock, shortstop,
Indianapolis Hoosiers
(National League),
Allen & Ginter Co.,
1887.

Bob Caruthers,
pitcher, Brooklyn
Bridegrooms
(American
Association), Goodwin
& Co., 1888.

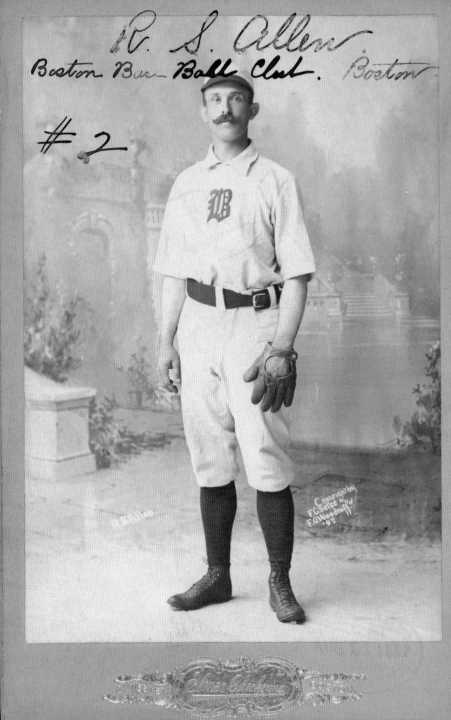

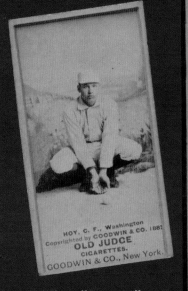

William "Dummy"
Hoy, center fielder,
Washington
Nationals (American
Association),
Goodwin & Co., 1888.

R. S. Allen, shortstop, Boston Beaneaters (National League), mounted
cabinet card, photograph by Elmer Chickering, 1897.

Charles Brynan,
pitcher, Des Moines
(minor league),
Goodwin & Co., 1888.

OPPOSITE: Stock poster, Strobridge Lith. Co.,
Cincinnati & New York, 1897.

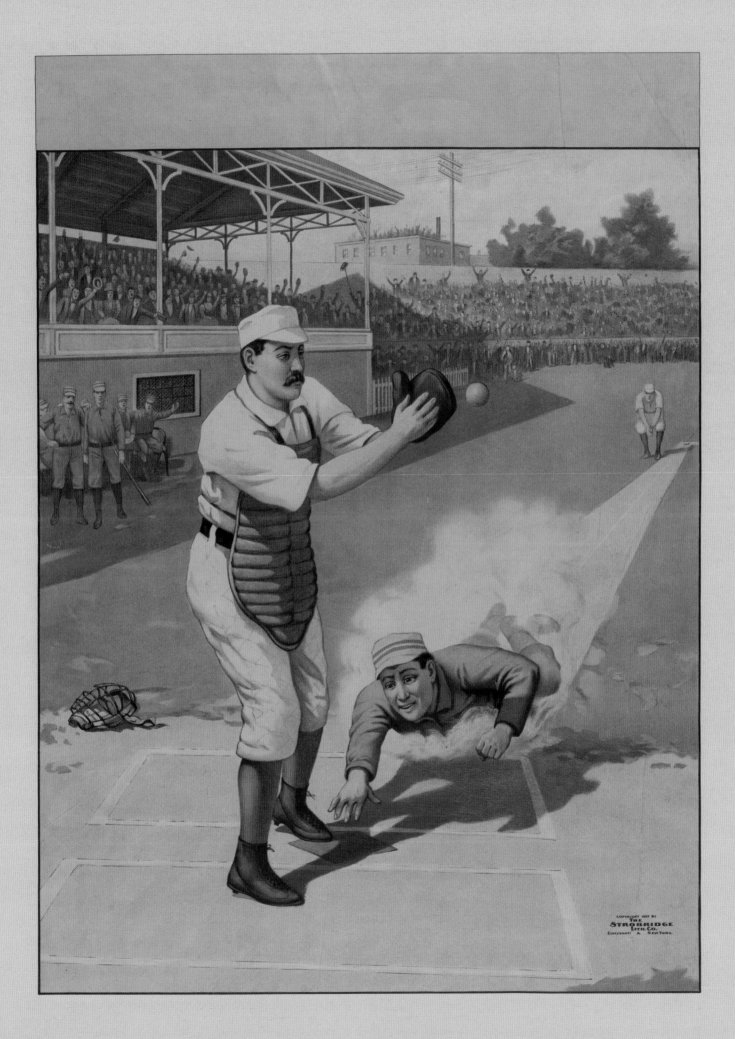

OPENING DAYS
⟨THE BASEBALL CENTURY BEGINS⟩
(1900–1920)

The first two decades of the twentieth century have been called baseball's "Glory Years." Widespread economic prosperity brought an increase in leisure time and more fans to games than ever before. An explosion of media coverage helped make the newly established World Series an autumnal event followed by millions. After the numerous trade wars and player-owner disagreements of the tumultuous 1880s and 1890s, Major League Baseball found relative stability, and hometown team loyalty blossomed. Players' nicknames reflected the variety and vibrancy of American society: Ty Cobb, "the Georgia Peach"; Honus Wagner, "the Flying Dutchman"; Walter "Big Train" Johnson; and Christy Mathewson, "the Christian Gentleman." While Major League cities erected monumental parks that could house up to twenty-five thousand fans, amateur and semiprofessional ball flourished on sandlots and city streets.

OPPOSITE: **Chromolithograph, 1915.** Philadelphia Athletics manager Connie Mack commissioned this print with the schedules of his team and their National League counterparts, the Phillies. The poster features Mack's one-time star, Rube Waddell, who had passed away the previous year.

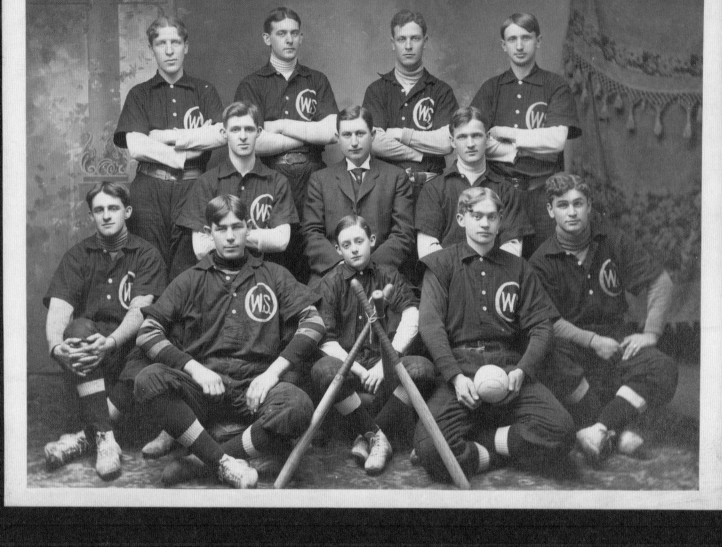

Indoor Baseball World Champions, 1905–1906. This studio portrait of the Owosso, Michigan, team shows the player sitting second from the right, front row, holding a large ball, which was used in the indoor version of the game. George Hancock of Chicago is credited with developing the game in 1887, and Louis Rober, a Minneapolis firefighter, further refined it as a way to keep his colleagues in shape during the winter months. Athletes throughout the upper Midwest played indoor baseball in gyms, using shorter bats and rules that differed from traditional baseball. Eventually, the term "softball" replaced "indoor baseball," and the game itself moved outdoors as well.

In the off-season, Major Leaguers toured the country as vaudeville attractions. Whether to escape the doldrums of farm life or the wretchedness of work in an urban factory, Americans everywhere, black and white, male and female, rushed to fill their free time with some form of watching, playing, or talking about the sport that was truly living up to the moniker National Pastime.

A major development in the business of baseball occurred in late 1902, when the warring American and National leagues agreed to reconcile their differences and continue under the umbrella later to be known as organized baseball. The conflict had begun in 1899 when Byron Bancroft "Ban" Johnson, president of the minor Western League, decided to change the name of his league to the American League, move teams into National League markets, and (most important) refuse to honor National League player contracts and their unwritten "reserve" clauses. After two years of player snatching and salary escalation, the self-termed "magnates" of the National League waved the

white flag. The two leagues came together under a new National Agreement to recognize each other's player contracts and consolidate a monopoly on Major League Baseball.

The reserve clause would remain a bedrock underpinning player contracts for most of the twentieth century. It allowed an owner to reserve a player's services as long as he wanted; a player could not negotiate a better contract with another team until he was released. The effect was that as owners' profits soared in the 1910s, player salaries remained stagnant. Washington Senators ace Walter Johnson called it "baseball slavery." An attempt to unionize in 1912, with the formation of the Fraternity of Professional Baseball Players of America, failed to break the contractual gridlock. In 1914, one-third of Major League players left to join the newly minted Federal League. Although the Federal League survived for two seasons, in the end it simply could not compete with the more established American and National leagues. Ban Johnson and other owners raised salaries enough to keep their biggest stars, such as Ty Cobb and Joe Jackson, from making the switch, and when they banded together to buy out the principal financial backers of the Federal League teams, the league folded. The Federal League represented the last real challenge to the grip owners held on the baseball market until the beginning of free agency in the 1970s.

Historians and students of the game have given another name to this period of baseball's history: the Dead Ball Era. Although the ball itself was revamped in 1910, when balls with a cork center and a layer of rubber one-eighth of an inch

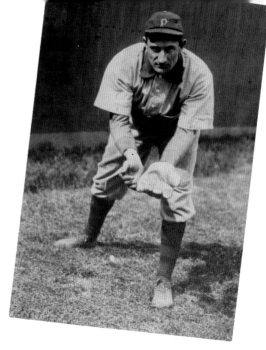

ABOVE: **Honus Wagner, shortstop, Pittsburgh Pirates, Bain News Service, ca. 1911.**

BELOW: **The Ball Team, young glass-workers in Indiana, photograph by Lewis Hine, August 1908.** Photographer and social reformer Lewis Hine used his camera on behalf of the National Child Labor Committee to document and improve the lot of working-class children in the early twentieth century.

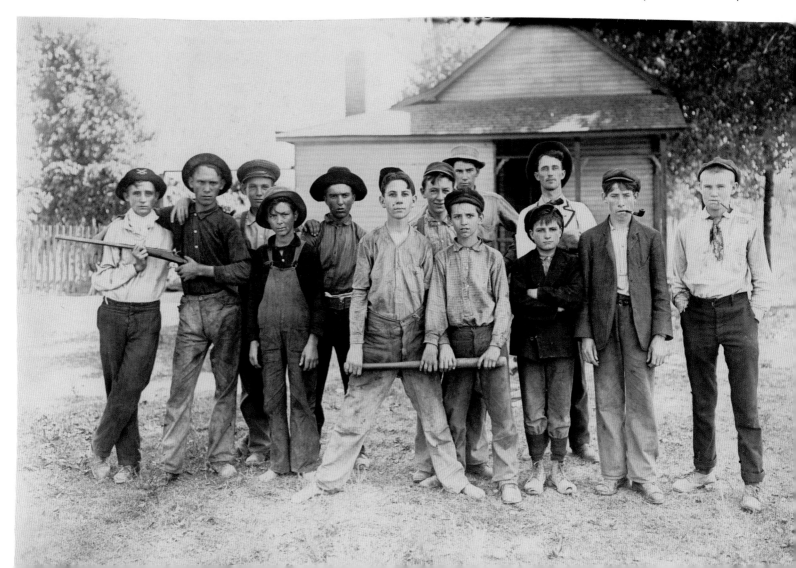

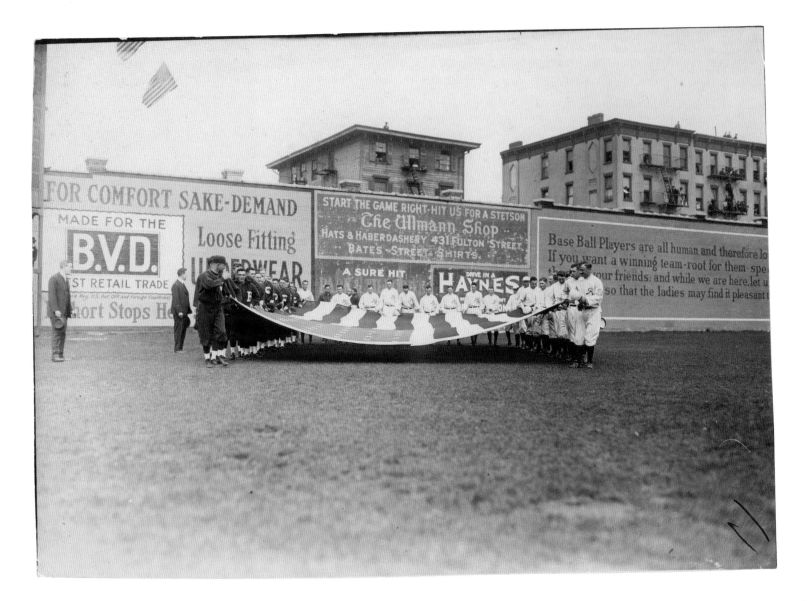

Buffalo Bisons and Brooklyn Tip Tops, Washington Park, Brooklyn, Federal League, Bain News Service, 1914. The Brooklyn Tip Tops, shown at right in a pregame ceremony with the Buffalo Bisons, played in Washington Park, the Dodgers' old facility, for the two years of their existence in the Federal League. Note the advertisements on the outfield wall, including one for BVD underwear. A public service announcement at right reminds fans to mind their manners because "Base Ball Players are all human" and "so that the ladies may find it pleasant" to be at the ballpark.

OPPOSITE: Portion of "Casey at the Bat" (1888), by Ernest Thayer, illustration by Edgar Keller, page from reprint published by M. Witmark & Sons, New York, 1904.

thick were introduced, improving overall hitting slightly, baseball in these first two decades was wholly dominated by defense. Early in the century, two rule changes had shifted the balance between batter and pitcher considerably to the advantage of the latter. In 1900, the standard home plate was changed from a twelve-inch square to a five-sided figure seventeen inches across. Two years later, both the National and the American leagues agreed to call the batter's first two foul balls strikes.

With a larger strike zone and strikeouts more easily attainable, scoring plummeted. The strategy of "inside baseball" ruled, with teams scraping their way to runs. Managers such as John McGraw, Clark Griffith, and Connie Mack were known as field generals, cunning baseball scientists willing to use a variety of techniques to move runners around the bases and get them home. Hitters choked up on the bat and punched balls into play in order to gain a base. Stealing and the hit-and-run were perfected to the level of art. With so much riding on each play, umpires were subjected to torrents of abuse from fans, players, and managers in the event of a questionable call. Out of the eye of the umpire (most games were still overseen by a single field judge), a base runner was

known to throw up his spikes during a slide, and an infielder might temporarily hold up a base runner by slipping a finger under his opponent's belt. Pitchers lathered their balls in spit, licorice, and grime. "Baseball is not unlike a war," Detroit outfielder Ty Cobb famously remarked, and the war on the field was one that valued gritty determination and hand-to-hand combat.

The game on the field may have become rougher, and the crowd-pleasing home run further reduced to a rare occurrence, but baseball fanatics populated bleachers and grandstands in droves. Several baseball traditions were born in this period as well. Ernest Thayer's poem "Casey at the Bat," first published in the *San Francisco Examiner* on June 3, 1888, grew widely popular through reprints and theatrical adaptations on stages throughout the country. In 1908, Jack Norworth, who claimed he had never actually been to a baseball game, penned the lyrics to a tune called "Take Me Out to the Ball Game," in which Katie Casey, a "baseball mad" girl, begs her beau for a date at the ballpark. Norworth's wife started singing the song at vaudeville shows, and its refrain became the unofficial anthem of the sport. In 1910, President William Howard Taft threw out the opening-day pitch for the Washington Senators, starting a venerable presidential tradition.

Cy Young, pitcher, Boston Red Sox, July 23, 1908. A brief review of Cy Young's career statistics reveals why the coveted Cy Young Award is given annually to the top American League and National League pitchers. He won thirty games in a season five times and was the first pitcher to toss no-hitters in both leagues. When Young ended his twenty-two-year career at age forty-four, it was not because his sturdy arm had worn out, but because he had gained so much weight that batters could bunt their way on base against him.

Then from five thousand throats went up a lusty yell;
It rumbled in the valley and rattled in the dell,
It knocked upon the mountain top and recoiled upon the flat,
For Casey, mighty Casey, was advancing to the bat.
There was ease in Casey's manner as he stepped into his place,
There was pride in Casey's bearing and a smile on Casey's face,
And when responding to the cheers he lightly doffed his hat,
No stranger in the crowd could doubt 'twas Casey at the bat.

Ten thousand eyes were on him as he rubbed his hands in dirt,
Ten thousand hands applauded as he wiped them on his shirt,
And when the writhing pitcher ground the ball into his hip,
Defiance glanced in Casey's eye, a sneer curled Casey's lip.
And now the leather-covered sphere came whirling through the air,
And Casey stood a-watching it in haughty grandeur there.
Close by the sturdy batsman the ball unheeded sped.
"That ain't my style," said Casey. "Strike one," the umpire said.

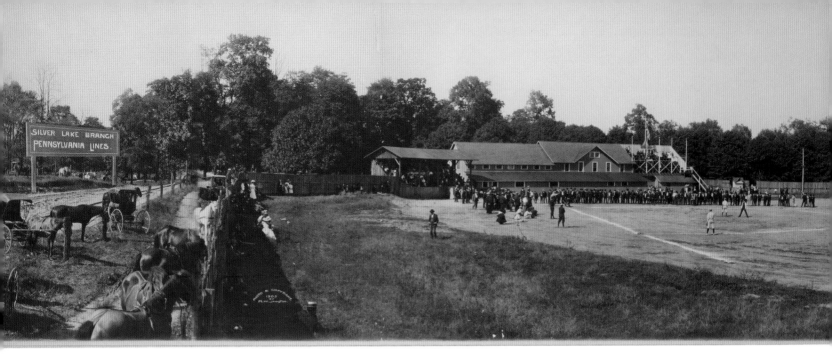

Baseball Park, Silver Lake, Ohio, R. W. Johnston photograph, 8½ x 45½ in., 1905. Before it became a residential village in 1918, Silver Lake was an amusement park that boasted a racetrack, a ball field, and a roller coaster.

Miss Myrtle Rowe, Bain News Service, March 14, 1910. Shortly before Miss Rowe, eighteen, posed for this photograph, *The New York Times* reported that she had signed to play first base for the Antler Athletic Club of New Kensington, a men's semiprofessional team near Pittsburgh, Pennsylvania. The *Times* noted that "this is Miss Rowe's third year with the Antlers, and both her fielding and batting averages are said to rank toward the top of the semiprofessionals in this neighborhood. The girl plays in the uniform of the club, her costume being a short-sleeve, loose-fitting blouse and a short skirt. She is a favorite with the 'fans,' and her work is generously applauded at all the games."

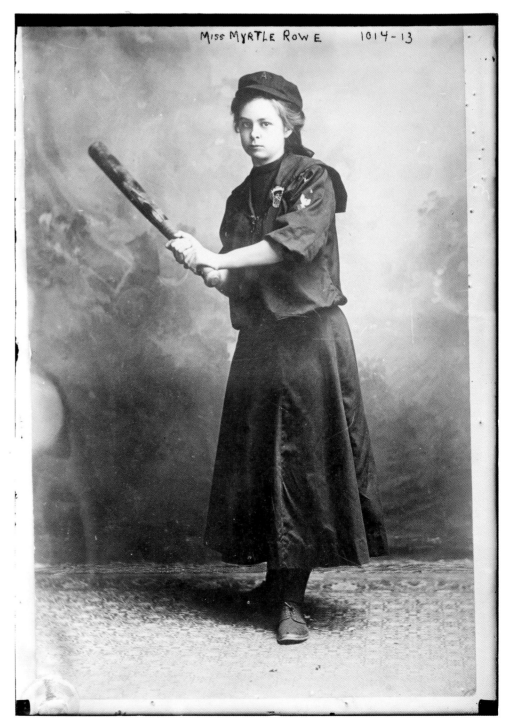

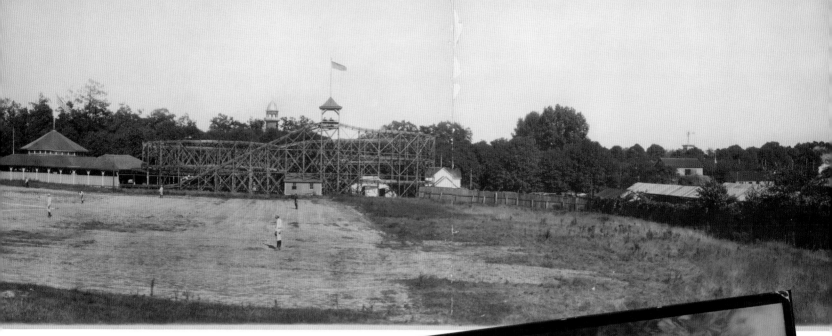

Meanwhile, women continued to form a growing percentage of baseball fandom. Anecdotal evidence, as well as photographs of crowds from the period, supports the claim that it had become more suitable for women to attend baseball games. There is also little doubt that more women were playing the sport than ever. All-female and mixed teams competed all over the country, and many athletic departments at women's colleges supported their students playing the sport. Touring teams, often going by the name "Bloomer Girls," would arrive in a small town and challenge the local team; after playing a few games, and taking their cut of the ticket receipts, the team would move on. These teams often employed men playing in wigs and makeup as a stunt. Smoky Joe Wood, who later played in the Major Leagues and was a hero of the 1912 World Series, admitted to playing in drag for a women's team early in his career (see page 79).

For black players, baseball thrived in a similarly itinerant vein, but on a much larger scale. Traveling professional teams predominated until the 1920s, when more consolidated league structures were established. Players such as Andrew "Rube" Foster and John Henry "Pop" Lloyd became nationally recognized stars playing for such legendary squads as the Cuban X-Giants and the Chicago American Giants. Occasionally, these teams played exhibitions against

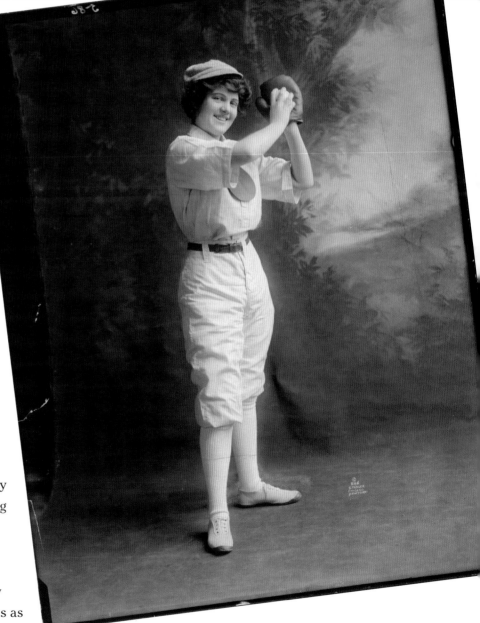

Bloomer girl, Stadler Studio, Chicago, 1914.

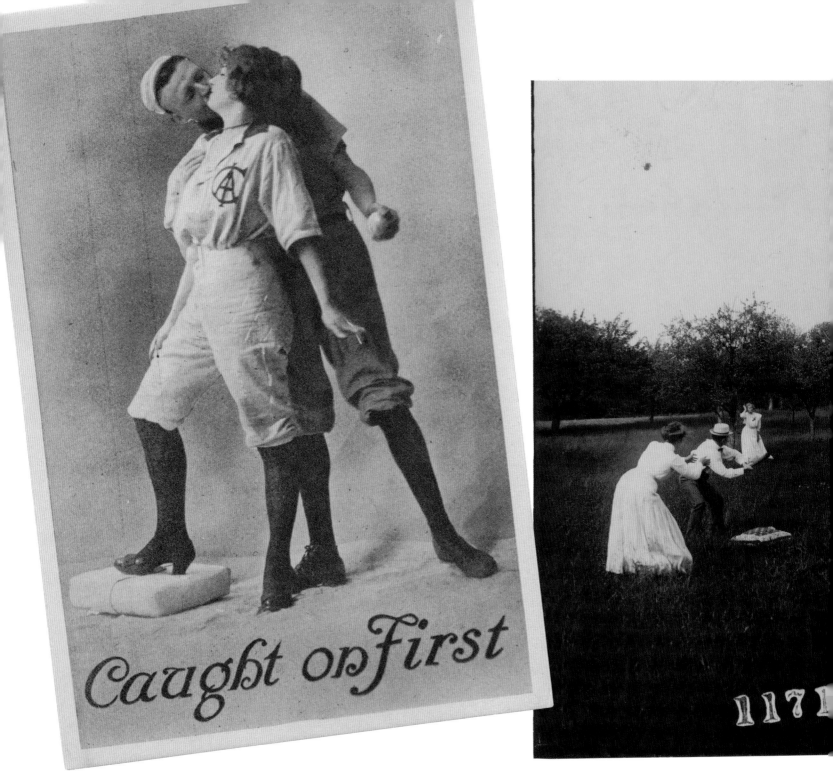

Caught on First, postcard, ca. 1910.

Major League teams, and they often won. Many were funded by white business-men, and their games drew large crowds of both white and black spectators. Lloyd was often called the "Black Wagner," to which the white (Honus) Wagner gave this appreciative response: "I was honored to have John Lloyd called the Black Wagner. It is a privilege to have been compared with him."

During these decades, baseball players and fans nationwide grappled with the sport's system of official racial segregation. In 1901, Baltimore's fiery player-manager, John McGraw, attempted to integrate the game by stealth when he announced that the Orioles had signed Charlie Tokohama, a Cherokee Indian. Before McGraw's prospect ever played a game, though, it was revealed that Tokohama was actually Charlie Grant, a black second baseman who had

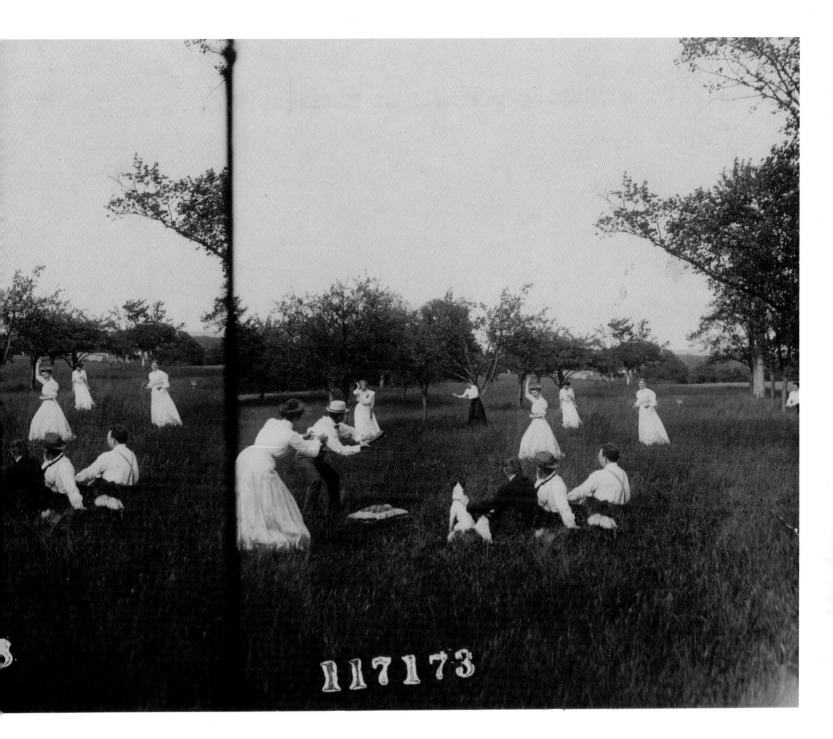

117173

previously played for an all-black team in Chicago. McGraw backed down after Charles Comiskey and others raised familiar racist objections.

Black fans were not absent from Major League bleachers, however (even though the game on the field remained segregated), and games between all-black teams became a popular Sunday afternoon tradition. Some held out hope that the insistence on separate leagues, no matter how successful, would evaporate. Sol White, a black baseball pioneer and Hall of Famer, wrote in 1906 of the player he hoped would someday break the color barrier, a remarkable prediction of Jackie Robinson: "There are grounds for hoping that some day the bar will drop and some good man will be chosen out of the colored profession that will be a credit to all, and pave the way for others to follow."

Baseball in the park, Madison, New Jersey, Underwood & Underwood stereograph, 1910. A group of picnickers enjoy a game of ball, even though the pitcher, catcher, and fielders are impractically clad. By this time, Alta Weiss, who put herself through medical school as a successful, crowd-drawing pitcher on men's semiprofessional teams, had given up trying to play in conventional women's wear and switched to bloomers. "I found that you can't play ball in skirts," she explained. "I tried. I wore a skirt over my bloomers and nearly broke my neck."

COLLEGE BALL

At the turn of the twentieth century, the Big Man on Campus was often a baseball player, although at some schools football players were successfully competing for the title. The establishment of land-grant colleges nationwide following the Civil War and greater investment in public education also meant riches measured in diamonds—baseball diamonds. By the 1880s, baseball was the top collegiate sport, as deans approved of its "healthful" aspects and the school spirit it fostered. Teams tended to play informal schedules, while well-funded squads toured nationally on extended spring breaks. In 1897, editors of the *Atlanta Looking Glass* were positively giddy after the University of Georgia "covered itself with glory," earning a no-hit victory over the University of Pennsylvania, a resounding slap in the face to the "haughty athletes of the great universities of the North." In the meantime, as colleges discovered that charging admission to games produced a handy source of revenue, there was growing concern that players who participated in summer leagues for minimal pay were "professionals" and not the gentlemen players their universities expected—or claimed—them to be. But by the early 1900s, the college game, like the Major Leagues before it, had become part of the growing sports industrial complex, with schools recruiting talent, granting athletic scholarships, expanding athletic facilities, forming booster clubs, and hiring former professionals as coaches.

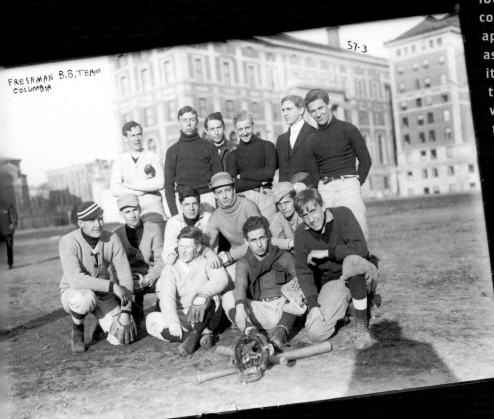

FRESHMAN B.B. TEAM
COLUMBIA

57-3

Freshman baseball team, Columbia University, 1908.

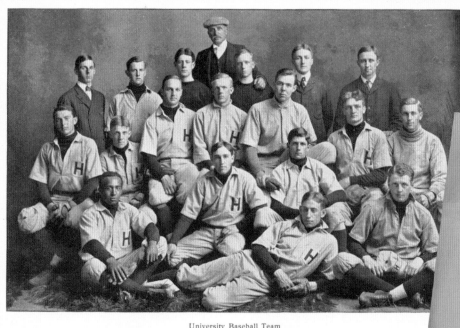

University Baseball Team

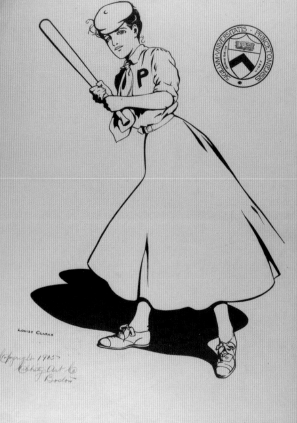

Louise Clarke

Copyright 1905
Chisolm Art Co
Boston

Harvard University baseball team, 1903. Harvard's team, perhaps the nation's best early twentieth-century college squad, posed for the university's 1904 calendar. Despite its success, not everyone was a fan. Harvard president Charles William Elliott viewed most college sports as unethical and corrupt. On one occasion, he said of a Crimson baseball team, "Well, this year I'm told the team did well because one pitcher had a fine curve ball. I understand that a curve ball is thrown with a deliberate attempt to deceive. Surely this is not an ability we should want to foster at Harvard." In 1905, stellar shortstop William Clarence Matthews (front row, left), a Selma, Alabama, native, led the team with a .400 batting average. Yet his remarkable talent on the field was not the only thing that unnerved opponents; some all-white teams refused to play Harvard because Matthews was black. After graduation, he declared, "What a shame it is that black men are barred forever from participating in the national game. . . . As a Harvard man, I shall devote my life to bettering the condition of the black man. . . ." Matthews earned a law degree from Boston University in 1908 and went on to have a successful career at the U.S. Justice Department. For the next forty seasons, Major League Baseball missed out on the contributions of Matthews and other black prospects. In 2006, the Friends of Harvard Baseball instituted the William Clarence Matthews Trophy, awarded annually to the winner of the Ivy League baseball championship.

Princeton University baseball player, by Louise Clarke, lithograph, 1905.
Baseball was an intramural sport at many women's colleges, from the Ivy League's Seven Sisters to private academies and state colleges. Fears that baseball was too violent for women forced upstart intercollegiate club teams, such as the one at Vassar, to disband in the 1860s, but by the early twentieth century, college administrators viewed the sport as a useful part of a well-rounded athletic curriculum for a cultured young lady.

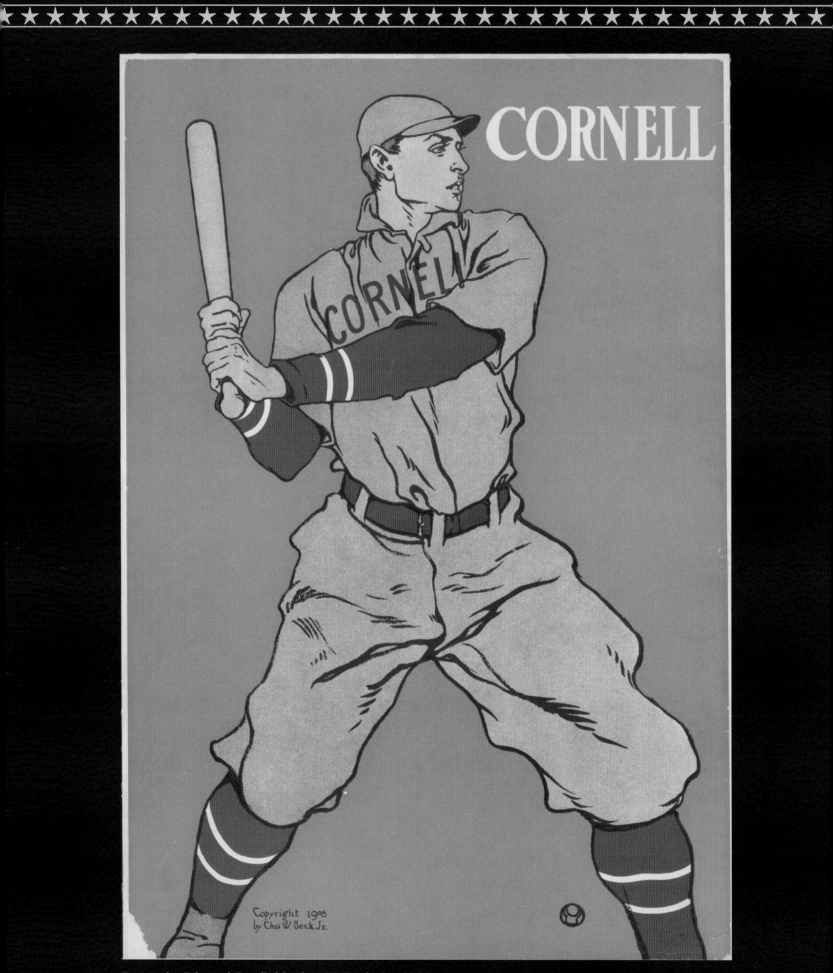

Poster by Edward Penfield, Chas W. Beck, Jr., 1908.

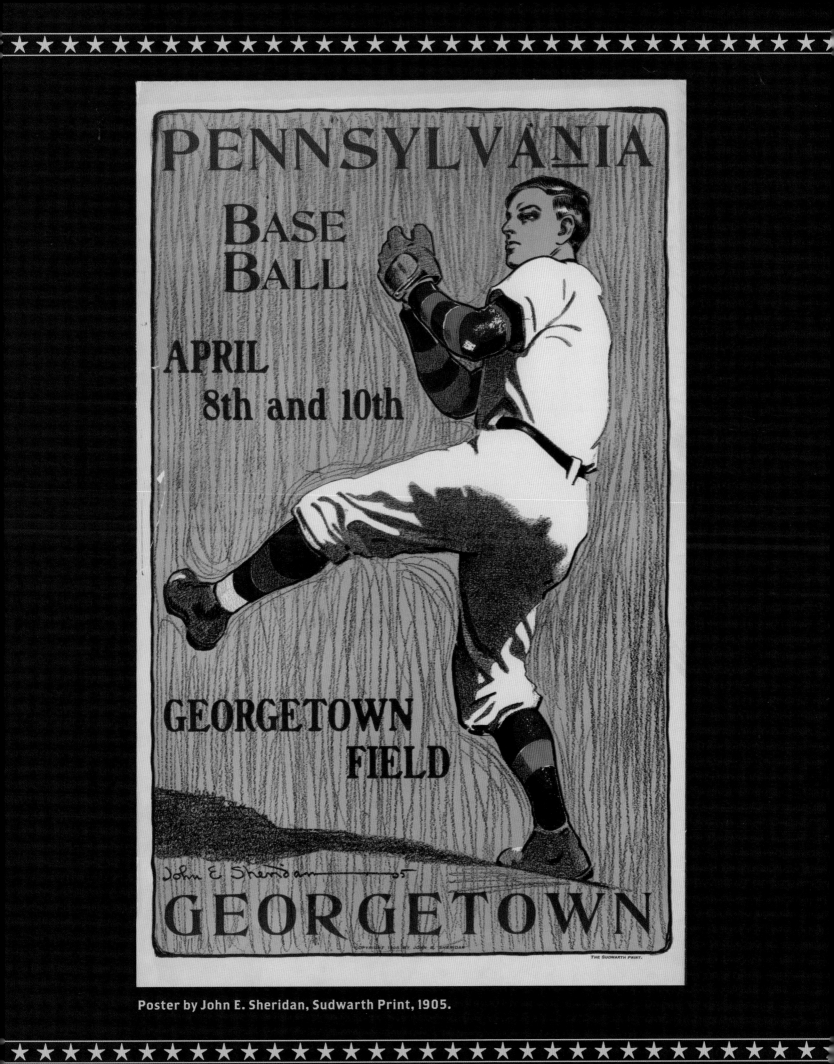

Poster by John E. Sheridan, Sudwarth Print, 1905.

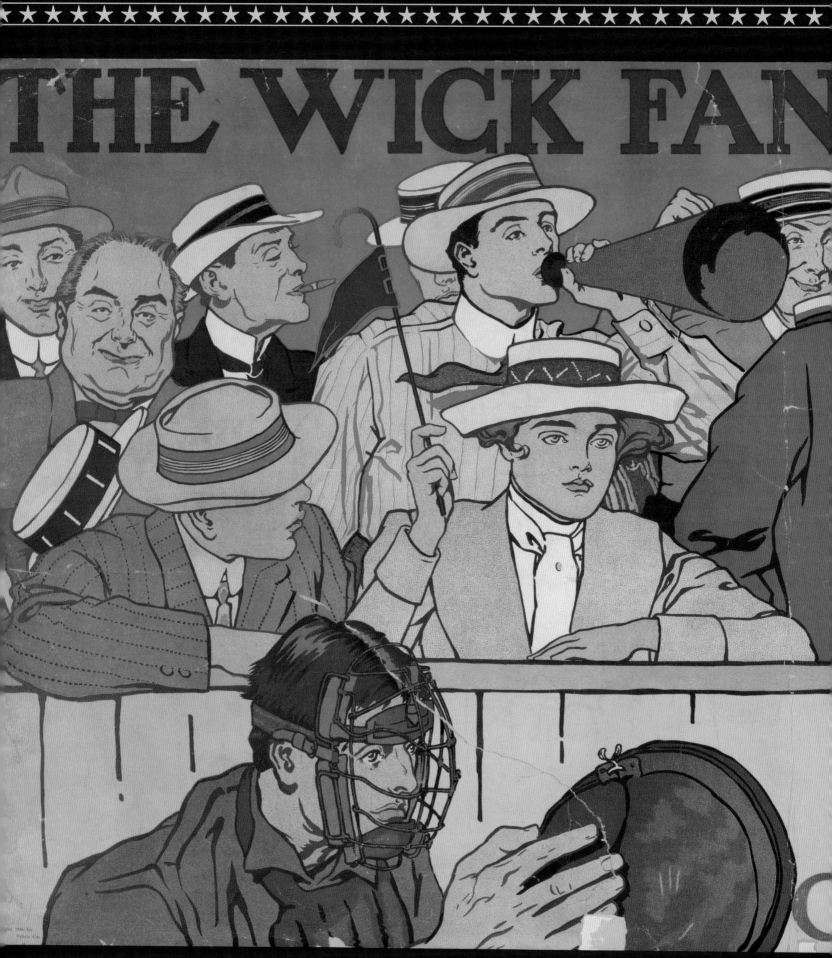

THE WICK FAN

Advertisement, chromolithograph, 1910.

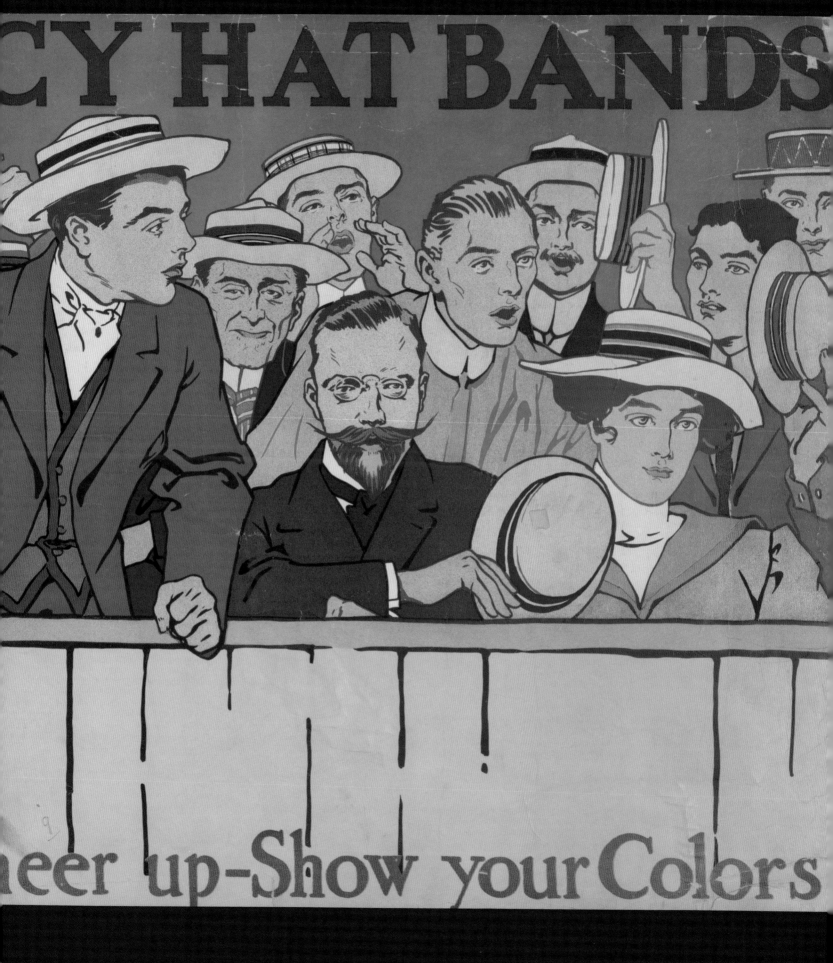

George Edward Waddell, three-color plate, 1902. "Rube" Waddell began his peripatetic professional career pitching for the Louisville Colonels in 1897. Over the next fourteen years, he emerged as one of the game's most talented pitchers and most intransigent bad boys. In 1902, during a western barnstorming tour, he signed with the Los Angeles Looloos of the California League before Connie Mack, manager of the Philadelphia Athletics, lured him back east a few months later. Through several divorces, legendary drinking bouts, frequent absences, and countless remarkable episodes and adventures, Rube racked up the wins and ratcheted up the melodrama. One author, cataloging Waddell's activities for 1904, included twenty-two wins for the A's, a run on stage playing himself in the melodrama *The Stain of Guilt*, "courted, married, and became separated from May Wynne Skinner of Lynn, Massachusetts, saved a woman from drowning, accidentally shot a friend through the hand, and was bitten by a lion."

Hall of Famer and Western League teammate Sam Crawford recalled, "He'd pitch one day and we wouldn't see him for three or four days after. He'd just disappear, go fishing, or something, or be off playing ball with a bunch of twelve-year olds in an empty lot somewhere. You couldn't control him 'cause he was just a big kid himself. We'd have a big game scheduled for a Sunday, with posters all over Grand Rapids that the great Rube Waddell was going to pitch that day. . . . Sunday would come and the little park would be packed way before game time, everybody wanting to see Rube pitch. But half the time there would be no Rube. Nowhere to be found. The manager would be having a fit. And then just a few minutes before game time there'd be a commotion in the grandstand and you'd hear people laughing and yelling: 'Here comes Rube, here comes Rube.' And there he'd come, right through the stands. He'd jump down on to the field, cut across the infield to the clubhouse, taking off his shirt as he went. In about three minutes—he never wore any underwear—he'd run back out in uniform and yell, 'All right, let's get 'em!' "

His stressful lifestyle and hard-drinking habits took their toll, and he died in 1914, at thirty-seven, in a San Antonio sanitarium. Rube Waddell was voted into the Baseball Hall of Fame in 1946.

Three-Color Presswork by Walter N. Brunt

Colored Plates by Britton & Strong

GEORGE EDWARD WADDELL

Pitcher, Los Angeles Base Ball Club, 1902; also Pitcher of the Athletics of Philadelphia (Philadelphia American League Base Ball Club) 1902

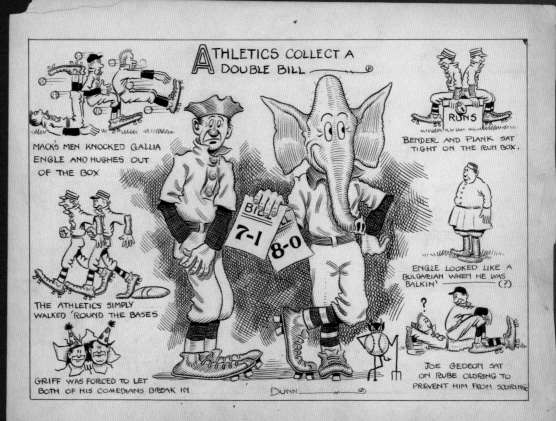

Cartoon by Charles Dunn.

SMOKY JOE AND THE BLOOMER GIRLS

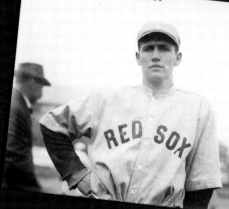

Women's baseball teams, known as "Bloomer Girls" for the practical pantaloons the players wore, barnstormed across the country beginning in the 1890s, and some teams continued to play into the 1930s. Many of the early Bloomer Girl nines included a couple of male ringers wearing wigs to disguise their gender. Ambiguity made for high drama and higher ticket sales. "Is he coming or going?" Is the pitcher male or female? Red Sox righty Joe Wood, who retired from the Majors in 1922, years later related, somewhat abashedly, how he got his start as a seventeen-year-old back in 1906:

The Boston Red Sox Pitcher, Bain News Service, 1912.

I might as well just take a deep breath and come right out and put the matter bluntly: the team I started with was the Bloomer Girls. Yeah, you heard right, the Bloomer Girls. . . . The girls were advertised on posters around Ness City [Kansas] for weeks before they arrived, you know, and they finally came to town and played us and we beat them.

Well, after the game the fellow who managed them asked me if I'd like to join and finish the tour with them. There were only three weeks left of the trip, and he offered me $20 if I'd play the infield with them those last three weeks. "Are you kidding?" I said. I thought the guy must have been off his rocker.

"Listen," he said, "you know as well as I do that all those Bloomer Girls aren't really girls. That third baseman's real name is Bill Compton, not Dolly Madison. And that pitcher, Lady Waddell, sure isn't Rube's sister. If anything, he's his brother!"

. . . So I asked Dad if I could go. He thought it was sort of unusual, but he didn't raise any objections. I guess it must have appealed to his sense of the absurd.

Fact is, there were four boys on the team: me, Lady Waddell, Dolly Madison, and one other, the catcher. The other five were girls. In case you're wondering how the situation was in the locker room, we didn't have clubhouses or locker rooms in those days. We dressed in our uniforms at the hotel and rode out to the ball park from there. I think everybody except maybe some of the farmer boys must have known that some of us weren't actually girls, but the crowds turned out and had a lot of fun anyway. In case you're interested, by the way, the first team Rogers Hornsby ever played on was a Bloomer Girl team, too. So I'm not in such bad company.

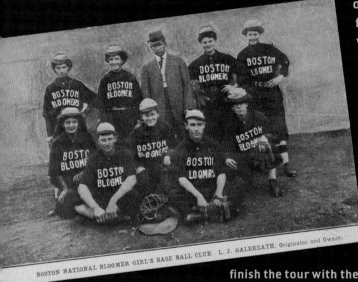

BOSTON NATIONAL BLOOMER GIRL'S BASE BALL CLUB. L. J. GALBREATH, Originator and Owner.

Boston National Bloomer Girls Base Ball Club, ca. 1906. Wood is seated at front right.

RIGHT: **Lithograph printed in colors, copyrighted by W. P. Needham, manager, 1904.**

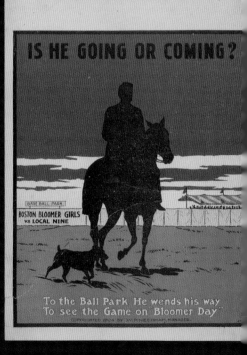

IS HE GOING OR COMING?

BOSTON BLOOMER GIRLS vs LOCAL NINE

To the Ball Park He wends his way
To see the Game on "Bloomer Day"

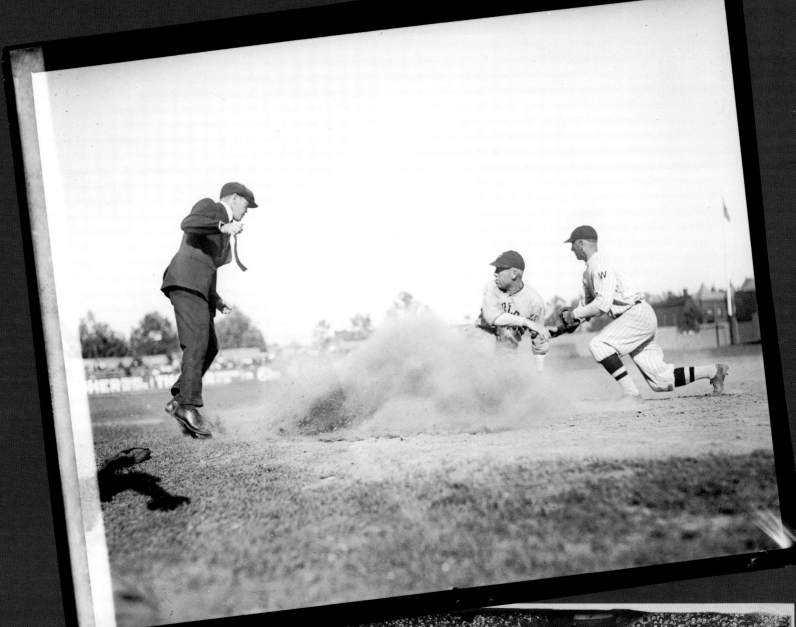

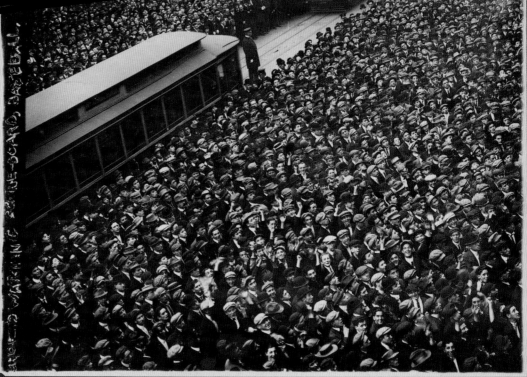

ABOVE: **Sliding into base, National Photo Company, 1921.** RIGHT: **Fans watching baseball scoreboard, World Series Game, New York City, Bain News Service, October 27, 1911.** By the early twentieth century, camera shutter speeds were fast enough and lenses long and sharp enough to capture the fleetest drama unfolding on the field and the epic gatherings outside big city stadiums. In the nation's newspapers, readers enjoyed daily glimpses of unprecedented sporting tableaux. Such European modernists as Frenchman Henri Cartier-Bresson and Russian Alexander Rodchenko were celebrated for their compositional innovations, which were routine for the talented commercial photographers working for American news services.

**The Polo Grounds, New York, Bain
News Service, October 8, 1908.** "There is no record
of a sporting event that stirred New York as did the game yesterday," intoned the *New
York Times* on October 9, 1908. "No crowd so big ever was moved to a field of contest as
was moved yesterday. Perhaps never in the history of a great city, since the days of Rome
and its arena contests, has a people been pitched to such a key of excitement as was New
York 'fandom' yesterday." More than 35,000 fans of every sort—including a clergyman and a
streetcar conductor, seen here above—crushed against each other in a record turnout to watch
the Chicago Cubs and the New York Giants, tied for first place in the National League, play for
the pennant. Tens of thousands more were shut out of the stadium, many of them squeezing
their way onto Coogan's Bluff, the elevated rail tracks, grandstand fences—anything that might
offer a view. Behind the pitching of "Three Finger" Brown, the Cubs won 4-2, setting off mad
rejoicing in the Windy City. But in Gotham, the *Times* observed, "It is impossible to believe . . .
that the earth is still on the same track it was clinging to twenty-four hours ago. Time stopped
. . . everything came to an end yesterday when Chicago got four runs in one inning."

**Mordecai "Three-Finger" Brown,
half-tone with foil postcard, The Rose
Company, 1908.** As a youth, Mordecai
Brown lost most of his right index finger
to a corn shredder, while a subsequent fall
mangled the rest of his digits. After recovering
from his injuries, Brown discovered he could
grasp a baseball like no other pitcher, and for
much of his professional career his curveball
proved unhittable. Disabilities were rare but
not unknown in professional baseball, and in
the parlance of the day, deaf ballplayers were
often called "Dummy," and Mordecai became
known as "Three Finger" Brown. He retired in
1916 with a 239-130 record and a lifetime 2.06
ERA. In 1908, he led the Chicago Cubs to their
second consecutive World Series win. This
delightfully decorative and defective postcard
displays the portrait of Mordecai Brown,
although the caption refers to Buster "Yank"
Brown. (Mordecai also appeared properly in
this postcard series as a Cub.) Buster Brown,
a journeyman pitcher for the Phillies, St. Louis
Cardinals, Boston Braves, and other teams
over the course of a nine-year career, threw
just seven innings for the Phils in 1908, the
year this rare and highly sought-after card was
published.

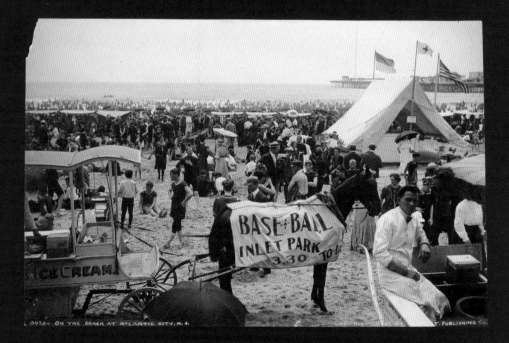

LEFT: **Game advertisement on ice cream
wagon horse, Atlantic City, New Jersey,
ca. 1905.**

PANORAMAS: THE WIDE WORLD OF BASEBALL

★ ★ ★ ★ ★ ★ ★ ★ ★ ★ ★ ★ ★ ★ ★ ★ ★ ★

Primitive forms of the panoramic image were created in the early 1840s, soon after the invention of photography, but the panorama as a popular art form did not develop until the early twentieth century. The pictures, usually about three feet wide and less than a foot high, were sold as posters, and among the most popular themes in the United States were cityscapes,

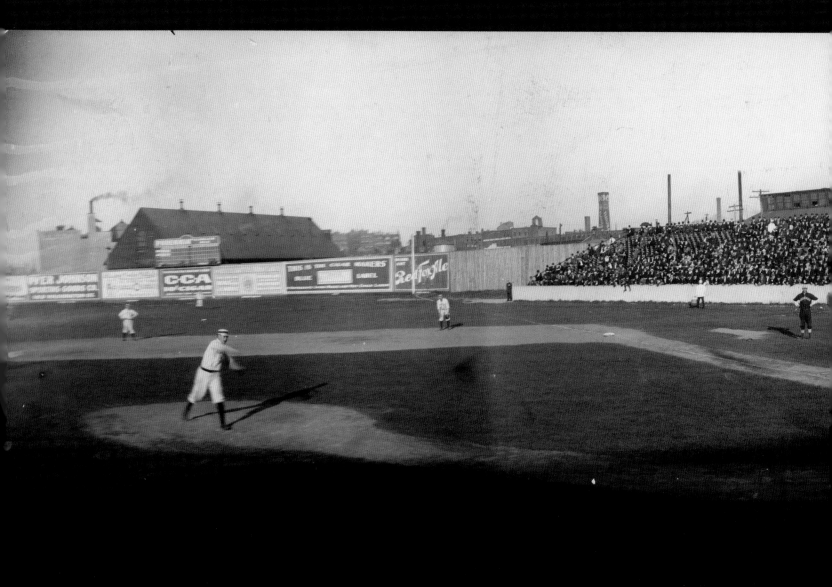

landscapes, group portraits (especially of baseball and football teams), and sporting events. What excited photographers was that a panoramic image could contain a view that the human eye could not take in. Thus, these images presented their subjects in a way that was both familiar and foreign, distorting and warping shapes and time. The trickery did not end there; for example, when ball clubs posed for a team panorama (see pages 86–87 and 102–103), the players stood in an arc that put each of them an equal distance from the camera. The photographer then panned from left to right, taking in each player, and the end result was the illusion of players standing in a straight line.

Boston, American League baseball grounds, E. Chickering & Co. photograph, 9½ x 29½ in., 1903. This image illustrates a fictitious moment as the pitcher, at left, is seen making his throw, but the batter, catcher, and umpire at right are not the least bit engaged in the play. Not only that, but the ball that should be in flight is missing. In the thirty seconds or so that it took for the camera to pan from one end of the scene to the next, the pitcher made his throw and what followed is anybody's guess: the batter hit a foul ball, swung and missed, or took a strike or a ball. By the time the camera had home plate in its sights, the play was over, and the threesome on the right were all standing up straight again.

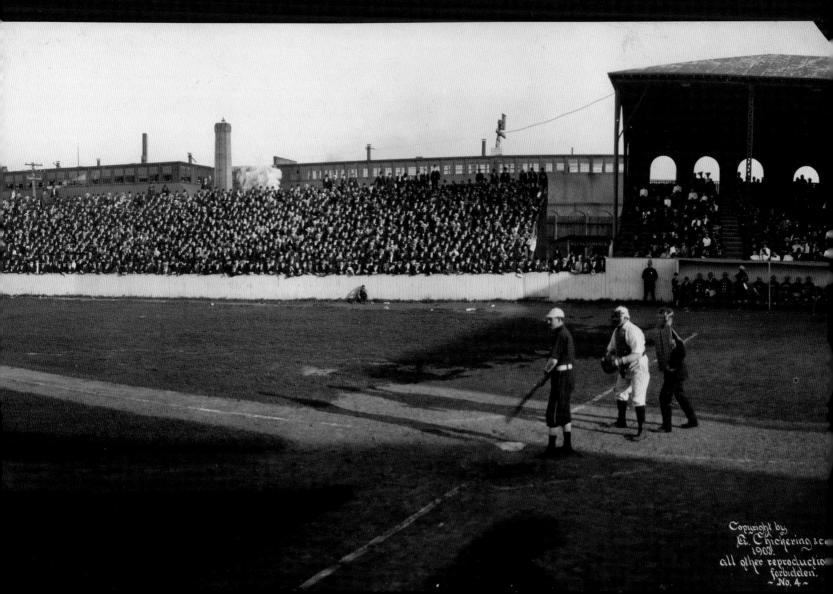

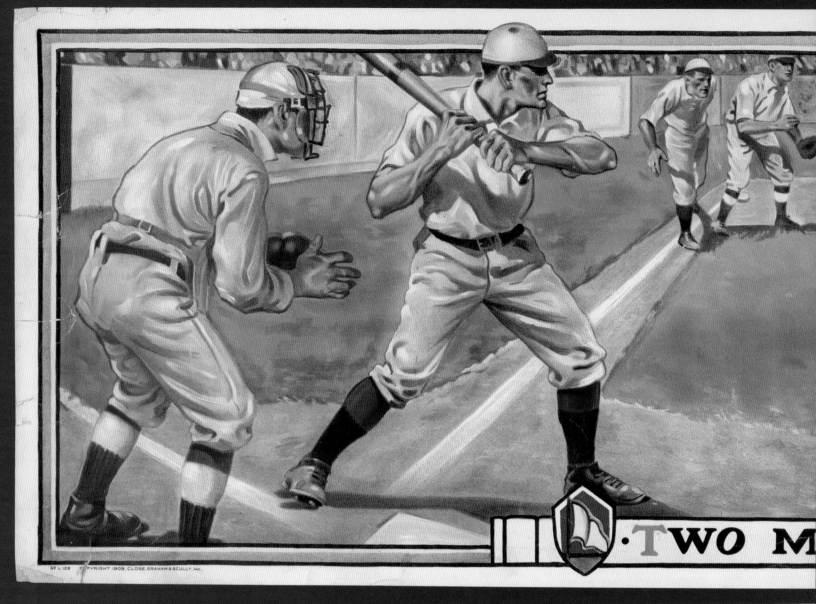

Decorative poster, chromolithograph, Close, Graham & Scully, Inc., 1909.

·T WO M

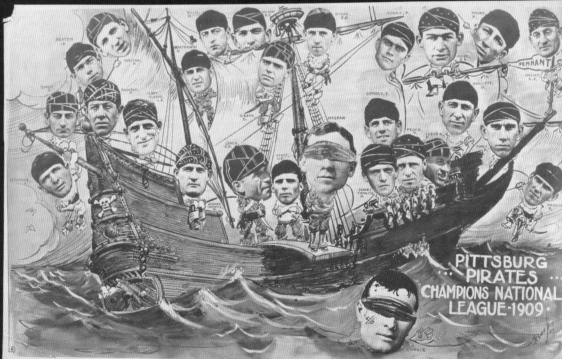

PITTSBURG PIRATES CHAMPIONS NATIONAL LEAGUE·1909·

ABOVE: **Decorative poster, chromolithograph, Close, Graham & Scully, Inc., 1909.**

RIGHT: **Pittsburgh Pirates, Champions, National League, by Rudolph, October 8, 1909.**
Pittsburgh's hearty crew disposes of their league foes, forcing John McGraw, the abrasive manager of the New York Giants, to walk the plank, while the head of Frank Chance, the Chicago Cubs' first baseman, bobs in the waves below. The Pirates' venerable star shortstop, Honus Wagner, is shown in the upper right, gripping the treasured pennant. Pittsburgh went on to win the World Series in seven games against the Detroit Tigers.

N DOWN ·

The BOYS' BEST WEEKLY PRICE 5 cents

JACK STANDFAST'S GREAT PITCHING

The ARTHUR WESTBROOK Company
CLEVELAND, U.S.A.

Forbes Field, Pittsburgh, Pennsylvania, by George Aaron Rogaliner, 1909.

LEFT: Jack Standfast's Great Pitching, *The Boys' Best Weekly*, **1910.** Dime novels—small, cheap books geared toward boys—were best sellers in the late nineteenth and early twentieth centuries. The most popular subject was the Wild West, but there were also numerous dime novel series devoted to sports, especially baseball. Despite its name, the series shown here was intended for both boys and girls, and Jack Standfast was likely an imitation of the All-American Frank Merriwell character. At least two writers, working under the name Horace Paine, authored Standfast stories, which included tales of his "Keen Batting" and "Clever Catch."

Brooklyn Baseball Club, panoramic gelatin silver print, 10 x 36 in., 1911. With a nod to their nickname—inspired by "trolley dodging" locals on Brooklyn's busy streets—the Dodgers pose for their annual team photograph on trolley tracks running through the heart of the borough.

Chinese baseball team, Honolulu, Hawaii, Bain News Service, 1910. China's sketchy and erratic baseball history dates back to 1863, when American missionaries established the Shanghai Baseball Club. Later missionaries and railroad engineers introduced the game elsewhere in China in the 1880s, and by 1895, a Shanghai university and two in Peking (Beijing) sponsored teams. Missionaries continued to spread the game through a handful of universities, with league play and tournaments held until 1925. Meanwhile, Chinese in Hawaii formed an Overseas Baseball Club that in 1911 defeated the New York Giants in an exhibition game held in San Francisco.

Honolulu ball team, Bain News
Service, September 2, 1910.

The Princeton–Yale game, R. H. Rose and Son photograph, 12½ x 35½ in., 1907.

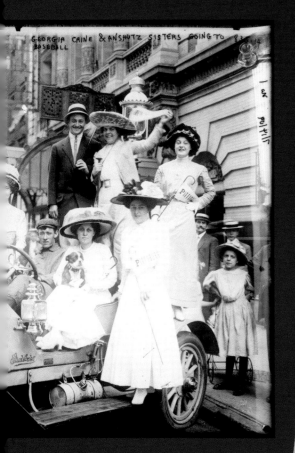

ABOVE: **Georgia Caine and the Anshutz Sisters, July 14, 1909.** Miss Caine (a Broadway star and film actress), accompanied by her dog, driver, and friends, en route to a Pittsburgh Pirates game during the team's championship season.

RIGHT: *Some Day*, by John E. Sheridan, *Sunday Magazine*, newspaper supplement, June 18, 1911.

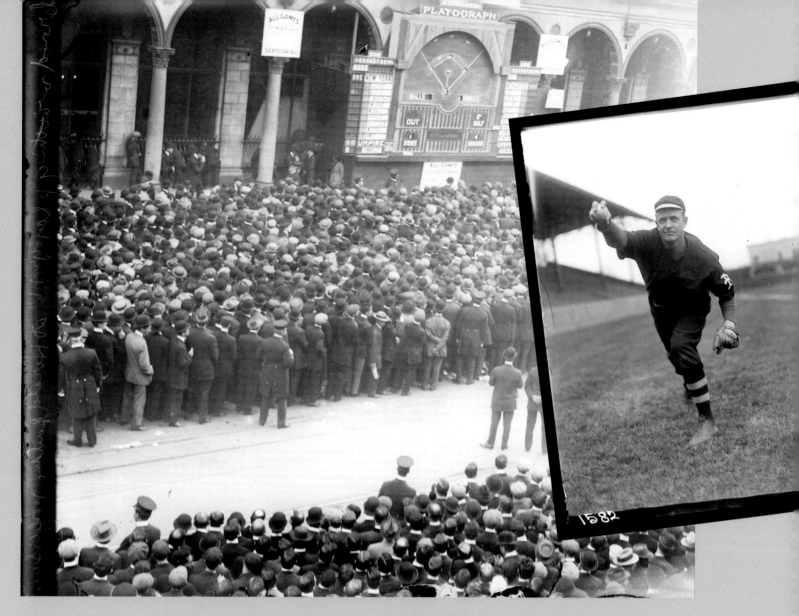

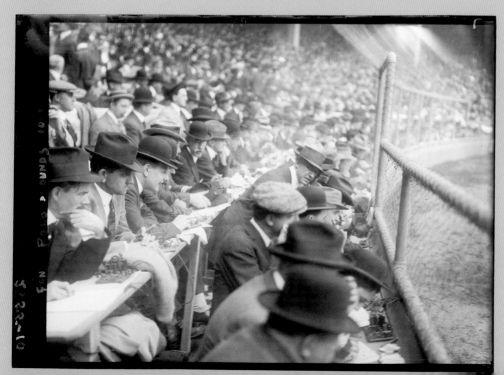

Receiving the news, sending the news, Bain News Service photographs.
A crowd gathers outside the New York Herald Building (ABOVE) to "watch" a 1911 World Series game between the Athletics and the Giants on the Playograph. As reporters telegraphed play-by-play action from Shibe Park, Philadelphia, operators in New York adjusted the device's large diamond and scoreboard to reflect up-to-the-minute happenings. Reporters are seen hunched over telegraph devices at Shibe Park (BELOW) when the teams met again in the 1913 World Series.

ABOVE, RIGHT: **Christy Mathewson, pitcher, New York Giants, Bain News Service, 1911.** At Bucknell College, Christy Mathewson headed up two literary societies, sang in a church choir, and was the dominant baseball, football, and checkers player on campus. In the Major Leagues, he foiled batters with his "fade away" pitch (later called a "screwball"). Dubbed "the Christian Gentleman," Mathewson was among the five players first elected to the Baseball Hall of Fame.

BASEBALL CUBAN STYLE

Cuba has enjoyed a rich ball-playing tradition dating back to the mid-nineteenth century. The islanders' skills, affinity for the game, and light skin tone allowed a few of them to escape the Major League ban on non-white players. The earliest officially recognized Major League Cuban players included slugger Rafael Almeida and pitcher Armando Marsans, who both broke in with Cincinnati in 1911. Adolfo Domingo De Guzmán "Dolf" Luque first signed with the Boston Braves in 1914 but soon ended up in Cincinnati as well, where he spent twelve years.

Raphael Almeida, third base, Cincinnati Reds, baseball card, American Tobacco Company, 1912.

Lying just ninety miles southwest of Key West, Florida, Cuba became a sanctuary for black players and a frequent destination for off-season touring teams. In the winter of 1910, Ty Cobb and his defending American League champion Detroit Tigers traveled to Cuba to contest stars drawn from the country's two dominant professional clubs, the Almandieras and the Habanas. The Cubans beat the Tigers several times in front of enthusiastic crowds. The Habanas team (OPPOSITE, BOTTOM) was led by Hall of Famer John Henry "Pop" Lloyd (a Florida native called "Sam" by his Cuban teammates, short for "Uncle Sam"). Babe Ruth later said that Lloyd was the most complete baseball player he had ever seen. During the twelve-game series, Lloyd pounded Tiger pitching. Also shown are Hall of Famer Preston "Pete" Hill, fresh from posting a .328 average for Rube Foster's all-black champion team, the Chicago American Giants; Grant "Home Run" Johnson, who would eventually play twenty years in the Negro Leagues and winter

Adolfo "Dolf" Luque, pitcher, Cincinnati Reds, Bain News Service, 1919.

MARSANS

Armando Marsans, pitcher, Cincinnati Reds, Bain News Service, 1913.

ball in Cuba; the sure-gloved third baseman Carlos Moran, who batted .333
against the Tigers; and J. H. "Kiko" Magrinat, who spent thirty-eight years
as an umpire after his playing days.

1—Gonzalo Sanchez, catcher. 2—Sam Lloyd, short stop. 3—Ricardo
Hernandez, outfielder. 4—Preston Hill, outfielder. 5—Grant Johnson,
short stop y second base. 6—Luis Padron, right fielder. 7—J. H. Magri-
nat, outfielder. 8—Carlos Moran, third base. 9—Camilo Valdes, mascota.
JUGADORES DEL "HABANA."

Jugadores del "Habana," photo-
mechanical print, *Spalding's Official
Base Ball Guide*, Spanish-American
edition, American Sports Publishing
Company, 1911.

BASEBALL CARDS: THE SECOND WAVE

★ ★ ★ ★ ★ ★ ★ ★ ★ ★ ★ ★ ★ ★ ★ ★ ★ ★

While the first generation of baseball card sets was created out of commercial competition, the second set came out of a corporate monopoly. The American Tobacco Company, a muckraker's dream also known as "the Tobacco Trust," once again began using cards, coupons, and premiums to advertise and promote its cigarettes in an effort to completely control the marketplace and differentiate product lines.

The popularity of tobacco cards grew as the country became increasingly industrialized. Spectator sports and leisure activities flourished while cigarettes gained social acceptance, especially for men. By 1910, the Tobacco Trust had produced and issued nearly seventy-five different baseball card series. These sets include the storied T206 series, which encompassed the celebrated Honus Wagner card along with images of more than five hundred ballplayers. The card backs advertised such tobacco brands as Carolina Brights, Hindu, Drum, Sweet Caporal, Broadleaf, and American Beauty.

Following the success of the T206, the American Tobacco Company soon presented another series now known as the T205s. These designations were coined by pioneering card historian Jefferson Burdick in his landmark publication *The American Card Catalog* (1953). Three innovations set the T205s apart from any card previously produced. First, to distinguish them from the T206 set, known as the "White Borders," the T205 portraits are framed by delicate gold leaf borders. Second, the cards showed facsimile autographs and for the first time contained the batting and pitching statistics of the individual players on the reverse. The anecdotal player biographies are filled with period detail; for example, they unabashedly acclaim the success of "spitballers" Cy Morgan, Arthur "Bugs" Raymond, and Ed Walsh, among others.

BRESNAHAN
Catcher, St. Louis N. L.

Roger Bresnahan, catcher, Saint Louis Cardinals (National League), American Tobacco Company, 1909.

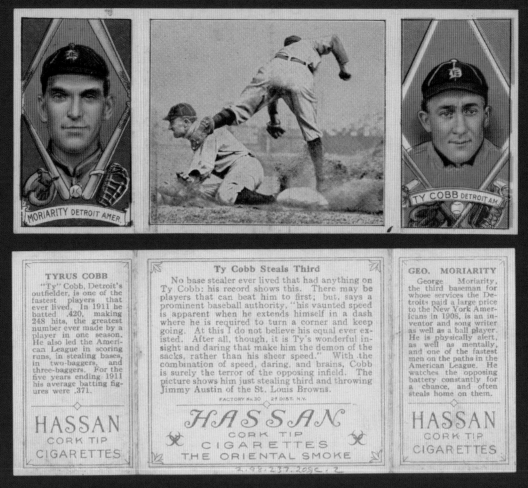

George Moriarty (LEFT), first baseman, Ty Cobb (CENTER, SLIDING, AND AT RIGHT), Detroit Tigers (American League), American Tobacco Company, 1912.

Moriarty's name is misspelled on this Hassan Triple Folder card. Triple Folders featured a black-and-white action shot flanked by color illustrations of individual players, which could be folded over the photograph. Unlike the card shown here, in many cases there was no connection between the players in the photograph and the men depicted on either side.

The third innovation was that cards in the series were based on original, wonderfully contemplative close-up studies by talented New York City–based news photographer Paul Thompson. He went out to the New York ballparks during the 1910 season to photograph stars of the game. Against the rough plywood backdrops of the dugouts he produced simple head-shot portraits of Christy Mathewson, Ed Walsh, Chief Meyers, Johnny Evers, Eddie Collins, and many others. Using a shallow depth of field, he brought out in sharp relief their leathery faces and steel-eyed stares, archived forever on film. He captured their personal pride and tough

Ty Cobb, center fielder, Detroit Tigers (American League), Honest Long Cut and Miners Extra, 1912.

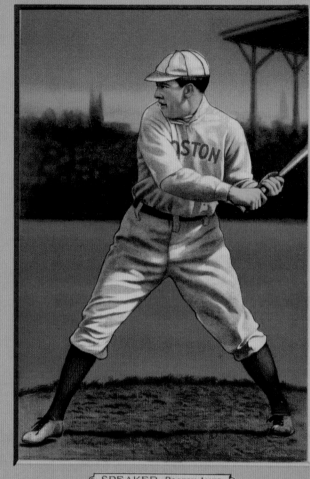

Napoleon "Nap" Lajoie, second baseman, Cleveland Naps (American League), American Tobacco Company, 1911.

Tris Speaker, center fielder, Boston Red Sox (American League), American Tobacco Company, 1911.

demeanor, as well as the effects of extended weathering and exposure in the field. As original components in the production of early baseball cards, the photographs are remarkable (see page 97); but as sensitive occupational portraits of turn-of-the-twentieth-century American professional baseball players, they are extraordinary.

Importantly and uniquely, a significant selection of Thompson's baseball portraits and the cards made from them are preserved together in the Library of Congress. They represent a melding of multiple processes into a single image; the photographic portrait incorporated within a chromolithograph becomes a unique, unified graphic jewel. In March and April 1911, Thompson sent several dozen of his portrait photographs to the U.S. Copyright Office in the Library of Congress. He registered no other baseball images before or after, perhaps knowing that these images were very special.

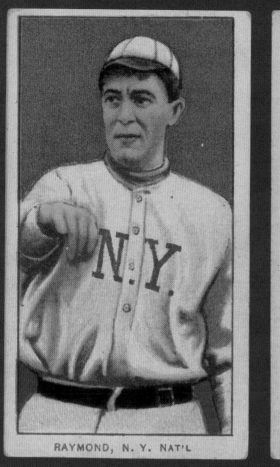

RAYMOND, N. Y. NAT'L

ARTHUR L. RAYMOND

Arthur L. Raymond, the big spitball pitcher of the New York Nationals, started out with minor teams in the Middle West. He first played Class A ball in the Southern League, and while there developed his "spitter" to such an extent that he was thought good enough for big league work, and the St. Louis Cardinals got him. In 1908 he went to the Giants in the famous three-cornered deal with Cincinnati and St. Louis. When right, Raymond is a very effective pitcher, having terrific speed. He is physically rugged, and has lasted through some hard extra-inning games.

BASE BALL SERIES 400 DESIGNS

Piedmont

THE CIGARETTE
OF QUALITY

FACTORY Nº 25, 2ᵈ DIST. VA.

LEFT: Arthur "Bugs" Raymond, pitcher, New York Giants (National League), American Tobacco Company, T206 white border set, ca. 1909–1911.
RIGHT: Verso of T205 gold border set, 1911.

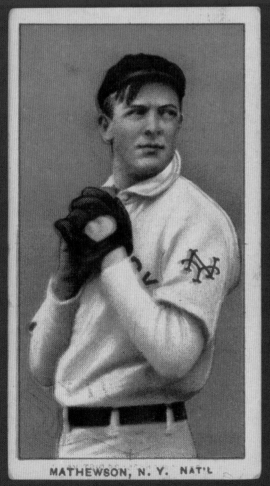

MATHEWSON, N. Y. NAT'L

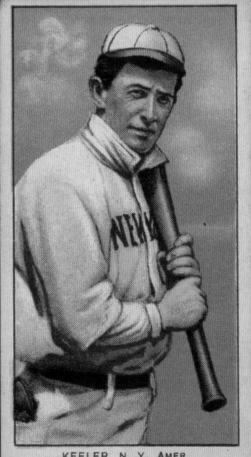

KEELER, N. Y. AMER.

Christy Mathewson, pitcher, New York Giants (National League), American Tobacco Company, ca. 1909–1911.

"Wee" Willie Keeler, outfielder, New York Highlanders (American League), American Tobacco Company, ca. 1909–1911.

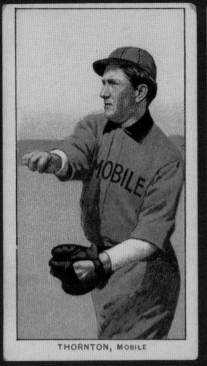

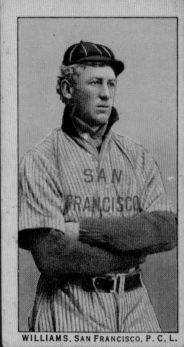

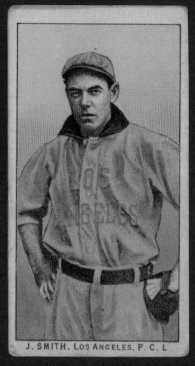

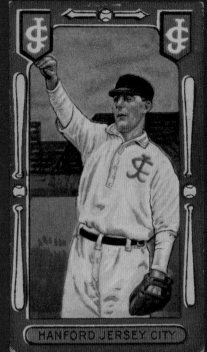

Woodie Thornton, Mobile Sea Gulls (Southern Association), American Tobacco Company, ca. 1909–1911.

Nick Williams, first baseman, San Francisco Seals (Pacific Coast League), American Tobacco Company, 1910.

J. Smith, Los Angeles Angels (Pacific Coast League), American Tobacco Company, 1910.

Charles Hanford, right fielder, Jersey City (Eastern League), American Tobacco Company, 1911.

DOUBLE-PLAY TRIO

Chicago Cubs infielders Joe Tinker, Johnny Evers, and Frank Chance formed the most memorable double-play combination in the history of baseball. Their consistently solid fielding and hitting led the Cubs to four National League pennants (1906–8, 1910) and two World Series wins (1907–8). In 1910, the same year that Paul Thompson photographed them for their baseball cards, New York newspaper columnist Franklin Pierce Adams immortalized the three ballplayers in a short verse. The Hall of Fame inducted Tinker, Evers, and Chance as a unit in 1946.

"BASEBALL'S SAD LEXICON"
These are the saddest of possible words:
"Tinker to Evers to Chance."
Trio of bear cubs, and fleeter than birds,
Tinker and Evers and Chance.
Ruthlessly pricking our gonfalon bubble,
Making a Giant hit into a double—
Words that are heavy with nothing but trouble:
"Tinker to Evers to Chance."

The term "gonfalon" refers to a flag or pennant, and Adams used the phrase "pricking our gonfalon bubble" to describe the repeated success of the Chicago Cubs and their celebrated infield against their National League rivals, his beloved New York Giants.

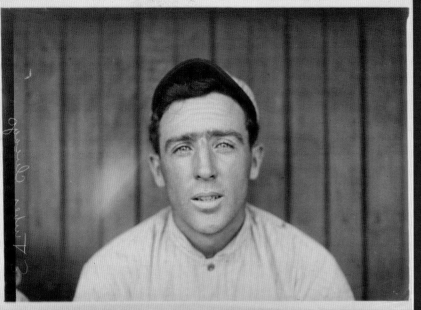

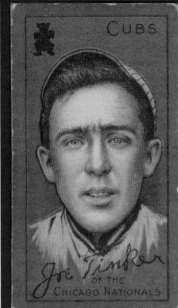

Joe Tinker, shortstop.

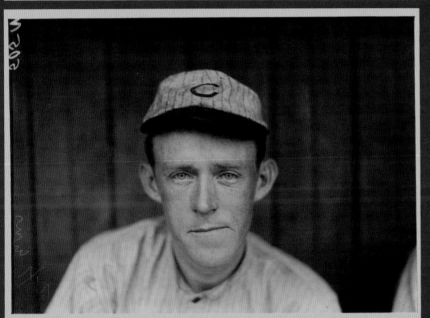

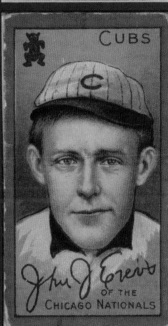

Johnny Evers, second baseman.

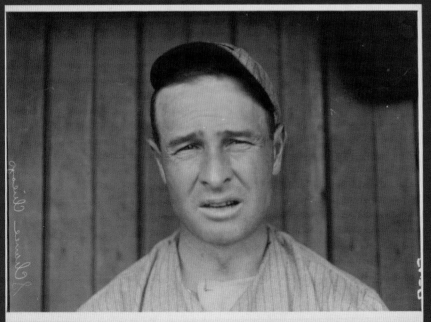

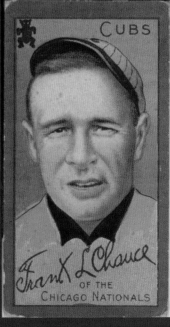

Frank Chance, first baseman.

Olympic baseball, Ostermalm Athletic Grounds, Stockholm, Sweden, July 17, 1912. Americans demonstrated the national pastime at the 1912 Summer Olympic Games in an exhibition game against Sweden's Vesteras Baseball Club, then in its third season. The official Olympic report, published in 1913, noted that because "a great deal depends on the . . . ability of the pitcher and catcher and as, compared with their opponents, the Swedish team was pretty weak in this respect, the captain of the American team was begged to allow two of his men to act as the battery for the home side. The visitors were kind enough to comply with this request. . . ." The American team comprised athletes who were at the Games competing in other sports. None of the Swedish players had ever before seen a game played by an experienced opponent, and not surprisingly, the Americans prevailed, 13–3. What struck the Olympic report's Swedish authors the most was "the ability of the pitcher to throw the ball so that it 'breaks' in the air, this making it very difficult for the striker to hit," a technique the home team "had not yet learnt." For the Swedes, "Matters turned out far better than had been expected . . . our team did not at all make such a bad figure in the field, though there were a number of mistakes, excusable on account of nervousness, etc."

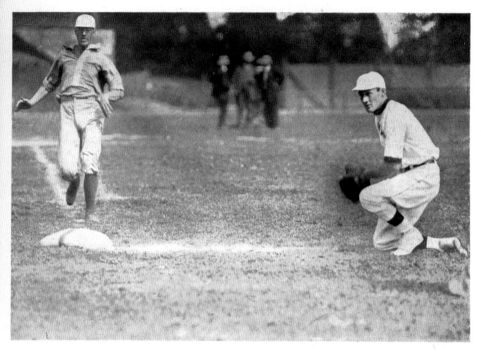

BASEBALL MATCH, U. S. A. v. SWEDEN.
WELIN, Sweden, racing to 1:st base after a short hit. BLANCHARD at 1:st base.

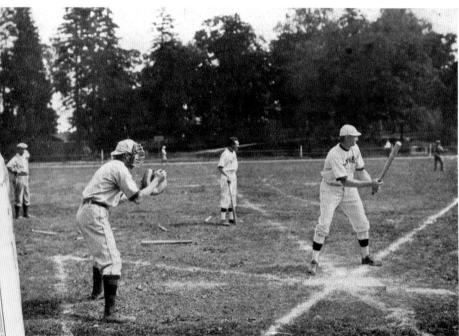

BASEBALL MATCH, U. S. A. v. SWEDEN.
SWEDEN in. U. S. A. fielding. ADAMS batting. DAVENPORT catcher.

Advertisement, 1911.

OPPOSITE: **Ray Schalk, catcher, Chicago White Sox, National Photo Company, ca. 1913.**

Frank "Home Run" Baker, batting grip and baseball card, 1912.
Frank Baker, a third baseman for the Philadelphia Athletics and later the New York Yankees, was tagged "Home Run" for his performance in the 1911 World Series. He was the American League home run king from 1911 through 1914 and had ninety-six career home runs, an impressive figure in the Dead Ball Era.

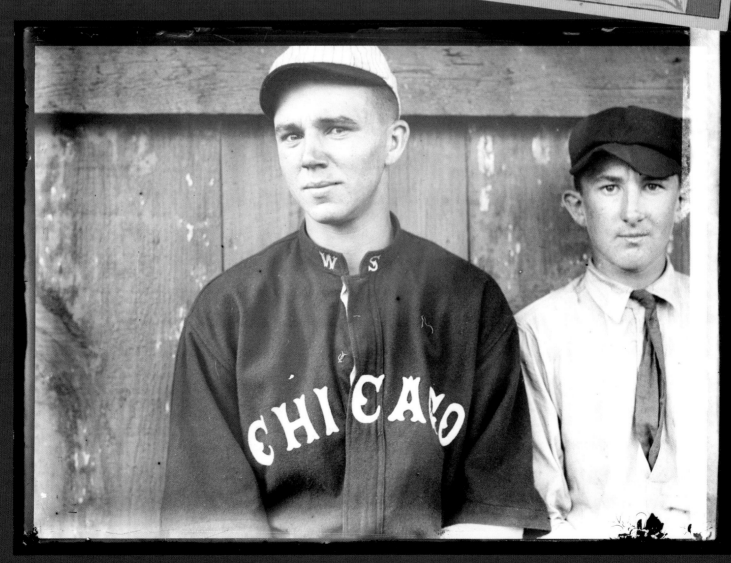

RIGHT: Miss Ebbets throws out opening pitch, exhibition game, Bain News Service, April 5, 1913. Genevieve Ebbets, daughter of Charles Ebbets, co-owner of Brooklyn's brand-new stadium and president of the Dodgers, carries out first-pitch duties prior to an exhibition game between her team and the New York Yankees. The ceremonial first-pitch tradition, in which dignitaries or celebrities toss out a ball to the home team's catcher just before the game, dates back to the late nineteenth century. On April 14, 1910, Howard Taft became the first U.S. president to throw the inaugural pitch on Opening Day when he attended the Washington Senators' game at Griffith Stadium in Washington, D.C.

BELOW: Boston Ball Grounds (Fenway Park), Bain News Service, September 28, 1912. The Red Sox moved from their Huntington Avenue Baseball Grounds to Fenway Park on April 12, 1912, and the new park featured a thirty-seven-foot, two-inch high wall in left field dubbed "the Green Monster." Other photographs taken at the time show that back then spectators actually sat in bleachers at the Monster's base.

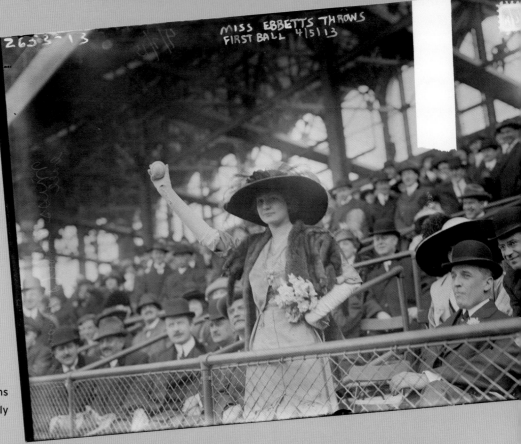

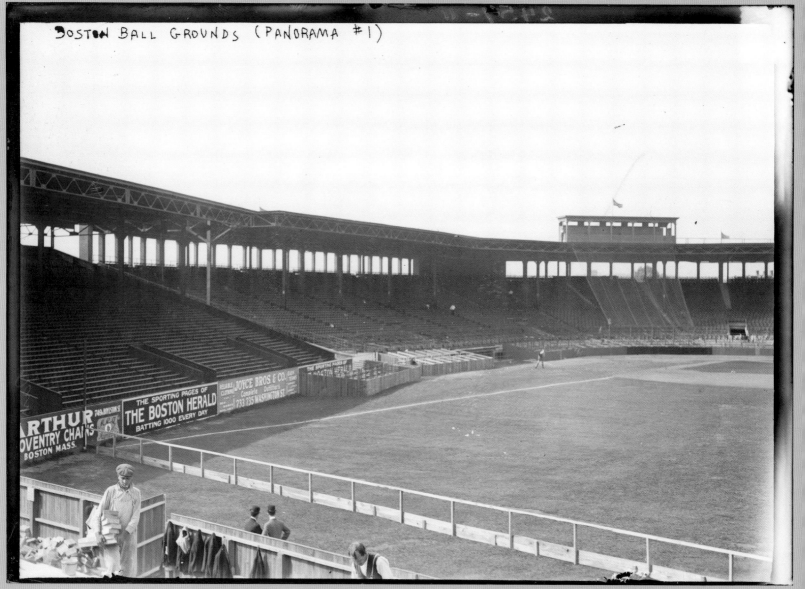

RIGHT: Ty Cobb, center fielder, Detroit Tigers, National Photo Company, 1913.

BELOW: Game 4 of the World Series, Boston Red Sox 3, New York Giants 1, the Polo Grounds, Bain News Service, October 11, 1912.

VIEW OF 4TH WORLD SIERIES

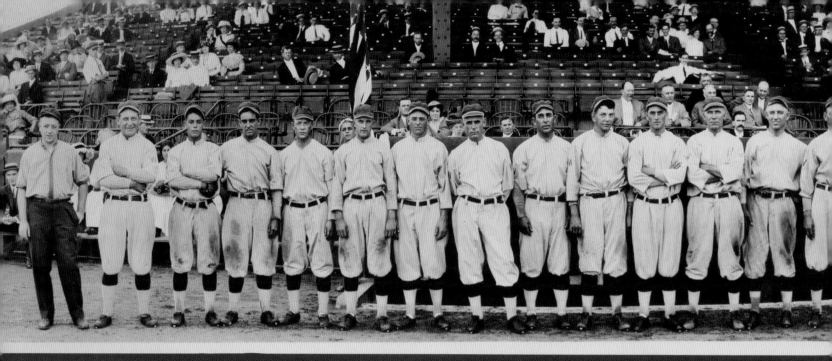

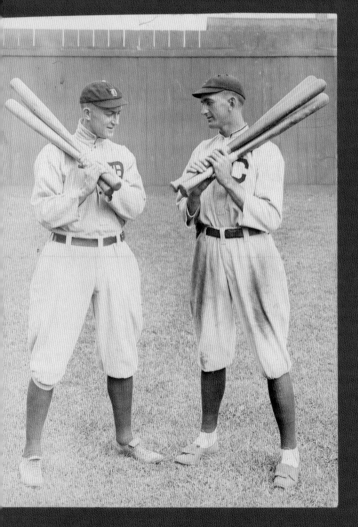

ABOVE: **The Washington Senators, Griffith Stadium, Schutz Group Photographers, 8 x 35 in., 1913.** In a panoramic shot, as the camera moved steadily from left to right, a person could pose at the left end of the viewfinder's range and then dash behind the photographer to the right side and appear in the picture again. Thus, the Senators' Herman "Germany" Schaefer shows up twice in this image.

ABOVE: **Ty Cobb, Detroit center fielder, and Joe Jackson, Cleveland left fielder, 1913.**

RIGHT: **Walter Johnson, pitcher, Washington Senators, National Photo Company, ca. 1913.** Nicknamed "Big Train" for his sizzling fastball—which may have topped 100 mph in his prime—Walter Johnson spent his twenty-one-year career (1907-1927) with Washington, racking up 417 wins and posting a lifetime 2.17 ERA. Johnson's deceptively fluid sidearm throwing motion slid off his lanky six-foot-one frame at speeds that dazzled batters. Said one impressed batter: "You can't hit what you can't see."

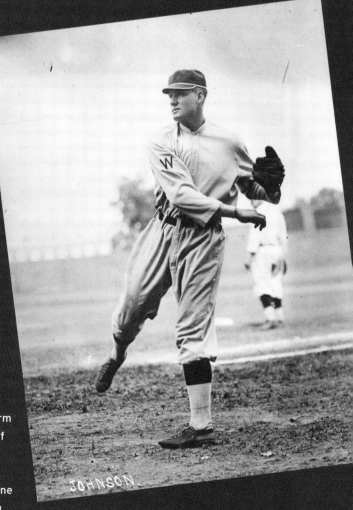

RIGHT AND BELOW: The New York Female Giants, 1913.
The Female Giants gather after a game before their fans (BELOW), who regularly turned out in the thousands to see Bloomer Girls in action. A batter, Miss Ryan (RIGHT), reacts to a high and inside pitch—and a gloved spectator flinches—but the catcher, Miss McCullum, has matters well in hand. In time, men on Bloomer teams dropped their disguises, and more teams boasted all-female lineups. Bloomers occasionally played each other, but most often they squared off against all-male amateur and semiprofessional clubs on their cross-country tours. While some squads had a sideshowlike character, others, such as Kansas City and Philadelphia in the 1920s, were highly skilled and regularly knocked off men's teams.

INDIAN BASEBALL

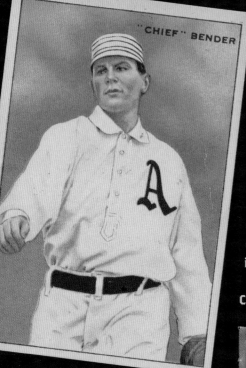

"CHIEF" BENDER

"Kill the Indian, save the man" expressed the theory of assimilation and education propounded by U.S. Army lieutenant Richard Henry Pratt, founder of the Carlisle Indian School in Pennsylvania, where American Indian students were sent beginning in the 1880s to learn and absorb white culture. There they found in sports not simply recreation but a facsimile of their warrior tradition; as one scholar, Patty Loew, has written: "On the baseball diamond, those who played controlled their own destiny. Like tribalism, baseball provided a unity of spirit, and for individual team members, a chance to shine." Recognition on the base paths for white ballplayers often meant economic escape from the coal mines or factories; for an American Indian, it signaled a victory for himself and his people: beating the white man at his own game.

Carlisle School, the Haskell and Hampton Institutes, Dartmouth College, and numerous other institutions providing education for

BELOW: **Meeting of the Chiefs, the Polo Grounds, New York, Bain News Service, 1911.** John "Chief" Meyers, left, catcher for the New York Giants, talks with the Philadelphia Athletics' pitcher Charles "Chief" Bender before the first game of the World Series. Bender had two wins and a loss as the Athletics won the title four games to two.

ABOVE: **Charles Albert "Chief" Bender, pitcher, Philadelphia Athletics, Honest Long Cut and Miners Extra baseball card, 1912.** Bender grew up on the White Earth Reservation in Minnesota and attended both Carlisle Indian School and Dickinson College. He won 212 big league games, pitched in five World Series for the Athletics, and ended his career with a stellar 2.64 ERA, including a no-hitter against Cleveland in 1910. "If I had all the men I've ever handled and they were in their prime and there was one game I wanted to win above all others," said legendary A's manager Connie Mack, "Albert would be my man."

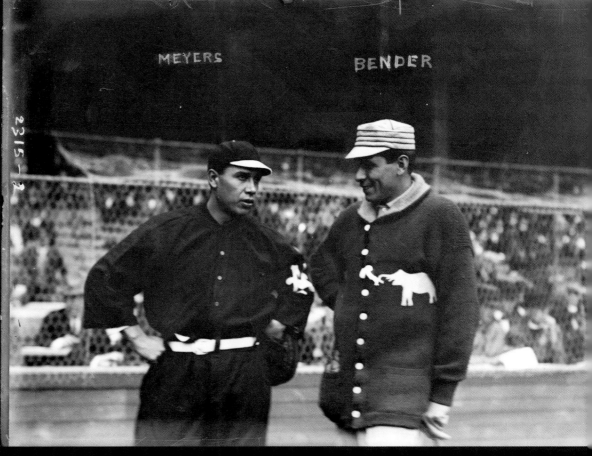

MEYERS BENDER

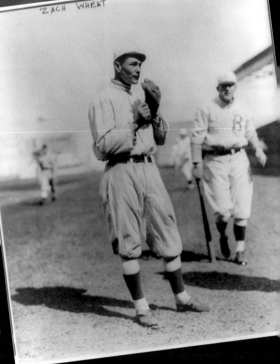

Jim Thorpe, outfielder, New York Giants, at the Polo Grounds,
1913. A gold medalist in both the pentathlon and the decathlon at the 1912
Olympic Games in Stockholm, Thorpe signed with the Giants the following
year. He often played both professional baseball and professional football in
the same year, retiring from the former in 1922 and the latter in 1928.

Zach Wheat (LEFT),
left fielder, Brooklyn
Dodgers, 1914.

Indians nationwide produced at least forty-nine documented Major Leagu-
ers and many more minor-league players through World War II, including
Hall of Famer Charles Albert Bender and legendary Olympian Jim Thorpe, as
well as John Meyer, Michael Balenti, Allie Reynolds, Zack Wheat, and Rudy
York. Invariably called "Chief," "Nig," Squanto," "Kemosabe," or "Wahoo,"
Indians were subjected to both covert and overt racist treatment by fans
and fellow ballplayers. However, unlike black players, from the 1880s on
they were never openly barred from the Major Leagues.

STRIKE UP THE BAND AND STRIKE OUT THE SIDE

BASEBALL'S MUSICAL TRADITION

★ ★ ★ ★ ★ ★ ★ ★ ★ ★ ★ ★ ★ ★ ★ ★

Baseball never limited its greatest hits to shots to the outfield bleachers, and no other American sport has inspired anywhere near as many songs as baseball. The game's musical tradition precedes the Civil War, it flourished in the late nineteenth and early twentieth centuries, and it continues in the twenty-first century. Both professional composers and enthusiastic fans have written and copyrighted hundreds of marches, polkas, two-steps, rags, and pop tunes, while a few ballplayers themselves have been known to score both music and runs.

The songs served several purposes. While many were simply celebrations of the game, others were written to document particular achievements. In 1869, Hettie Shirley Austin composed "Red Stocking Schottisch" to commemorate the team's

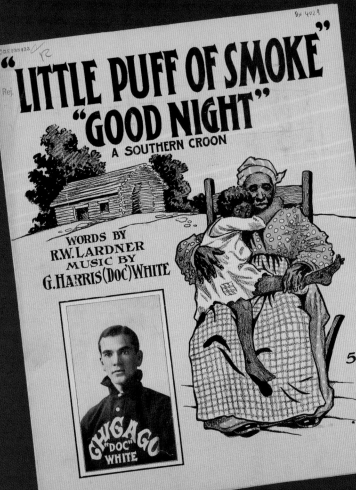

"Little Puff of Smoke, Good Night," 1910. Joe Tinker and Johnny Evers, who did not get along but were two-thirds of the Chicago Cubs' legendary double-play combination, were on suitable enough terms in July 1908 to allow music publisher Will Rossiter to use their names as authors in selling his new tune, "Between You and Me." Two years later, across town, White Sox pitcher Guy Harris "Doc" White actually did write a song—he composed the music for "Little Puff of Smoke, Good Night," with lyrics by his pal, Chicago sportswriter Ring Lardner. White was pictured on the sheet music cover in his baseball uniform, even though the song was not baseball related. However, the pair did put out a baseball song in 1911, "Gee, It's a Wonderful Game."

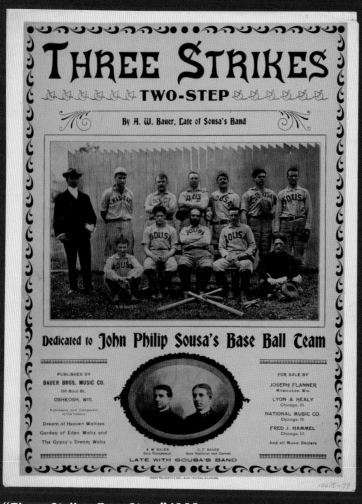

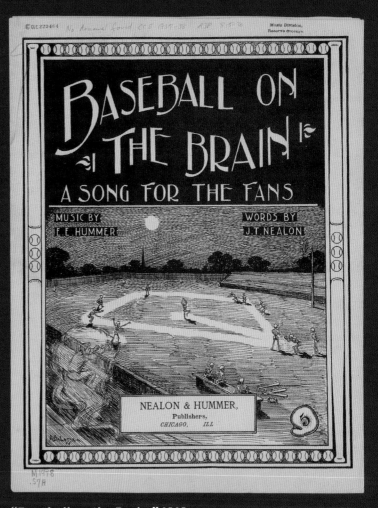

"Three Strikes Two-Step," 1902. John Philip Sousa, master of the American military march and patriotic hymn, wrote "The National Game" (1925) in honor of the sport he had played in childhood; the upbeat piece was seemingly late in coming, given his love for the game and the fact that his famous band had its own team, which formed around 1900. The team is pictured on this sheet music written by A. W. Bauer, a former Sousa band member. All but one player is shown with "Sousa" emblazoned on his chest; the fellow wearing the "Nassau" uniform is John Philip Sousa Jr., a first baseman on the Princeton University nine. The band successfully competed against military, semiprofessional, and gentlemen's clubs, and for several years Sousa, in his fifties, would trade his conductor's baton for a ball and glove to pitch the opening inning. In the 1920s, Sousa's band had so many ball-playing musicians that it could support two teams, leading to an intraband rivalry between the brass and the woodwinds.

"Baseball on the Brain," 1910. Aside from ruminations on going to the game, wanting to go to the game, and being at the game, another favorite baseball subject was the intense dedication of certain fans. In "Baseball on the Brain" a local coroner—a former umpire—and a jury of baseball fans certify that an unclaimed corpse has died of baseball on the brain. The corpse's ghost goes on to haunt the ballpark late at night except during the off-season, when it spends the winter in Florida.

championship season—and thoughtfully dedicated it "to the Ladies of Cincinnati." Other songs honored star players (Ty Cobb, Honus Wagner, Babe Ruth, Joe DiMaggio, and Jackie Robinson were each the subject of more than one worshipful musical ode). And some writers and publishers tried to cash in on baseball's popularity by using images of the sport on their sheet music covers, even if the songs had nothing to do with the game.

Baseball songs were disseminated around the country the same way other music was—primarily through the sales of piano sheet music. To grab customers' attention, sheet music covers often featured elaborate and colorful illustrations (later supplemented by photographs). In most

"Base Ball Game of Love," 1909. Songwriters routinely used baseball as a metaphor for romance, as in "I've Been Making a Grand Stand Play for You" (1911) and "You're Batting a Thousand in the Game of Love" (1915). Then there was the master of them all shown here: "I thought 'twas just a base hit that you made / And you'd be caught in stealing second base / But you went the whole way 'round and very soon I found / There was going to be a real live pennant race." The chorus concludes: ". . . And as we two reach'd third together / Cupid gave us such a shove / That we both slid for the home plate / In our base ball game of love."

"I Can't Get to First Base with You," 1935. Eleanor Gehrig, wife of the New York Yankees' star first baseman, was credited with cowriting this ditty with Tin Pan Alley veteran Fred Fisher. The song opens with the line "I've sacrificed and bunted my heart." Although the song was not a particular success with the public, it certainly was with the man for whom it was written.

moderately educated, middle-class households, one could expect to find a piano in the parlor, and family and neighborhood sing-alongs were a primary source of domestic entertainment from the late nineteenth century until World War I. As James Parton wrote in the July 1867 issue of the *Atlantic Monthly*, "almost every couple that sets up housekeeping on a respectable scale considers a piano only less indispensable than a kitchen range."

"The Baseball Polka" (1858), written by J. R. Blodgett of the Base Ball Club of Buffalo, holds the distinction of being the first published baseball song. "Slide, Kelly, Slide!" (1889), a tribute to the Boston Beaneaters' superstar Mike "King" Kelly (who introduced the practice of signing autographs for fans), was the game's first *recorded* hit single. Songstress Maggie Cline popularized the song in her stage show, and two years later vocalist George J. Gaskin put the tracks on wax. The wax cylinders were played on early

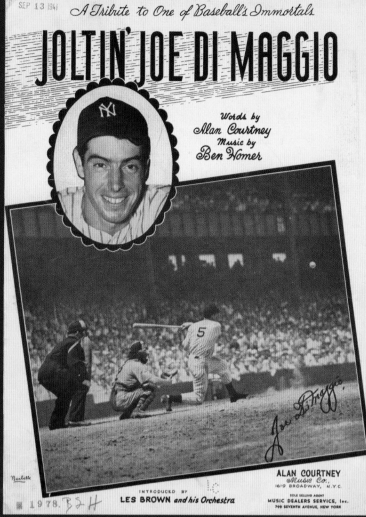

"Jake! Jake! The Yiddisha Ball Player," 1913. Irving Berlin, one of America's greatest—and most prolific—musical geniuses, paid his dues in Tin Pan Alley and would probably have paid every one else to forget this particular effort. Berlin, a Russian-Jewish immigrant who was quite ignorant of the game, and his collaborator, lyricist Blanche Merrill, attempted to tap into both baseball's fan base and a Jewish audience for their song about a spectator whose half-dollar bet depends on Jake's success at the plate. The sheet music industry specifically commissioned songs to appeal to various American ethnic groups, including German, Irish, Italian, and Jewish communities.

"Joltin' Joe DiMaggio," 1941. A picture of the Yankee Clipper taken during his fifty-six game hitting streak graced the cover of this energetic number that celebrated his amazing feat: "He started baseball's famous streak / That's got us all aglow / He's just a man and not a freak / Joltin' Joe DiMaggio!" The song peaked at number twelve on the pop music charts.

Edison phonographs, and Gaskin's version of "Slide, Kelly, Slide!" was the nation's first pop hit record.

There was a significant change in tone in American music in the 1890s, as the rapidly increasing demand for inexpensive, mass-produced upright pianos, sheet music, and phonographs prompted more music publishers to regard their line of work as a for-profit enterprise, rather than a wholly artistic and cultural pursuit. Thus, the Tin Pan Alley era began, as New York publishing houses sought hired guns to write thousands of tunes that would appeal to general American audiences. Baseball was inevitably a source of inspiration for writers trying to satisfy national tastes.

The best-known baseball song found its way into American culture via the New York subway, where Tin Pan Alley resident Jack Norworth jotted down the lyrics to "Take Me Out to the Ball Game" (1908). With Albert Von Tilzer

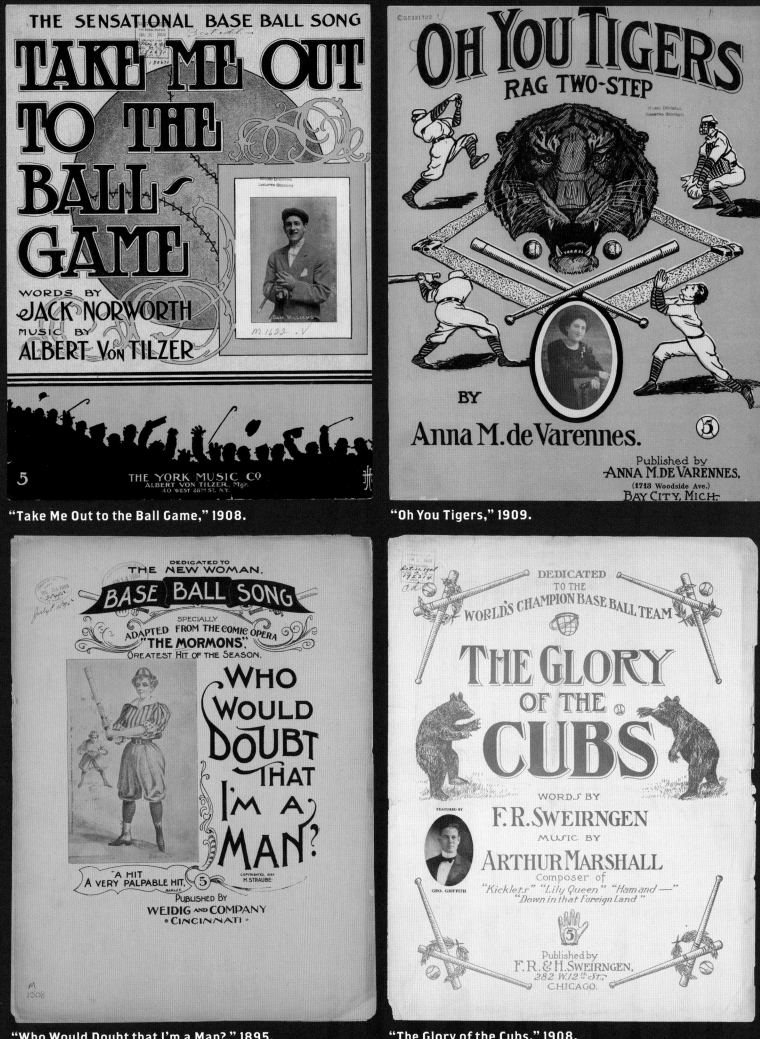

"Take Me Out to the Ball Game," 1908.

"Oh You Tigers," 1909.

"Who Would Doubt that I'm a Man?," 1895.

"The Glory of the Cubs," 1908.

"They All Know Cobb," 1913.

"Home Run Polka," 1867.

"The Baseball Bug," 1911.

"Come on to the Baseball Game," 1911.

"The Baseball Song," 1888.

"The Red Sox Speed Boys," 1912.

"Batter Up, Uncle Sam Is at the Plate," 1918

supplying the music, this American classic was written in less time than it takes to play two typical innings. (The sheet music cover shown on page 110 is marked May 2, 1908, the date it was registered in the U.S. Copyright Office at the Library of Congress.) The complete song describes how baseball-mad Katie Casey urges her beau to take her to a game rather than to a show. The song owed some of its tremendous success to an early form of the music video: color-tinted "lantern slides" of actors playing out scenes from the song (filmed at New York's Polo Grounds) that were shown at nickelodeons during intermissions. With the song lyrics appearing at the bottom of the screen, theatergoers sang along, accompanied by the house pianist. Many of them presumably bought the sheet music soon after. Despite its long-standing popularity and frequent use at the ballpark, crowd renditions of the song did not become a customary seventh-inning stretch ritual at Major League games until the 1970s, when Chicago White Sox owner Bill Veeck convinced announcer Harry Caray to introduce it as a regular feature.

The success of "Take Me Out to the Ball Game" prompted a rash of imitations, and Tin Pan Alley cranked out some eighty baseball songs annually in the next few years. The most notorious was George M. Cohan's quickie release of "Take Your Girl to the Ball Game" (1908), which flopped. Game attendance was apparently a popular theme, as similar tunes included "Follow the Crowd to the Ball Game" (1909), "Come to the Baseball Game," (1911) and two different songs called "I Want to Go to the Ball Game" (1909 and 1912).

Other musical numbers were heard regularly at the ballpark as well. "The Star-Spangled Banner," which became the official national anthem of the United States in 1931, had been performed on occasion at games since the late nineteenth century, but with the onset of World War II it become standard practice to play it before the start of Major League games. Live organ music, a feature at most Major League ballparks from the 1950s until the

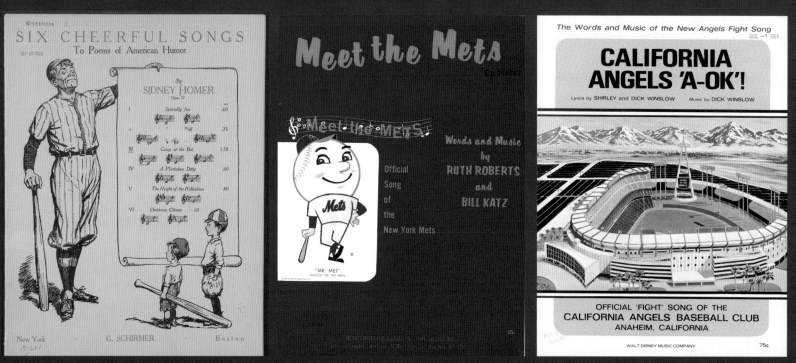

"Six Cheerful Songs," 1920.　　　"Meet the Mets," 1961.　　　"California Angels 'A-Ok'!," 1966.

1990s, debuted at Chicago's Wrigley Field in 1941. And the six most familiar notes at any sporting event—Da-da-da-DUT-da-DUH, ending with the crowd yelling "CHARGE!"—thundered across the field at Los Angeles Dodgers home games in 1958. University of Southern California drum major Tommy Walker wrote the fanfare in 1946 for the school's football team, but after the Dodgers adopted it, it quickly spread to other venues, and Philadelphia Phillies organist Paul Richardson further popularized its use.

The Tin Pan Alley era wound down in the 1930s as the typical pop music fan tuned in to the radio and bought more records than sheet music. Baseball's musical heyday was over, but the game still produced hits—"Joltin' Joe DiMaggio" (1941), "Did You See Jackie Robinson Hit That Ball?" (1949)—and misses, such as "Mickey Mantle Mambo" (1956), which reflected the Latin American craze sweeping the entertainment industry, even though the Mick was from Oklahoma. By the 1960s, music publishers were producing packets of generic tunes, such as *Dozens O' Diamond Ditties*, that radio stations and stadiums could use for game-related festivities. Among the dozens of ditties were "Don't Kill the Umpire," "The All-Star Game Is Coming Up," "Stand Up (Seventh Inning Song)" and "Wow, Wotta Wallop."

In the meantime, nearly every team had one or more songs, with available sheet music, whether officially sanctioned or not. Among the latter was "Let's Keep the Dodgers in Brooklyn" (1957), a fans' protest song by local comedian Phil Foster. What might be considered its historical counterpart was Ruth Roberts and Bill Katz's "Meet the Mets," which introduced New Yorkers to their new National League team. The spirit of "Meet the Mets," with its invitation to "Step right up and greet the Mets / Bring your kiddies, bring your wife / Guaranteed to have the time of your life," was very much in keeping with the upbeat, celebratory sensibility of traditional baseball songs, dating back to "The Baseball Polka," its century-old ancestor.

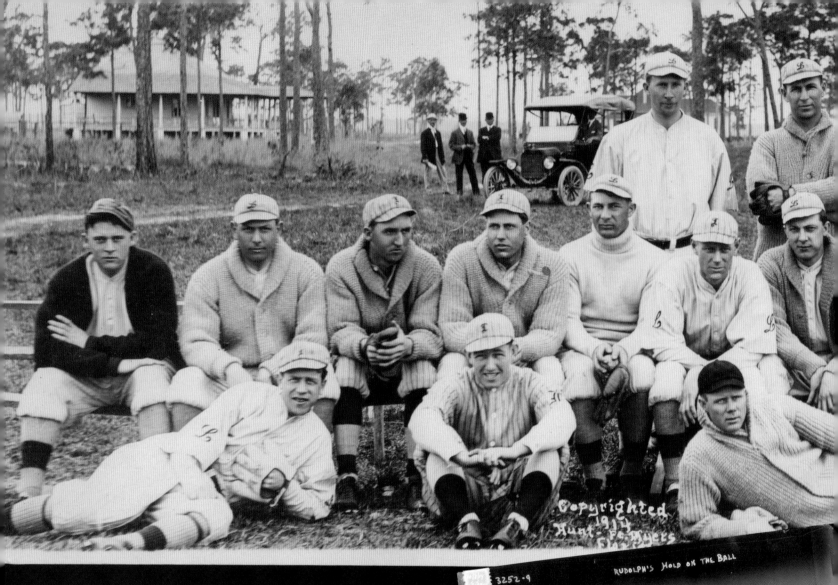

The Louisville Colonels, 1914. The Triple A minor-league Colonels of Louisville, Kentucky, pose for a team photo on a chilly day in Fort Myers, Florida, during spring training.

Rudolph's hold on the ball, Bain News Service, 1914. Dick Rudolph, pitcher for the Boston Braves, demonstrates his fastball grip the year he won twenty-seven games and the "Miracle Braves" soared from last place in early July to win the National League pennant and defeat Philadelphia in the 1914 World Series.

Water baseball, Bain News Service, July 27, 1914.

GOWDY-TYLER-CONNELLY

Boston Braves, Bain News Service, 1914. Hank Gowdy (catcher), Lefty Tyler (pitcher), and Joe Connolly (outfielder) of the "Miracle Braves" await their turns in the batting cage. During World War I, Gowdy was the first Major Leaguer to enlist in the U.S. military.

PHOTOG'RS - POLO GROUNDS

Photographers at the Polo Grounds, New York, Bain News Service, 1914.

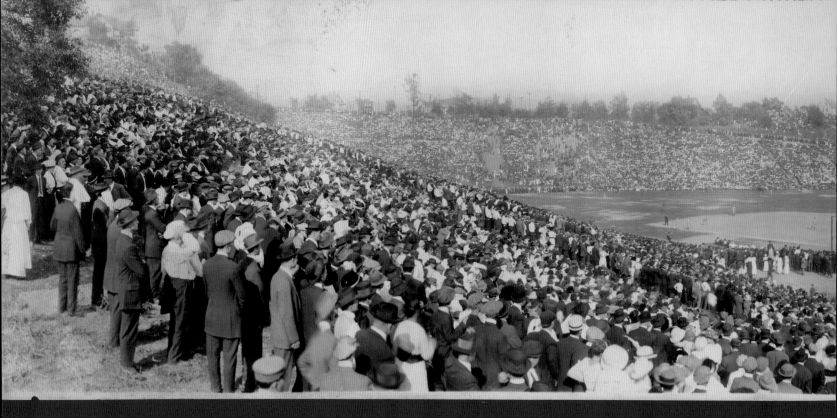

Amateur championship game, Brookside Park, Cleveland, Miller's Studio photograph, 10 x 43½ in., September 20, 1914. A crowd of 83,753 formally dressed fans—as counted by a squad of men armed with counting registers—jammed into seats and staked out hillside spots to watch the Telling Strollers defeat Hanna's Cleaners 8-3. Some of the largest attendance figures for baseball games were tallied at this field for amateur contests, drawing numbers that Major League games have rarely surpassed.

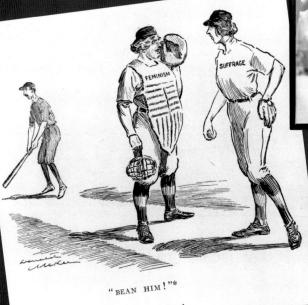

"BEAN HIM!"*

*Note for ignorami—Hit him in the head

Political cartoon by Donald McKee, July 9, 1914.

Red Sox Rooters, Bain News Service, 1915. Long before the Red Sox Nation began serenading the home team with "Sweet Caroline," it was the Red Sox Rooters, first known as the Royal Rooters, who incessantly sang out the Broadway number "Tessie" to stir the hearts of the local nine and distract their rivals. Tessie and the Rooters made their presence felt during the inaugural 1903 World Series when the Sox defeated Honus Wagner's Pittsburgh Pirates. Pirates outfielder Tommy Leach remembered the song's maddening effect: "'Tessie' was a real popular song in those days. You remember it don't you? 'Tessie, you make me feel so badly / Why don't you turn around / Tessie, you know I love you madly / Babe, my heart weighs about a pound. . . .' Only instead of singing 'Tessie, you know I love you madly,' they'd sing special lyrics to each of the Red Sox players: like 'Jimmy [Collins, third base], you know I love you madly.' And for us Pirates they'd change it a little. Like when Honus Wagner came up to bat they'd sing: 'Honus, why do you hit so badly / Take a back seat and sit down / Honus, at bat you look so sadly / Hey, why don't you get out of town.' Sort of got on your nerves after a while. And before we knew what happened, we'd lost the World Series."

The Red Sox Rooters disbanded in 1918, the year the Sox won the World Series and ushered in an eighty-six-year world championship drought.

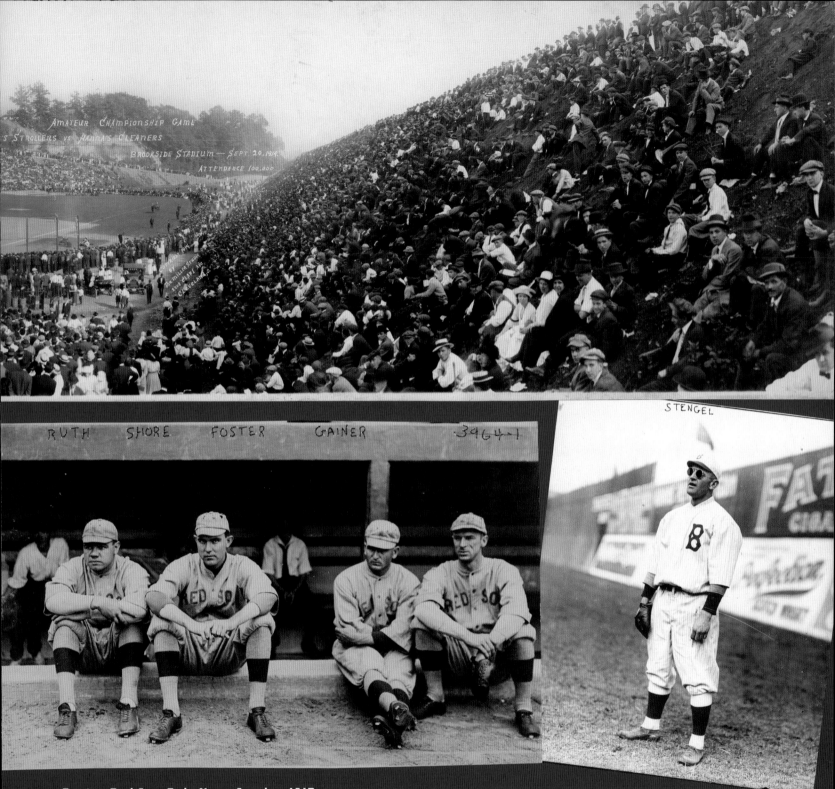

Amateur Championship Game
'S Strollers vs. Hanna's Cleaners
Brookside Stadium — Sept. 20, 1914.
Attendance 100,000

RUTH SHORE FOSTER GAINER 3964-1

STENGEL

Boston Red Sox, Bain News Service, 1915. George Herman "Babe" Ruth, Ernest G. "Ernie" Shore, George "Rube" Foster, and Dellos "Del" Gainer.

Casey Stengel, outfielder, Brooklyn Dodgers, 1915. Casey Stengel, seen here in the fourth year of his fourteen-year Major League playing career, had modest (and apparently stylish) success on the field but made his mark in the dugout as a manager and master tactician. A native of Kansas City, Missouri, Stengel has a unique place in New York City's baseball history, having played for both the Brooklyn Dodgers and the Giants, and

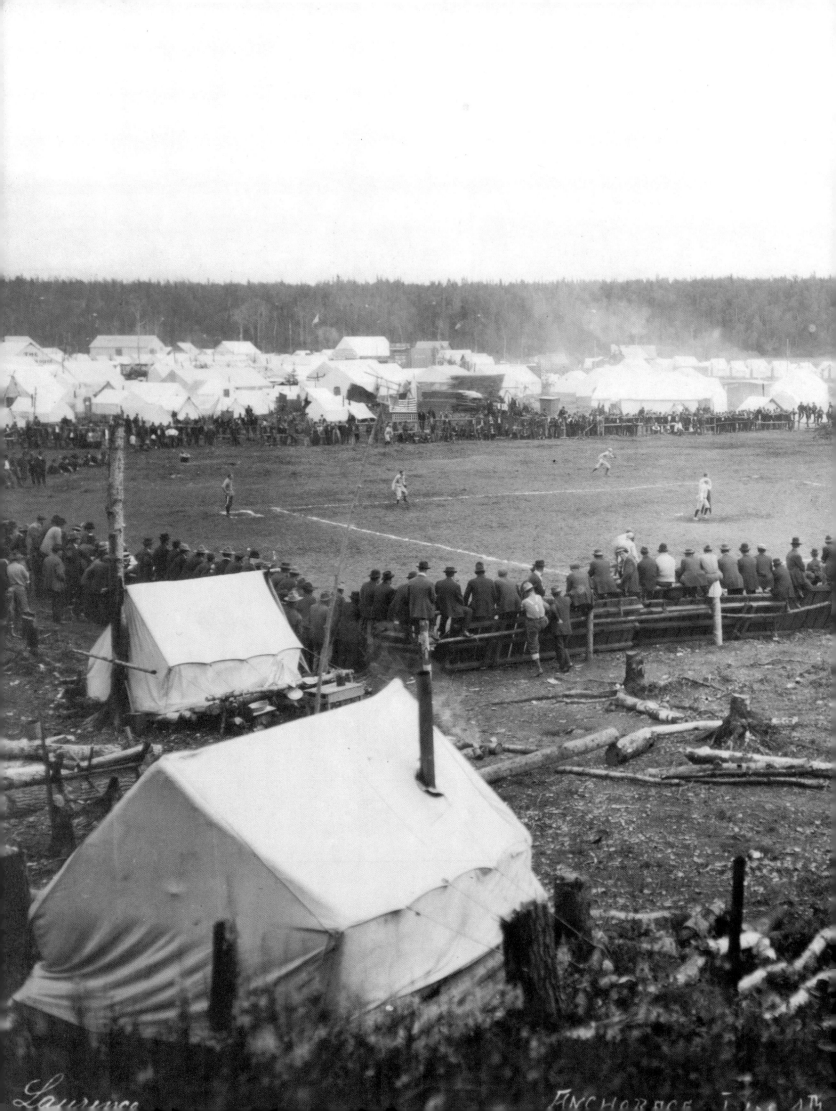

Laurence ANCHORAGE

ABOVE: **Soldiers' ball game, American Expeditionary Force, France, Bain News Service, ca. 1917–1918.** Doughboys on leave play outside a YMCA recreation hut during World War I. Military officials strongly encouraged organized baseball at army camps and naval stations before the troops went overseas as way to help them stay in shape, develop a "fighting instinct," and, perhaps most important, prevent them from contracting venereal diseases—a danger if they had too much free time. On disembarking in Saint-Nazaire, France, servicemen could play ball on seventy-seven newly set up diamonds. American Expeditionary Force (AEF) teams representing engineering, medical, transport, and other units played some two hundred games daily throughout France, and the quality of play could be quite high given the heralded Major Leaguers and professional athletes (including Grover Cleveland Alexander, Christy Mathewson, Hank Gowdy, Branch Rickey, and Ty Cobb) in the service. Americans tried to teach their French allies the game, but most efforts came to naught.

LEFT: **Ball game, Anchorage, Alaska, July 4, 1915.**

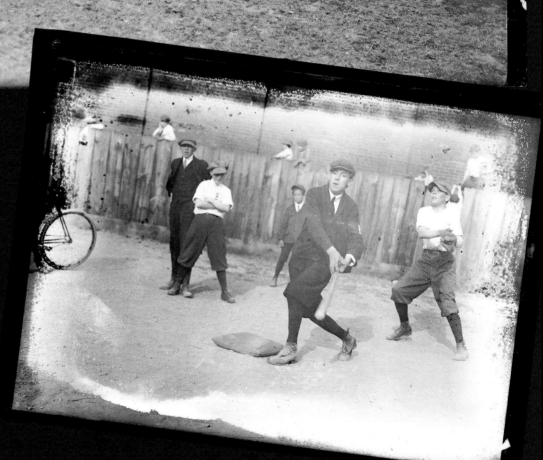

World Series umpires, Bain News Service, 1916. Ernie Quigley, Tom Connolly, Hank O'Day, and Bill Dinneen formed a stellar umpiring lineup that oversaw the World Series between Boston and Brooklyn. O'Day and Dinneen had both been Major League pitchers, and all four highly respected umpires went on to have decades-long careers. The foursome also witnessed significant history on the job: in 1903, Connolly and O'Day were on duty for the first World Series; O'Day was behind the plate for the 1908 Giants–Cubs contest that culminated infamously with Merkle's Boner (he ruled hours later that New York had not won but that the game had officially ended in a tie); Quigley worked the scandalous Black Sox World Series in 1919; and in 1933, Dinneen was selected to umpire baseball's first All-Star Game. When Connolly retired from the field in 1931, he became the American League's first umpire supervisor. He was inducted into the Hall of Fame as an umpire in 1953.

Playground game, Washington, D.C., National Photo Company, 1918.

WATCHING SHIBE PARK 1910

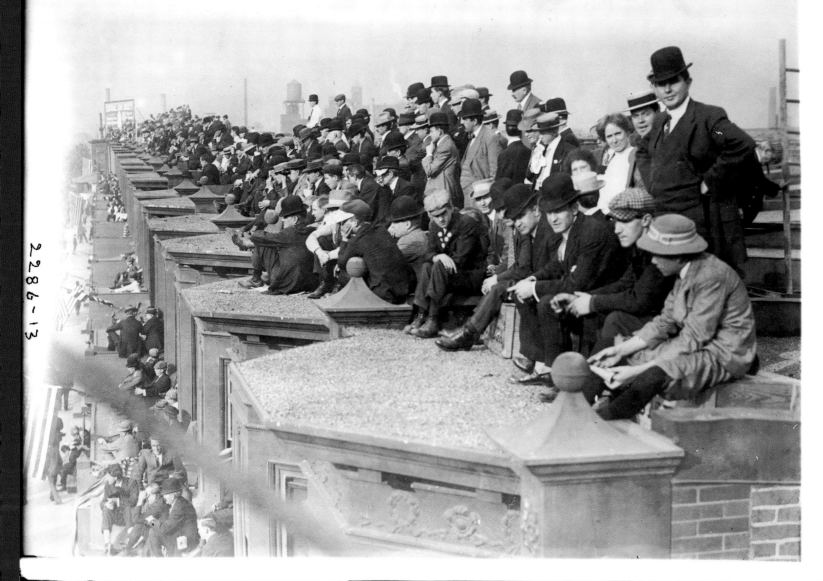

2286-13

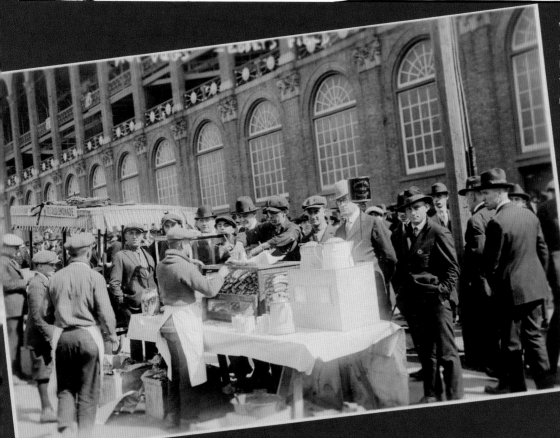

Watching at Shibe Park, 1910. Crowds settle in on row-house rooftops overlooking Philadelphia's Shibe Park to watch the Phillies. The outfield fence was later raised to prevent nonpaying fans from watching the games.

Food vendors, Ebbets Field, New York, October 6, 1920. Hot dog vendors fill orders next to a lemonade stand, offering a menu that had been available at Major League ballparks since the 1890s. The molasses-covered popcorn treat called Cracker Jack—introduced at the 1893 World's Columbian Exposition—was sold at Major League stadiums by 1907, a year before Jack Norworth mentioned it in his lyrics to "Take Me Out to the Ball Game."

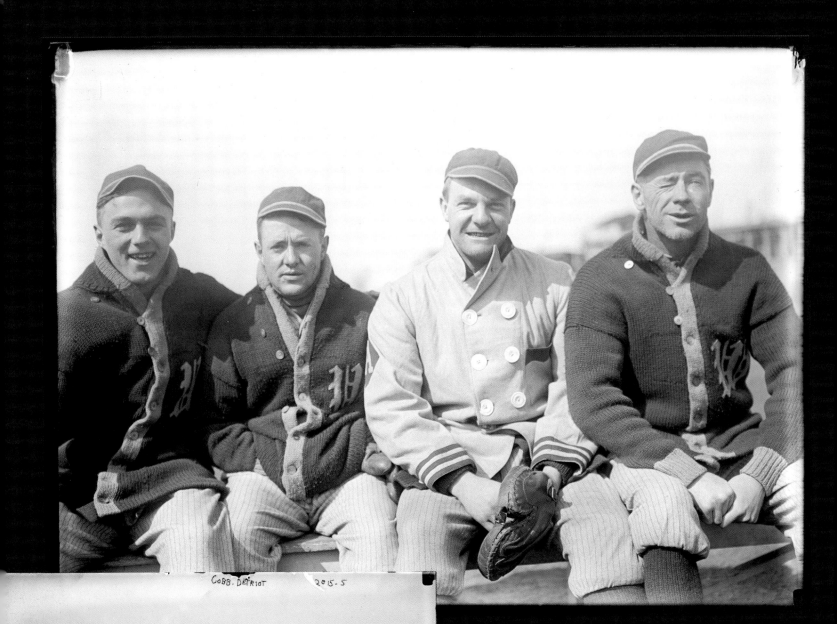

ABOVE: **Joe Engel, Eddie Foster, John Henry, and "Long" Tom Hughes, Washington Senators, Harris & Ewing, Inc., 1913.**

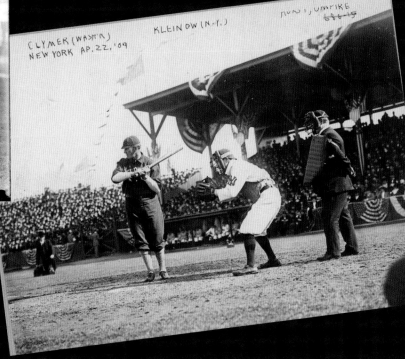

ABOVE: **Ty Cobb, Detroit outfielder, Bain News Service, 1910.**

RIGHT: **Washington's Otis Clymer at bat with Red Kleinow of the New York Highlanders (later called the Yankees) behind the plate, Hilltop Park, New York City, Bain News Service, April 22, 1909.**

ABOVE: **Emerson Wright Playground, Springfield, Massachusetts, photograph by Lewis Hine, June 27, 1916.**

LEFT: **Playground game, Washington, D.C., National Photo Company, 1918.**

WHEN THE GAME WAS SILENT
BASEBALL IN THE EARLY MOVIES

★ ★ ★ ★ ★ ★ ★ ★ ★ ★ ★ ★ ★ ★ ★ ★ ★ ★

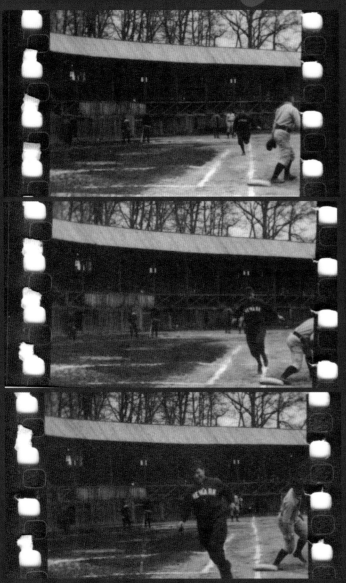

The familiar, essential sounds of the ballpark—the crack of the bat, the roar of the crowd, and the peanut vendor's cry—were not heard on film in nickelodeons and movie theaters for the first thirty years that baseball appeared in motion pictures. To American audiences, though, the game's peculiar choreography—the pirouette of a double play, a collision at home plate—was readily understood in silence. The new technology of cinema translated pastoral greenery and Arcadian scenery into a black, white, and gray field of play and converted the smooth loping stride of a base runner into a jerky gait projected at about sixteen frames per second. Baseball in motion was probably first seen on screen in 1898 with the Edison Company's release of *The Ball Game*. Originally running just under a minute, the film, shot entirely from behind first base, shows Newark's home nine at bat against the Reading, Pennsylvania, team. According to the company's own catalog description, the "exciting" film was "A most excellent subject, treated brilliantly."

Filmmakers did not make baseball films because it was the national game; rather, because the sport was everywhere, it was inevitably a subject motion picture pioneers exploited. Major League ballplayers

The Ball Game, **Edison Manufacturing Co., 1898.** A Newark player races down a slightly crooked baseline toward first base in the earliest known movie of a baseball game. Edison's crew shot at the ballpark in Newark, New Jersey, May 16-18, 1898, and copyrighted the one-minute film two days later.

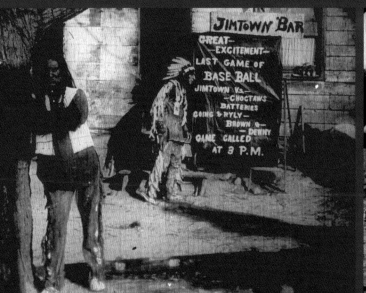

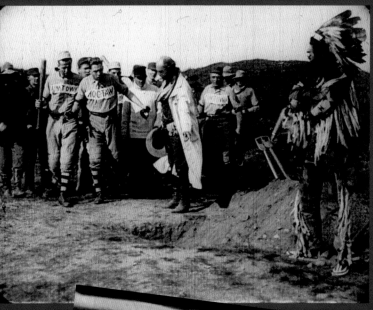

***His Last Game*, International Motion Picture Co., 1909.** The film opens (LEFT) with a shot of ace pitcher William Going, left, and friend outside the local saloon, where a sign announces that afternoon's ball game. After being harassed by gamblers who want the pitcher to throw the game, Going shoots and kills one of the men on the spot. Promised a judicial reprieve if he can win the game for the Choctows, Going comes through heroically, but an impatient lawman orders him executed before word from the judge arrives. Reaching the scene moments later, the players (RIGHT) are horrified to discover Going in his freshly dug grave.

began turning up in the movies as early as 1906, when Selig Polyscope released *The World Series Baseball Games—White Sox and Cubs*. For fans in the Far West or the Deep South, where there were no Major League clubs, the movies offered an opportunity to see a favorite team or player of national renown. In addition to chronicling professional baseball, filmmakers grasped that the game's inherent drama would illuminate their own fictional text. Even in nonbaseball movies, kids with baseball caps askew and mitts seemingly fused to their hands appeared regularly, a clear reflection of American life. Unfortunately, about 90 percent of all films made before 1920 no longer exist, but the archival record notes that hundreds of newsreels and movies with baseball themes were released during the silent era.

A profoundly melodramatic twelve-minute offering that did survive, *His Last Game* (1909), marked one of the first baseball photoplays (a motion picture with a fictional scenario). Cheaply made—the teams' names are handprinted on paper pinned to the players' uniforms—the movie illustrates the difficulty early filmmakers had in capturing the game's unique angles. The game footage was shot at eye

***The Pinch Hitter*, New York Motion Picture Corp., 1917.** Charles Ray stars as the hapless Joel Parker, who tries out for the Williamson College baseball team. "He plays ball like a sick oyster on stilts," says one coach to another, "but he is such a boob that he ought to bring us luck." Thus, Parker becomes the team's bench-warming mascot. In a championship game against Bensonhurst, Williamson has run out of pinch hitters, and, in the scene above, the coach begs him to enter the game (ABOVE). The crowd is mortified to see him at bat: "Won't somebody please shoot him?" yells a fan. Another remarks, "His only chance is to hit with his head." But Parker, whose girlfriend seated in the stands telepathically urges him to have confidence, miraculously connects on a game-winning hit. The popular film was reissued in 1920 and 1923 and remade in 1925.

Shut Out in the Ninth, Thomas A. Edison, Inc., 1917.

level behind the catcher, with the umpire standing awkwardly off to one side. The bases were placed a few paces apart so as to cram as much of the infield into the frame as possible. Directors would soon learn to shoot from elevated camera locations and to logically edit close-ups since viewers were accustomed to seeing the entire field at once at actual games. The challenge of filming a baseball game as a narrative was that, unlike boxing or football and other sports with goals to defend, play did not move back and forth, easily followed by a panning camera. Instead, the action jumped around in bursts from home plate to the outfield and all around the base paths. Mastering baseball geography on film was part of the hanging learning curve for the young movie industry.

From it earliest fictional moments, the baseball movie created its own cinematic architecture, as patterns emerged and themes were duplicated again and again: corruption and the evil influences of gambling; redemption available at the ballpark; success on the field rewarded with the love of a good woman; overcoming great odds to succeed (the protagonist hits the game-winning home run in an alarmingly high percentage of films). *His Last Game* opens with gamblers attempting to bribe a pitcher, while a hopelessly clumsy rube saves the day in *The Pinch Hitter* (1917). A cocky young pitcher gets his comeuppance and redeems himself in *Slide, Kelly, Slide* (1927). *Trifling with Honor* (1923) tied a number of these plot clichés together, summed up neatly in the film's tagline: "A man's honor and a woman's happiness depended on ONE HOME RUN."

In the meantime, Major League players made cameo appearances in movies with incidental baseball scenes, while others, beginning with Michael Joseph Donlin (known as "Turkey Mike"), starred in full-length feature films. Donlin played a fellow similar to himself in *Right off the Bat* (1915), went on to have a successful Hollywood career as a character actor, and paved the way for other ballplayers to become leading men. In 1916, Detroit's Ty Cobb—the game's biggest name at the time—portrayed a ball-playing bank teller in *Somewhere in Georgia* and was reportedly paid $10,000 for his earnest efforts. Cobb heroically foils his rival's

Speedy, **Paramount Pictures, 1928.** Babe Ruth greatly enjoyed his memorable role as himself in Harold Lloyd's film about a man so obsessed with baseball that he is unable to hold down a job. Getting work as a cabdriver, Harold "Speedy" Swift comes upon Ruth passing out baseballs to schoolchildren and in need of a lift to Yankee Stadium. Speedy is so thrilled to have Ruth as his backseat passenger that he continually turns to chat with him, oblivious to oncoming traffic. The Babe did a fine job displaying a range of terrified looks as the cab rockets through New York City.

"Trifling With Honor"

A man's honor and a woman's happiness depended upon ONE HOME RUN.

COUNTRY OF ORIGIN AND PRODUCTION U.S.A.

Lobby card, Universal Pictures, 1923.

attempts to keep him out of a ball game (which he wins at the last moment) and gets the girl. Babe Ruth began his string of film credits in 1920 with *Headin' Home*, in which he starred as a bumbling ice deliveryman who hits the mandatory game-ending home run using a bat he has whittled himself. The film was quite inexpensive to produce since newsreel footage of Ruth playing at the Polo Grounds was incorporated into the movie—and because the picture's backers failed to pay their star in full. Ruth got all his money ($50,000) up front for his second starring role, in *Babe Comes Home* (1927). In the film, Ruth hits the requisite grand slam and gives up tobacco to please his new wife, whose love has made him a winner.

In 1920, producer Lincoln A. Borthwick turned his lens on the game's dark side. In what may have been the first investigative reporting of baseball on film, *The Great Baseball Scandal* was billed as "a single reel, slow motion camera exposé of the trickery of baseball." Using a "scientific treatment" and slowing the film down to 120 pictures a second, the filmmakers claimed to reveal "the actual plays that a crooked player can safely make without being caught by the naked eye of the fans or umpire." The film was released a month after a grand jury convened to investigate the Black Sox; thus, the movie's promoters noted that "The scandal recently uncovered in connection with the great national game makes this picture unusually timely...."

Sound first came to the on-screen ballpark in the roundly panned *Warming Up* (1928), released with music and annoyingly unsynchronized sound effects. That year, Ruth played himself in *Speedy*, comedian Harold Lloyd's classic last silent film release. Baseball's first talkie, *Fast Company* (1929), adapted from Ring Lardner and George M. Cohan's Broadway play, *Elmer the Great,* differed from previous offerings only in that it included spoken dialogue. Otherwise, it followed in the long-established tradition with its crooked gamblers, a declaration of love from the stands, and the all-important game-winning play.

BOOM AND BUST

‹THE BLACK SOX, MURDERERS' ROW, AND THE GREAT DEPRESSION› (1919–1939)

Though it is likely apocryphal, a reported incident outside a Chicago courthouse in 1920 has come to symbolize one of baseball's lowest moments. After confessing his part in throwing the 1919 World Series, Shoeless Joe Jackson met a teary-eyed young fan on the courthouse lawn. "Say it ain't so, Joe," the boy pleaded. "I'm afraid it is, son," Jackson responded. No matter how much baseball fans wanted to disbelieve it, the evidence was undeniable.

Some members of the highly favored Chicago White Sox, in league with professional gamblers, altered their play to ensure losing to the Cincinnati Reds. Resolving the Black Sox scandal took two years, when in the summer of 1921 seven players were acquitted by a Cook County, Illinois, jury.

At first, players thought that the acquittal had saved their careers, but former federal judge Kenesaw Mountain Landis, newly installed commissioner of baseball, banned

OPPOSITE: The *Olympian*, magazine of the Olympic Club, San Francisco, illustration by Fred Glauser, April 1936.

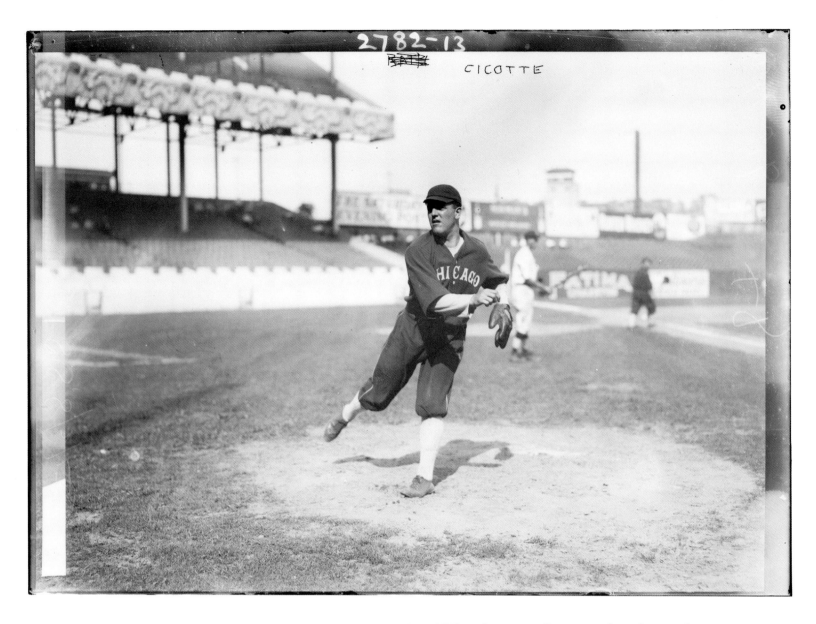

Eddie Cicotte, pitcher, Chicago White Sox, Bain News Service, 1914. Eddie Cicotte led the American League in wins in 1919, the year he helped the Sox throw the World Series. The pitcher accepted $10,000 in cash from gamblers the night before the series began, and in the first inning he beaned Cincinnati's Morrie Rath as a signal that the fix was on. The White Sox fell to the underdog Reds five games to three in the best-of-nine contest.

for life the seven indicted White Sox, as well as two other players also implicated.

Success followed crisis for baseball after World War I. The fixing of the 1919 World Series embarrassed everyone in the baseball community, yet by the time the scandal had blown over, the sport's savior had emerged. Babe Ruth transformed the game both on the field and off. His prodigious swing and dedication to the home run inspired hitters in both leagues as his happy embrace of celebrity, with all its perks and perils, shaped the larger-than-life mold of the modern-day superstar athlete. Baseball fused wonderfully with the decadent, glamorous 1920s memorialized by F. Scott Fitzgerald. Ruth and his cohorts became media stars, mingled with celebrities, appeared in silent movies, and earned unheard-of salaries—the Babe's $80,000 salary famously eclipsed that of the U.S. president in 1930.

Following Ruth's lead, batters unleashed a barrage of offensive firepower in the 1920s. Batting averages rose and strikeouts dropped dramatically. Although the decade featured great pitching from the likes of Dolf Luque, Stan Coveleski, and Dazzy Vance (while Grover Cleveland Alexander and Walter "Big Train" Johnson still threw and Lefty Grove opened his dazzling career) and small-ball

tactics continued to dominate dugout strategy, rarely in the history of baseball was there a better time to be swinging a bat.

In addition to the influence of the Ruth-style swing, rules changes during the 1920s benefited hitters. Greasing balls with spit or any other substances by pitchers was banned, and umpires introduced more, and more tightly wound, new balls per game than ever before. Thus, the ball approaching a batter was probably whiter, livelier, easier to see, and more likely to be swatted deep into the outfield. Statistics from the period prove the point: in 1919, the Major Leagues produced a total of 447 home runs, but in 1930, the total had soared to 1,565. In the same period, runs per game in the National League increased from 3.65 to 5.68. The era's other offensive star, the often overlooked Rogers Hornsby, batted over .400 three times during the 1920s. The dominant team of the decade was Ruth's Yankees, who won six pennants and three World Series titles. Their intimidating lineup in 1927, when the team led the Majors in nearly every

Chicago Cubs Big Three, September 27, 1930. Center fielder Hack Wilson, manager and second baseman Rogers Hornsby, and right fielder Kiki Cuyler were still in the hunt for the National League pennant at the end of the 1930 season until finishing two games behind the St. Louis Cardinals. But what a season it was: Wilson belted in a staggering 191 runs (originally counted as 190) and hit 56 home runs while Cuyler posted a .355 batting average.

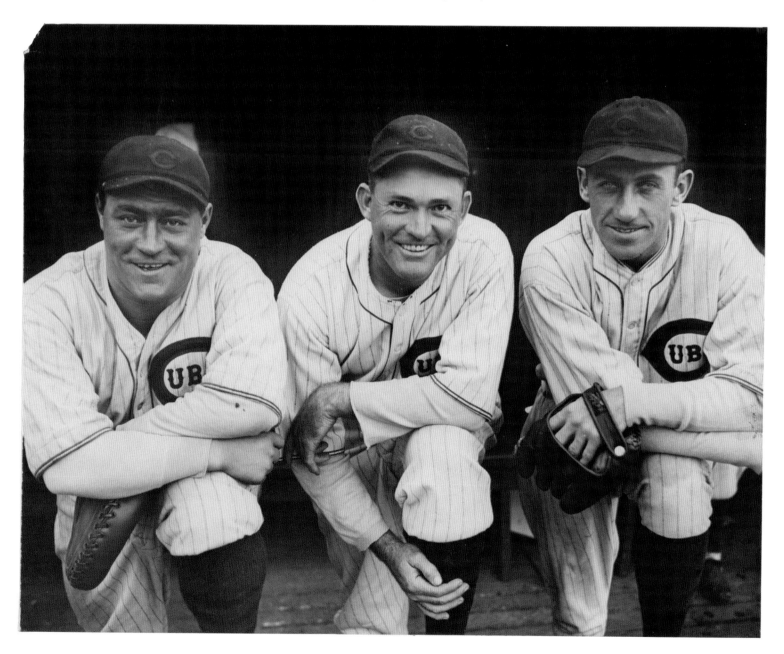

conceivable offensive category and won 110 regular-season games, was called "Murderers' Row."

Whether owners and rule makers engineered the scoring onslaught or it had simply been inspired by the Great Bambino's exploits, fans flocked to witness the spectacle. Even as baseball met new competition from college football and other forms of recreation (movies, Sunday driving), attendance at Major League games grew at a rate greater than that of the U.S. population, swelling from increased immigration. With their gate receipts and total profits at new levels of success, owners were reluctant to tinker with the formula, and fought the entrance of new technology—radio broadcasts and stadium-lit night games—claiming the former would keep fans at home and the latter would cheapen the sport to the level of theatrical entertainment.

Nationwide prosperity reached other corners of baseball's professional realm, including the Negro Leagues. Largely through the efforts of mastermind Rube Foster, a stable circuit with league standings and a minimum of player snatching was sustained through much of the decade. Negro League games on holidays and weekends, often held in the vacated parks of Major League teams on road trips, could draw crowds of up to ten thousand fans. The first black World Series was held in 1924, a nine-game contest between the western champion Kansas City Monarchs and the eastern champion Hilldale Athletic Club of

Baseball game, postcard, Buffalo, New York, ca. 1920.

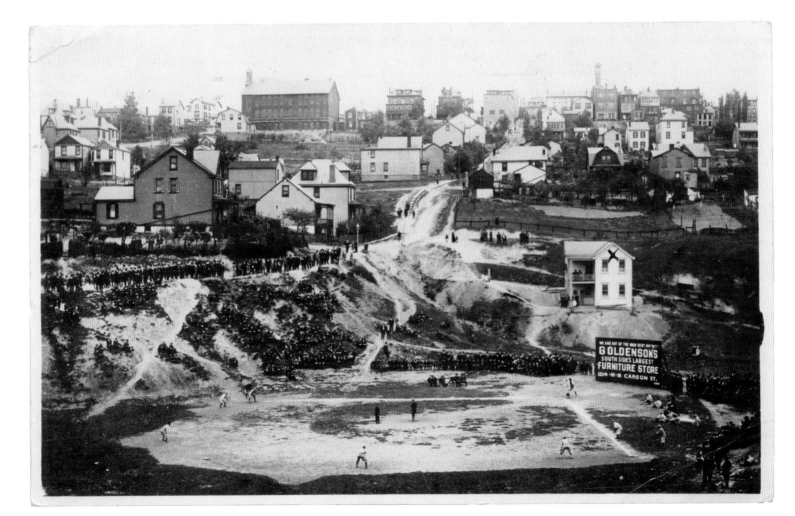

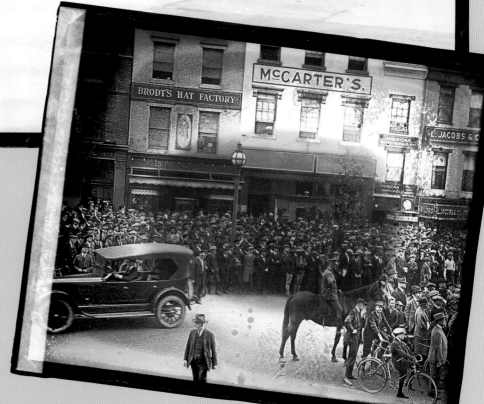

House of David, after visiting the White House, Washington, D.C., National Photo Company, 1920. The House of David was one of the more eye-catching barnstorming baseball squads of the early twentieth century. The religious commune, established in 1903, in Benton Harbor, Michigan, forbade, among other things, cutting hair and shaving, which gave the team a distinctive look, but they fielded an impressive starting nine that drew large crowds. Some time around 1922, players invented what became the popular game of pepper, which the team performed with increasing razzle-dazzle before games and between innings. Throughout the 1930s, the sect sponsored several teams that regularly covered different regions of the country, and they hauled high-powered lighting equipment with them to play night games. Among the big names that played for the House of David—and who were spared the hair requirements—were former Major Leaguers Grover Cleveland Alexander and Chief Bender, Negro League star Satchel Paige, minor-league sensation Jackie Mitchell, and 1932 Olympic heroine Babe Didrikson.

World Series crowd, New York City, National Photo Company, 1921.

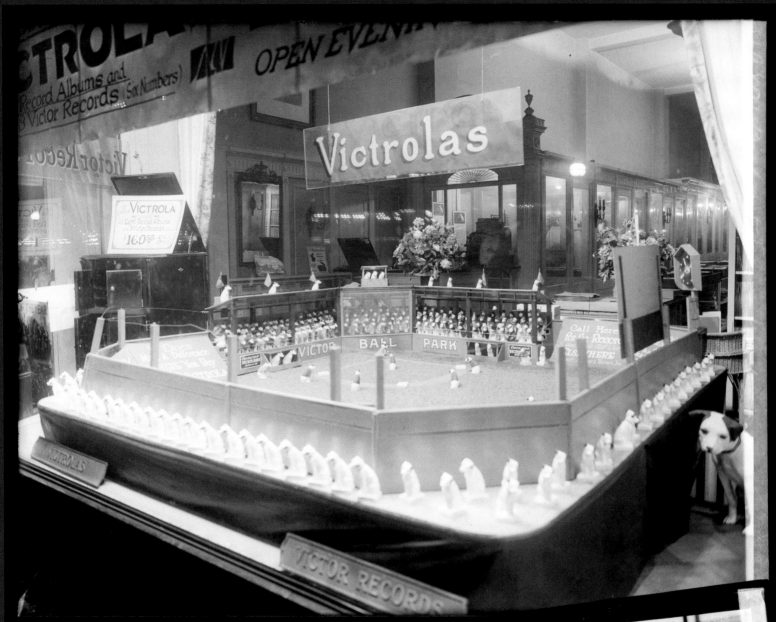

Bishop & Turner, Victrola dealership, Washington, D.C., ca. 1920. Nipper, the canine mascot for the Victor Talking Machine Company, sits near an elaborate store-front window display of miniature Nippers at play and in the stands of the Victor Ball Park.

Little ones at the ballpark, National Photo Company, 1921.

LEFT: **Vice President Calvin Coolidge, Griffith Stadium, Washington, D.C., National Photo Company, 1921.**

BELOW: **Washington Senators see how pitchers Tom Zachary and Philadelphia's Slim Harris measure up, National Photo Company, April 28, 1923.**

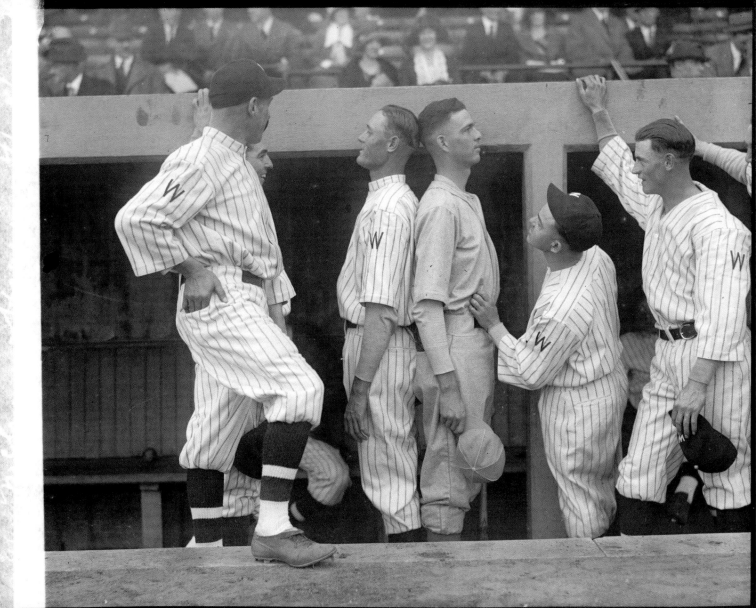

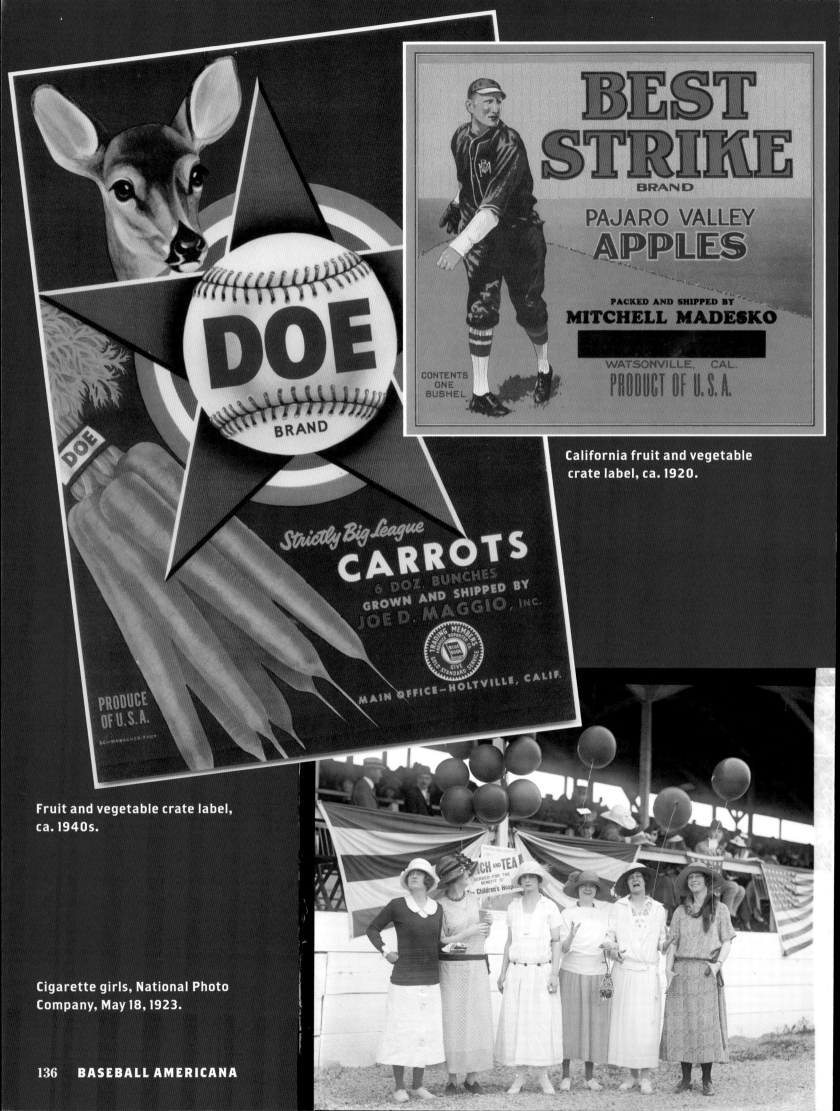

California fruit and vegetable crate label, ca. 1920.

Fruit and vegetable crate label, ca. 1940s.

Cigarette girls, National Photo Company, May 18, 1923.

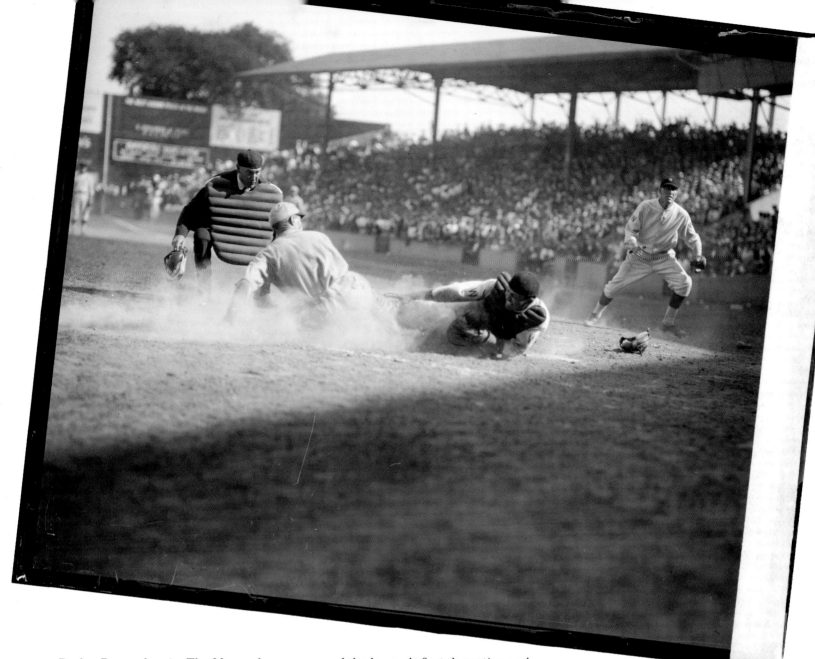

Darby, Pennsylvania. The Monarchs were one of the league's first dynasties and the chief rivals to Foster's Chicago American Giants. In 1930, the team became the first professional club to acquire portable lighting equipment and play games after dark, a trend the Majors would follow five years later.

Minor-league baseball, in its last years of independence before the modern farm system came into place in the 1930s, enjoyed its own golden age during the first half of the 1920s. The Baltimore Orioles club of the International League was the era's greatest minor-league dynasty. Led by the stingy baseball genius Jack Dunn, who had discovered Babe Ruth, the team held on to most of its Major League talents for as long as possible and won seven pennants in a row from 1919 to 1925. Dunn managed to keep Lefty Grove in the club for three seasons, during which Grove was occasionally called the best pitcher in baseball even though he played in a minor league, before finally selling him in 1924 to the Philadelphia Athletics for a record sum. When a minor-league draft and a limit on player sales were imposed in 1924, Dunn's empire began to dwindle.

Like many of the Jazz Age's booming industries, baseball was in the midst of a bubble that was bound to burst. In the first years after the great stock market

Safe at home, Griffith Stadium, Washington, D.C., National Photo Company, July 19, 1924.
Washington pitcher Allen Russell, right, races to back up his catcher, Bennie Tate, as St. Louis shortstop Wally Gerber slides home safely under the eyes of umpire Dick Nallin in the tenth inning to give the Browns a 10-9 victory.

crash of 1929, the business of baseball stayed afloat. But by 1932, as the Great Depression deepened, attendance had fallen sharply (from a peak of 9 million in 1930 to just 6.3 million in 1932) and most clubs finished in the red. Besides the quick fix of cutting player salaries, owners were slow to attempt the kind of drastic innovation that might bring fans back to their ballparks. The idea of inter-league play, for instance, was batted around but never adopted, and ticket prices were not lowered. Most owners also refused to trust the potential that new technologies offered for drawing more fans. Although baseball's first radio-broadcast game had occurred in 1921, most teams remained suspicious of the medium, fearing it would hurt attendance; New York teams did not retract a citywide ban on broadcast ball games until 1939. Likewise, night games remained rare events until after World War II, even though the first Major League game played under the lights, in Cincinnati in 1935, drew a crowd ten times larger than the current weekday average.

Major League owners, however, were not completely bereft of good decisions during the Depression, as shown by the creation of two important and popular baseball institutions. Both the annual All-Star Game and the Hall of Fame induction ceremony were inaugurated during the 1930s. In 1933, the old generals

World Series game, Griffith Stadium, Washington, D.C., by Theodor Horydczak, 1933.

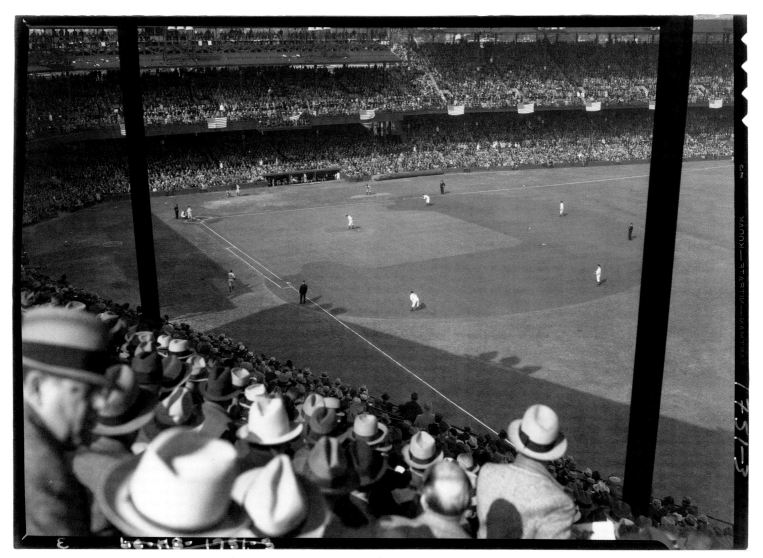

Connie Mack, still leading the Philadelphia Athletics, and John McGraw, of failing health and just a year away from death, led the squads from the American and National leagues in a game at Comiskey Park. Forty-nine thousand fans watched as the American League club, powered by Babe Ruth's homer in the third inning—the first in All-Star history—won 4–2. The establishment of the Hall of Fame in 1936 was a similar effort to drum up fan interest in the game. The first players selected for induction were Babe Ruth, Christy Mathewson, Walter Johnson, Ty Cobb, and Honus Wagner, and in 1939, the centennial of the sport's fabricated birth, the site of the National Baseball Hall of Fame and Museum was dedicated in Cooperstown, New York.

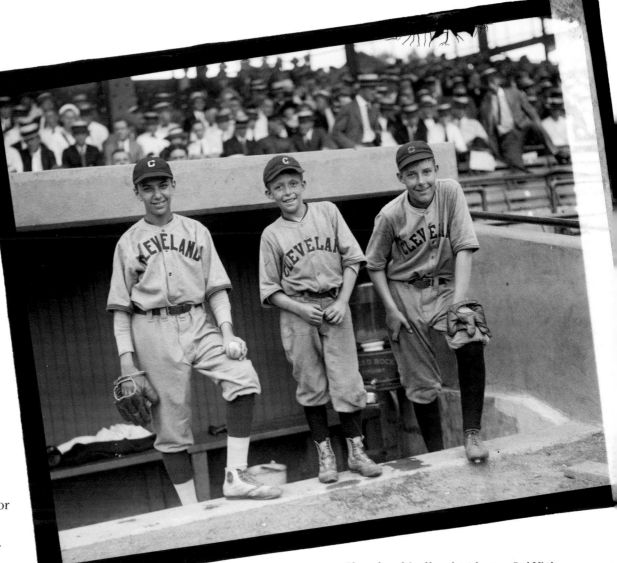

Cleveland Indian bat boys, Griffith Stadium, Washington, D.C., National Photo Company, July 22, 1922.

The years between World War I and World War II were tumultuous for both baseball and the nation at large. Through the scandal-ridden, consumer-driven excesses of the 1920s and Depression-driven deprivations of the 1930s, the sport continued to represent an aspect of American culture that was pure, pleasurable, and essentially joyful. Team allegiances bred local and regional pride and unity, often transcending political, religious, social, intellectual, or economic differences.

In the 1930s, as part of President Franklin Roosevelt's New Deal program for public works to promote the arts, job growth, and economic stimulation, the Farm Security Administration sent out photographers at government expense to document daily American life. During their assignments, FSA photographers produced images depicting ordinary Americans from all walks of life and all regions of the country enjoying baseball. Looking back over these visual records, it is difficult to find one frowning face among players and spectators. Baseball offered a respite from economic hardship, leaving intact a portion of American life otherwise in disarray.

SENATORS AND MONARCHS RULE 1924

The Washington Senators won their only World Series title in the nation's capital in 1924, knocking off the New York Giants four games to three. Bucky Harris, just twenty-seven years old, doubled as the Senators second baseman and manager, successfully matching wits against the Giants' venerable skipper, John McGraw. Pitching ace Walter Johnson, an elder statesman at thirty-six, finally made it to the Fall Classic only to lose his two starts—but he came back to pitch scoreless relief in the twelve-inning Game 7. Meanwhile, the first black World Series featured the Kansas City Monarchs, winner of the Negro National League pennant, against the Eastern

Lawrence "Mr. Megaphone" Phillips, Washington Senators fan, Griffith Stadium, Washington, D.C., National Photo Company, 1924.

Miss Elsie Tydings, Washington, D.C., October 1, 1924. Early in the morning, Miss Tydings staked out a spot at the front of the line to buy the first ticket sold for the 1924 World Series.

Graham McNamee, Game 2, World Series, Griffith Stadium, Washington, D.C., National Photo Company, October 5, 1924. Radio coverage of sporting events was still in its infancy when McNamee, soon to be America's favorite broadcaster, called the series for New York's WEAF. McNamee was no baseball virtuoso, but as a trained singer with a pleasing voice and an ability to convey vivid detail and atmosphere, he became an influential sportscaster. In 1927, he was featured on the cover of *Time* magazine, which noted that "Sports experts grumble that he does not know the sport he is describing. Radio executives answer that neither do most of the listeners; that colorful, general reports are more satisfying to the masses than accurate technical descriptions."

Colored League champions, Hilldale Athletic Club, of Darby, Pennsylvania. Rube Foster, a cofounder of the Negro National League, and Alex Pompez, the flashy owner of several teams, organized the series, which was held at four venues, beginning in Philadelphia, continuing in Baltimore and Kansas City, and concluding in Chicago. The Monarchs reigned supreme, five games to four.

Player-manager Bucky Harris, Game 1, World Series, Griffith Stadium, Washington, D.C., National Photo Company, October 4, 1924. Harris, Washington's "Boy Manager," is called out at first as the Giants take the first game 4-3.

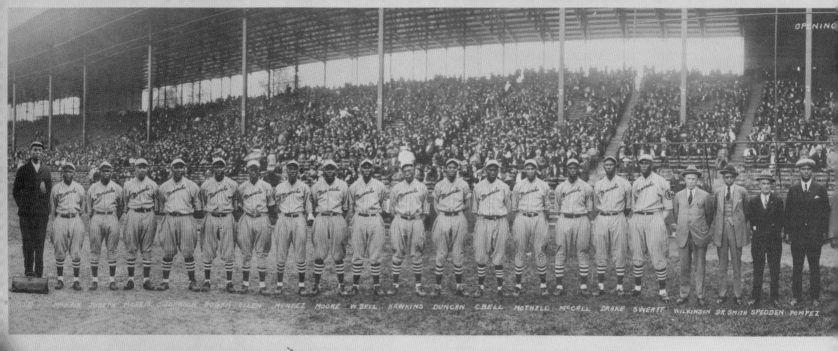

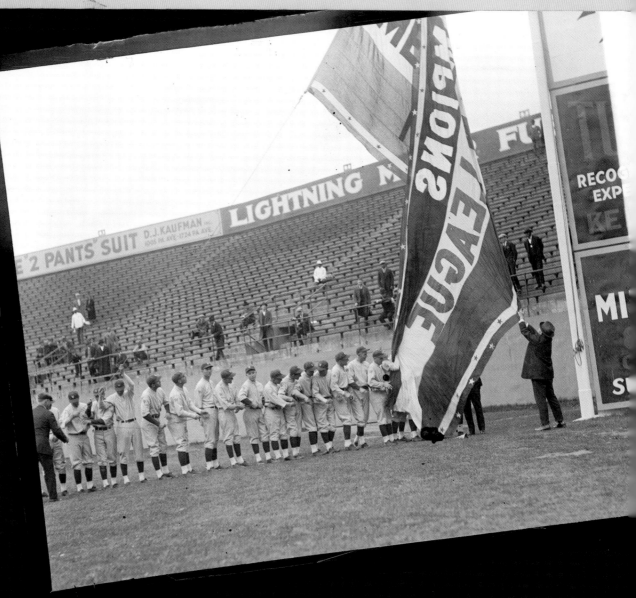

"First Colored World Series," Kansas City Monarchs and Hilldale Daisies, Muehlebach Park, Kansas City, Missouri, October 11, 1924. The handwritten caption suggests that this panoramic image was taken at the start of the series, but it was actually shot before Game 5, when the contest moved to Kansas City. Series organizers Rube Foster and Alex Pompez are seen at center, wearing light-colored caps. Several future Hall of Famers played in the series, including the Monarchs' "Bullet" Joe Rogan, pitcher, and Jose Mendez, pitcher and shortstop, sixth and eighth from the left, respectively, and Hilldale shortstop (and later star catcher) Biz Mackey, tenth from the right.

Raising the pennant, Griffith Stadium, Washington, D.C., National Photo Company, May 1, 1925. The defending world champion Senators raise the American League pennant at their home field early in the new season prior to defeating the Philadelphia Athletics 9-4.

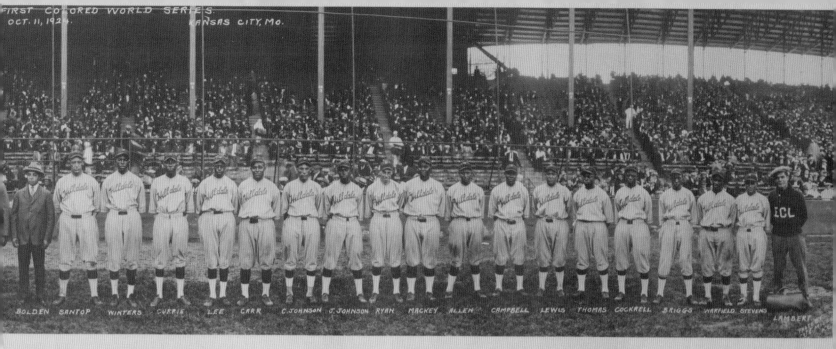

BOLDEN SANTOP WINTERS CURRIE LEE CARR C.JOHNSON J.JOHNSON RYAN MACKEY ALLEN CAMPBELL LEWIS THOMAS COCKRELL BRIGGS WARFIELD STEVENS LAMBERT

Grounds crew preparing the diamond, Griffith Stadium, Washington, D.C.,
National Photo Company, October 3, 1924.

Judge Kenesaw Mountain Landis,
first commissioner of Major League
Baseball, National Photo Company,
June 11, 1925.

Bucky Harris meets his fans,
Griffith Stadium, Washington,
D.C., National Photo Company,
September 8, 1925.

Food vendor and fans, World Series game 4, Griffith Stadium, Washington, D.C., National Photo Company, October 11, 1925. The Washington Senators returned to the World Series to defend their title, and the fans were in high spirits with the home team up two games to one when this picture was taken. But their mood soured as the Pittsburgh Pirates charged back to capture the series in seven games.

Union Printers International Baseball League, New York delegation, National Photo Company, 1925. In 1908, printers' unions in Boston, Chicago, Cincinnati, Pittsburgh, Philadelphia, New York, St. Louis, and Washington, D.C., formed a baseball association, and its members competed in an annual national tournament. Over time, printers' unions from many more major cities joined in. Here, fans of the New York team settle in for pregame festivities.

BASEBALL GIRL IN JAPAN

LEFT: **"Baseball Girl in Japan,"** Bain News Service, December 12, 1925. ABOVE: **Japanese ambassador and Keio College team, National Photo Company, ca. 1928.** Trans-Pacific shipping was kept busy in the 1920s ferrying American and Japanese baseball teams across the ocean for thousands of exhibition games. The Osaka Mainichi Baseball Club toured the United States in the spring of 1925, playing minor-league clubs and American college teams, including Chicago, Howard, Michigan, Notre Dame, and Ohio State. In August, the University of Chicago sent its team to Japan, with stops at Waseda, Neiji, and Keio universities. (Stanford and Washington had a similar itinerary the following year.) In September, *New York Times* correspondent Thomas F. Millard reported from China that "the Shanghai Amateur Baseball Club, an American organization, has assigned to it for use in summer, as part of the public recreation ground of the International Settlement [a foreign-run entity of Westerners and Japanese that governed parts of the city] . . . a baseball field; but under the rule the American Baseball Club cannot use the field to play with Chinese teams, nor admit Chinese in large numbers to witness the games. Japanese teams may play there, and a Korean team has also . . . We are in a way to make baseball the leading outdoor game in Asia: already it is spoken of as the 'national game of Japan' and it is equally popular in the Philippines." However, not all American efforts to spread the baseball gospel were successful. On December 2, the *Los Angeles Times* reported that the Philadelphia Bobbies, a team of teenage girls, had arrived in Victoria, British Columbia, following a financially disastrous tour of Japan. They were presently wards of the Canadian Pacific Railway Company and "had been rescued from want by a wealthy merchant of Hong Kong."

OPPOSITE: *The Saturday Evening Post*, cover illustration by Alan Foster, May 28, 1927.

THE SATURDAY EVENING POST

An Illustrated W[...]
Founded A.º D.º 1728 by B[...] [Fr]anklin

MAY 28, 1927

5 cts. THE COPY

Alan Foster

THE BAMBINO

★ ★ ★ ★ ★ ★ ★ ★ ★ ★ ★ ★ ★ ★ ★ ★ ★ ★ ★ ★

I SWING BIG, WITH EVERYTHING I'VE GOT. I HIT BIG OR I MISS BIG. I LIKE TO LIVE AS BIG AS I CAN.
—BABE RUTH

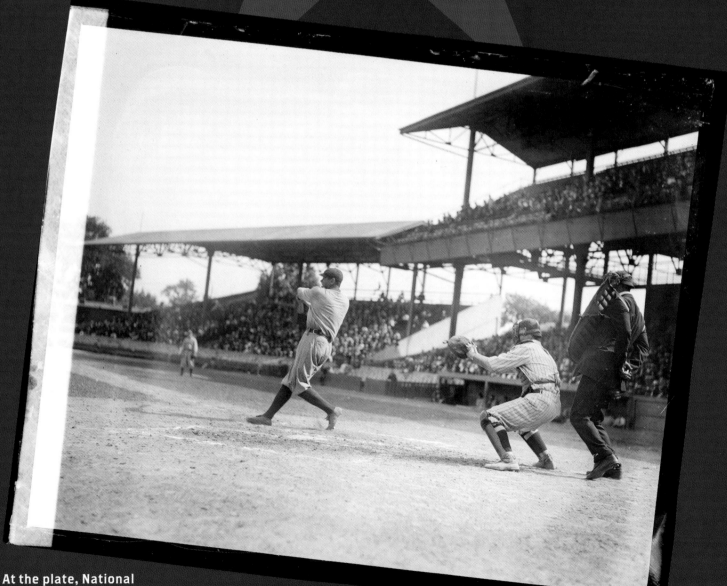

At the plate, National
Photo Company, 1920.

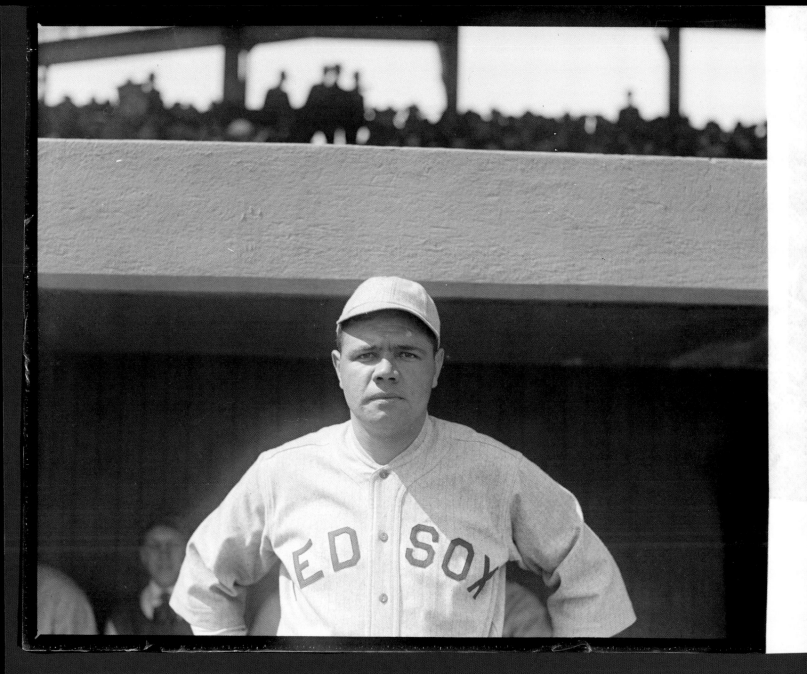

Young Babe, National Photo Company, 1919. The Babe in his last season with his first Major League team, the Boston Red Sox.

"Writing about Babe Ruth is akin to trying to paint a landscape on a post-age stamp," mused *New York Times* sportswriter Arthur Daley two days after Ruth's death in 1948. "The man was so vast, so complex, and so totally incredible...." *Time* magazine said of him at his passing, "In the golden '20s, the years of the big names—the years of Dempsey, Tilden and Bobby Jones—Babe Ruth was the biggest draw of them all."

George Herman "Babe" Ruth (1895–1948), a saloonkeeper's son born in Baltimore and an unruly street urchin at St. Mary's Industrial School, began his Major League career with the Boston Red Sox in 1914. When he left the game after twenty-two seasons, he owned fifty-six Major League records, many of which remain standing in the twenty-first century. Such accomplishments in a sport obsessed with numbers and statistics ensured that the Ruth legend would continue long past his retirement and death. Yet what made Ruth and his career so unique was not just his overwhelming presence

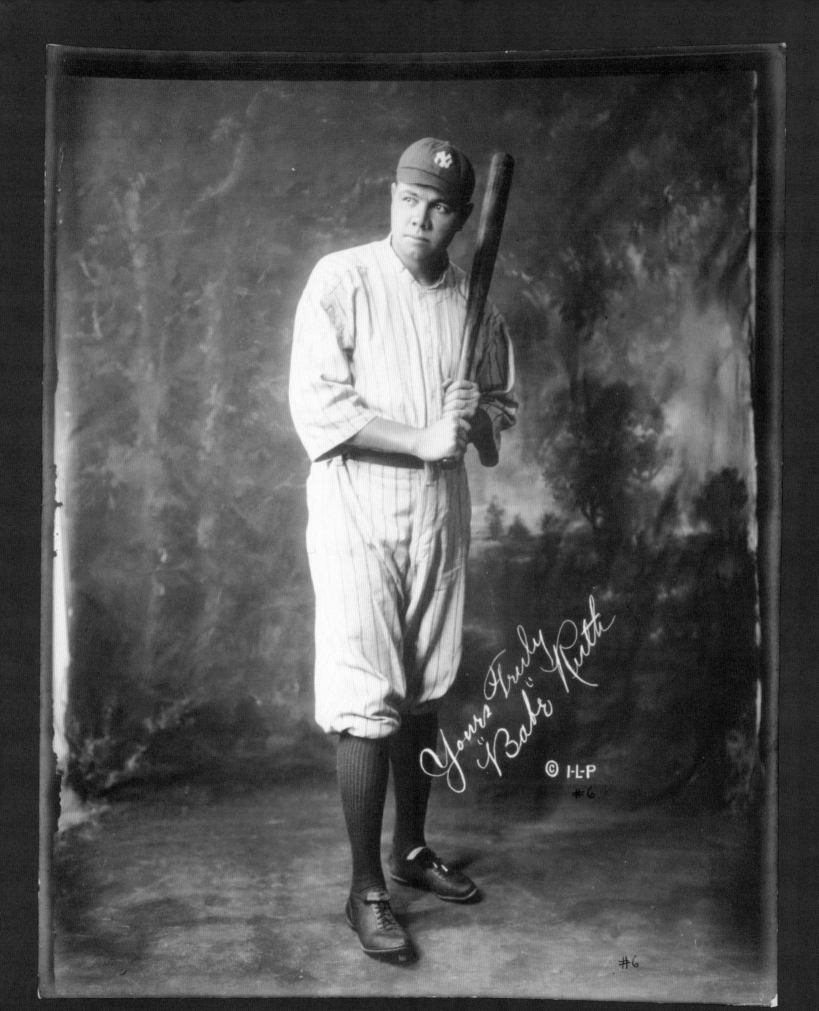

Signed portrait, Irwin, La Broad, & Pudlin, 1920.

in the record books, or that he transformed himself from an outstanding pitcher into a powerful home-run hitter, and in so doing broke open the sport from a defensive and "inside baseball" style of play to a long-ball game. Nor was it that, as many claim, he single-handedly saved the national pastime through his spectacular play for the New York Yankees after the Chicago Black Sox scandal rocked public confidence in the game. (In the 1928 film *Speedy*, comedic star Harold Lloyd tells Ruth, playing himself, "Gee, Babe, you've done more for baseball than cheese did for Switzerland.") Rather, Ruth's singular stardom sprang from a perfect storm of skill, charisma, and circumstance. The amiable Babe dominated the country's favorite sport while playing for its foremost team in America's leading city during a national high-water mark of entertainment and excess, the Roaring Twenties.

In combining his phenomenal talent and his extravagant, rollicking off-field exploits, the Ruth name and persona were inescapable, seeping so deeply into public consciousness and American culture as no sports figure ever had—or likely will again. Those who knew nothing of baseball recognized the name Babe Ruth, and even Ireland's legendary playwright George Bernard Shaw reportedly asked, "Who is this Baby Ruth? And what does she do?"

What the twice-married father of two, who greeted friends and fans with a cheerful "Hi, Kid!," did was capture the American

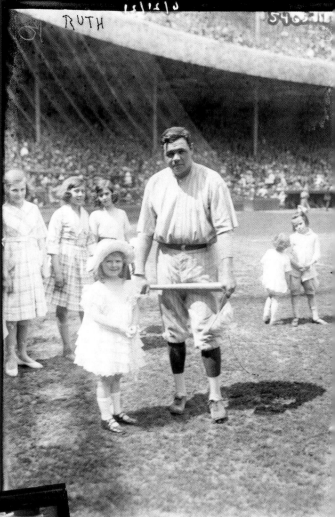

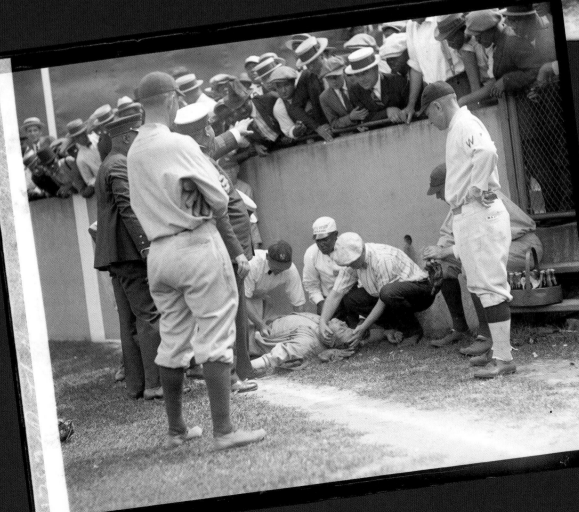

ABOVE: **Ruth and some young admirers, Bain News Service, 1921.**

LEFT: **Knocked out.** Ruth was in right field on July 5, 1924, for a doubleheader against the Washington Senators at Griffith Stadium, a match that drew the largest crowd ever to see a ball game in the capital city. In the fourth inning of the opener, he crashed into a concrete wall going after a foul ball and was knocked unconscious for about five minutes. Concerned fans peered over the wall as police, players, the Yankees' trainer, and even a stadium soda pop vendor gathered around. The *Washington Post* reported the next day that despite his injuries, Ruth "gamely insisted on sticking in that game and also the second."

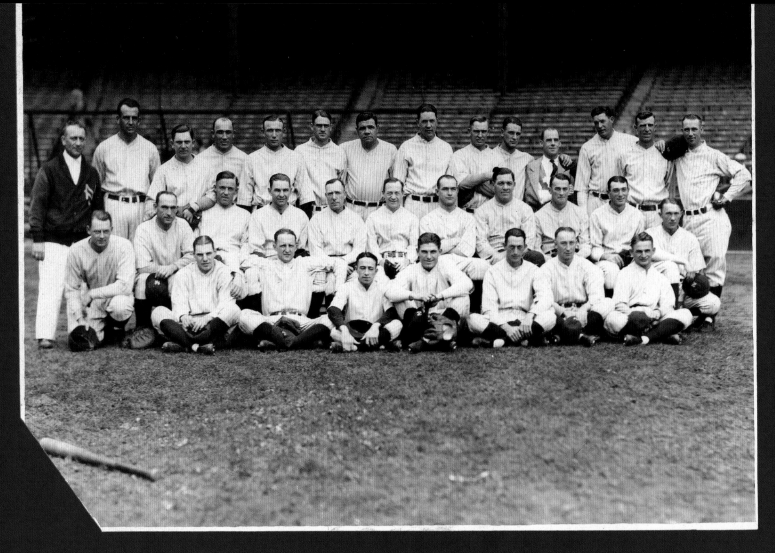

The 1926 Yankees. After an illness brought on by his off-field antics marred Ruth's 1925 season, the 1926 Yankees benefited from the Bambino's renewed dedication to fitness. The team captured the American League pennant before losing in seven games to the St. Louis Cardinals in the World Series. But Ruth (BACK ROW, CENTER) was just warming up—the storied 1927 season was in the offing.

imagination and hold it happily hostage. In 1925, the nation waited breathlessly for updates on the most famous bellyache in American history, when, after suffering from what was publicly reported as the flu and indigestion, the Babe collapsed in an Asheville, North Carolina, train station and then knocked himself out in a washroom aboard a New York–bound train. Ruth was hospitalized for weeks, underwent surgery, and missed two months of the 1925 season. In an open letter to Ruth in his popular newspaper column "The Once Over," H. I. Phillips chided the Bambino for his Jazz Age indulgences, made all the worse by his fame and its effects: ". . . when you had a stomachache the other day it was put on the front page of papers in England, Brazil and Japan, whereas King George, President Coolidge, Georges Clemenceau and Benito Mussolini have had stomachaches galore without getting any publicity whatsoever. . . . You are particularly the idol of the boys of the land but you are in way of making yourself a bad influence. I have a boy of my own and unless you reform I may have to shoot him for his own good." Ruth adjusted his ways somewhat, made a remarkable comeback in 1926, and with teammate Lou Gehrig became the heart of the Yankees' "Murderers' Row" lineup, leading New York to the 1927 World Series title

and setting his iconic record of sixty home runs that season.

Ruth was indeed known internationally, having played exhibition games as a member of the unbeaten All-American All Stars during their hugely successful 1934 tour of Asia; he made the news experimenting briefly with cricket in England and spent time in Mexico pursuing a manager's position. He appeared in feature films shown worldwide. In the brutal fighting in the Pacific during World War II, Japanese combat troops, aiming to hurl as great an insult as possible, were heard on at least one occasion to shout, "To hell with Babe Ruth!" as they charged American lines. (Yet when it was announced that Ruth had died, on August 16, 1948, all baseball games in Japan paused for a minute of silence in tribute to him, and his death was front-page news in British newspapers, whose readers were virtually ignorant of the game.)

The 2008 closure of "The House that Ruth Built"—he had baptized Yankee Stadium on Opening Day in 1923 by hitting the first home run at the new ballpark—did nothing to lessen the Bambino's continued presence in American life. To be called "the Babe Ruth" of one's profession is a badge of honor. The man even has his own adjective, "Ruthian" (as in a prodigious or enormous accomplishment), a term that entered the English language before he himself entered baseball's Hall of Fame in its inaugural class. As much as he mattered to baseball and America, the game and its opportunities meant just as much to him, because George Herman Ruth might not have been "the Babe Ruth" of any other realm. "What I am, what I have, what I am going to leave behind me," he said shortly before his death, "all this I owe to the game of baseball, without which I would have come out of St. Mary's Industrial School in Baltimore a tailor, and a pretty bad one, at that."

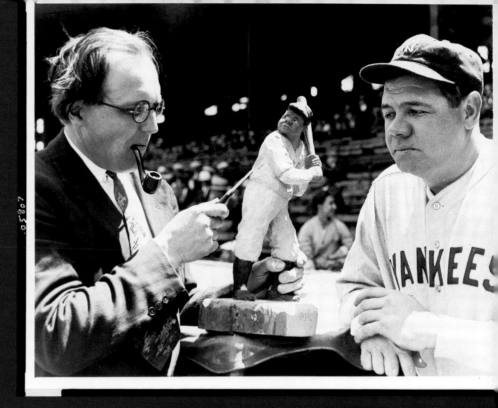

Ruth in wood, Chicago, July 15, 1930. Ruth's name and image appeared on all manner of items, from the obvious to the more creative. Here, renowned carver Carl Hallsthammar puts a final touch on his statuette of the Babe, which Ruth autographed.

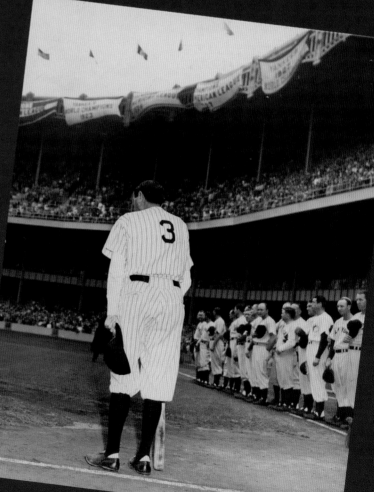

Babe Ruth Day, Yankee Stadium, photograph by Nat Fein, June 13, 1948. Fein snapped his Pulitzer Prize-winning photograph as the Yankees honored their sport's biggest star and retired his fabled uniform number. Weakened by the cancer that would take his life two months later, Ruth held on to the bat of Cleveland Indians pitcher Bob Feller and appeared at home plate for the last time.

Fannie Gerhart behind the plate, Mrs. Ritchie at bat, National Photo Company, ca. 1920.

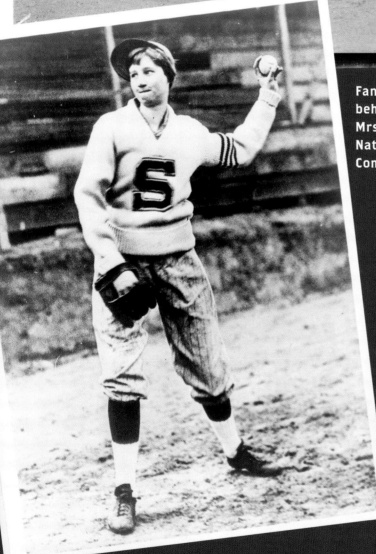

Jackie Mitchell, pitcher, Acme Photograph, 1931.

Summer camp softball, Plano, Illinois, August 5, 1930.

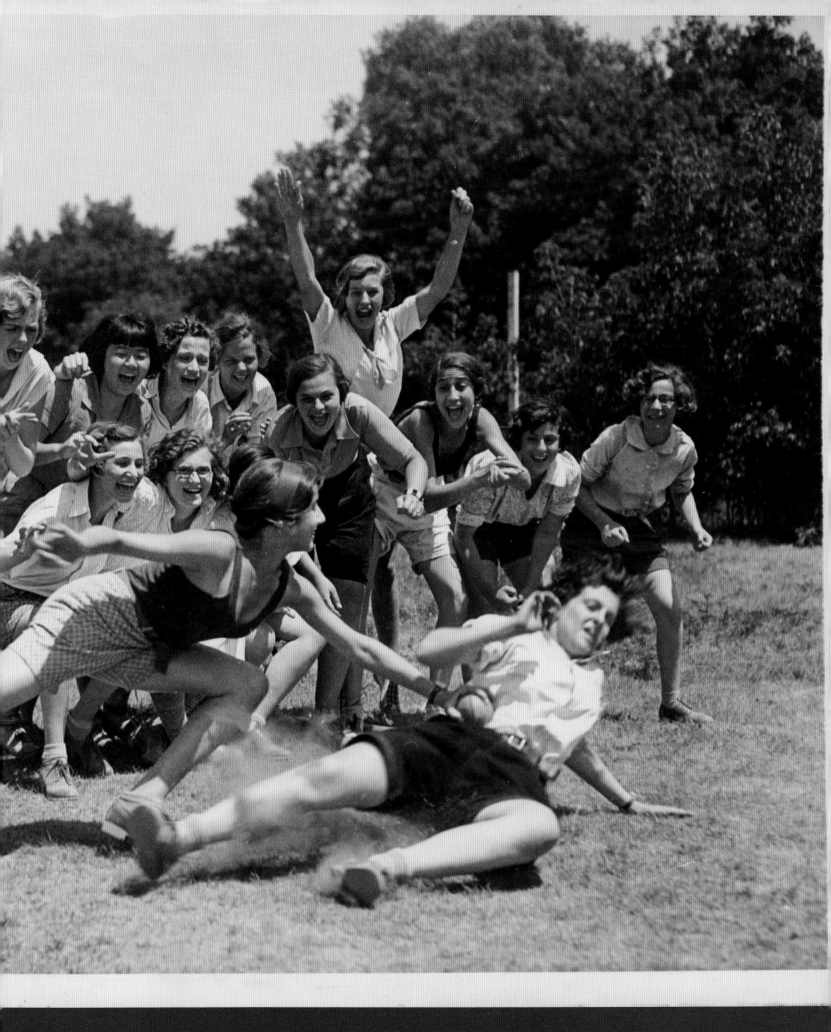

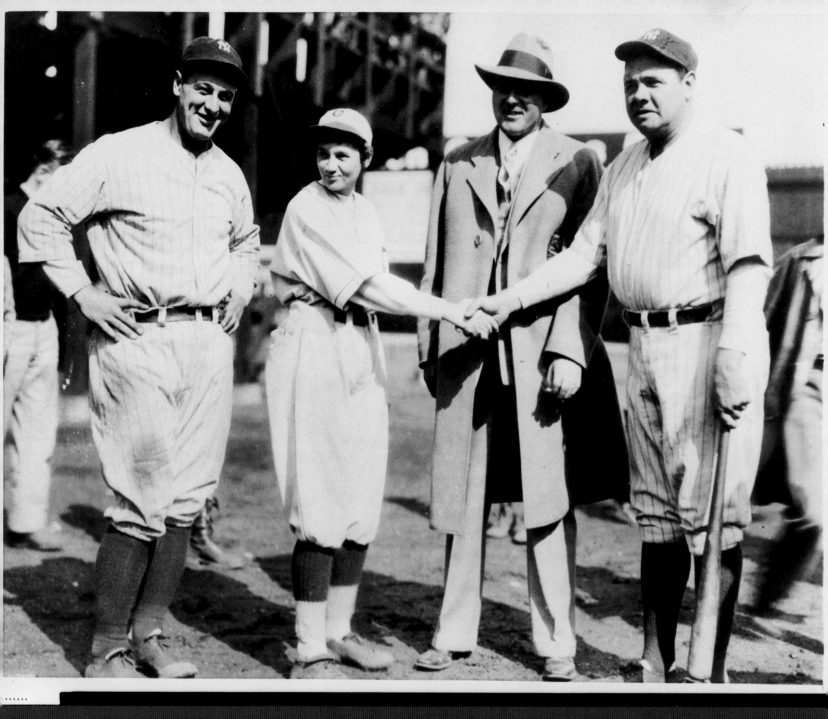

Lou Gehrig, Jackie Mitchell, Joe Engel, and Babe Ruth, April 2, 1931. Joe Engel, a former Major League pitcher, was the owner and president of the minor-league Class AA Chattanooga Lookouts; he was also a wildly creative promoter and a highly regarded scout, which is how Jackie Mitchell, a newly signed, seventeen-year-old wonder girl pitcher with a nasty curveball, came to strike out two of the game's greatest players. Following spring training, the New York Yankees arrived in Chattanooga for a scheduled exhibition game, drawing a crowd of four thousand. Of all people, the first batter the young rookie faced was none other than Babe Ruth. Mitchell got the Babe to whiff on two pitches, and he promptly tossed his bat aside after a called third strike. Gehrig, up next, swung and missed on all three pitches. Mitchell received a roaring ovation, but after walking Tony Lazzeri, the third batter, she was pulled from the game. Her minor-league career ended just days later when the evidently embarrassed commissioner of baseball, Kenesaw Mountain Landis, declared her contract invalid and barred women from the farm team system. However, Mitchell continued to pitch with barnstorming teams, including the House of David (see page 133), until retiring in 1937.

OPPOSITE: **Advertisement, Coca Cola Company, 1938.**

Delicious and Refreshing

THE PAUSE THAT REFRESHES

It's part of the game to take "time-out" for ice-cold Coca-Cola ... adding to relaxation what relaxation always needs, – pure, wholesome refreshment.

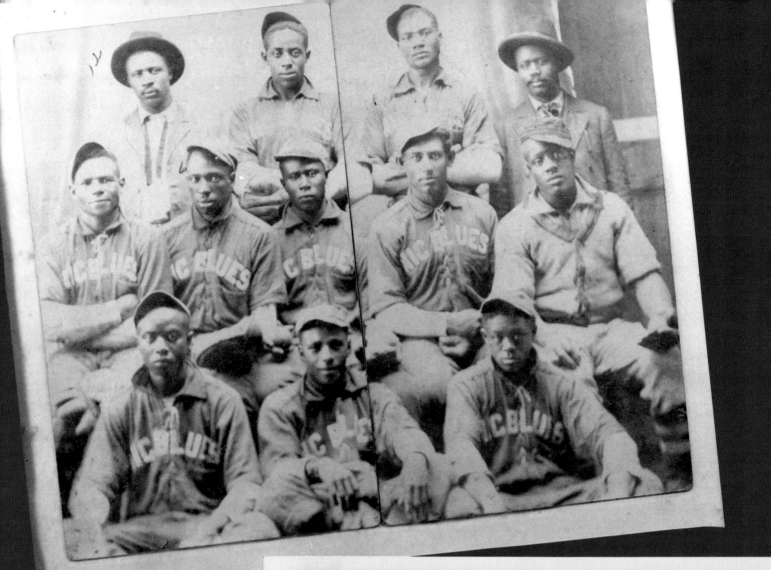

ABOVE: **The NicBlues, Nicodemus, Graham County, Kansas.** During the Great Depression, photographers working for the Historic American Buildings Survey, a New Deal program, documented the architectural features of noteworthy structures and districts in towns across the country. Nicodemus, in northwestern Kansas, was noteworthy as an all-black burg founded in 1877 by former slaves seeking a better life outside the South. National Park Service historians found old images of the local ball club and added them to their survey documentation.

Hitting one into the Generation Gap.
RIGHT: Mrs. Sydney Martin swings and misses as the ball sails over the plate toward catcher Polly Lewis in a mother-daughter game at Shady Hill Country Day School in the 1930s.
OPPOSITE: Orson Lowell captured the intensity of a father-son match for the June 1935 issue of *Boys' Life.*

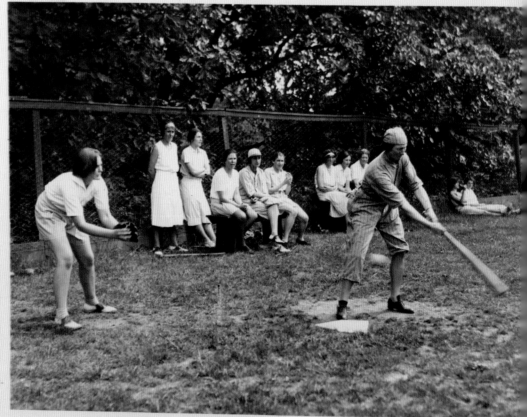

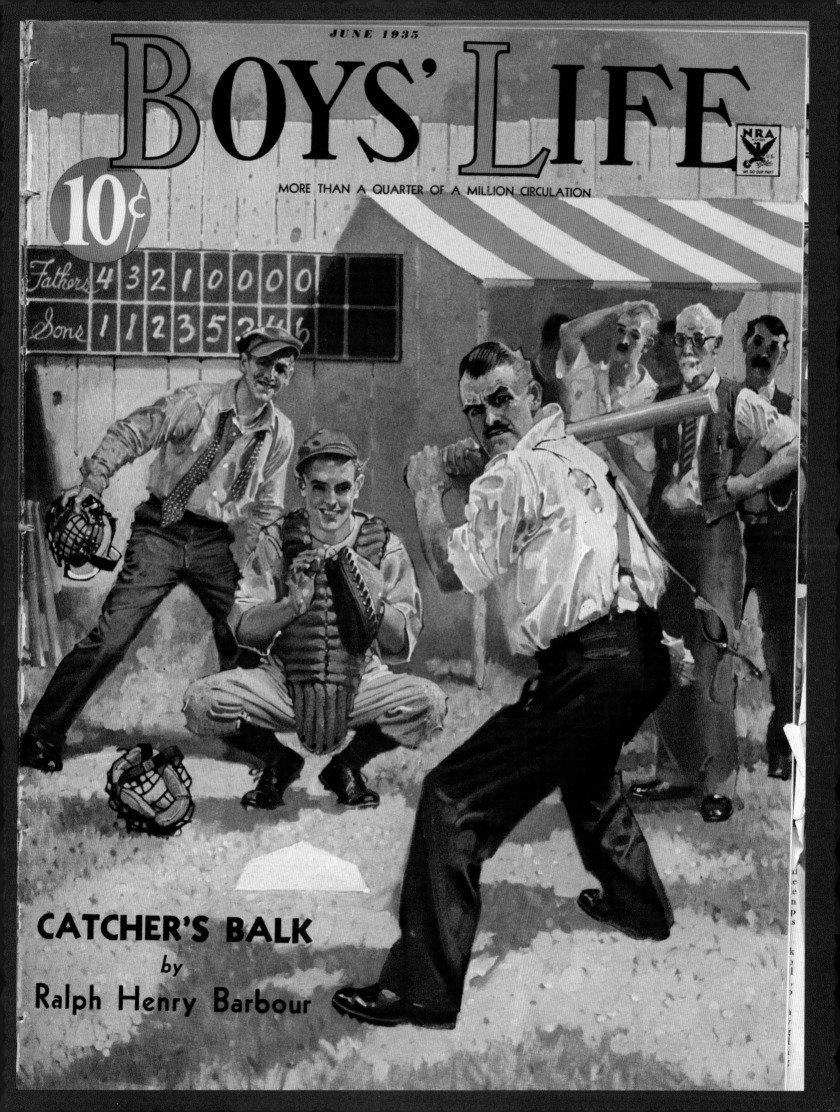

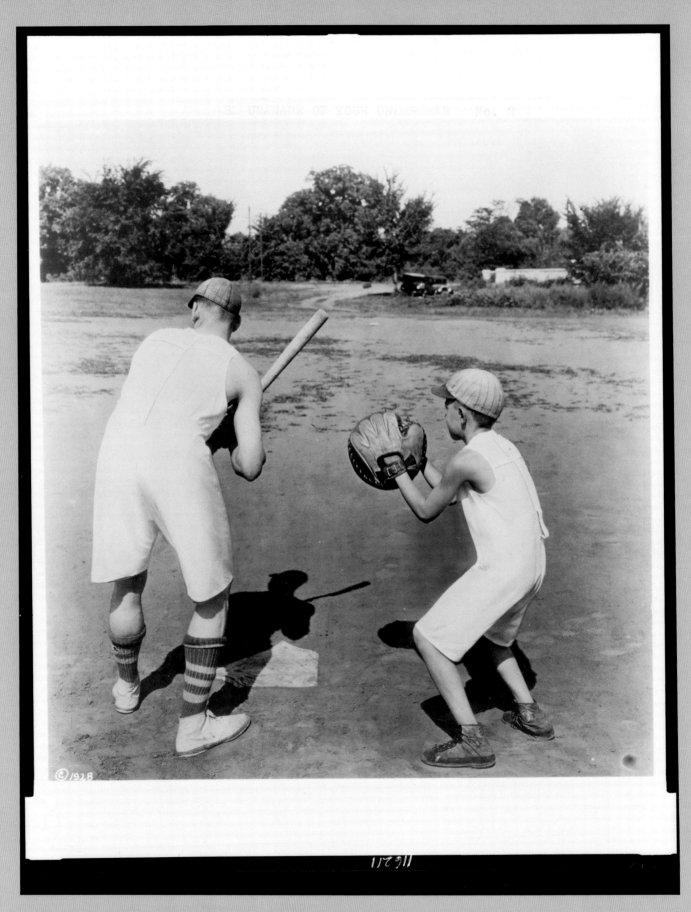

"Be unaware of your underwear," union suit underwear advertisement, 1928.

OPPOSITE: Wheaties cereal, magazine advertisement, 1938.

BASEBALL'S NEW DEAL: DEPRESSION AND WAR YEARS

★ ★ ★ ★ ★ ★ ★ ★ ★ ★ ★ ★ ★ ★ ★ ★ ★ ★

In an unprecedented and remarkable economic initiative during the Great Depression, the United States government hired photographers under the Resettlement Administration, the Office of War Information, and the Farm Security Administration to document living conditions and daily life throughout America. Such celebrated photographers as Gordon Parks, Dorothea Lange, and Walker Evans chronicled the lives of average citizens going about their activities in cities, towns, and rural areas in every region of the country. Recreation remained a much-needed respite from the hardship endured by so many, and FSA photographers found baseball wherever they went.

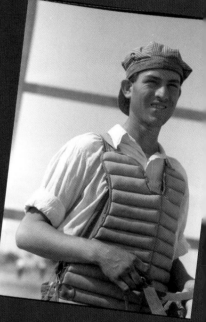

The Catcher, Agua Fria Migratory Labor Camp, Arizona, by Russell Lee, May 1940.

Farmer's game, off U.S. 62, northern Arkansas, by Dorothea Lange, August 1938.

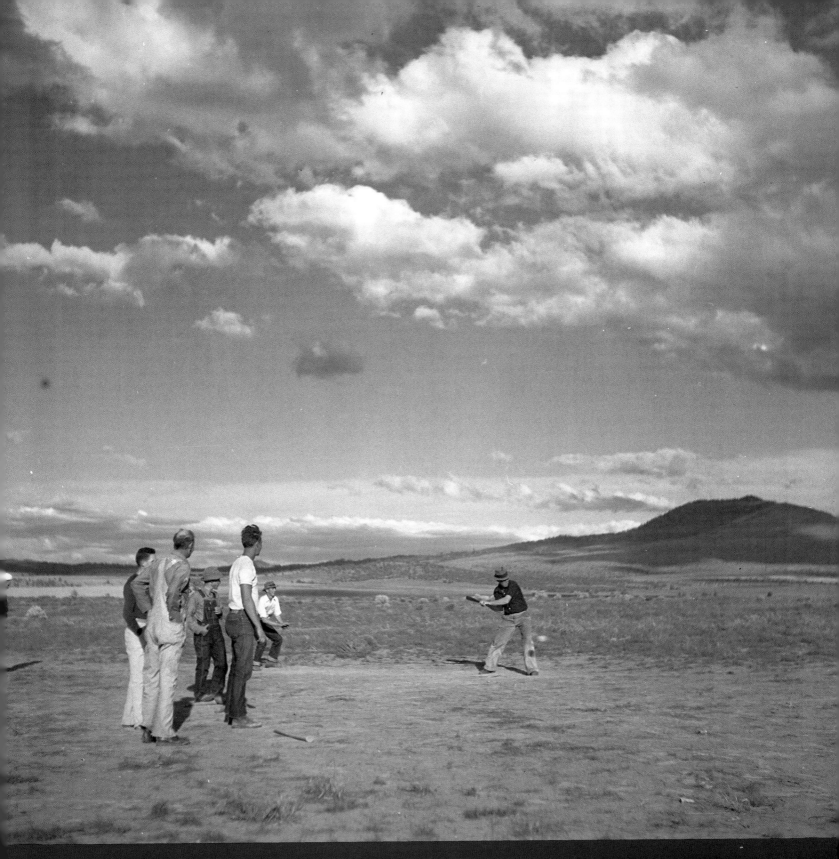

Resettlement Administration Rimrock Camp, near Madras, Oregon,
by Arthur Rothstein, July 1936.

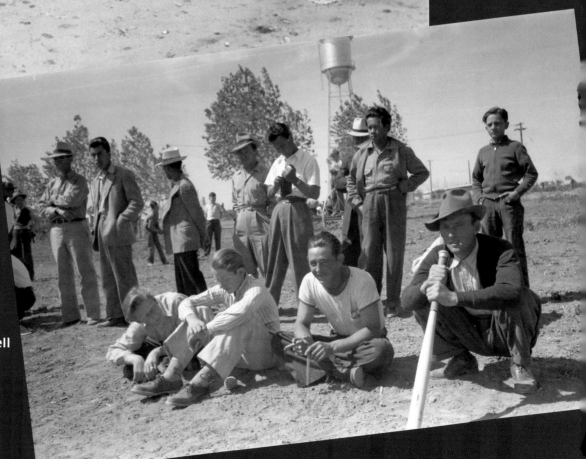

Cedar Grove team, near
Chapel Hill, North Carolina,
by Dorothea Lange,
July 4, 1939.

FSA camp, Yuma, Arizona, by Russell
Lee, March 1942.

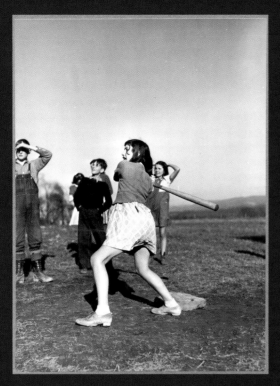

A homestead school game, Dailey, West Virginia, by Arthur Rothstein, December 1941.

Saturday morning ball game, FSA camp, Robstown, Texas, by Arthur Rothstein, January 1942.

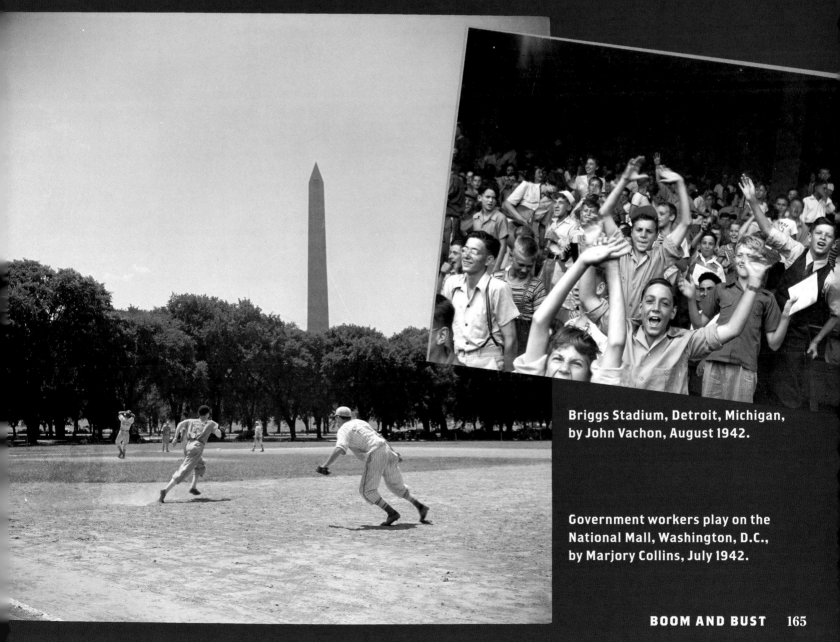

Briggs Stadium, Detroit, Michigan, by John Vachon, August 1942.

Government workers play on the National Mall, Washington, D.C., by Marjory Collins, July 1942.

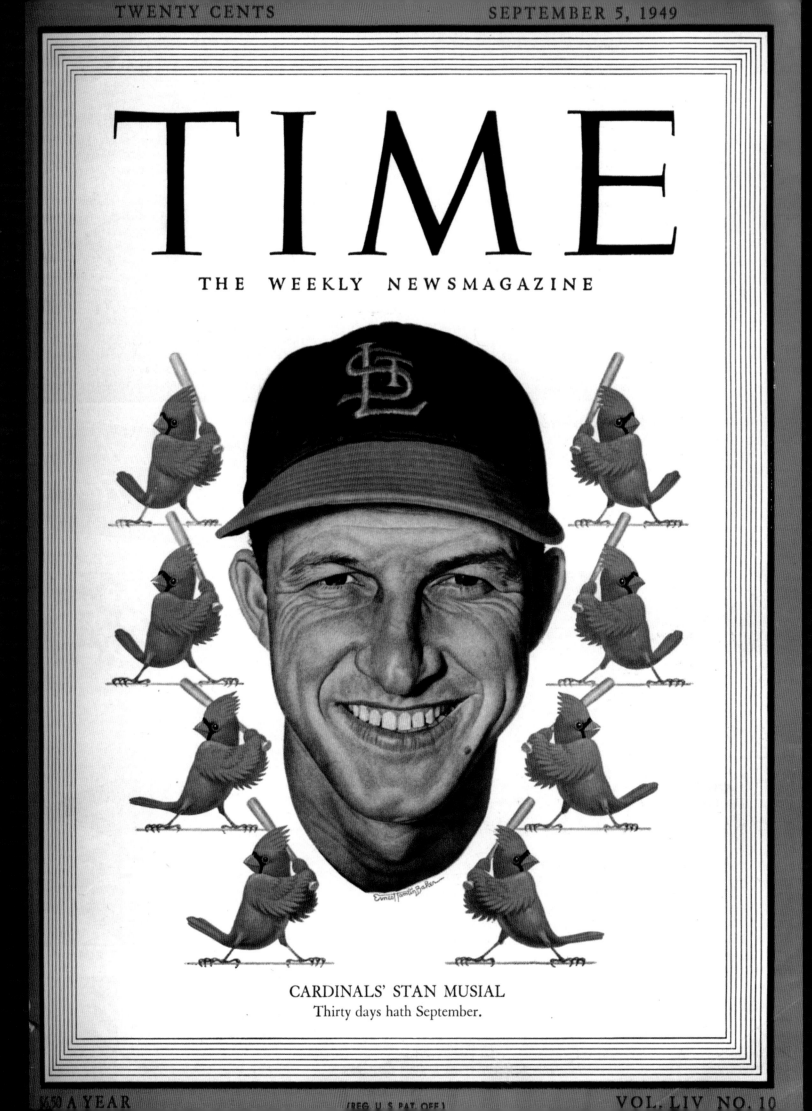

TWENTY CENTS

SEPTEMBER 5, 1949

TIME

THE WEEKLY NEWSMAGAZINE

CARDINALS' STAN MUSIAL
Thirty days hath September.

$6.50 A YEAR

(REG. U S PAT OFF)

VOL. LIV NO. 10

THE WAR YEARS USHER IN THE WONDER YEARS

(1940–1970)

As the nation was shocked into renewed economic vitality by the onset of World War II, baseball felt the tremors as well. The peacetime military draft had already taken stars such as Detroit's Hank Greenberg—who had nearly reached the magic mark of sixty home runs back in 1938—away from the sport before the country's official entry into the fray in 1941.

In 1942, President Roosevelt declared to Commissioner Landis that Major Leagues should play on, if only for the purpose of entertaining the home front: "I honestly feel it would be best for the country to keep baseball going. . . . There will be few people unemployed and everybody will work longer hours and harder than before. And that means that they ought to have a chance for recreation and for taking their minds off their work even more than before."

OPPOSITE: Stan Musial, first baseman and outfielder, St. Louis Cardinals, *Time* magazine, September 5, 1949.
The most popular player ever to wear a Cardinals uniform, Stan "the Man" Musial enjoyed an impressive career from 1941 through 1963, spending all twenty-two seasons with St. Louis. In that time, he knocked in at least 100 runs a year ten times and scored at least 100 runs eleven times, claimed seven National League batting crowns, won two World Series championships, and made the cover of *Time* magazine.

Harry "the Horse" Danning, catcher, New York Giants, Play Ball baseball card, Gum, Inc., 1941.

RIGHT: **Ted Williams, left fielder, Boston Red Sox, contact sheet images by Bob Sandberg, 1955.** Ted Williams kept fans riveted during the historic 1941 season as his batting average hovered around the magic .400 mark. He entered the last day of play hitting .399, but smacked six hits during a double-header at Cleveland to raise his average to a remarkable .406. Two wars and fourteen years later—he served as a Marine Corps flight instructor and combat pilot—Williams was still at it, hitting .356 at age thirty-seven, when these pictures of his famous "perfect" swing were taken.

OPPOSITE: *The Saturday Evening Post*, cover illustration by Douglass Crockwell, August 20, 1940.

Still, an estimated 60 percent of Major League players were out of the game and involved in some aspect of the war effort by 1944.

Despite the thinning of Major League rosters, baseball was still played everywhere, both at home and abroad. Perhaps it was the dearth of players at the Major League level that opened doors for others as the war raged on. The All-American Girls Professional Baseball League, the brainchild of Chicago Cubs owner Philip Wrigley in 1943, was conceived as a way to provide baseball entertainment on the home front. Besides, close to fifty thousand young women played organized or semipro softball in rural America during the early 1940s, so there was a ready pool to feed into a ready market. The war years also represented the peak of the Negro Leagues, which was inevitably drained of its talent after Jackie Robinson broke the Major League's color barrier in 1947. The Negro Leagues' annual East-West All-Star Games drew thousands of fans to Major League ballparks such as Comiskey Park in Chicago and Griffith Stadium in Washington, D.C. Washington's own Homestead Grays, who won an astounding ten Negro National League championships with stars Josh Gibson and Buck Leonard, frequently outdrew their Major League counterparts, the Washington Senators, between 1938 and 1947.

The spirit of the war and postwar years was epitomized by two players who began their careers at the end of the 1930s. Both Joe DiMaggio, the son of an Italian fisherman, and Ted Williams, whose Mexican-American mother worked at the Salvation Army, came from modest California roots to become two of the greatest hitters in the history of the game. During the historic 1941 season, DiMaggio and Williams accomplished astonishing batting feats—DiMaggio hit successfully in fifty-six consecutive games, and Williams finished the year with a .406 batting average. Their contrasting personalities seemed to embody the time period in different ways: DiMaggio, the cool, graceful husband of movie stars, and Williams, the boisterous, gangly workaholic. They played for the American League's most popular clubs, DiMaggio for the dominant New York Yankees and Williams for their archrivals, the Boston Red Sox. The competition they began gave lifeblood to an intense rivalry that remains undiminished.

THE SATURDAY EVENING POST

An ~~~~ kly
Founded ~~~~ Franklin

August 10, 1940

5c. the Copy

VOLUME 213, NUMBER 6

7c. in Canada
(INCLUDING TAX)

BEGINNING A BASEBALL SERIAL By HOLMES ALEXANDER

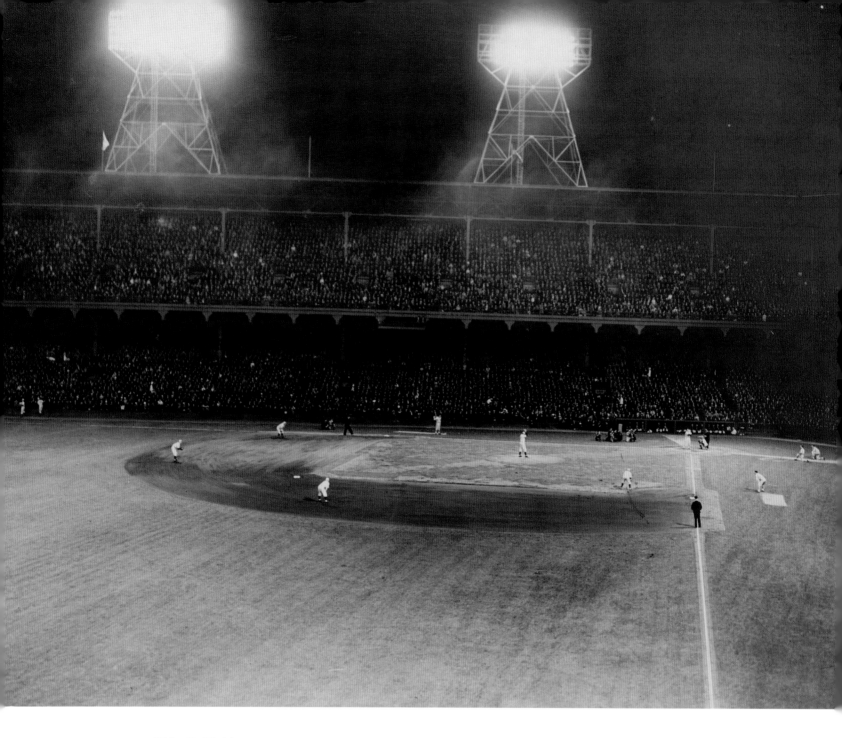

ABOVE AND OPPOSITE: **Ebbet's Field, New York, International News/UPI, ca. 1940; Cleveland Municipal Stadium, by Carl McDow, June 30, 1950.** In 1935, the Cincinnati Reds were the first Major League team play to home games at night, and three years later the Brooklyn Dodgers lit Ebbets Field. By the 1950s, yearly attendance at night games exceeded day-game attendance in most Major League cities.

The end of World War II in 1945 brought an unprecedented age of prosperity to the country. The manufacturing base that had grown up overnight to support the war effort now shifted toward the consumer economy, the GI Bill enabled veterans to attend college and buy homes, and black servicemen returned home with renewed vigor to confront segregation. These were just some of the many profound postwar changes at economic, social, and political levels, and baseball was affected as well.

A multiple-sport star at UCLA in the late 1930s, Jackie Robinson had been court-martialed during the war for refusing to move to the back of a segregated bus. In 1945, he was playing for the Negro League Kansas City Monarchs. Branch Rickey, then president of the Brooklyn Dodgers, was looking for a black player to break the Major League's color line, and not just for unselfish reasons—he wanted both to better his team and appeal to the large black fan base in the New

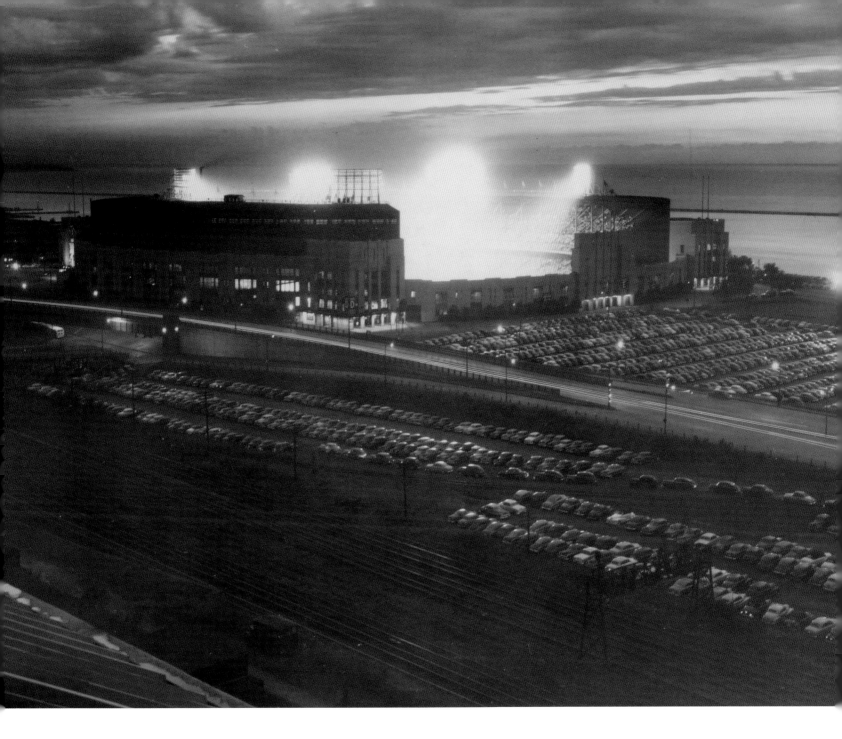

York area. By scouts' estimates, Robinson was not the best player in the Negro Leagues, but his maturity and toughness impressed Rickey and would be crucial to overcoming without incident the offensive and overt racism he would surely encounter. After spending a year playing for a Dodgers farm team in Montreal, Robinson entered Brooklyn's lineup on April 15, 1947. Baseball was integrated more than a year before President Harry Truman issued an executive order that began desegregating the U.S. military, seven years before the pivotal *Brown v. Board of Education* Supreme Court decision, and seventeen years before the major civil rights legislation of 1964. As shameful as baseball's color barrier had been, its abolition paved the way for integration elsewhere.

The introduction of Robinson encouraged and coincided with an increasing number of new stars on the baseball diamond. During the 1950s, the game became faster and seemed more energetic. Mickey Mantle, the multitalented star

It Happened in Flatbush,
lobby poster, 20th Century-
Fox, 1942.

from Oklahoma, wowed New York playing for the Yankees, while shy Willie Mays, from Westfield, Alabama, led the crosstown Giants with his spectacular play in center field. The trickle of black players entering the Major Leagues turned into a flood, with Larry Doby, Monte Irvin, Ernie Banks, Don Newcomb, and Hank Aaron earning fame. After 1948, the Negro Leagues felt the loss of talent and fan attention; and by the early 1960s, there were only a handful of black teams still playing. Although Cuban ballplayers had been playing in the Majors for decades, the flow of Latin American players increased dramatically. Turning the spigot was the Washington Senators' gifted scout, Joe Cambria (known as "Papa Joe"), an Italian native and a minor-league team owner who had specialized in identifying talent south of the border for decades. His frequent trips to the Caribbean, especially Cuba, where some Major Leaguers would play winter ball, led to hundreds of Hispanic players signing American contracts. Other teams would follow Papa Joe's lead, though none as successfully. By the time Cambria died in 1962,

Three not-so-little Indians: Lou Boudreau, shortstop/manager; Larry Doby, center fielder; and Hank Greenberg, farm team director, 1948.
Larry Doby and Hank Greenberg had each broken further bits of Major League ground when they arrived in Cleveland, where Lou Boudreau was a long-established star (all three would make it to the Hall of Fame). Doby became the American League's first black player in July 1947, when he crossed the color barrier that Jackie Robinson had brought down in April. Meanwhile, Greenberg had blazed a similar though less-harrowing trail in becoming one of the game's first big Jewish stars during his stellar career with the Detroit Tigers.

two generations of Latin American players had grown up influenced by media coverage of the U.S. game and knowing Papa Joe. In 1965, the Minnesota Twins' Zoilo Versalles, from Cuba, was the first foreign-born player to win the American League MVP Award; the Pittsburgh Pirates' Roberto Clemente, from Puerto Rico, won the National League MVP Award the following season; and others, such as Juan Marichal, Orlando Cepeda, and Tony Oliva, also gained prominence on the field. For the first time in its history, the diversity of baseball began to resemble the diversity of the country at large.

Complementing baseball's revolution on the field was a revolution in the way the game was disseminated. Baseball owners had tentatively broached the radio and television markets in the years leading up to World War II, but in the 1950s, the sport enjoyed even greater coverage. Every regular-season game was related over the radio airwaves, and the All-Star Game, the World Series, and Saturday and Sunday afternoon

Union Laguna team, Mexico City, Acme photograph, April 11, 1946. By the end of World War II, America's game had spread rapidly to all corners of the world, especially south of the border. Like American fans, Mexican spectators could be especially boisterous. Barbed wire separates the Union Laguna players of the Mexican League from the crowd to protect them from expressive, object-hurling fans.

baseball became staples of network television. Baseball broadcasters such as Dizzy Dean and Mel Allen were a new kind of celebrity, introducing the game to millions of fans in the Midwest and on the West Coast who had never seen a Major League game before. Topps Chewing Gum Company issued its first baseball card set in 1951, kicking off a third wave of baseball card production, and glossy periodicals such as *Sport* magazine and *Sports Illustrated* proliferated. For all this, a visual record emerged that was unique to the game's history up to that point. Baseball's most memorable moments from the period have corresponding images: Bobby Thomson's home run ("the shot heard 'round the world") that sent the New York Giants to the 1951 World Series; Willie Mays's amazing snag of a Vic Wertz ball hit deep into the outfield during the 1954 series; the celebration of Don Larsen's perfect game in the 1956 World Series; and Roger Maris's chase of Babe Ruth's single-season home-run record in 1961.

Although baseball's prevalence had long covered the entire American landscape, the locations of the sixteen Major League ball clubs remained unchanged

Gwen Verdon, publicity shot for *Damn Yankees*, **by Ormond Gigli, 1955.** Broadway went baseball mad when Gwen Verdon starred in the hit musical *Damn Yankees*, and the original production ran for two years and 1,019 performances. It also won six Tonys, including Best Musical and one for Verdon as Best Actress. Based on Douglas Wallop's novel *The Year the Yankees Lost the Pennant*, the show told the tale of Joe Boyd, longtime fan of the hapless Washington Senators, who agrees to give his soul to the devil in exchange for becoming the team's new star player. Verdon played Lola, Satan's sassy, seductive associate who tries to ensnare the virtuous Boyd. The image shown here is an outtake from a photo shoot Verdon did for *Sports Illustrated* to promote the show in its rookie season.

between the years 1903 and 1952; for huge portions of the populace, there was not a team to cheer for within hundreds of miles. The geography of big-league baseball shifted dramatically in the 1950s and 1960s, though, as expansion and franchise moves took Major League clubs to neglected fans in states such as Texas, Minnesota, Washington, and California. The long-suffering Boston Braves franchise was the first team to relocate, and in 1953, the team, newly settled in Milwaukee, Wisconsin, set a Major League attendance record and proved what a boon a change in address could be for business. The Philadelphia Athletics and St. Louis Browns followed suit, moving to Kansas City, Missouri, and Baltimore, Maryland, respectively; but it was not until 1957, when both the Brooklyn Dodgers and the New York Giants simultaneously announced their flight to the shores of sunny Los Angeles and windswept San Francisco, respectively, that baseball's early New York–dominated era drew to a close. Fans all over the Big Apple bemoaned their teams' departures and flung all sorts of enraged epithets at the owners behind the deal, the Dodgers' Walter O'Malley and the Giants' Horace Stoneham. In the end, the decision to move proved to be in the best financial interests of the teams, and the wounds of New York fans were partially assuaged by the birth of the Mets in 1962.

Since baseball's inception, it had naturally and steadily evolved. It began as a game, it became an organized sport, and, after 1869, when the Cincinnati Red

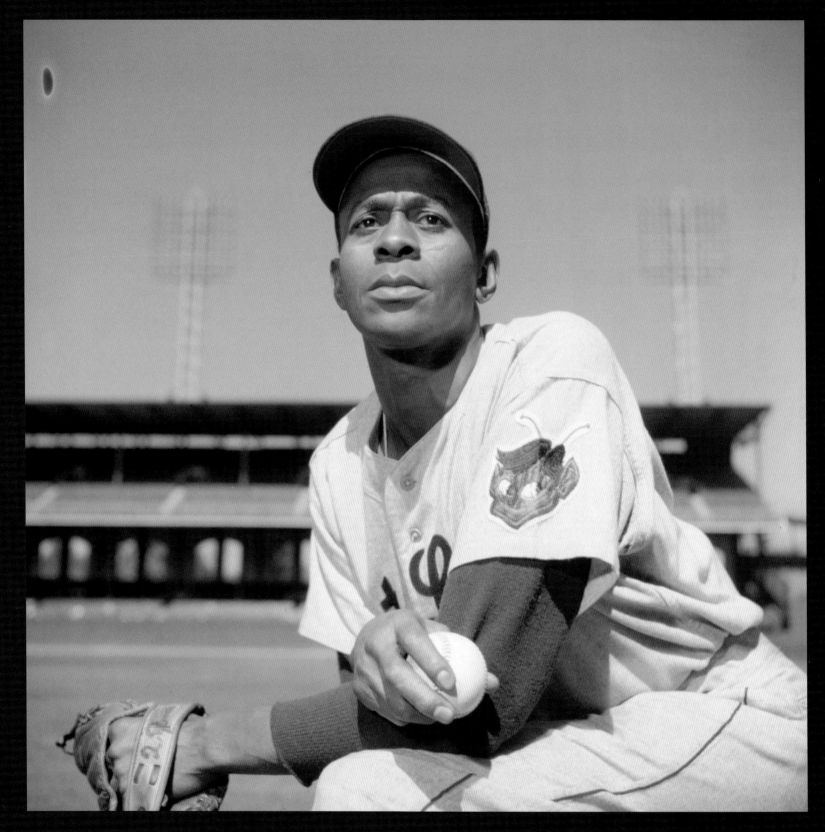

Satchel Paige, pitcher, Cleveland Indians, by Bob Lerner, 1952. Once the color barrier fell, older Negro League heroes, such as superstar Satchel Paige, also had success in the Major Leagues. Paige, whose age was always a bit of a secret, was likely over forty years old when he joined the Cleveland Indians in 1948. He held his own by notching six victories against a single defeat as the Tribe went on to win the World Series that year.

OPPOSITE: **"Pitchin' Paige,"** featuring Satchel Paige, from *True Sports Stories*, 1949.

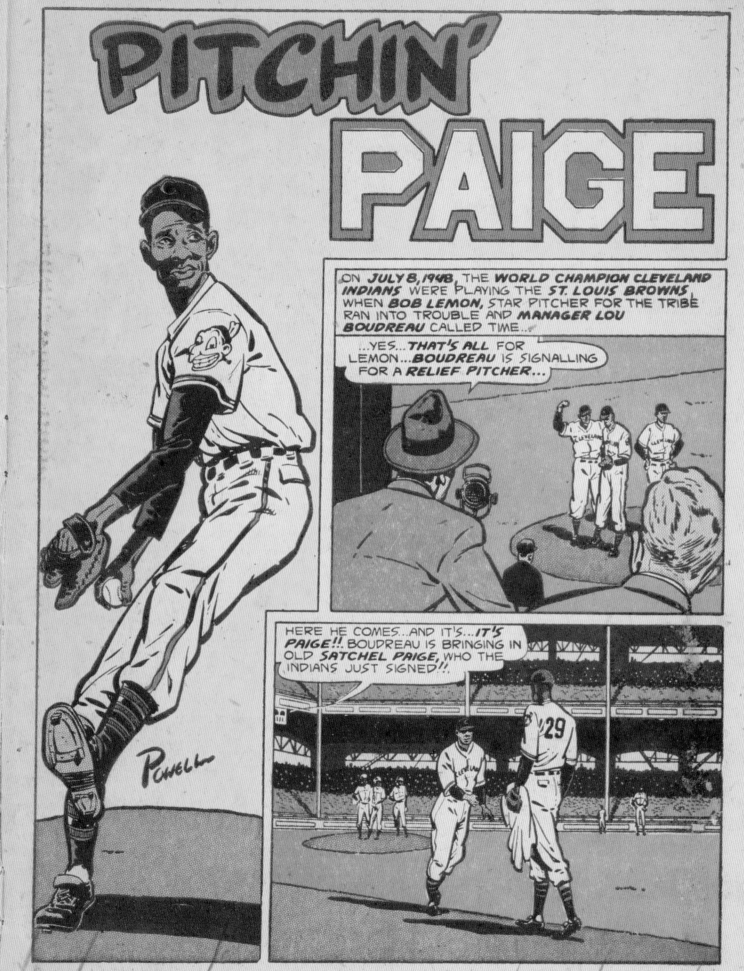

TRUE SPORT PICTURE STORIES is published bi-monthly by Street & Smith Publications, Inc., 775 Lidgerwood Ave., Elizabeth, New Jersey. Re-entered as Second-class Matter September 27, 1948, at the Post Office at Elizabeth, New Jersey, under the Act of March 3, 1879. Copyright, 1949, in U.S.A. and Great Britain by Street & Smith Publications, Inc. Vol. 5, No. 1, May-June, 1949. Allen L. Grammer, Chairman of the Board; Gerald H. Smith, President; Henry W. Ralston, Vice President and Secretary; Thomas H. Kaiser, Treasurer. General and Executive offices at 122 East 42nd Street, New York 17, New York. Single copy 10 cents. $1.00 for 12-issue subscription in the U.S.A.; in Pan-American Union, $1.25 for 12 issues; elsewhere $1.50 for 12 issues. All correspondence in reference to subscriptions and all money for subscriptions should be addressed to STREET & SMITH PUBLICATIONS, INC., PO Box 494, Elizabeth, N.J. We cannot accept responsibility for unsolicited manuscripts or artwork. Any material submitted must include return postage. The editorial contents of this magazine are protected by copyright and cannot be reprinted without the publishers' permission. All fictional characters mentioned in this magazine are fictitious. Any similarity in name or character to any real person is coincidental.

Printed in U.S.A.

WORLD SERIES, U. S. A., by John Falter

World Series U.S.A., photomechanical print, by John Falter, ca. 1950.
In the 1950s, the print media found themselves vying for the public's attention with a rapidly spreading form of visual communication—television. Popular announcers such as Red Barber, Mel Allen, and Vin Scully brought the game into one's own living room, a boon to fans who could not otherwise see a Major League game. And as John Falter's illustration demonstrated, beer and hot dogs belonged on the menu whether watching a game on TV or at the stadium.

Stockings were the first professional team, baseball was also indubitably and irretrievably a business. A century later, the game and the business were on the verge of yet another era.

In 1969, changes to the Major League game included lowering the pitcher's mound and reducing the strike zone to help batters generate more offense; the early 1970s saw a growing reliance on extensive relief pitching and, in the American League, lengthier games, the use of a designated hitter, and further adjustments to the strike zone resulting from a gradual transition from umpires' oversize exterior "pillow" pads to National League–style inside-the-shirt chest protectors. Fundamental business changes included the addition of six new teams and subsequent demand for more talent; the first of many player strikes and work stoppages (beginning in 1972); and the advent of free agency, in which a player, after a few years of service, was permitted to sign with another team.

Expansion had proceeded at a rather modest pace since 1953 but rapidly increased as four new teams organized in 1969: the Kansas City Royals, the Seattle Pilots (which soon became the Milwaukee Brewers), the Montreal Expos (the first Major League franchise in Canada), and the San Diego Padres. The Seattle Mariners and the Toronto Blue Jays, added in 1977, capped the burst of expansion, and no more teams were added for another sixteen years.

A crucial agreement in 1970 opened the floodgates when long-simmering conflict between owners and players—over issues that dated back to the turn of the twentieth century—boiled over. Team owners, apparently neither appreciating nor comprehending the gift they were giving the players, agreed to submit to independent arbitration when disputes arose between management and labor that were not related to "the integrity of the game." The same year, veteran outfielder Curt Flood, objecting to his being traded from St. Louis to Philadelphia, challenged the reserve clause and sued Major League Baseball for the right to become a free agent. The matter eventually reached the U.S. Supreme Court, which ruled against Flood; but by 1975, when independent arbitration in cases

Horsehide Theater, ink-and-blue pencil over graphite under drawing, cartoon by Johnny Walbridge, June 26, 1951.

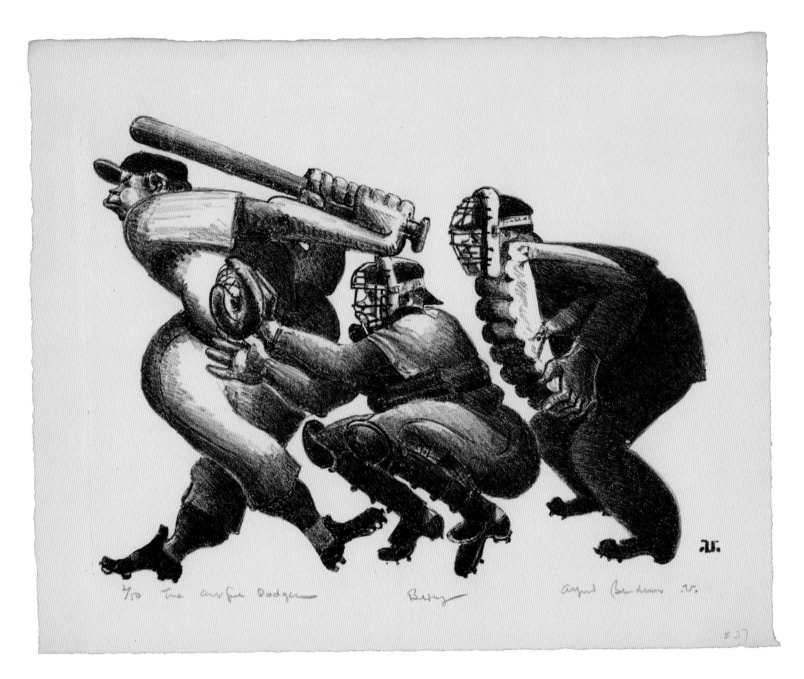

The Artful Dodger, by Alfred Bendiner, 1953.

involving pitchers Catfish Hunter, Andy Messersmith, and Dave McNally were decided in favor of the players, the reserve clause was dead. As a result, over time, fewer players spent their careers with the same team, and all saw their salaries skyrocket.

For the fans, the 1970s also brought about significant changes. To increase television viewership, Game 4 of the 1971 World Series between the Baltimore Orioles and the Pittsburgh Pirates was a night-game broadcast live from Three Rivers Stadium. The dramatic ratings boost prompted Major League Baseball to schedule more play-off and championship games at night. Within a few years, the introduction of cable television allowed subscribers to see many more games than the major networks provided and to watch teams from outside their region.

Meanwhile, entrepreneurs were recognizing monetary value in items that traditionally held mostly sentimental value. On any given weekend somewhere in the country, sport conventions catered to dealers, collectors, and regular fans,

and in 1977, the periodical *Sports Collectors Digest* hit the marketplace. Collectibles became commodities—and with substantial financial worth. Baseball cards were no longer simply traded; they were sold, resold, and auctioned at ever-higher prices. Cards, once bound by rubber bands and stored in shoeboxes or stuck between the spokes of a bicycle wheel to produce a nifty sound effect, were more often placed neatly in protective albums, displayed in specially designed stands, laminated, or encased in plastic slabs. Other items gained in value as well, such as autographs, home-run balls, jerseys, and bats. At the same time, lawsuits were filed over trading card company monopolies, and the Major League Baseball Players Association accelerated its own marketing and licensing deals.

Outside the Major Leagues, there was also major change afoot. As a result of Title IX, a 1972 federal statute barring sex discrimination in public schools, girls' and women's participation in softball (and other sports) soared, as did the number of high school and college teams. In 1974, the Little League permitted girls to play on teams. Many cities boasted amateur organized baseball leagues, and by the end of the decade, 20 million Americans were playing organized softball and another 10 million played casual backyard and barbecue ball.

Thus, by 1970, another of baseball's many eras was coming to a close; what made the game's future different this time around was the rapid pace with which major changes would occur. It is not surprising, though, that baseball, which has contributed more terminology, catchphrases, and sayings to American English than any other sport, should also produce a colloquialism in the 1960s that aptly described what lay ahead— "It's a whole new ball game."

Topps baseball card, 1966.

RIGHT AND BELOW: *The Winning Team*, starring Doris Day and Ronald Reagan, lobby cards, Warner Bros., 1952.

772-39

Sports Illustrated

JULY 13, 1970 60 CENTS

CINCINNATI'S BIG RED MACHINE

All-Star Catcher
Johnny Bench

Johnny Bench, catcher, Cincinnati Reds, *Sports Illustrated*, photograph by James Drake, June 13, 1970.

BULLETS AND BOMBS, BATS AND BALLS

BASEBALL IN WORLD WAR II

★ ★ ★ ★ ★ ★ ★ ★ ★ ★ ★ ★ ★ ★ ★ ★

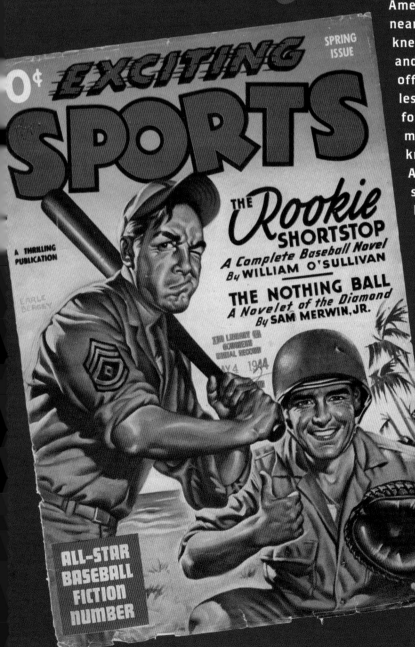

Exciting Sports, A Thrilling Publication, Spring 1944.

American soldiers manning checkpoints near the front lines in the European theater knew to be on the lookout for German spies and saboteurs trying to pass themselves off as their countrymen. With their flawless English, American uniforms, and forged identification cards, more Germans might have succeeded if they had known who won the 1939 World Series. As far as the GIs were concerned, anyone seeking to pass but unable to answer basic baseball trivia questions inevitably gave themselves away—they could not possibly be real Americans.

When Americans went to war overseas, baseball went, too.

To keep up morale, especially after surveys showed that three-quarters of the armed forces preferred baseball to football, military brass paid special attention to the game, approving resources for field construction, especially in the Pacific theater, sending out teams stocked with Major Leaguers to play exhibition games for the troops,

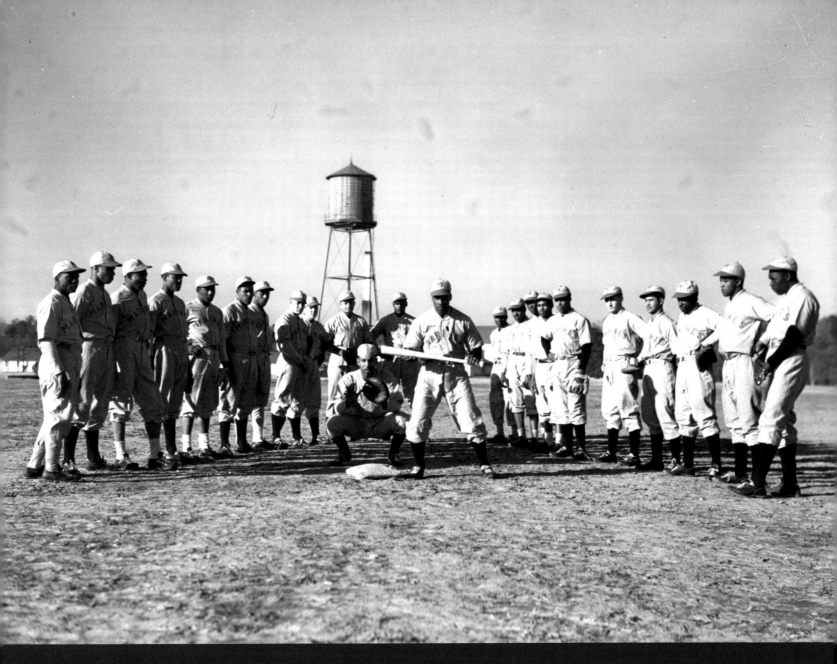

Integrated U.S. Marine Corps baseball team, Montford Point, Camp Lejeune, North Carolina, by Roger Smith, Office of War Information, March 1943. The U.S. Marine Corps began enlisting black volunteers on June 1, 1942, and the first class trained at Camp Lejeune's Montford Point. The camp's sports program and its baseball league were especially helpful in easing racial tensions, as black enlistees and white noncommissioned officers played on the same teams.

providing equipment and gear, and sponsoring several major events. Two were especially notable, the first being an elaborate 1944 Army-Navy matchup in Honolulu called the Servicemen's World Series. The other was the European Theater of Operations World Series, held shortly after the German surrender in 1945 and played in Nuremberg, where imprisoned Nazi leaders were about to go on trial for war crimes.

Americans played their national game wherever they could, even in POW camps. In Germany, when American servicemen began turning up in large numbers in 1943 and 1944, softball and baseball became part of the stalag routine. Prisoners crafted bats from old bedposts, and made balls from boot heels, shoe soles, and socks. Red Cross supplies included baseball

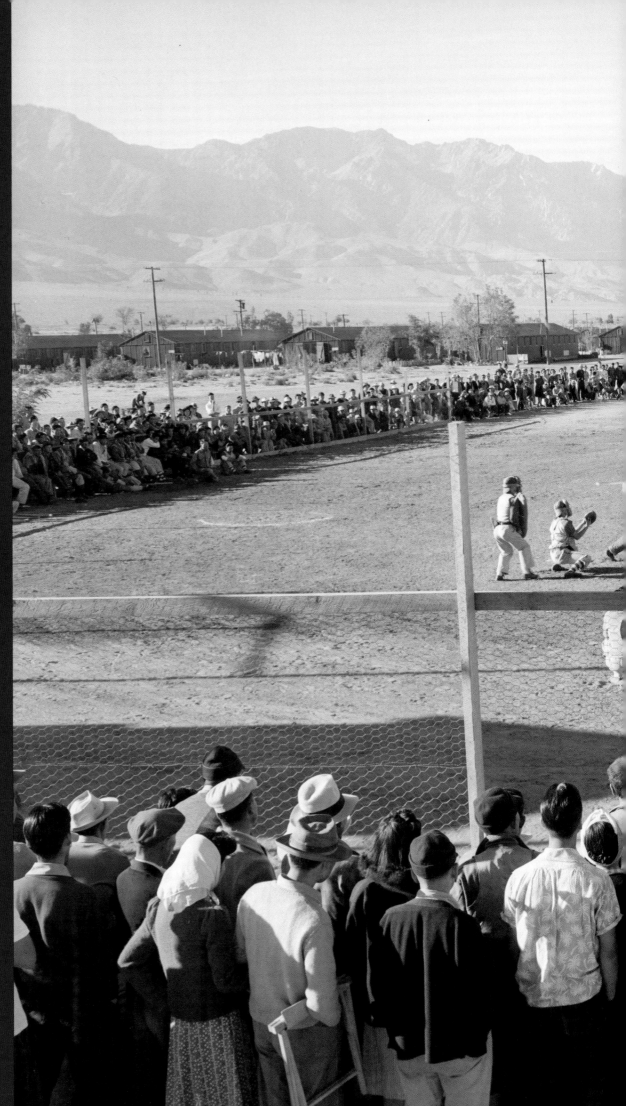

Manzanar Relocation Center, Manzanar, California, by Ansel Adams, 1943. Adams, who would soon become celebrated for his photographic odes to the American West, produced an astonishing portfolio documenting the experience of Japanese-Americans interned at the Manzanar Relocation Center in Inyo County, California. He depicted them not as internal enemy combatants but as fellow citizens, playing baseball and attending classes while caught up in national fearmongering and hemmed in by barbed wire and the same mountainous landscape that for Adams served as a metaphor for America's pristine majesty. Adams published his photographs in a 1944 book entitled *Born Free and Equal: The Story of Loyal Japanese-Americans*. He donated his original Manzanar negatives and a set of prints to the Library of Congress in 1965.

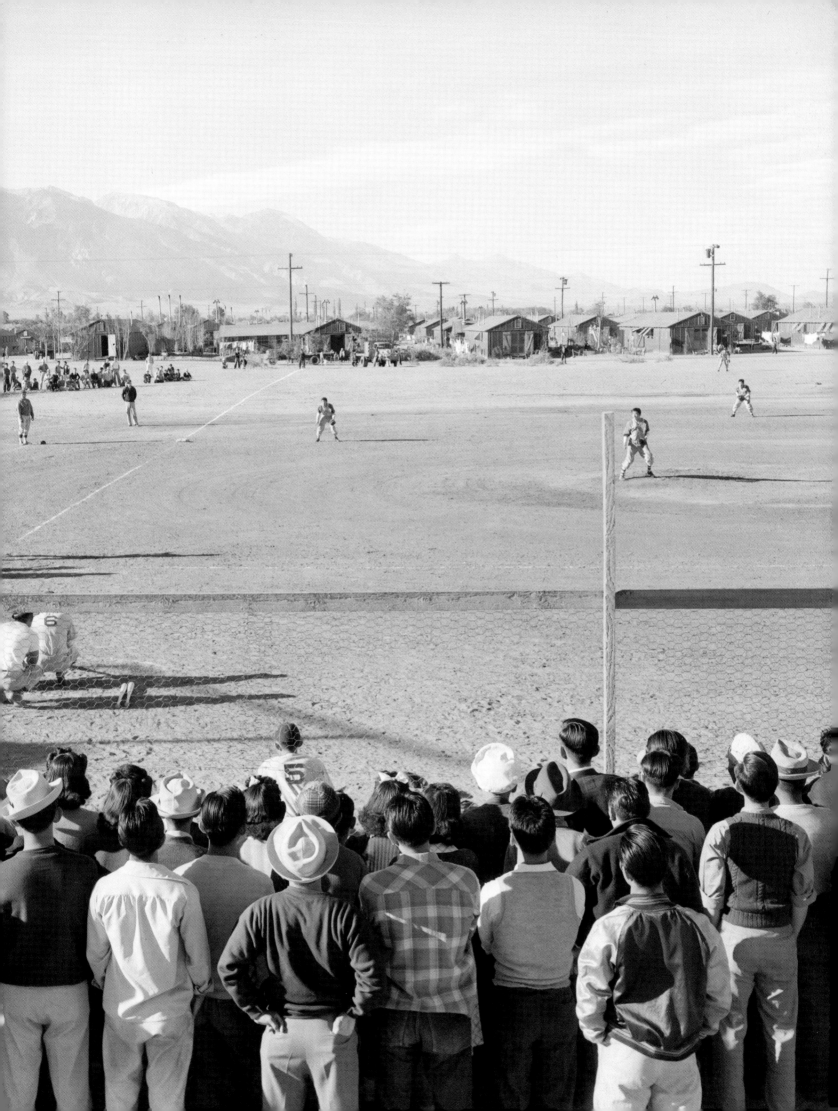

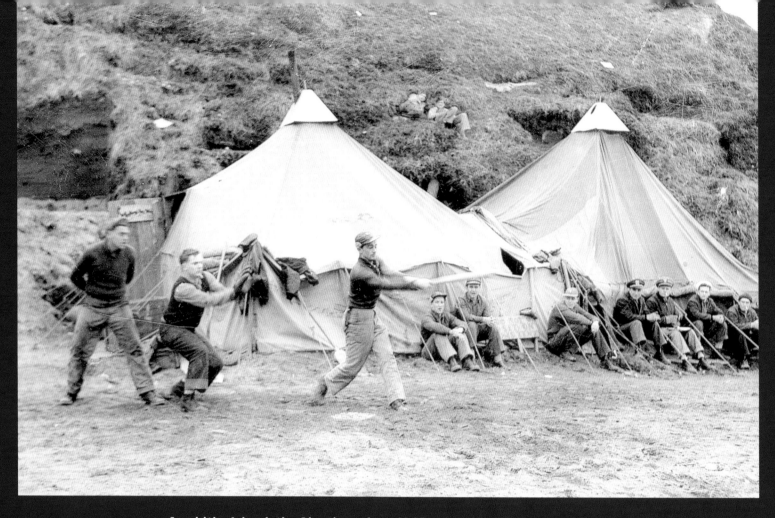

Amchitka Island, the Aleutians, June 1943. Emil A. Mrizek takes a cut during a game among Army Air Forces servicemen while a pair of spectators has nestled into a comfortable hillside nook for an elevated view.

equipment, and customized balls containing tiny radios manufactured in the United States were delivered past unsuspecting mailroom guards. By 1944, some five thousand Americans were held in Stalag Luft I near Barth, Germany, more than enough to support two leagues. One of those Americans was Army Air Forces colonel C. Ross Greening, who flew in the 1942 Doolittle Raid over Japan and was shot down over Naples, Italy, in 1943. Barbed-wire fences, watchtowers, and armed guards surrounded the tight area used for play, prompting the GIs to make "arrangements with the guards whereby a man carrying a flag could go out and retrieve balls knocked over the fence," said Greening. "As long as he was carrying the flag the guards wouldn't shoot him."

While most Germans were ambivalent toward the sport, the Japanese were not. One American POW told of laboring in a camp kitchen while guards outside played ball; at one point, he managed to give himself an extended break by showing them how to throw a curveball before being ordered back to work. On several American-held Pacific islands, U.S. servicemen reported

Game 2, all–St. Louis World Series, Sportsman's Park, St. Louis, Acme photograph, 1944. With Cardinal catcher Walker Cooper behind the plate, the Browns' Don Gutteridge strikes out in dramatic fashion.

that Japanese soldiers who had successfully gone into hiding were caught sitting in crowds watching a game—sometimes they were even disguised in American military uniforms, the lure of the sport being too much to resist. One witness to such an event was outfielder Enos Slaughter, a star of the St. Louis Cardinals. A year later, he was back home playing in the 1946 World Series.

Servicemen followed Major League and service-league results in the military newspaper *Stars and Stripes*, which featured a robust sports section, and regularly placed bets on their unit's squad. Radio operators kept buddies informed of scores, and those stationed on remote islands in the Pacific could often pick up U.S. rebroadcasts of games from the West Coast. There were even cases of Americans held in Japanese POW camps—which were notoriously brutal and inhumane— managing to hear games on radios they had surreptitiously pieced together. Once the Allies were victorious in the Pacific and Asia, U.S. military authorities strongly encouraged occupational forces to engage in baseball with civilians. The hope was that baseball would ease tensions during the occupation. The policy worked well.

Baseball team participants in the "Christmas Olympics," New Guinea, December 25, 1944.

Meanwhile, at home, the All-American Girls Professional Baseball League (see page 198) played lengthy schedules of one hundred games or more, and the Major Leagues, thanks to President Roosevelt's "green light" pronouncement (see page 167), continued throughout the war, although many of the game's top stars traded their Louisville Sluggers for M-16 rifles. Naturally, the quality of the game at the highest levels was adversely affected. In 1944, fifteen-year-old Joe Nuxhall pitched in a game for the depleted Cincinnati Reds (he would return to the Majors older and stronger in 1952), and the unlikeliest of teams, the St. Louis Browns, took advantage of the decimated Major League rosters. As a team, they hit at an embarrassingly low .252 clip, and only one regular player batted over .300, but they did capture the American League pennant. Their crosstown rivals, the Cardinals, led by Stan Musial and Marty Marion, ended the Browns' surprising run in a six-game World Series.

Staying occupied in occupied territory, Plauen, Germany, April 23, 1945. Allied forces pushed forward into Germany in the spring of 1945, and the crippled Third Reich was only two weeks from surrendering when this photo was taken of off-duty servicemen playing ball in the occupied city. Here, Staff Sergeant Joseph Galano races to first base while Lieutenant Ballard waits for the throw.

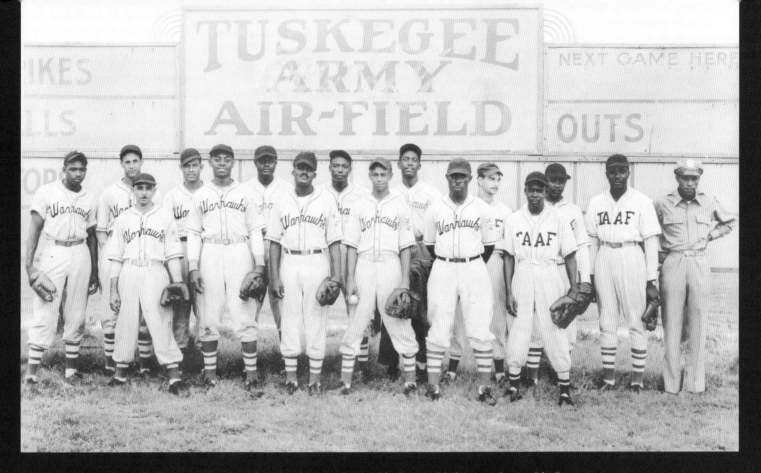

Tuskegee Warhawks, Tuskegee Army Air Base, Alabama, Army Air Forces Training Command photograph, 1945. Tuskegee, Alabama, was home to a civilian flight training center before the United States entered World War II, but in 1941, it was the setting for an experimental military program to train black servicemen as pilots, navigators, bombardiers, and aircraft maintenance and support personnel. Combating both racial animosity and the German Luftwaffe, the Tuskegee Airmen triumphed over both. They formed the highly decorated 332nd Fighter Group that served in the Mediterranean theater, and they also produced an excellent baseball team that played other service units from around the country. Private John Watson, third from right, served as a crew chief in the aircraft inspection department and played catcher for the Warhawks.

Perhaps most poignant were the teams and leagues that got no attention outside their miserable surroundings, though they were indispensable for their players and fans. These were the teams that passed time in America's internment camps.

Fearful that those of Japanese descent in the United States posed a national security threat, President Roosevelt signed Executive Order 9066 in February 1942, which led to the internment of some 119,000 people—most of them American citizens. At nine isolated, guarded compounds around the country, internees made the best of harsh living conditions and their loss of civil rights. Men, women, and children all played baseball, forming intra-camp leagues, and at some camps all-star teams challenged local semipro outfits. In March 1942, Shiro Kashino, of Seattle, Washington, was sent to the Minidoka Relocation Center in Hunt, Idaho, with 10,000 others. "While we were interned, baseball saved us," he said long after the war. "Baseball made our lives easier during a time of distress. During a bleak moment, baseball gave us hope."

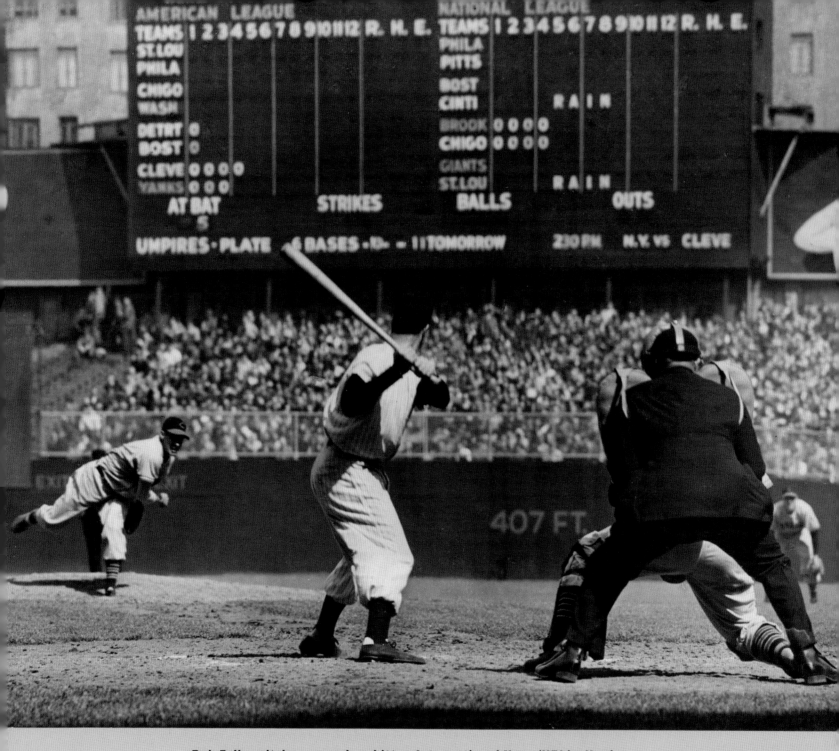

Bob Feller pitches second no-hitter, International News/UPI by Hugh Broderick, April 30, 1946. Perhaps in an effort to show fans that more than five years in the U.S. Navy during World War II did nothing to cool his red-hot fastball, Cleveland Indians pitcher Bob "Rapid Robert" Feller vanquished New York at Yankee Stadium by tossing his second of three career no-hitters. Feller is seen here successfully battling fellow military veteran Joe DiMaggio as umpire Ed Rommel calls the game behind Indian catcher Frank Hayes. Cleveland won 1-0 when Hayes hit a towering home run thirty rows deep into the left center field bleachers.

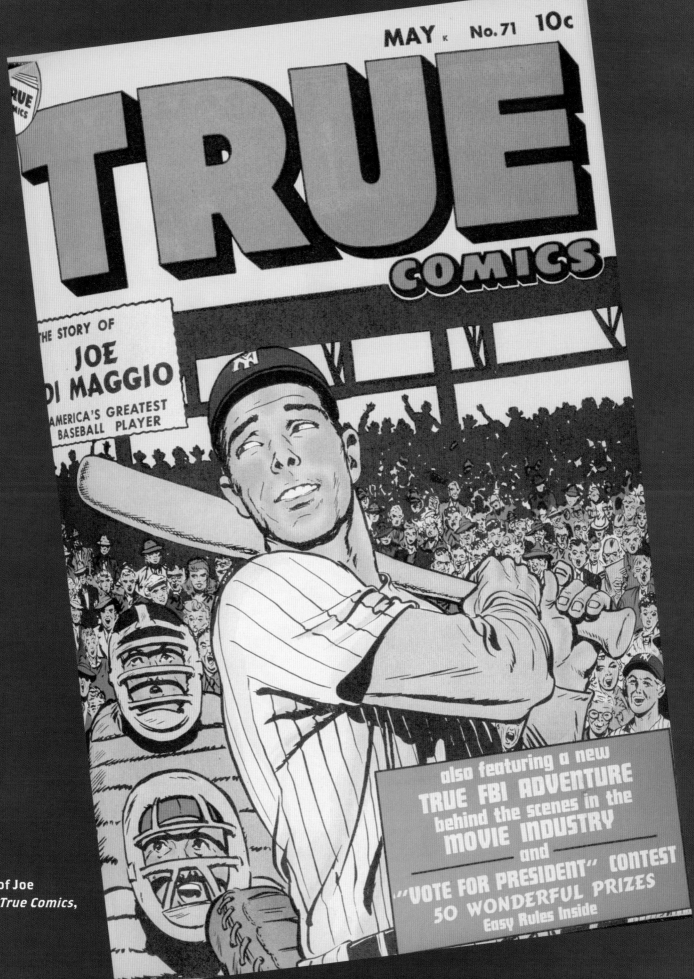

"The Story of Joe DiMaggio," *True Comics*, May 1948.

LITTLE LEAGUE

Little League
BASEBALL

1952 Official Rules

Little League Baseball 1952
Official Rules Book.

Kids had been playing baseball—or an ancestral form of the game—in America for more than 150 years when Carl Stotz of Williamsport, Pennsylvania, founded the Little League in 1939. He convinced local businesses to kick in $30 each to sponsor a team—enough to cover uniforms and equipment for thirty boys. The league debuted on June 6, as Lundy Lumber trounced Lycoming Dairy 23–8. In 1947, Williamsport hosted its first Little League World Series, and by 1952, some fifteen hundred local leagues were operating around the country. The championship series was first televised in 1953, and two young announcers who would become significant figures in sportscasting handled the play-by-play: Jim McKay for CBS Television and Howard Cosell for ABC Radio. That same year, RKO-Pathe released a sixteen-minute film, *This Is Little League*, which described how the league functioned, pointing out that dads volunteered as coaches while moms were especially good at handling organizational tasks. The Red Sox of suburban Roslyn, Long Island, New York, were featured in the film and are seen here cheering as a teammate tries to work his way out of a rundown.

Official measurements for laying out
LITTLE LEAGUE BASEBALL FIELD

4

Baseball Field Measurements,
Little League Baseball 1952
Official Rules Book.

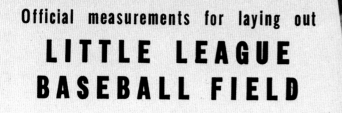

ABOVE AND BELOW: *This Is Little League,*
RKO-Pathe, 1953.

Infield fly, Atlanta, Georgia, Wide World photograph, April 9, 1955.
During an Amateur Softball Association game, Linda McConkey of the Atlanta Lorelei Ladies executes a full-extension dive into third base as Jerrie Rainey of the Tomboys jumps for the ball. The Lorelei Ladies won a number of state titles and made appearances in the ASA national tournament, which held its first championship for women's teams in 1933. By the 1940s and 1950s, star players were developing local and regional followings with heads-up—and headfirst—play.

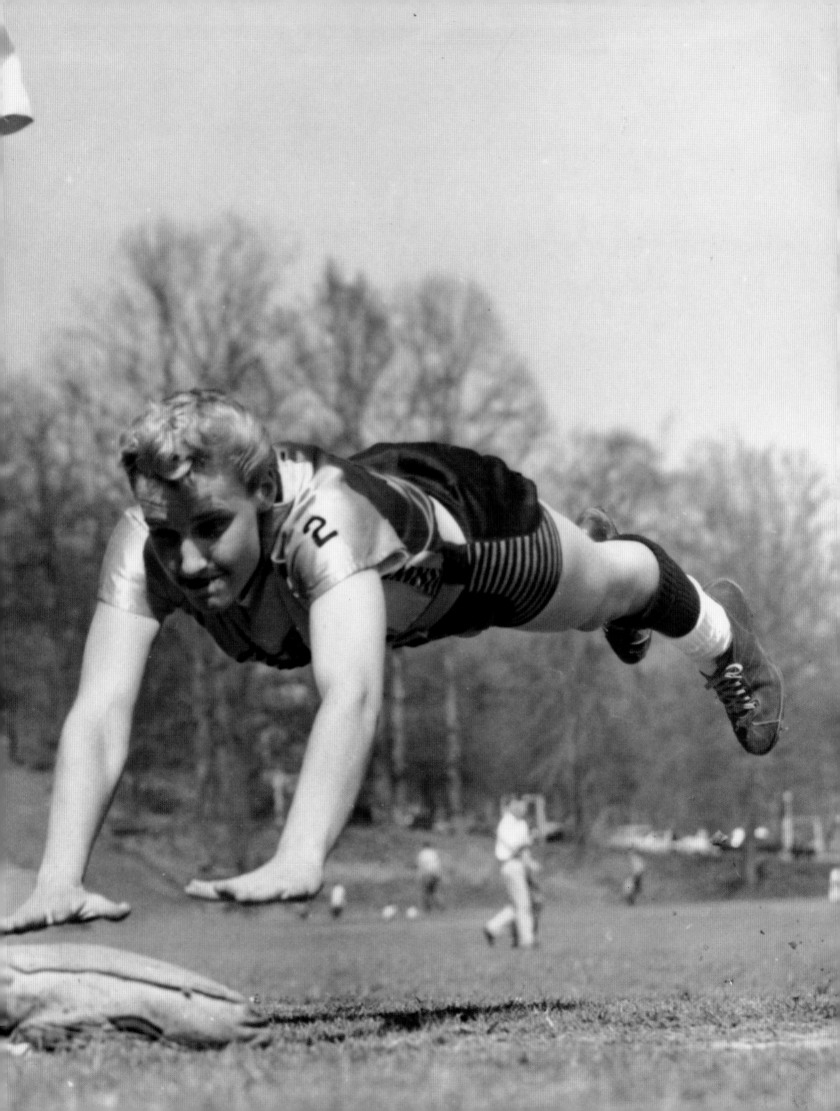

THE ALL-AMERICAN GIRLS PROFESSIONAL BASEBALL LEAGUE

★ ★ ★ ★ ★ ★ ★ ★ ★ ★ ★ ★ ★ ★ ★ ★ ★

Since Rosie the Riveter could replace a man in the factory, there was no reason why a Connie Wisniewski, a Dottie Kamenshek, or a Ruth Lessing could not do the same on the professional baseball diamond. When it was thought that the Major Leagues might disappear (as did many farm teams) or play might be suspended during the war, Chicago Cubs owner and chewing-gum magnate Philip Wrigley proposed a professional women's league to keep the home front entertained. Branch Rickey and Paul V. Harper joined Wrigley in establishing the nonprofit, community-oriented venture, and Hall of Famer Max Carey signed on as league president. In 1943, women from all over the country traveled to Chicago to try out for positions on four teams:

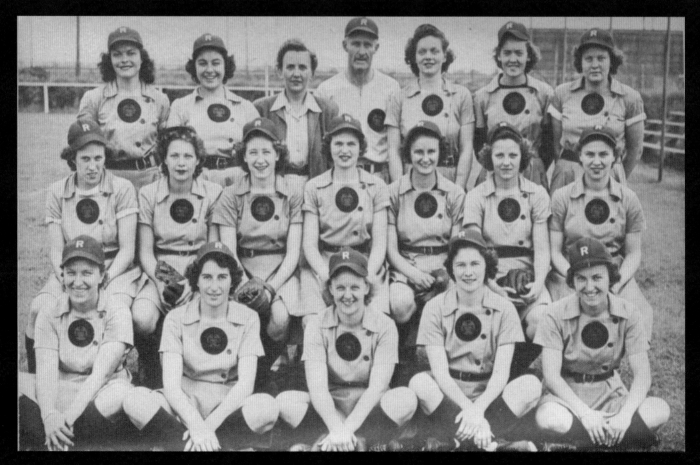

The Rockford Peaches, 1945 champions.

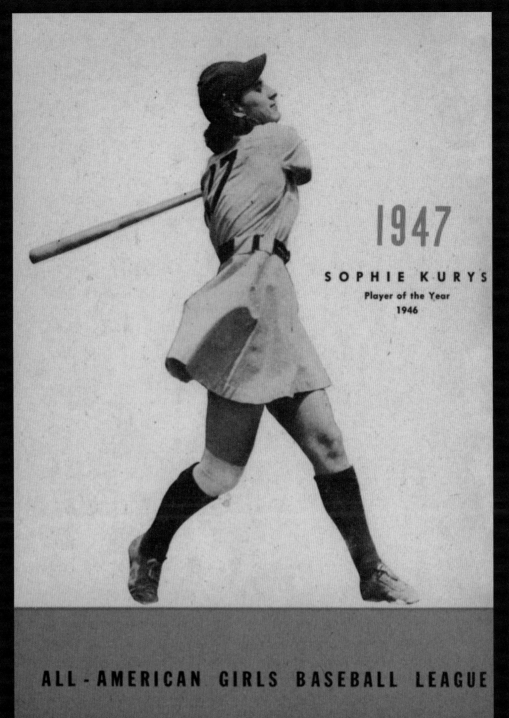

1947

SOPHIE KURYS
Player of the Year
1946

ALL-AMERICAN GIRLS BASEBALL LEAGUE

Sophie Kurys, second baseman, Racine Belles, 1946. Kurys was a marvel at second base, whether stealing it or defending it. In 1946, she stole a league-leading 201 bases and posted a .973 fielding mark.

the Kenosha Comets, the Racine Belles, the Rockford Peaches, and the South Bend Blue Sox. From the beginning, league officials emphasized the femininity and character of its players, writing in their summary of the 1946 season that the women "meet the highest standards of feminine appearance, deportment and behavior and they are guided during their playing season by an individual team chaperone who acts as their counselor and friend."

During the first season, softballs were used, but with each passing year the balls got smaller, the baselines longer, and in 1948, the league adopted full overhand pitching regulations. Unlike in softball, however—and at Wrigley's insistence—the league allowed stealing to inject more action into the game. (In their short skirts, players accumulated "strawberries on top of strawberries," painful marks that resulted from bare-legged sliding in the dirt.) Teams went through spring training together in various southern locales, followed by an exhibition tour throughout the region. In 1947,

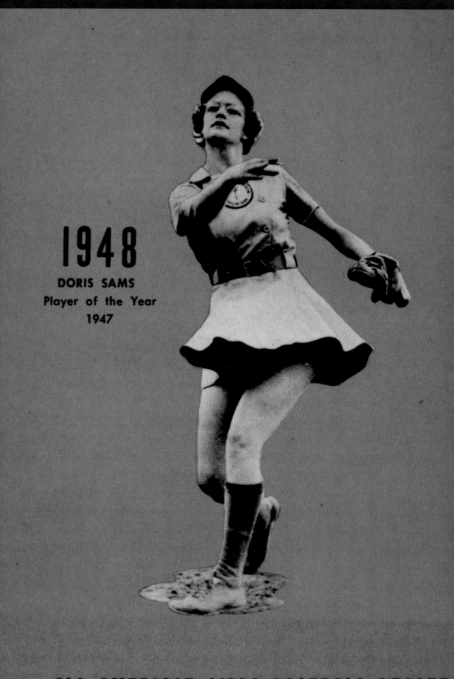

1948

DORIS SAMS
Player of the Year
1947

ALL AMERICAN GIRLS BASEBALL LEAGUE

Doris Sams, pitcher, Muskegon Lassies, 1947. Sams played all twelve seasons that the league operated, excelling on the mound, in the outfield, and at the plate. In 1947, she went 11-4 with a microscopic 0.98 ERA and threw a perfect game against Fort Wayne.

spring training was in Havana, Cuba, where the teams enjoyed enthusiastic crowds, and twenty thousand people came out to see a game between the Racine Belles and the Muskegon Lassies. That season, radio stations began broadcasting league games.

In its twelve-year existence, the league operated in midsize or larger midwestern cities, and in its strongest seasons fielded ten teams and drew more than a million fans. More than six hundred women played in the AAGPBL, and depending on their experience and ability, pay ranged from $50 to $125 a week, which was very good money for the time. By 1954, however, with the Major Leagues enjoying a golden age that included a bevy of new stars, a faster style of play, and televised games, the days of the AAGPBL came to a close.

LEFT, ABOVE LEFT, AND RIGHT: *The Kalamazoo Klouters*, **Mel Allen's Sports Show, 1952.** A nine-minute film short shown before 20th Century-Fox feature films, *The Kalamazoo Klouters* covered the team (or "feminine phenoms") at play against the Fort Wayne Daisies and the Battle Creek Belles, relaxing at the lake, and at their day jobs. The English teacher, bank teller, housewife, and printer all shared a common love of the game, and, as the narrator explained, "These typically American girls may play ball with masculine magnificence, but off the field they perform with traditional feminine finesse." **UPPER LEFT:** Kalamazoo warms up with a game of pepper while star shortstop Dottie Schroeder of Fort Wayne gets a last-minute batting tip from manager and former Major Leaguer Jimmie Foxx (**LEFT**). With strong performances from Buttons Pearson at shortstop (**UPPER RIGHT**) and Bonnie Baker, the Lassies knocked off the Daisies 1–0.

LEFT: The Racine Belles, 1947. Beyond wartime entertainment, the league was also committed to the civic good. The Belles sponsored nearly a thousand kids participating in Racine's recreation league. Here they are giving instruction to teenage players at the municipal park.

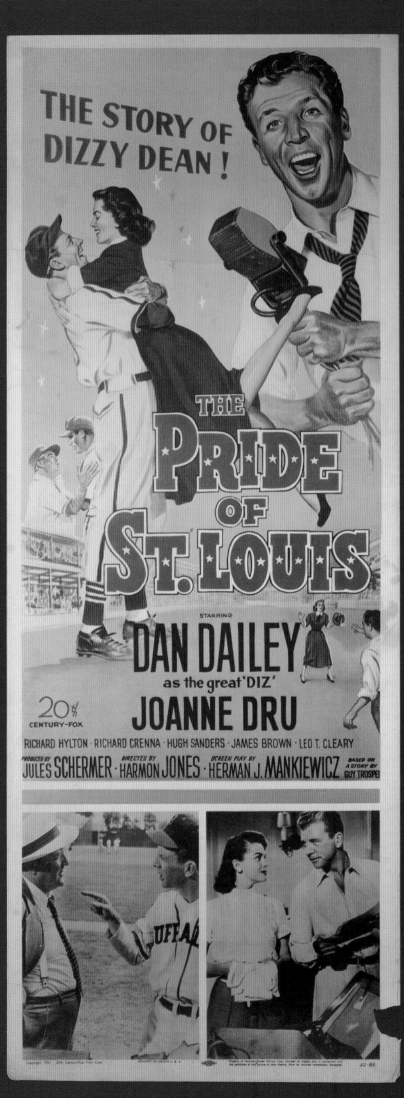

The Pride of Saint Louis, lobby poster, 20th Century-Fox, 1951.

OPPOSITE: **Superman and the Legion of Super-Heroes**, *Action Comics*, June 1970.

CLASSIC NEW YORK BASEBALL

New York City boasted three storied Major League franchises that dominated the game in the 1950s: the New York Giants, anchored by a pair of former Negro Leaguers, Willie Mays and Monte Irvin; the Brooklyn Dodgers, whose passionate fans worshipped the likes of Duke Snider, Pee Wee Reese, Gil Hodges and, of course, Jackie Robinson; and the omnipresent New York Yankees, winners of ten World Championships and another five American League Pennants from 1947 through 1964. Among many classic New York moments from the era: The crowd carries a stunned and happy Bobby Thomson (OPPOSITE, BOTTOM) after he hit a walk-off three-run homer off Brooklyn's Ralph Branca in the ninth inning of the third National League play-off game. Thomson's "Shot Heard 'round the World" prompted WMCA radio announcer Russ Hodges to famously shout across the airwaves, "The Giants win the pennant! The Giants win the pennant! The Giants win the pennant! The Giants win the pennant!" It also caused Thomson's mother to pass out in front of her television set. In 1955, the Brooklyn Dodgers finally won the World Series, defeating the New York Yankees four games to three. In Game 4 (OPPOSITE, TOP), umpire Bill Summers gives an emphatic safe sign as Dodger shortstop Pee Wee Reese beats out Yankee pitcher Johnny Kucks to first base; first baseman Joe Collins can only look on helplessly. The 1956 World Series

Yogi Berra and Don Larsen, New York Yankees, Yankee Stadium, Wide World photograph, October 8, 1956.

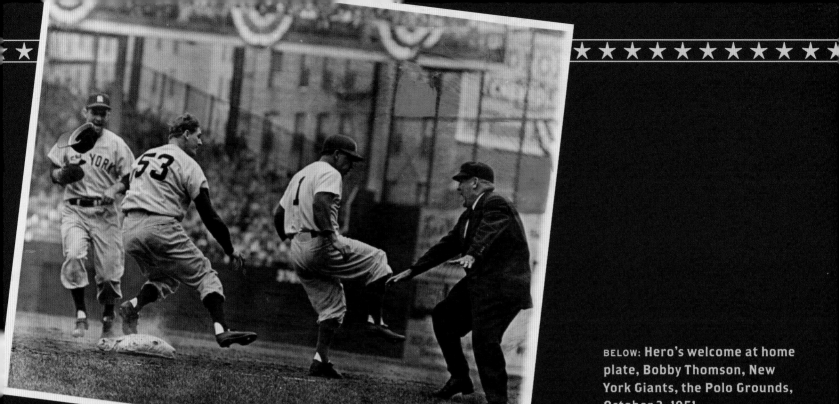

BELOW: **Hero's welcome at home plate, Bobby Thomson, New York Giants, the Polo Grounds, October 3, 1951.**

Dancing to a safe decision, Ebbets Field, Wide World photograph, October 1, 1955.

was a Dodgers-Yankees rematch that featured New York pitcher Don Larsen hurling a "perfect game" in Game 5 by retiring all twenty-seven Dodger batters. Larsen's final pitch, a called strike three, set off an explosion of cheers led by catcher Yogi Berra, who flew into the arms of his pitcher (OPPOSITE). *Washington Post* sports columnist Shirley Povich wrote on October 8, 1956: "The million-to-one shot came in. Hell froze over. A month of Sundays hit the calendar. Don Larsen today pitched a no-hit, no-run, no-man-reach-first game in a World Series."

Yankee Stadium, New York City

7A-H2099

Yankee Stadium, postcard, New York City, ca. 1950.

Ebbets Field, Brooklyn, New York, Sanborn Company Map, 1932, updated 1951. Insurance companies used Sanborn maps to determine a property's fire liability, but the maps also provide a detailed view of community organization and how baseball has fit—literally—into city life. Crammed into four-and-a-half acres neighboring the Department of Sanitation garage, the United Parcel Service distribution depot, and a venetian blind manufacturer, Ebbets Field was hallowed ground, a belt of steel and concrete wrapped around a dash of green in Brooklyn's Flatbush area. Generations of fans rooted for "da bums" (the Dodgers) from the ballpark's crowded confines, a thriving example of the game's urban heritage and its continued necessity in a city of nearly 7 million people in 1930. Although Ebbets was among the first of the "modern" American stadiums when it opened in 1913, it was soon obsolete, its tight quarters preventing major upgrades. Compared with its contemporaries, Detroit's Tiger Stadium and Boston's Fenway Park, Ebbets Field enjoyed a relatively short life span. It was demolished in 1960, making way for another staple of urban life, the high-rise apartment.

OPPOSITE: *The Saturday Evening Post,* cover illustration by Norman Rockwell, April 22, 1949.

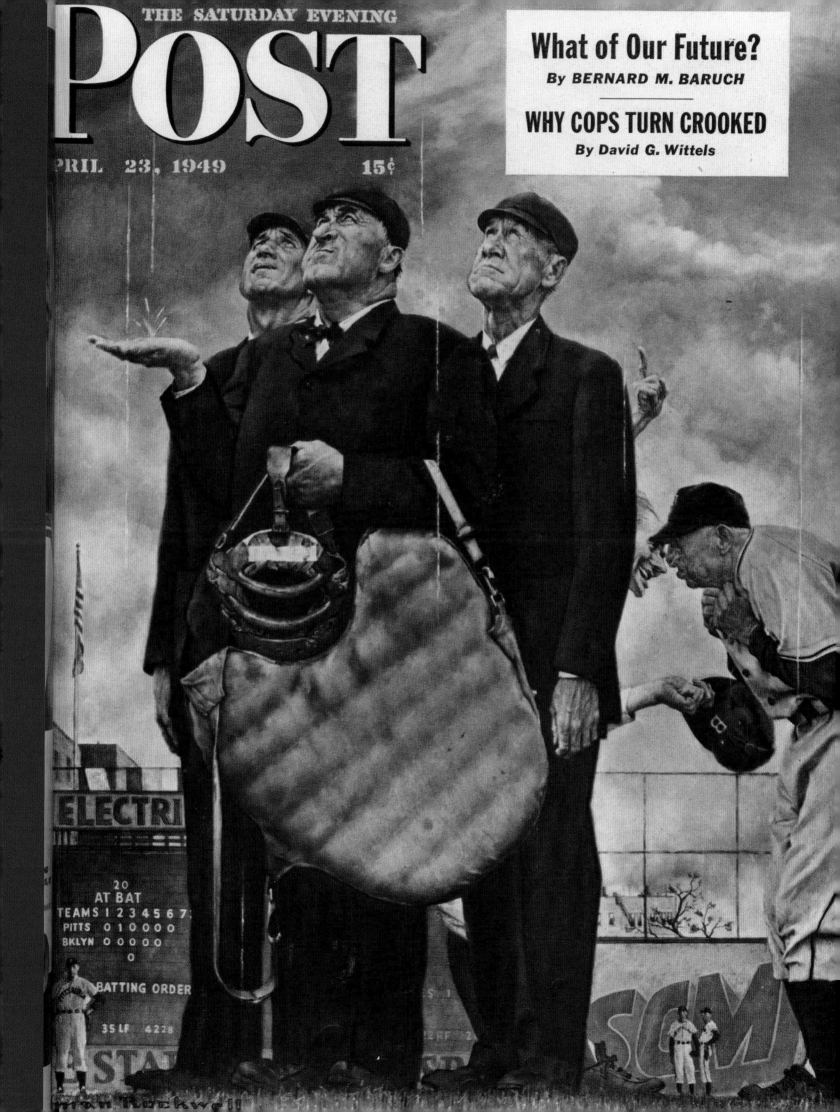

MR. ROBINSON

★ ★ ★ ★ ★ ★ ★ ★ ★ ★ ★ ★ ★ ★ ★ ★ ★ ★

JACKIE, WE'VE GOT NO ARMY. THERE'S VIRTUALLY NOBODY ON OUR SIDE. NO OWNERS, NO UMPIRES, VERY FEW NEWSPAPERMEN. AND I'M AFRAID THAT MANY FANS WILL BE HOSTILE. WE CAN CONVINCE THE WORLD THAT I'M DOING THIS BECAUSE YOU'RE A GREAT BALLPLAYER, A FINE GENTLEMAN.
—BRANCH RICKEY, PRESIDENT AND GENERAL MANAGER OF THE BROOKLYN DODGERS, TO JACKIE ROBINSON ON THEIR PLANS TO BREAK MAJOR LEAGUE BASEBALL'S COLOR BARRIER, 1947

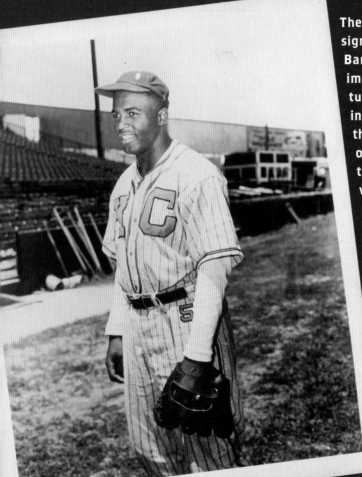

The year before Babe Ruth died, Jackie Robinson signed with the Brooklyn Dodgers and joined the Bambino as one of the two most influential and important baseball players of the twentieth century. Robinson bravely integrated the game during a sometimes agonizing journey, withstanding the icy reception of his teammates, taunts from opposing fans, and death threats. In spite of that, he maintained a calm outward demeanor while introducing a thrilling and daring brand of baseball that led to a fast, open, and free style of play. He was a dangerous hitter and an outstanding glove man, but his work on the base paths was revolutionary. Once on base,

Kansas City Monarchs, 1945. A four-letter sports star at UCLA and a second lieutenant in the U.S. Army during World War II, Robinson was an immediate sensation with the Kansas City Monarchs, the longest-running professional ball club in Negro League history. After hitting an impressive .387, he signed with the Minor League Montreal Royals a year later before moving on to the Brooklyn Dodgers in 1947.

ONE OF AMERICA'S GREAT NEWSPAPERS

NEW YORK
Amsterdam News

NATIONAL EDITION

VOL. XXXVIII—NO. 20 SATURDAY, APRIL 19, 1947 Entered As Second Class Matter Post Office, Bethlehem, Pa. 10c

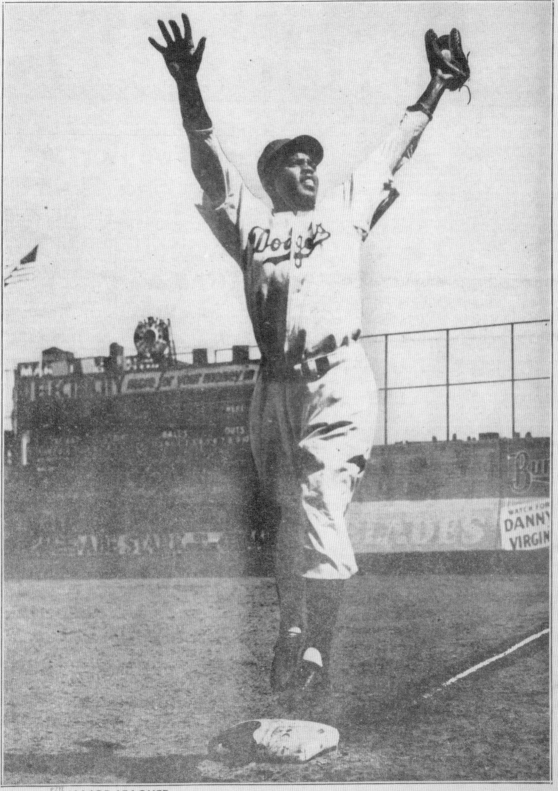

MAJOR LEAGUER: Jackie Robinson of the National League's Brooklyn Dodgers.—Solomon Photo.

New York Amsterdam News, **Saturday, April 19, 1947.** Robinson's Major League contract with Brooklyn sent a jolt through black America, and the *New York Amsterdam News*, one of the country's most influential black newspapers, was on hand to cover the new Dodger from the beginning.

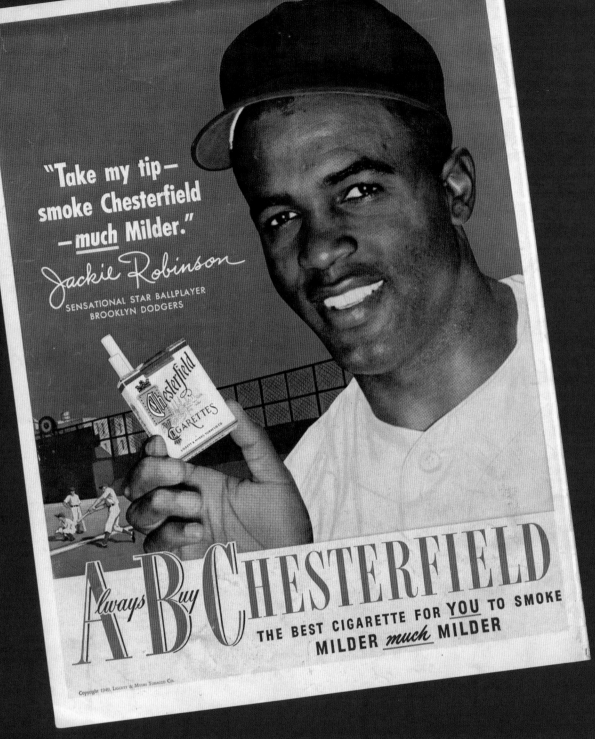

Chesterfield cigarette advertisement, 1949.

Robinson dared opposing pitchers into hurried throws, mental errors, and other mistakes. He successfully stole home an incredible nineteen times and was credited by teammates and opposing players alike as being able to change the course of a game by whatever was needed—speed or power. "Above anything else," he said, "I hate to lose."

In 1947, his first year in the Majors, Robinson immediately improved the Dodgers and earned Rookie of the Year honors. Two years later, after hitting at a .342 clip, he was named the National League's Most Valuable Player. A triple threat with his bat, glove, and speed, he led the Dodgers to a World Series championship in 1955. All in all, Robinson's teams won six pennants during his ten seasons in the Majors. He retired in 1956, just before the Dodgers' last season in Brooklyn, and was inducted into the Baseball Hall of Fame in his first year of eligibility.

Beyond his individual success, Robinson gave hope to countless other black players, such as future stars Willie Mays, Ernie Banks, and Hank Aaron,

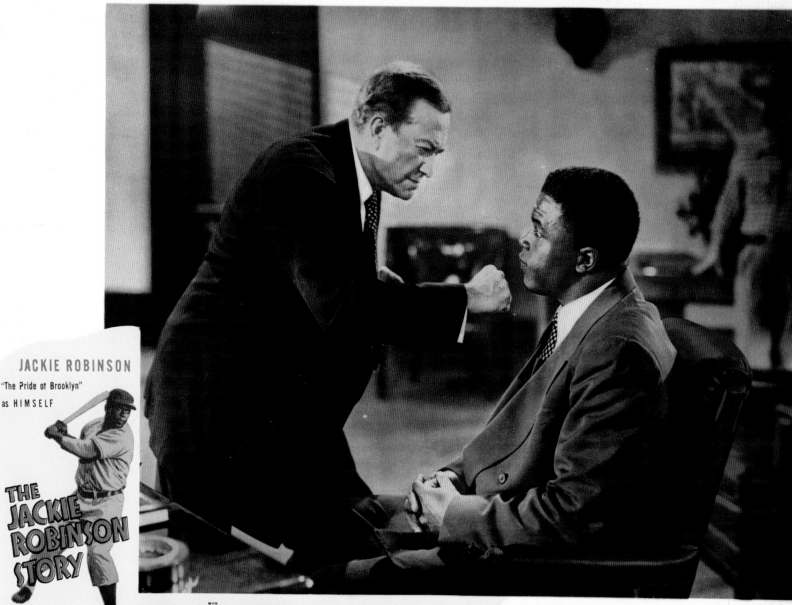

JACKIE ROBINSON

"The Pride of Brooklyn"

as HIMSELF

THE JACKIE ROBINSON STORY

Copyright 1950 Pathe Industries, Inc.

MINOR WATSON · RUBY DEE · RICHARD LANE
as "Branch Rickey" of "Anna Lucasta" fame as "Clay Hopper" of the
BILLY WAYNE as "Clyde Sukeforth" "Montreal Royals"

Directed by ALFRED E. GREEN who gave you "The Jolson Story"
Written for the screen by Lawrence Taylor and Arthur Mann
Produced by MORT BRISKIN · An Eagle Lion Films Release

PROPERTY OF NATIONAL SCREEN SERVICE CORP. LICENSED FOR
DISPLAY ONLY IN CONNECTION WITH THE EXHIBITION OF THIS PICTURE
AT YOUR THEATRE. MUST BE RETURNED IMMEDIATELY THEREAFTER. 50/330

The Jackie Robinson Story, lobby card, Pathe Industries, Inc., 1950. Robinson played himself and Minor Watson portrayed Branch Rickey in a film dramatization that focused on Robinson breaking into the Major Leagues. The *New York Amsterdam News* complained that "the picture is too short" and "too much of a documentary. . . . There is not too much entertainment," but the reviewer was impressed with Robinson's performance. The paper also forecasted that "the JR movie should receive success in each city it plays. This is true of the South, too, because there is nothing in the film which could possibly offend even an anti-negro white."

that they, too, could play in the Major Leagues. That was no small thing. What he and Rickey did was a significant precursor to the civil rights movement, an act that baseball later came to understand and appreciate. In 1987, the Rookie of the Year Award was renamed the Jackie Robinson Award, and all Major League teams have retired his famous number 42.

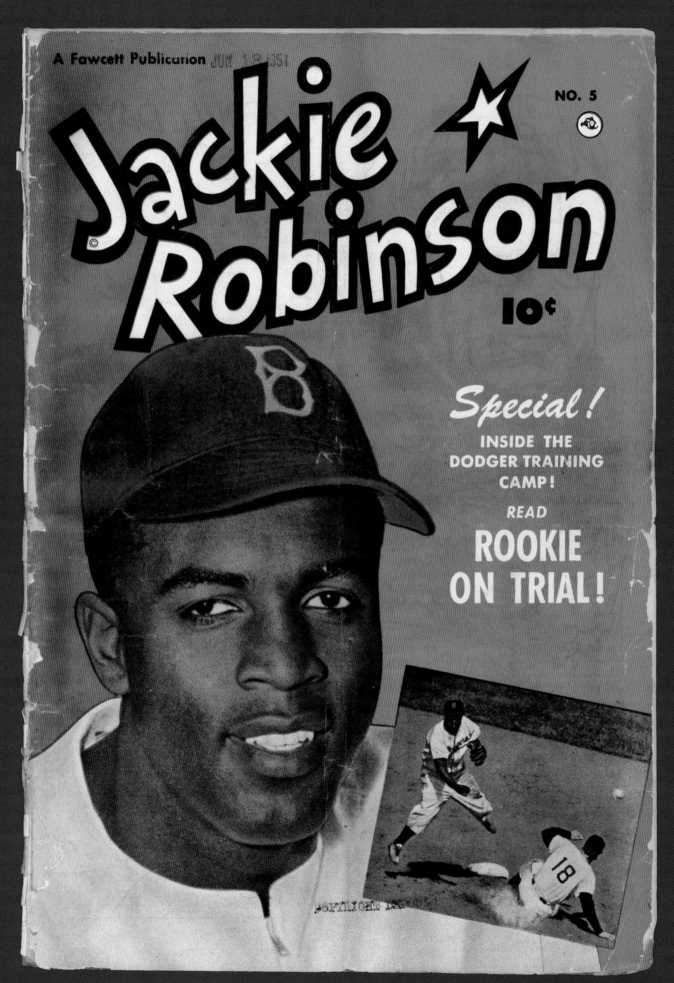

Jackie Robinson, comic book, 1951.

Warming up, by Bob Sandberg, 1954.

763

CONGRATULATIONS
by WESTERN UNION

.NBA307 CGN DL PD=HOUSTON TEX 28 116PMC=.
JACKIE ROBINSON, THE BROOKLYN DODGERS BASEBALL=
:DELIVER=

JUST SAW YOU STEAL HOME ON TV GREAT FROM A 50 YEAR OLD
DEEP SOUTH WHITE MAN I SAY YOU ARE THE FINEST AND A
GENTLEMAN BEAT THE YANKEES=
JIM VANCE=

763-55

Congratulations (16).

..NBB359 SCL 9=CNT FD MONTREAL QUE 9 535P= 1954 OCT 9 PM 7 22
:JACKY ROBINSON, CARE BROOKLYN DODGERS
:=EBBETTS FIELD=

:CONGRATULATIONS FOR TODAY WILL BE ROOTING FOR YOU TOMORROW=
:MENDES BEAUTY SALON=:

ABOVE AND RIGHT: **Western Union
telegrams, 1955.**

Pittsburgh Pirates infield, ink and watercolor over graphite under drawing,
cartoon by Willard Mullin, April 7, 1963.

Roy Campanella, catcher, Brooklyn Dodgers, ink and blue pencil over graphite under drawing, cartoon by Murray Olderman, ca. 1957.

Advertisement, California
Raisin Advisory Board,
Fresno, California, 1956.

RIGHT: *The Mighty Casey (A Baseball Opera)*, by Jeremy Gury and William Schuman, libretto and music, 1954.

OPPOSITE: Handwritten score for "Peanuts, Popcorn, Soda, Cracker Jacks," from *The Mighty Casey*, by William Schuman. It was only a matter of time before America's most celebrated fictional baseball hero—who had appeared in poems, vaudeville, film, and more—would turn up in his own opera. Based on Ernest L. Thayer's 1888 poem "Casey at the Bat," the production premiered in Hartford, Connecticut, on May 4, 1953, and the libretto and music were published the next year.

LOOK BACK

★ ★

LOOK magazine appeared on American newsstands from 1937 to 1971, focusing on social and political issues, including international affairs, medicine and technology, sports, food, fashion, and lifestyles. The magazine was recognized for its outstanding behind-the-scenes photographic features on familiar aspects of American life. One of baseball's golden eras—the 1950s and 1960s—coincided with the magazine's heyday, and *LOOK* hired many of the nation's best documentary photographers to cover Major Leaguers from all angles: on the field, in the dugout, at the clubhouse, or just hanging around in their civvies.

Jackie Robinson and Pee Wee Reese, Brooklyn Dodgers, by Kenneth Eide, 1953.

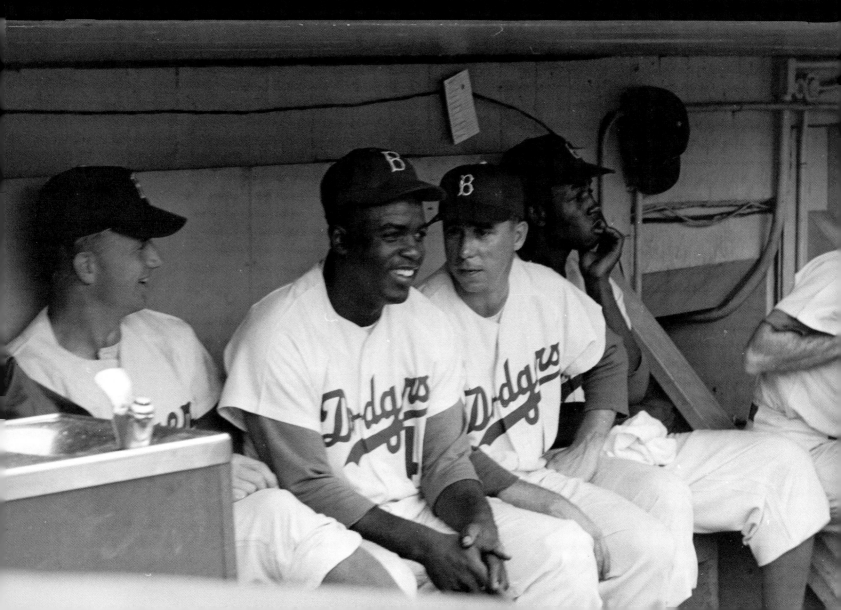

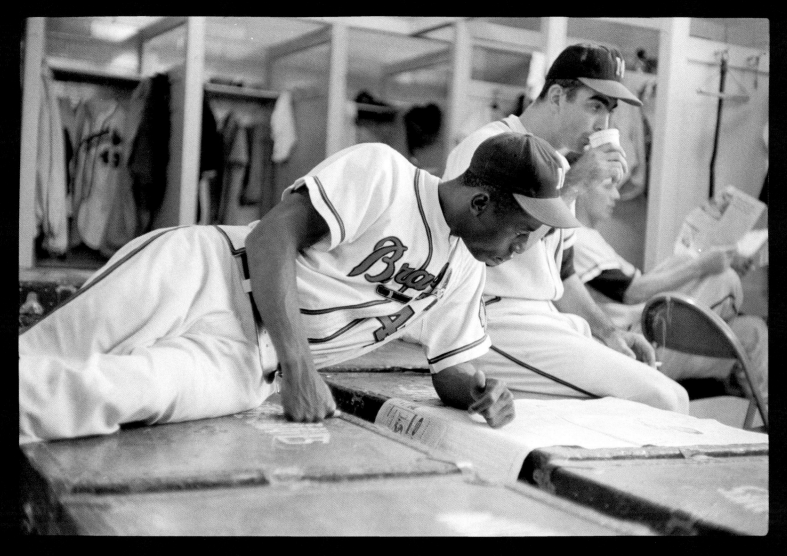

Henry "Hank" Aaron, Milwaukee Braves, by Phillip A. Harrington, 1955.
He was quiet, shy and respectful, and for most of his twenty-three-year playing career Henry
Aaron avoided the spotlight, playing for the Braves in Milwaukee and Atlanta. Aaron is best
known as the man who chased, caught, and then broke Babe Ruth's "impossible" record of 714
career home runs, finishing his career with 755. (Unfortunately, Aaron's memorable march to
the record was accompanied by racially themed death threats.) He also displayed a remarkable
level of long-term consistency: for twenty consecutive years, he hit 20 or more home runs per
season, and eight times he smacked 40 or more round-trippers.

**The crowd at Milwaukee County
Stadium, by Marvin E. Newman,
1956.**

Cleveland Indians pitching staff: Mike Garcia, Bob Lemon, Bob Feller, Early Wynn, Art Houtteman, and Hal Newhouser, by Jim Hansen, 1954.

Fan at Milwaukee County Stadium, by Marvin E. Newman, 1956.

A very happy crowd at Milwaukee County Stadium, by Marvin E. Newman, 1956.

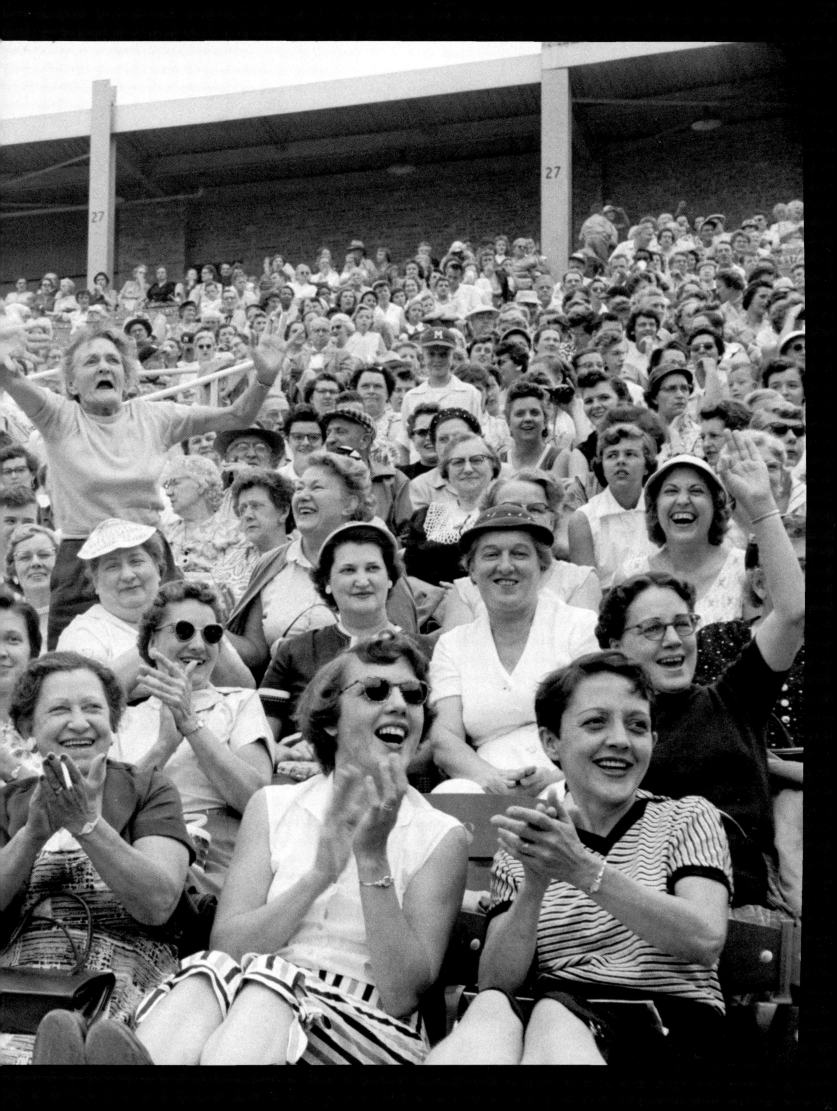

Mickey Mantle, New York Yankees, by Thomas R. Koeniges, 1968. Fresh from tiny Commerce, Oklahoma, Mickey Mantle (also known as "the Commerce Comet" and "the Mick") seemed to be the very prototype of 1950s and 1960s baseball. Blond and swaggering, he combined unprecedented power and average at the plate for a switch-hitter, he stole bases almost at will, and could lay down a drag bunt as no one else. Mantle was also the heir to the rich Yankee tradition that descended from Ruth to Gehrig to DiMaggio. Despite suffering some horrific injuries that eventually slowed him down, he led his team to a championship more often than not. When he retired in 1968 after eighteen seasons—with 536 home runs while batting over .300 ten times—he was the most popular baseball player in the world. The image of Mantle in contemplation (**LEFT**) originally appeared in *LOOK* in 1956; the magazine captured him again twelve years later (**ABOVE**), at the end of his career, awaiting his turn at bat.

Mickey Mantle, New York Yankees, by Marvin E. Newman, 1956.

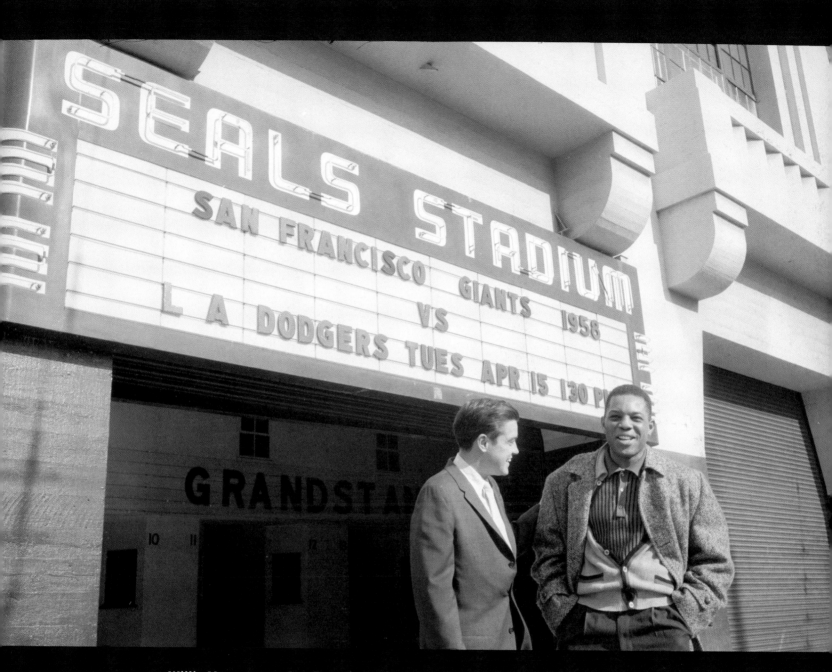

Willie Mays (RIGHT), **San Francisco Giants, by Maurice Terrell, 1958.** Willie Mays put together a twenty-two-year career that was marked by a certain unmatched joy, flair, and style, and the numbers he posted are remarkable: 660 home runs, and more than 3,200 hits while hitting over .300 ten times. On defense, he patrolled the outfield with speed and grace. Ted Williams said it best: "He played with controlled abandon." Mays was, simply, one of the most exciting and complete ballplayers ever. (*Sporting News* named him the Player of the Decade for the 1960s.) In April 1958, *LOOK* chronicled Mays bringing baseball to his new city when the Giants moved to San Francisco.

Roger Maris, New York Yankees, by Frank Bauman, 1960. During the summer of 1961, Mickey Mantle and his Yankee teammate Roger Maris jointly assaulted Babe Ruth's single-season home run mark of sixty. Although Mantle's injuries sidelined him for the last several games, he still finished with a hefty fifty-four round-trippers. The star that year, however, turned out to be the other Yankee. Maris tied the Bambino's record in his 158th game, then exceeded it when he hit number sixty-one in the last game of the year. Maris's single-season home-run record stood for thirty-seven years, a longer period of time than Ruth held the record.

Stan Musial, St. Louis Cardinals, by Jim Hansen, 1963.

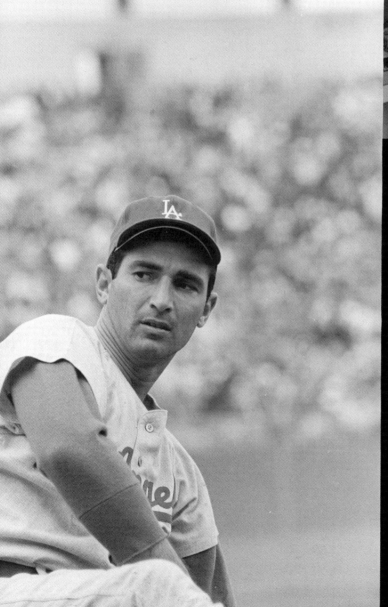

LEFT AND ABOVE: Sandy Koufax, Los Angeles Dodgers, by Phil Bath, 1966. Major Leaguers hit more than three thousand home runs in the 1962 season, alarming Commissioner Ford Frick. After the season, Frick convinced the Rules Committee to reverse a twelve-year-old rule that defined the strike zone as running from a batter's armpits to the top of his knees. The strike zone was enlarged, so that it stretched from the top of a batter's shoulders to the bottom of his knees. What had been a hitter's paradise turned into a pitcher's delight, and one of the most dominant pitchers of the 1960s was the Los Angeles Dodgers' speedballer Sandy Koufax. Previously a wild and unpredictable pitcher, by the early 1960s Koufax had become a master of control. From 1962 through 1967, he was almost untouchable, pitching four no-hitters (including a perfect game), and winning three Cy Young Awards. He also broke the single-season strikeout record set in 1904 by Rube Waddell, fanning 382 hitters in 1965. Hitting against Koufax, said Pittsburgh Pirate Hall of Famer Willie Stargell, was "like drinking coffee with a fork." The Dodger ace led his team to World Championships over the New York Yankees in 1963 and the Minnesota Twins in 1965. Then, just after the 1966 season, having won twenty-seven games with a minuscule 1.73 ERA, Koufax, concerned about his arthritic elbow, stunned baseball when he retired at the age of thirty. Five years later, he would become the youngest man elected into the Baseball Hall of Fame.

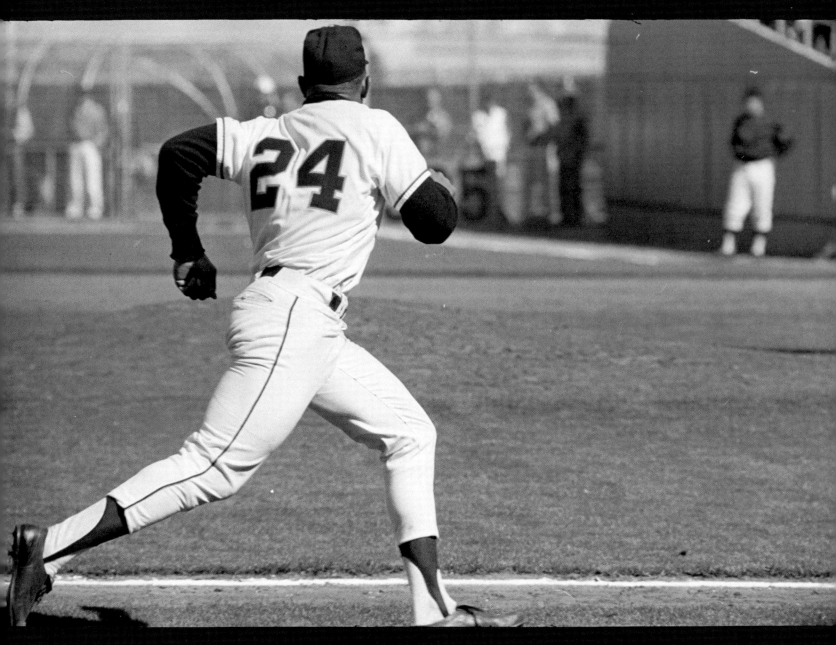

Willie Mays, San Francisco Giants, by Marvin E. Newman, 1965.

Juan Marichal, San Francisco Giants, by Vincent Nanfra, 1968.

ABOVE (CENTER) AND RIGHT: **Roberto Clemente, Pittsburgh Pirates, by Jim Hansen, 1967.**

Roberto Clemente, whose career spanned from 1955 until 1972 (when he was killed in an airplane crash while on a humanitarian mission), was not only one of the game's greatest stars, but he also exerted tremendous influence on a generation of Hispanic players coming up the ranks. A consummate player, Clemente spent his entire career with the Pittsburgh Pirates, winning four batting titles; he also had an impressive .317 lifetime batting average, and his defensive skills earned him twelve consecutive Gold Gloves.

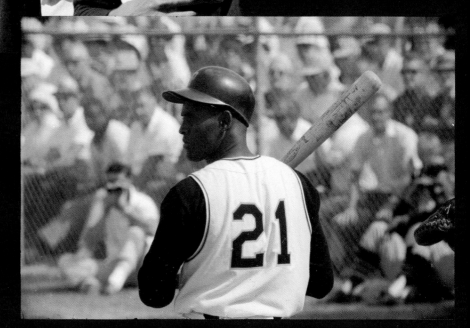

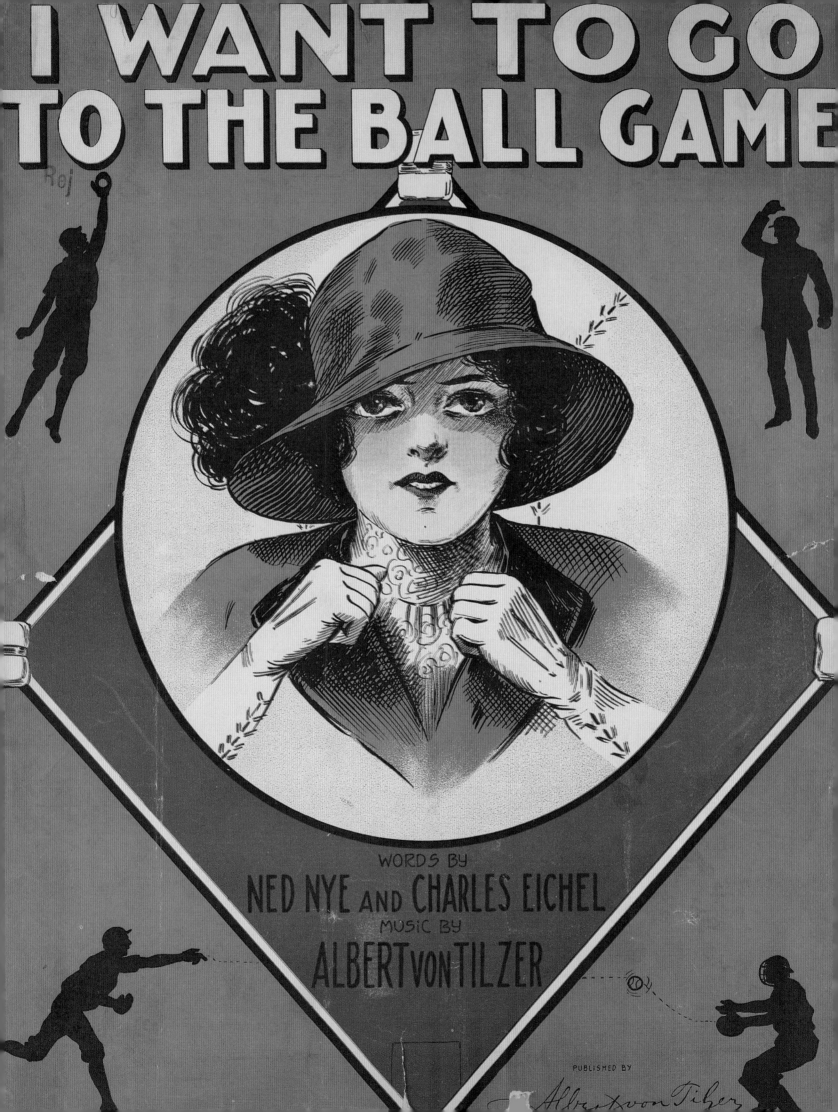

READ MORE ABOUT IT

Block, David. *Baseball Before We Knew It: A Search for the Roots of the Game.* Lincoln: University of Nebraska Press, 2005.

Dewey, Donald, and Nicholas Acocella. *The Biographical History of Baseball.* New York: Carroll and Graf Publishers, 1995.

Heaphy, Leslie A., and Mel Anthony May, eds. *Encyclopedia of Women and Baseball.* McFarland and Company, Inc., 2006.

Hogan, Lawrence. *Shades of Glory: The Negro Leagues and the Story of African-American Baseball.* Washington, D.C.: National Geographic, 2006.

Jones, David, ed. *Deadball Stars of the American League.* Dulles: SABR, 2006.

Kirsch, George B. *Baseball in Blue and Gray: The National Pastime During the Civil War.* Princeton: Princeton University Press, 2003.

Nemec, David, ed. *20th Century Baseball Chronicle: A Year-By-Year History of Major League Baseball.* New York: Beekman House, 1991.

Powers-Beck, Jeffery. " 'Chief': The American Indian Integration of Baseball, 1897–1945." *American Indian Quarterly*, vol. 25, no. 4 (Autumn, 2001): 508–538.

Ritter, Lawrence S. *The Glory of Their Times.* New York: Perennial, 2002.

Seymour, Harold. *Baseball: The Early Years.* New York: Oxford University Press, 1989.

———. *Baseball: The Golden Age.* New York: Oxford University Press, 1989.

———. *Baseball: The People's Game.* New York: Oxford University Press, 1989.

Simon, Tom, ed. *Deadball Stars of the National League.* Dulles: Brassey's, Inc., 2004.

Sullivan, Dean A. *Early Innings: A Documentary History of Baseball, 1825–1908.* Lincoln: University of Nebraska Press, 1995.

———. *Middle Innings: A Documentary History of Baseball, 1900–1948.* Lincoln: University of Nebraska Press, 1998.

———. *Late Innings: A Documentary History of Baseball, 1945–1972.* Lincoln: University of Nebraska Press, 2002.

Thorn, John, ed. *Baseball: A Journal of the Early Game* [semi-annual serial], McFarland & Co.

Ward, Geoffrey, and Ken Burns. *Baseball: An Illustrated History.* New York: Knopf, 1994.

www.baseball-almanac.com, Baseball Almanac, Inc.

www.baseball-reference.com, Sports Reference, LLC.

www.sabr.org, The Society of American Baseball Research.

OPPOSITE: **Music sheet cover, 1912.**

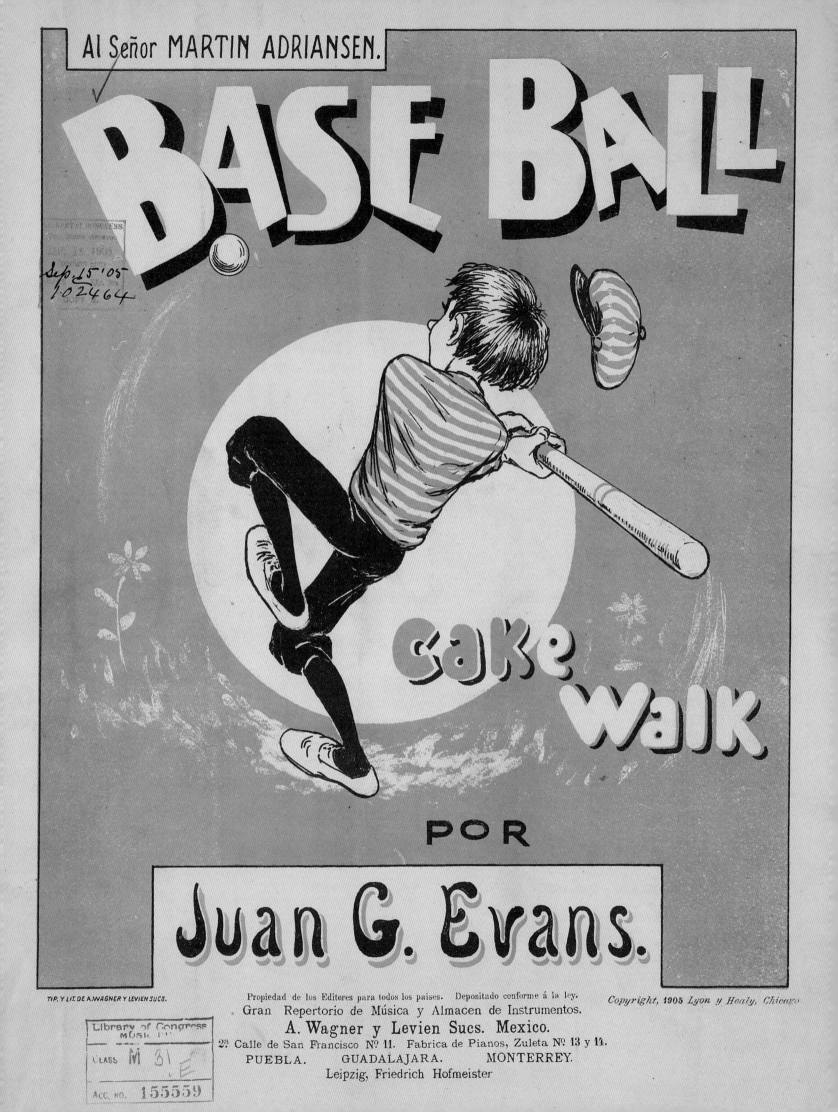

Al Señor MARTIN ADRIANSEN.

BASE BALL

Cake Walk

POR

Juan G. Evans.

TIP. Y LIT. DE A. WAGNER Y LEVIEN SUCS.

Propiedad de los Editores para todos los paises. Depositado conforme á la ley.
Gran Repertorio de Música y Almacen de Instrumentos.
A. Wagner y Levien Sucs. Mexico.
2ª Calle de San Francisco Nº 11. Fabrica de Pianos, Zuleta Nº 13 y 14.
PUEBLA. GUADALAJARA. MONTERREY.
Leipzig, Friedrich Hofmeister

Copyright, 1905 Lyon y Healy, Chicago

ACKNOWLEDGMENTS

Befitting a book on baseball, this publication has been a team effort, and the authors wish to thank all those who have helped in its creation.

Harry Katz wishes to thank his collaborators Frank Ceresi, Phil Michel, Wilson McBee, and Susan Reyburn for working so hard and long, both individually and collectively, on the project. He gratefully acknowledges the strong support and constant encouragement of Smithsonian Books executive editor Elisabeth Dyssegaard and Library of Congress Publishing Office director Ralph Eubanks and the excellent work of Kate Antony at HarperCollins and book designer Laura Lindgren. Harry also wishes to thank the following Library of Congress colleagues: Jeremy Adamson, Mark Connor, Frank Evina, Jim Flatness, Ed Redmond, Peggy Wagner, and Linda Osborne. In particular, he is grateful, for support through the years, to Librarian of Congress James H. Billington. Finally, Harry wishes to acknowledge his family and fellow Red Sox travelers, through good times and bad: Annie Hutchins, Devereux Katz, Charlotte Aladjem, and Arthur and Jamie Katz.

Frank Ceresi would like to thank Carol McMains, Joyce Bradford, Larry Hogan, John Thorn, Barry Sloate, Paul Dickson, John Holway, John Rogers, Lew Lipset, Hank Thomas, and Larry Lester; from the National Baseball Hall of Fame, Jim Gates, Bill Francis, and Gabriel Schechter; and members of the Society of American Baseball Research (SABR), in particular, those who frequent the society's Nineteenth Century listserve. Frank also wishes to thank his own personal star players, his children, Dan and Nicole Ceresi, for the unwavering support they generously gave to their dad's seeming obsession with a simple bat-and-ball game, a game that, in time, they also learned to love. Finally, Frank would like to acknowledge the tremendous influence of his late father Anthony Ceresi, not only for the many years of ruminating, dissecting, and discussing the game they both loved but also for the lessons that he taught his son, lessons about the most important game of all, the game of life.

Phil Michel wishes to acknowledge contributions from the staff of the Library of Congress Prints and Photographs Division, including Acting Chief Helena Zinkham, Kit Arrington, Maricia Battle, Beverly Brannan, Sara Duke, Bonnie Dziedzic, Jan Grenci, and Woody Woodis, as well as colleagues Steve McCollum and Jeff Flannery. He also thanks his home team, Cindy, Jenna, Erin, and Nick, for their enduring patience, support, and love.

Music sheet cover, 1905.

Wilson McBee thanks expert photographer Lee Ewing; Library of Congress colleagues Clark Evans, curator, Rare Book Division; Dave Kelly, Main Reading Room reference librarian; Georgia Higley, specialist, Periodicals Division; and the reference staffs in the Prints and Photographs Division, Manuscript Division, and Motion Picture, Broadcasting and Recorded Sound Division.

Susan Reyburn thanks colleagues in the Library of Congress Publishing Office, especially Christel Schmidt for her valuable technical and historical film expertise, and Blaine Marshall, Linda Osborne, Peggy Wagner, and Athena Angelos for their enthusiastic assistance in this project. Thanks also to Susan Clermont, music specialist, Performing Arts Division; Zoran Sinobad, reference librarian, Motion Picture, Broadcasting, and Recorded Sound Division; Margaret Kieckhefer, Photoduplication Service; and Tom Wiener and Rachel Mears, Veterans History Project, American Folklife Center, for their expert help; and to Abigail Colodner and Benjamin Boss for their research contributions. Special thanks goes to the Reyburn family, which bleeds Dodger Blue, and to Ken Reyburn, master of baseball trivia.

Without their help and support, this ambitious work could not have been accomplished. We owe any success to their assistance, yet any errors are our own.

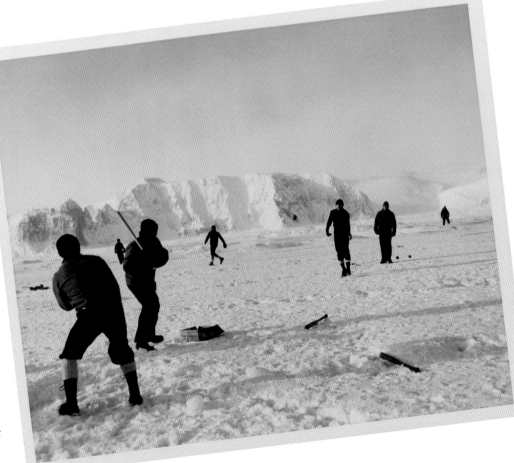

Guardsmen on ice, U.S. Coast Guard photograph, 1953. Crew from the icebreaker *Northwind* play ball in subzero sunshine on shore-fast ice in the Bering Sea. Perhaps they consulted *Haney's Base Ball Book of Reference*, published in 1868, beforehand.

IMAGE CREDITS

Reproductions of images in this book with Library of Congress identification numbers may be ordered. Please note that many of these images ***are not*** in the public domain and restrictions on their use may apply. Visit the Photoduplication Web Site at http://www.loc.gov/preserv/pds for further information. All reasonable efforts have been made when necessary to secure usage permission from copyright holders. Image creators are identified in captions.

All images reproduced in this book are from Library of Congress divisions. Key to division abbreviations:

GC: General Collections
G&M: Geography & Map Division
MBRS: Motion Picture, Broadcasting, and Recorded Sound Division
MSS: Manuscript Division
MUS: Music Division
P&P: Prints and Photographs Division
RBD: Rare Book and Special Collections Division
VHP: Veterans History Project, American Folklife Center

FRONT MATTER
Title page: detail, P&P LC-DIG-ppmsca-18401. Copyright page: RBD. vi–vii: P&P LC-DIG-ppmsca-19417. viii–ix: P&P LC-DIG-ppmsca-19535. x: P&P LC-DIG-ppmsca-18449. xi: P&P LC-DIG-bbc-0385f. xii: P&P LC-DIG-ggbain-29005. xiv: LC-DIG-ppmsca-18402. xvi: P&P LC-DIG-ppmsca-17527.

CHAPTER 1
2: MSS. 3. MSS. 4. RBD. 5. RBD. 6. RBD (both). 7: RBD (all). 8: RBD. 9: P&P: LC-DIG-ppmsca-09310. 10–11: LC-DIG-ppmsca-17524. 10: RBD. 11: GC. 12: RBD (both). 13: P&P: LC-DIG-pga-00564. 14: RBD. 15: RBD. 16: P&P LC-USZC4-6396. 17: P&P LC-DIG-ppmsca-17526 (top), LC-DIG-pga-00600 (bottom). 18: P&P LC-USZC4-1291 (top), LC-DIG-ppmsca-17530 (bottom). 19: MUS. 20–21: P&P LC-DIG-ppmsca-09312. 22: P&P LC-DIG-ppmsca-17525. 23: P&P LC-DIG-ppmsca-17529 (top), LC-DIG-ppmsca-09564 (bottom). 24: P&P LC-DIG-ppmsca-09311. 25: P&P LC-DIG-ppmsca-18480.

CHAPTER 2
26: P&P LC-DIG-ppmsca-18405. 28: P&P LC-DIG-ppmsca-18773. 29: P&P LC-DIG-ppmsca-18389 (top), RBD (bottom). 30: P&P LC-DIG-ppmsca-18581. 31: P&P LC-DIG-ppmsca-18836. 32–33: P&P LC-DIG-ppmsca-18836. 34: G&M. 35: G&M (top), P&P LC-DIG-ppmsca-11502 (bottom). 36: P&P LC-DIG-ppmsca-18398 (top), LC-USZC4-2776 (bottom). 37: P&P LC-DIG-ppmsca-18392 (top), LC-DIG-ppmsca-18775 (bottom). 38: P&P LC-DIG-ppmsca-18396 (top), LC-DIG-ppmsca-18772 (bottom). 39: P&P LC-DIG-ppmsca-18391 (top), LC-USZ62-114266 (bottom). 40: RBD. 41: GC. 42: GC (all). 43: GC (all). 44: P&P LC-DIG-pga-03350. 45: P&P LC-D4-12586 (top), LC-DIG-pga-02288 (bottom). 46–47: P&P LC-DIG-ppmsca-18397. 47: P&P LC-DIG-bbc-0562f. 48–49: P&P LC-DIG-bbc-0562f. 50–51: Photo by Carol Highsmith. 52: P&P LC-DIG-bbc-0562f (top), LC-USZ62-26149 (middle), LC-DIG-ppmsca-18404 (bottom). 53: P&P LC-USZC4-6864 (top), LC-DIG-ppmsca-18403 (bottom). 54: P&P LC-DIG-ppmsca-09631 (top left), LC-DIG-bbc-0072f (top right), LC-DIG-ppmsca-09629 (bottom left), LC-DIG-ppmsca-09630 (bottom right). 55: P&P LC-DIG-bbc-0053f (top left), LC-DIG-bbc-0053b (top center), LC-DIG-bbc-0032f (top right), LC-DIG-bbc-0002f (bottom left), LC-DIG-bbc-0005f (bottom center), LC-DIG-bbc-0009f (bottom right). 56: P&P LC-DIG-bbc-0181f (top left), LC-DIG-bbc-0542f (top center), LC-DIG-bbc-0154f (top right), LC-DIG-bbc-0233f (bottom left), LC-DIG-bbc-0554f (bottom center), LC-DIG-bbc-0237f (bottom right). 57: P&P LC-DIG-bbc-0576f. 58: P&P LC-USZ62-55758 (left), LC-USZ62-97622 (right). 59: LC-USZ62-1013. 60: P&P LC-DIG-bbc-0004f (top left), LC-DIG-ppmsca-18776 (center), LC-DIG-bbc-0560f (top right), LC-DIG-bbc-0383f (bottom left), LC-DIG-bbc-0505f (bottom right). 61: P&P LC-DIG-ppmsca-09337.

CHAPTER 3
62: P&P LC-DIG-ppmsca-18450. 64: P&P LC-DIG-ppmsca-18471. 65: LC-DIG-ppmsca-18464 (top), LC-DIG-nclc-01159 (bottom). 66: P&P LC-DIG-ppmsca-18468. 67: P&P LC-DIG-ppmsca-18467 (top), GC (bottom). 68–69: P&P LC-USZ62-111826 & LC-USZ62-111827. 68: P&P LC-DIG-ggbain-04721 (bottom). 69: P&P LC-DIG-ppmsca-18577 (bottom). 70: LC-DIG-ppmsca-19536 (left). 70–71: P&P LC-DIG-ppmsca-18472. 72: P&P LC-DIG-ggbain-00283. 73: GC (left), P&P LC-DIG-ppmsca-18837 (right). 74: P&P LC-DIG-ppmsca-18479. 75: P&P LC-DIG-ppmsca-18478. 76–77: P&P LC-DIG-ppmsca-18476. 78: GC *Base Ball: The History, Statistics and romance of the American National Game from its Inception to the Present Time* (1902), by Seymour Roberts Church (top), P&P LC-DIG-ppmsca-18833 (bottom). 79: P&P LC-DIG-ppmsca-18833 (top left), LC-DIG-ggbain-10314 (top right), LC-DIG-ppmsca-18448 (bottom).80: P&P LC-DIG-npcc-04376 (top), LC-DIG-ppmsca-18452 (bottom). 81: P&P LC-DIG-ggbain-02322 (top left), LC-DIG-ppmsca-19054 (top right), LC-DIG-ppmsca-19541 (bottom). 82–83: P&P LC-USZC2-6131. 84–85: P&P LC-DIG-ppmsca-18401. 84: LC-DIG-ppmsca-18470 (bottom). 85: P&P LC-DIG-ppmsca-18454 (middle right), GC (bottom left). 86–87: P&P LC-USZ62-131787. 86: P&P LC-DIG-ggbain-08356 (bottom). 87: P&P LC-DIG-ppmsca-18456 (bottom). 88: P&P pan 6a29668 (top),

LC-DIG-ggbain-04056 (left), GC (right). 89: P&P LC-DIG-ggbain-09872 (top left), LC-DIG-hec-01448 (top right), LC-DIG-ggbain-14488 (bottom). 90: P&P LC-DIG-bbc-1778f (left), LC-DIG-ggbain-29193 (right). 91: P&P LC-USZ62-105850 (top), LC-USZ62-119884 (bottom right). 92: P&P LC-DIG-bbc-0638f. 93: P&P LC-DIG-bbc-2061f (top), LC-DIG-bbc-2061b (middle), LC-DIG-bbc-2098f (bottom). 94: P&P LC-DIG-bbc-1708f (left), LC-DIG-bbc-1701f (right). 95: P&P LC-DIG-bbc-0809f (top left), LC-DIG-bbc-1412b (top right), LC-DIG-bbc-0794f (bottom left), LC-DIG-bbc-0982f (bottom right). 96: P&P LC-DIG-bbc-1087f (far left), LC-DIG-bbc-1321f (left), LC-DIG-bbc-1266f (right), LC-DIG-bbc-1534f (far right). 97: P&P LC-DIG-ppmsca-15619 (top left), LC-DIG-bbc-1383f (top right), LC-DIG-ppmsca-13532 (middle left), LC-DIG-bbc-1368f (middle right), LC-DIG-ppmsca-13533 (bottom left), LC-DIG-bbc-1367f (bottom right). 98: GC (both). 99: P&P LC-DIG-ggbain-09859 (top left), LC-DIG-bbc-2099f (top right), LC-DIG-npcc-19119 (bottom). 100: P&P LC-DIG-ggbain-12681 (top), LC-DIG-ggbain-10960 (bottom). 101: P&P LC-DIG-npcc-19121 (top), LC-DIG-ggbain-11858 (bottom). 102–103: P&P LC-USZ62-119122. 102: P&P LC-DIG-ppmsca-18474 (left), LC-DIG-npcc-19194 (right). 103: P&P LC-DIG-ppmsca-18462 (middle), LC-DIG-ggbain-13489 (bottom). 104: P&P LC-DIG-bbc-2068f (left), LC-DIG-ggbain-09861 (bottom). 105: P&P LC-DIG-ggbain-14466 (top), LC-USZ62-28925 (right). 106–113: MUS (all). 114–115: P&P LC-DIG-ppmsca-18580. 114: P&P LC-DIG-ggbain-16651 (bottom left), LC-DIG-ggbain-17422 (right). 115: P&P LC-DIG-ggbain-14456 (bottom left), LC-DIG-ggbain-17529 (right). 116–117: P&P LC-USZ62-97618. 116: P&P: LC-USZ62-108047 (bottom left), LC-DIG-ggbain-17313 (right). 117: P&P LC-DIG-ppmsca-18459 (left), LC-DIG-ppmsca-18466 (right). 118–119: P&P LC-DIG-ppmsc-02240. 119: P&P LC-DIG-ggbain-25770. 120: P&P LC-DIG-ggbain-22967 (top), LC-DIG-npcc-28196 (bottom). 121: P&P LC-DIG-ggbain-09704, LC-DIG-ppmsca-18463. 122: P&P LC-DIG-hec-02777 (top), LC-DIG-ggbain-08008 (bottom left), LC-DIG-ppmsca-18453 (bottom right). 123: P&P LC-DIG-nclc-05096 (top), LC-DIG-npcc-28193 (bottom). 124–127: MBRS (all).

CHAPTER 4

128: GC. 130: P&P LC-USZ62-97879. 131: P&P LC-DIG-ppmsca-18597. 132: P&P LC-DIG-ppmsca-19537. 133: P&P LC-DIG-npcc-01485 (top), LC-DIG-npcc-05138 (bottom). 134: P&P LC-DIG-npcc-29533 (top), LC-DIG-npcc-04400 (bottom). 135: P&P LC-DIG-npcc-03922 (top), LC-DIG-npcc-08343 (bottom). 136: P&P LC-DIG-ppmsca-19539 (top left), LC-DIG-ppmsca-19540 (top right), LC-DIG-npcc-08576 (bottom). 137: P&P LC-DIG-npcc-11826. 138: P&P LC-DIG-thc-5a47422. 139: P&P LC-DIG-npcc-06715. 140: P&P LC-DIG-npcc-12054 (top), LC-DIG-npcc-12198 (bottom). 141: P&P LC-DIG-npcc-12274 (top), LC-DIG-npcc-12271 (bottom). 142–143: P&P LC-DIG-ppmsca-18576. 142: P&P LC-DIG-npcc-13495 (bottom). 143: LC-DIG-npcc-12300 (bottom). 144: P&P LC-DIG-npcc-13809 (top), LC-USZ62-51270 (bottom). 145: P&P LC-DIG-npcc-14779 (top), LC-DIG-npcc-14168 (bottom). 146: P&P LC-DIG-ggbain-38869 (left), LC-DIG-npcc-18156 (right). 147: GC © 1927 SEPS: Licensed by Curtis Publishing, Indianapolis, IN. All Rights Reserved. www.curtispublishing.com. 148: P&P LC-DIG-npcc-02009. 149: P&P LC-DIG-npcc-00316. 150: P&P LC-USZC4-7246. 151: P&P LC-DIG-ggbain-32384 (top), LC-DIG-npcc-11744 (bottom). 152: P&P LC-USZ62-97851. 153: P&P LC-USZ62-105807 (top), LC-DIG-ppmsca-07845 (bottom) reprinted with permission, AP Images. 154: P&P P&P LC-DIG-ppmsca-18596. 155: P&P LC-DIG-npcc-00415 (top), LC-USZ62-119162 (bottom). 156: P&P LC-USZ62-122449. 157: GC. 158: P&P HABS # KS-49-29 (top), LC-DIG-ppmsca-06615 (bottom). 159: GC By permission of *Boys' Life* magazine, June 1935, published by the Boy Scouts of America. 160: P&P LC-USZ62-116211. 161: GC. 162: P&P LC-USF34-018962-E (left),

LC-USF33-012661-M5 (right). 163: P&P LC-DIG-fsa-8b27902. 164: P&P LC-DIG-fsa-8b34021 (top), LC-USF33-013267-M4 (bottom). 165: P&P LC-USF34-024408-D (top left), LC-USF34-024798-D (top right), LC-USF34-100457-E (bottom left), LC-USW3-007089-D (bottom right).

CHAPTER 5

166: GC Reprinted through the courtesy of the Editors of TIME magazine © 2009 Time Inc. 168: P&P LC-DIG-ppmsca-19542 (left), LC-DIG-ppmsca-19173 (frames #16-21) (right). 169: P&P LC-DIG-ppmsca-18823 © 1940 SEPS: Licensed by Curtis Publishing, Indianapolis, IN. All Rights Reserved. www.curtispublishing.com. 170: P&P LC-DIG-ppmsca-18598. 171: P&P LC-DIG-ppmsca-18598. 172: P&P LC-DIG-ppmsca-18591. 173: P&P LC-DIG-ppmsca-18818. 174: P&P LC-DIG-ppmsca-18793. 175: MUS Reprinted with permission/Bob Fosse-Gwen Verdon Collection, Library of Congress. 176: P&P LC-DIG-ppmsca-18778. 177: GC. 178: P&P LC-DIG-ppmsca-18787. 179: P&P LC-DIG-ppmsca-18830. 180: P&P LC-DIG-ppmsca-18587. Reproduced by permission of The Bendiner Foundation. 181: P&P LC-DIG-ppmsca-19534. 182: MBRS (both). 183: GC Reprinted with permission, Getty Images. 184: GC. 185: P&P P&P LC-USW3-022973-C. 186–187: P&P LC-DIG-ppprs-00369. 188: VHP Emil Mrizek Collection (AFC/2001/001/53699), Veterans History Project, American Folklife Center, Library of Congress. 189: P&P LC-DIG-ppmsca-18797. 190: VHP John Dietrich Collection (AFC/2001/001/49140), Veterans History Project, American Folklife Center, Library of Congress (top), Joseph Galano Collection (AFC/2001/001/1439), Veterans History Project, American Folklife Center, Library of Congress (bottom). 191: VHP John Watson Collection (AFC/2001/001/43101), Veterans History Project, American Folklife Center, Library of Congress. 192: P&P LC-DIG-ppmsca-18796. 193: GC. 194: GC. 195: MBRS (top left and bottom), GC (top right). 196–197: P&P LC-DIG-ppmsca-18795. Reprinted with permission, AP Images. 198: GC. 199: GC. 200: GC. 201: MBRS (top left, top right, middle), GC (bottom). 202: P&P LC-DIG-ppmsca-18592. 203: GC. Action Comics #389 © 1970 DC Comics. All Rights Reserved. Used with permission. 204: P&P LC-DIG-ppmsca-18786. Reprinted with permission, AP Images. 205: P&P LC-DIG-ppmsca-18788 (top) reprinted with permission, AP Images; LC-DIG-ppmsca-18789 (bottom). 206: P&P LC-DIG-ppmsca-19538 (top left), G&M (right). Use of Sanborn map reprinted/used with permission from The Sanborn Library, LLC. 207: P&P LC-DIG-ppmsca-18824. © 1949 SEPS: Licensed by Curtis Publishing, Indianapolis, IN. All Rights Reserved. www.curtispublishing.com. 208: P&P LC-DIG-ppmsc-00039. 209: MMS. 210: P&P LC-DIG-ppmsca-18819. 211: MBRS, P&P LC-USZC4-6146. 212: P&P LC-USZC4-6144. 213: P&P LC-L9-54-3566-O, #7 (top), MSS (center left, bottom right). 214: P&P LC-DIG-ppmsca-18825. 215: P&P LC-DIG-ppmsca-18828. Reprinted with permission of Murray Olderman. 216: GC (top), MUS (bottom). 217: MUS. 218: P&P LC-DIG-ppmsca-18870. 219: P&P LC-DIG-ppmsca-18845 (top), LC-DIG-ppmsca-18849 (bottom) © Marvin E. Newman, courtesy Bruce Silverstein. 220–221: P&P LC-DIG-ppmsca-18869. 222: P&P LC-DIG-ppmsca-18851 © Marvin E. Newman, courtesy Bruce Silverstein. 222–223: P&P LC-DIG-ppmsca-18854 © Marvin E. Newman, courtesy Bruce Silverstein. 224: P&P LC-USZ6-2396 (top), LC-USZ6-2386 (bottom) © Marvin E. Newman, courtesy Bruce Silverstein. 225: P&P LC-DIG-ppmsca-18871. 226: P&P LC-DIG-ppmsca-18868 (top), LC-DIG-ppmsca-18876 (bottom). 227: P&P LC-DIG-ppmsca-18862 (top), LC-DIG-ppmsca-18866 (bottom). 228: P&P LC-DIG-ppmsca-18858 © Marvin E. Newman, courtesy Bruce Silverstein. 229: P&P LC-DIG-ppmsca-18861 (top), LC-DIG-ppmsca-18860 (center), LC-DIG-ppmsca-18875 (bottom). 230: MUS. 232: MUS. 234: P&P LC-DIG-ppmsca-06616. 240: P&P LC-DIG-nclc-02814.

INDEX

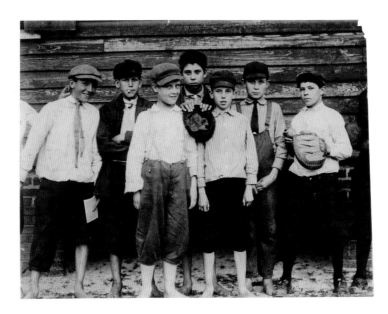

***Night Work,* photograph by Lewis Hine.** Young workers at the Massey Hosiery Mills, Columbus, Georgia, April 1913.

No. 100. Hill's Patent Spring Bat. $9.00 Per Doz. Best Sapling Ash.

No. 101. Hill's Patent Fluted Bat. $6.00 Per Doz. Best American Willow.

No. 102. Picked American Willow Bat. 8.00 Per Doz. Full French Polished.
No. 103. Same as No. 102. Half Polished. $5.00 Per Doz.

No. 104. American Willow, (Wound Handle). $6.00 Per Doz.
No. 108. Am. Willow, (Ash Loaded). $9.00 Per Doz. Lightest and Toughest made.
No. 109. Lyman's Patent Self-Adjusting Bat. $9.00 Per Doz.

MUTUAL B.B.C. MODEL.

No. 110. Ash and American Willow Bat. $3.50 Per Doz.

PECK & SNYDER Manufacturers, 126 Nassau Street, New York.

No. 152. No. 153. No. 152. No. 153. No. 152. No. 153. No. 152.

No. 154. No. 155. No. 154. No. 155. No. 154. No. 155. No. 154.

No. 156. No. 157. No. 156. No. 157. No. 156. No. 157. No. 156.

No. 164. No. 165. No. 164. No. 165. No. 164. No. 165. No. 164.